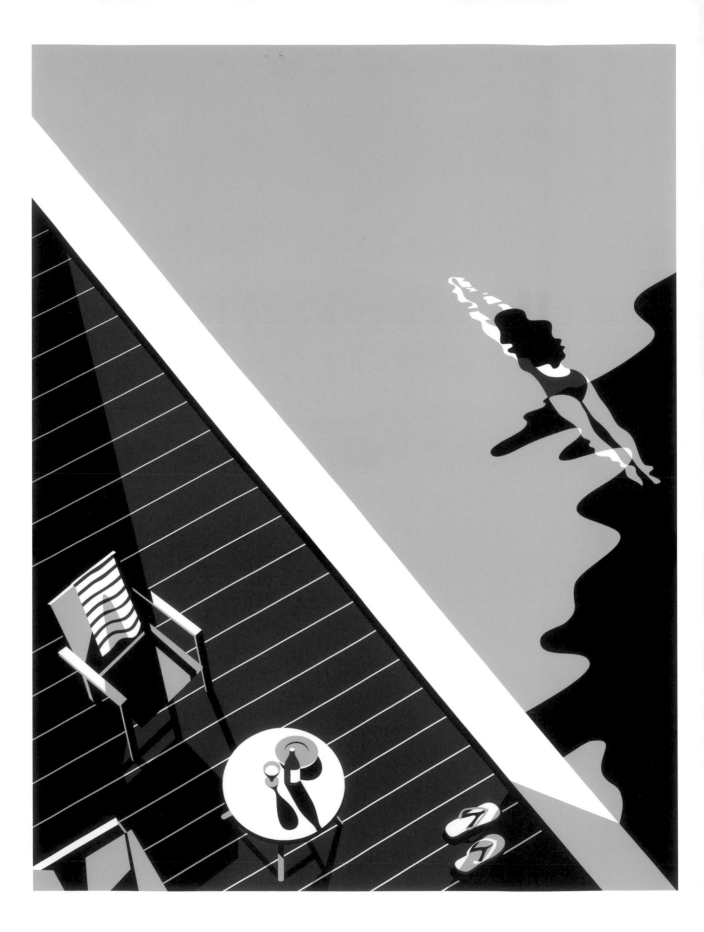

Edited by
Julius Wiedemann

ILLUSTRATION NOW!

5

TASCHEN

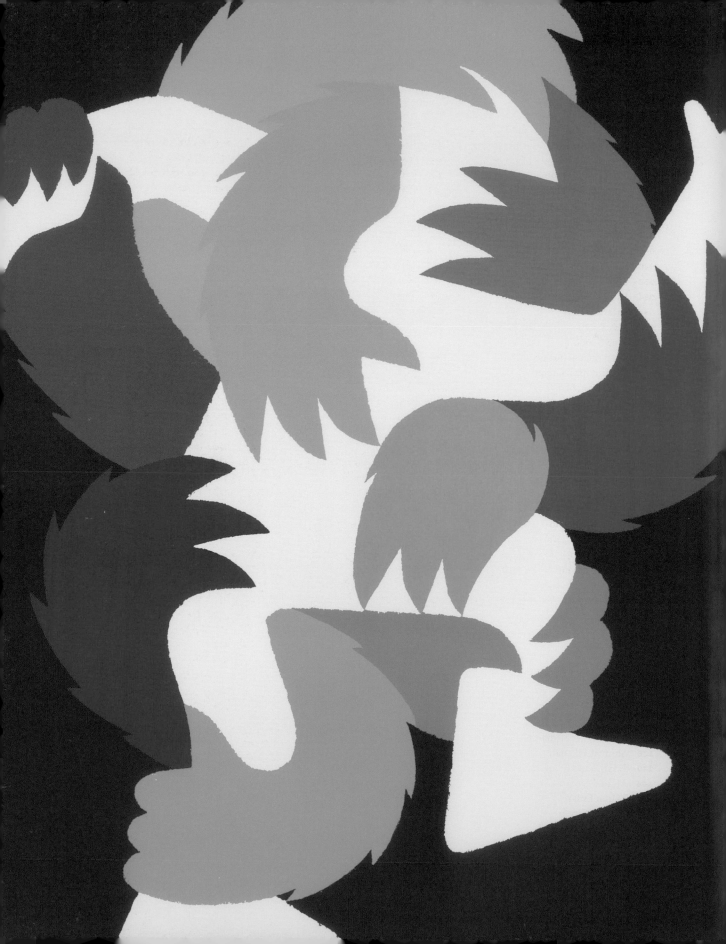

007	A Powerful Mixture	011	Styles in Transition	446	Agents Index
008	Ein starker Mix	015	Stilwechsel		
009	Un mélange puissant	019	Styles en transition		

024	Esther Aarts	164	Ricardo Fumanal	304	Caleb Morris
026	Youssef Abdelké	166	Justin Gabbard	308	Nik Neves
030	Mattias Adolfsson	170	Paolo Galetto	312	Robert Nippoldt
034	Yanneth Albornoz	174	Paul Garland	316	Nomoco
036	Clara Aldén	176	Ugo Gattoni	320	Nomono
040	Rafael Alvarez	180	Leonardo Gauna	324	Agata Nowicka
044	Toril Bækmark	182	Owen Gildersleeve	328	Eiko Ojala
046	Noma Bar	184	Ricardo Gimenes	332	Luigi Olivadoti
048	Jonathan Bartlett	186	Bex Glover	336	Zé Otavio
052	Moa Bartling	188	Neil Gower	340	Otto
054	Pablo Bernasconi	190	Sam Green	342	Simón Prades
058	Ricardo Bessa	194	Roya Hamburger	344	Daniel Ramirez Perez
060	Lisa Billvik	196	Emma Hanquist	346	David de Ramón
062	Lina Bodén	198	Adam Herbert	350	Sophie Robert
064	Katarzyna Bogucka	202	Maria Herreros	352	Jeff Rogers
066	Oscar Bolton Green	206	Jakob Hinrichs	354	Jungyeon Roh
068	Beata Boucht	208	Jack Hughes	356	Catell Ronca
072	Christopher Brown	212	Primary Hughes	360	Malin Rosenqvist
076	Yelena Bryksenkova	216	Meg Hunt	362	Conrad Roset
080	Dominic Bugatto	220	Sarah Jackson	364	Stacey Rozich
082	Marc Burckhardt	222	David Jien	366	Bożka Rydlewska
086	Jon Burgerman	224	Adrian Johnson	370	Sac Magique
088	Cachetejack	228	Paweł Jońca	374	Jérémy Schneider
092	Jill Calder	232	Erik Jones	376	Jared Schorr
094	Marjolein Caljouw	234	Melinda Josie	378	Carmen Segovia
096	Natsuki Camino	236	Chris Kasch	380	Matthias Seifarth
100	Gwénola Carrère	240	Yann Kebbi	384	Adam Simpson
102	Stanley Chow	244	Gary Kelley	388	Katy Smail
104	Lucie Clement	246	Sarah King	390	Mark T. Smith
108	Russell Cobb	248	Edward Kinsella	392	Véronique Stohrer
110	Sue Coe	252	Uli Knörzer	394	Kera Till
114	Hugh Cowling	254	Rory Kurtz	396	Ole Tillmann
116	Paul Cox	258	Gian Paolo La Barbera	400	Robert Tirado
118	Dan Craig	260	Tim Lahan	402	Saurabh Turakhia
122	Craig & Karl	262	Poul Lange	404	Patrick Vale
126	Deedee Cheriel	264	Jules Le Barazer	408	Andrea Ventura
128	Peter Donnelly	266	Gwendal Le Bec	410	Alexander Vorodeyev
130	Elzo Durt	268	Yann Legendre	412	Holly Wales
132	Sarah Egbert Eiersholt	270	David Litchfield	414	Sarah Walton
134	Thomas Ehretsmann	272	Junior Lopes	416	Angie Wang
138	Shimrit Elkanati	274	Diogo Machado	420	Zhang Weber
140	Ellakookoo	278	Mágoz	422	Ellen Weinstein
142	Miguel Endara	282	Gregory Manchess	426	Dave White
146	Maren Esdar	286	James McMullan	428	Richard Wilkinson
150	Chrigel Farner	288	Carlo Miccio	432	Ben Wiseman
154	Malika Favre	290	Russ Mills	436	Pam Wishbow
156	Nathan Fox	292	Dyna Moe	438	Wishcandy
158	Jonna Fransson	294	Narges "Hasmik" Mohammadi	440	Andy Yang
160	Shannon Freshwater	298	Anette Moi	442	Ping Zhu
162	Carla Fuentes	300	T. Dylan Moore	444	Lynnie Zulu

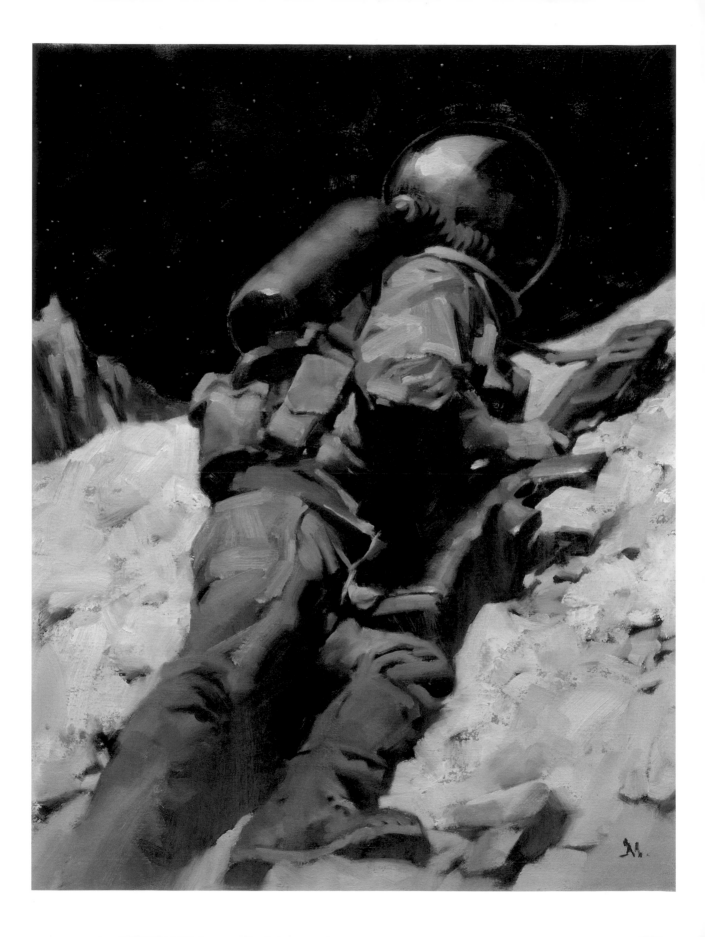

A Powerful Mixture

by Julius Wiedemann

Today illustration is all around us. This is what I have come to realize, after the seven previous books in the *Illustration Now!* series.

For each book Steven Heller and I select 150 strong and individual artists—and no one should underestimate how hard it is to impress Heller, whose knowledge of art, design, typography and illustration means it is just like winning an award for those illustrators who make the cut and get to join the group. Together, their work combines to form one beautiful book. In this sense, we are not aiming for a normal showcase, but a publication that features the best quality of illustration nowadays. With this editorial point of view we have always hoped to receive recognition from the professionals in the field. And there are many—from the artists to their agents, from art directors to stylists, from admen to product developers.

When I now see our illustration books in the living-rooms of people who perhaps normally wouldn't be interested in draftsmanship, it really lifts me up. It shows that after a decade of struggle, and presumed pushed aside by digital, illustration has been resurrected and has exploded in such a way that people can really understand what it can do. Illustration is more used now than ever. There is an incredible number of newcomers in the field, and the magnificent work of illustration veterans fills galleries and museums.

I'm happy to feature pieces by some of these old masters in this edition, the eighth to appear, who for one reason or another still hadn't made their way into earlier selections. Some people would call them old-school, or traditional illustrators, I call them the enlighteners of these publications. These guys have been in the field for over 20 years, and decided against all odds to become illustrators full-time. They have faced a period when people thought everything could be solved by a teenager in front of a computer. And I believe it is because of these veterans, who have raised the bar so high, that there are now teenagers doing such outstanding work, and who value the effort and the craft of what makes a good artist.

Our selection process has taught us a lot about the art of illuminating—the origin of the word illustration—especially because there are boundaries that can be crossed today, but which were hard even to imagine a couple of decades ago. Is it the decay of purism? In those disappearing limits I see a powerful mixture of talent, hard work, technological shift and (why not?) luck, being what sets illustrators free to find their paths. And I am sure the future will be even brighter. I feel that we have achieved a milestone with this series—now looking more and more like art books.

I hope you enjoy the works by the brave artists here who tell their dramatic, romantic, intriguing, spooky, and most of all beautiful stories, illuminating our daily lives with ever-strong emotions.

Ein starker Mix

von Julius Wiedemann

Heute geht ohne Illustration gar nichts. Das ist mir nach den sieben vorherigen Bänden der Serie *Illustration Now!* klar geworden.

Für jede Ausgabe suchen Steven Heller und ich 150 überzeugende, originelle Künstler – wobei man wissen muss, dass Heller notorisch schwer zu beeindrucken ist. Angesichts seines immensen Wissens über Kunst, Design, Typografie und Illustration kommt die Aufnahme in diesen illustren Kreis einer Auszeichnung gleich. Das gesammelte Werk dieser Illustratoren bildet ein wunderschönes Buch. Schließlich wollen wir keinen üblichen Schaukasten präsentieren, sondern vielmehr die besten Illustrationen, die heute entworfen werden. Mit diesem redaktionellen Ansatz hoffen wir, die Anerkennung der ganzen Branche zu gewinnen. Und die hat viele Vertreter: die Künstler selbst ebenso wie ihre Agenten, die Artdirectors und Stylisten, die PR-Leute und Produktentwickler.

Wenn ich unsere Illustrationen-Bücher heute bei Menschen im Wohnzimmer liegen sehe, die mit Grafik eigentlich nichts im Sinn haben, empfinde ich das als eine wunderbare Bestätigung. Immerhin beweist es, dass die Illustration nach zehn mühsamen Jahren, in denen sie als digital überholt erschien, Wiederauferstehung feiert und derart Furore macht, dass den Menschen schließlich die Augen aufgegangen sind, was das Medium tatsächlich bewirken kann. Illustrationen finden jetzt häufiger Verwendung als je zuvor. Es gibt in der Branche unglaublich viele neue Namen, und die großartigen Illustrationen der Veteranen hängen in Galerien und Museen.

Ich freue mich, in diesem – dem achten – Band einige Arbeiten dieser alten Meister zu präsentieren, die aus dem einen oder anderen Grund irgendwie nie in früheren Büchern vertreten waren. Manche mögen sie *old-school* nennen oder traditionelle Illustratoren, für mich sind sie die Aufklärer dieser Veröffentlichungen. Diese Leute arbeiten seit über zwanzig Jahren in der Branche und entschieden sich entgegen dem Zeitgeist für ein Leben als freischaffender Illustrator. Das war in einer Zeit, als viele glaubten, ein vorm Computer sitzender Teenager könne alle anstehenden grafischen Probleme lösen. Nach meinem Dafürhalten gibt es heute nur dank dieser Veteranen und der Messlatte, die sie so hoch hängten, die vielen Teenager, die herausragende Arbeiten abliefern und die die Mühe und die Arbeit dessen, was einen guten Künstler ausmacht, zu schätzen wissen.

Während der Auswahl haben wir viel über die Kunst der Illumination – den Ursprung des Wortes „Illustration" – gelernt, vor allem weil es Grenzen gibt, die man sich vor zwanzig Jahren nie hätte vorstellen können und über die man heute hinausgehen kann. Ist das der Niedergang des Purismus? Ich erkenne in den sich auflösenden Grenzen eine kraftvolle Mischung von Talent, harter Arbeit, technischen Veränderungen und – warum nicht? – auch Glück, und all das zusammen erlaubt den Illustratoren, ihren jeweils eigenen Weg zu finden. Und die Zukunft wird noch strahlender werden, davon bin ich überzeugt. Ich habe den Eindruck, dass wir mit dieser Serie einen Meilenstein gesetzt haben – und die Bücher sehen zunehmend wie richtige Kunstbücher aus.

Ich hoffe, Ihnen gefallen die Arbeiten dieser mutigen Künstler, die ihre dramatischen, romantischen, spannenden, unheimlichen, vor allem aber schönen Geschichten erzählen und unseren Alltag mit mitreißenden Gefühlen – nun ja: illuminieren.

Un mélange puissant

par Julius Wiedemann

Aujourd'hui, l'illustration est partout autour de nous. C'est ce que j'ai fini par réaliser, après les sept précédents volumes de la série *Illustration Now!*

Pour chaque volume, Steven Heller et moi avons sélectionné 150 artistes individuels forts – et personne ne devrait sous-estimer combien il est difficile d'impressionner Heller, dont la connaissance de l'art, du design, de la photographie et de l'illustration fait qu'entrer dans ce groupe signifie tout autant que remporter un prix international. Leur travail se combine pour former un superbe ouvrage. En ce sens, nous n'avons pas essayé de créer une simple présentation, mais une publication qui donne à voir le meilleur de l'illustration aujourd'hui. C'est avec cette perspective rédactionnelle que nous avons toujours espéré obtenir la reconnaissance des professionnels du secteur. Et ils sont nombreux : les artistes et leurs agents, les directeurs artistiques et les stylistes, les publicitaires et les concepteurs de produits.

Lorsque je vois nos livres sur l'illustration trôner dans les salons de personnes qui ne s'intéresseraient peut-être pas normalement au métier de dessinateur, cela me fait vraiment chaud au cœur. Cela montre qu'après une décennie de lutte, et alors que certains avaient cru que le numérique l'avait mise sur la touche, l'illustration est revenue à la vie et a explosé de telle manière que les gens peuvent réellement comprendre ce qu'elle est capable de faire. L'illustration est plus en vogue que jamais. Il y a un nombre incroyable de nouveaux venus, et le magnifique travail des vétérans de l'illustration remplit les galeries et les musées.

Dans cette édition, la huitième à paraître, je suis heureux de présenter les œuvres de ces vieux maîtres qui, pour une raison ou une autre, n'avaient pas encore été inclus dans les sélections précédentes. Certains pourraient les qualifier d'illustrateurs traditionnels, ou de la vieille école, moi je trouve qu'ils sont les lumières de ces publications. Actifs dans ce secteur depuis plus de 20 ans, ils ont décidé contre vents et marées de devenir illustrateurs à plein temps. Ils ont dû traverser une période pendant laquelle on a pensé que n'importe quel problème pouvait être résolu par un adolescent campé derrière un ordinateur. Et je pense que c'est grâce à ces vétérans qui ont placé la barre si haut qu'il y a aujourd'hui des adolescents qui font un travail si admirable, et qui savent qu'un bon artiste se nourrit d'effort et de savoir-faire.

Notre processus de sélection nous a beaucoup appris sur l'art de l'illumination (l'origine du mot illustration), plus particulièrement parce qu'il y a des limites que l'on peut franchir aujourd'hui, mais que l'on avait du mal à imaginer il n'y a encore qu'une vingtaine d'années. Est-ce le déclin du purisme ? Dans ces limites qui disparaissent, je vois un mélange puissant de talent, de travail acharné, d'évolution technologique et (pourquoi pas ?) de chance, qui donne aux illustrateurs la liberté de trouver leurs chemins. Et je suis sûr que l'avenir sera encore plus brillant. Je pense que nous avons atteint une étape importante avec cette série, qui ressemble de plus en plus à une série de livres d'art.

J'espère que vous apprécierez les œuvres de ces courageux artistes, qui racontent ici leurs histoires dramatiques, romantiques, intrigantes, effrayantes, et surtout magnifiques, qui illuminent nos vies quotidiennes de leurs émotions toujours si intenses.

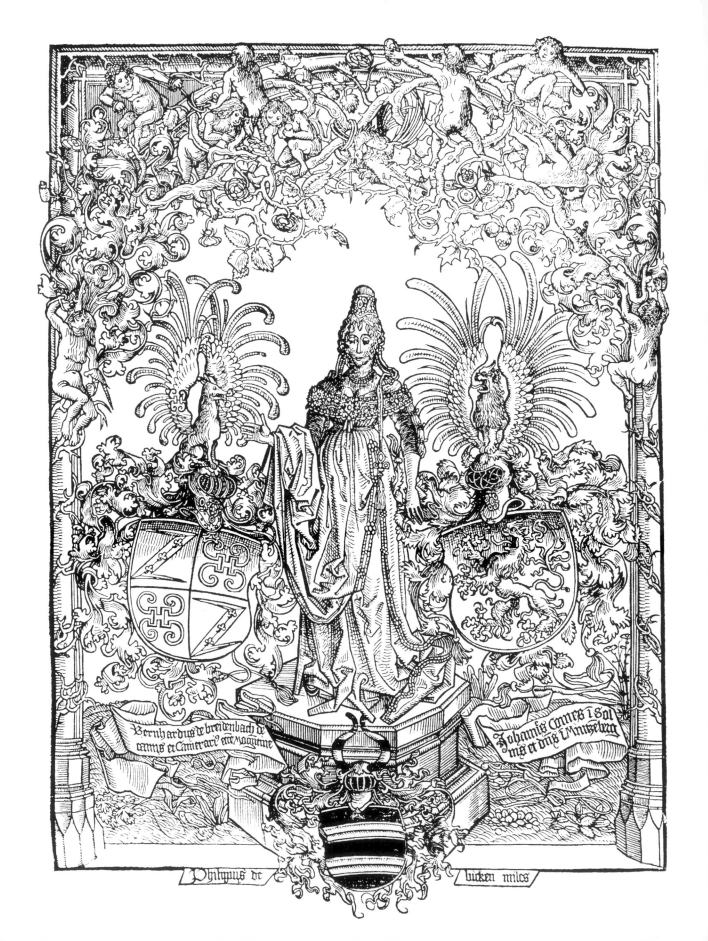

Styles in Transition

Illustration will never die

by Steven Heller

Foolishly, as it turns out, I've predicted that every edition of *Illustration Now!* marked the last gasp for illustration. Yet each year when a hefty new volume is published, my inner Nostradamus tells me, in unkind words, how short-sighted I am. Never again will I write or utter the phrase "Illustration is dead." So, here and now I vow that illustration will *never* die. This is my way to save face.

But wait! Just because my illustration's demise prediction is indeed premature, real changes in mass media have definitively altered the field and its practitioners. Change should not, obviously, be seen as gloom and doom, but there are implications for the future, and *Illustration Now!* represents the recent and impending future.

But first, let's look at the past: as far back as the 15th century, the invention of the printing press triggered technological, economical and even philosophical shifts in what was then the media that transformed the art of illustration. Gutenberg's wondrous machine made writing and illuminating sacred manuscripts by hand unnecessary. Centuries later, the ability to print lithographic and engraved images altered illustration methods and styles. In the early 19th century Friedrich Koenig's steam-powered rotary printing presses increased the overall number of publications—books, newspapers and magazines—providing illustrators with almost limitless publishing opportunities. In 1882, when Georg Meisenbach patented the halftone screen allowing photographs to be faithfully reproduced, illustration evolved from a realistic documentary to an impressionist storytelling art-form. And now digital advancements have impacted on the look, if not the content of illustration too. Change and renewal are frequent and recurring. During the decade since the publication of the first *Illustration Now!*, illustration has moved into an ever-increasing eclectic realm with so many styles and stylized artists to choose from that it would be hard for anyone, especially me, to predict the future of the field as being anything but sunny and bright.

The difference between today's illustration and the 1930s, '40s and '50s styles is day and night but illustration has continued to flourish unabated. When populist Romantic realism was replaced by hard-edged expressionism, the center-stage role of illustration in magazines declined, but the world didn't end. When '70s, '80s and '90s expressionistic conceptualism was usurped by what I call today's NeoNarrative-ism, illustrators were and are still in demand because illustration provides viewer interactions that other visuals do not.

The current crop of NeoNarrative illustration is not about making aggressive conceptual "statements," rather the current trend is for witty visual storytelling (and if you didn't know it, *storytelling* is the new buzzword in art and design) that combines representational, impressionist and expressionist methods—all in one or in measured amounts. These particular artistic methods are not new, but overall the narrative illustration practice is on a different track than ever before. Here's how:

When illustration was the primary visual medium, before photography became dominant in the '50s, its role was to help the viewer realize, idealize or concretize an internal vision of "content" that was conveyed by words. To this end, illustrators pictorially mimicked a line or passage from a manuscript. What you read is what you saw. So, rather than imagining what a subject looked like, the illustrator told the reader what to think and see—his illustration was a literal representation. This changed somewhat when certain audiences no longer wanted to be told how to imagine, but chose to conjure up their own images.

Illustration's current job, therefore, is more interpretive in a narrative context. Rather than show what's already been eloquently described in words, illustration presents alternative perspectives that enhance the storytelling experience by adding dimension to a page or whatever the medium may be.

Many illustrators are concept-driven in so far as they use symbol, allegory and metaphor to convey a message, represented here by the acerbic Sue Coe (p.110), beguiling Ben Wiseman (p.432) and entrancing Noma Bar (p.46). Their illustrations have integral meanings—they tell a story apart from whatever they are illustrating. NeoNarrative illustration is an amalgam of every

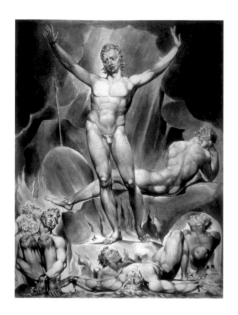

conceit, trope, method and technique available to the illustrator today. Yet it is not quite like "sampling," since individual illustrators focus on their own piece of the larger patchwork, but are influenced by many who came before.

This diversity is a hallmark of *Illustration Now! 5*. However, there are some graphic similarities within this selection that signal what may be the beginning (or end) of small trends. (Frankly, I consider two or more illustrators with similar traits a trend.) Below are the curious characteristics I noticed in this volume, here categorized in alphabetical order:

Absurdliness The juxtaposition of inexplicable or random objects: Mattias Adolfsson, Jonathan Bartlett, Pablo Bernasconi

Beardsleyesqueries Inclusion of curlicue for Beardsleyesque hair: Toril Bækmark, Sarah Egbert Eiersholt, Leonardo Gauna, Katy Smail

Cleverosity Humorous juxtapositions that trigger double-takes: Christopher Brown, David de Ramón

Colorphilia Unexpected, soothing color combinations: Moa Bartling, Erik Jones

Comic Book Revival Representational renderings that recall the golden age of romance and action comics: Rafael Alvarez, Dominic Bugatto, Nathan Fox, Agata Nowicka

Flora and Fauna Graphic forests, gardens and jungles (Rousseau style): Ricardo Fumanal, Sarah Jackson, Junior Lopes, Malin Rosenqvist, Bożka Rydlewska

Geometric Simplicity Simple shapes, flat colors and right angles: Katarzyna Bogucka, Lucie Clement, Craig & Karl

Goofy Simply, well, goofy: Jon Burgerman, Jules Le Barazer

Iconic Icons Logo-like pictograms and glyphs: Oscar Bolton Green, Ricardo Gimenes

Liquid Looseness Luscious, silky, wavy watercolor: Paul Cox, Paolo Galetto, Conrad Roset

Magic Realism Surrealist fantasy worlds: Marc Burckhardt, Dan Craig, Rory Kurtz

Noir Light in Color 21st-century Edward Hoppers: Thomas Ehretsmann, Primary Hughes

Vignette-Symphonics Orchestrated miniatures: Nik Neves, Zé Otavio, Patrick Vale

Granted, these are my personal categories, and a lot of the *Illustration Now! 5* contents do not fit any of my forced taxonomies. Still, it is fun to draw these connections because that is how styles are determined. If nothing else, *Illustration Now! 5* is about styles in transition. I can't wait for the next volume, now that I know illustration will never die.

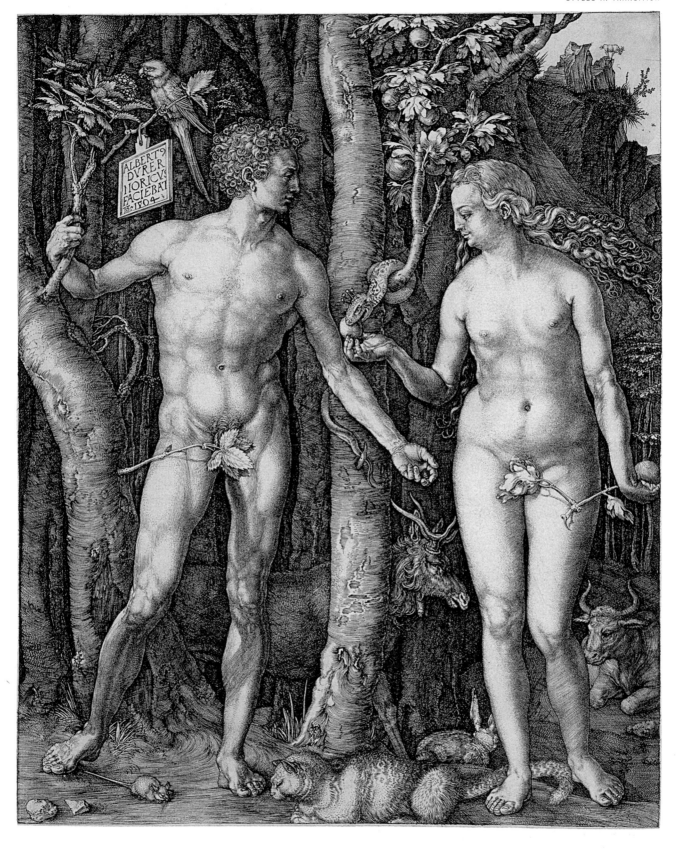

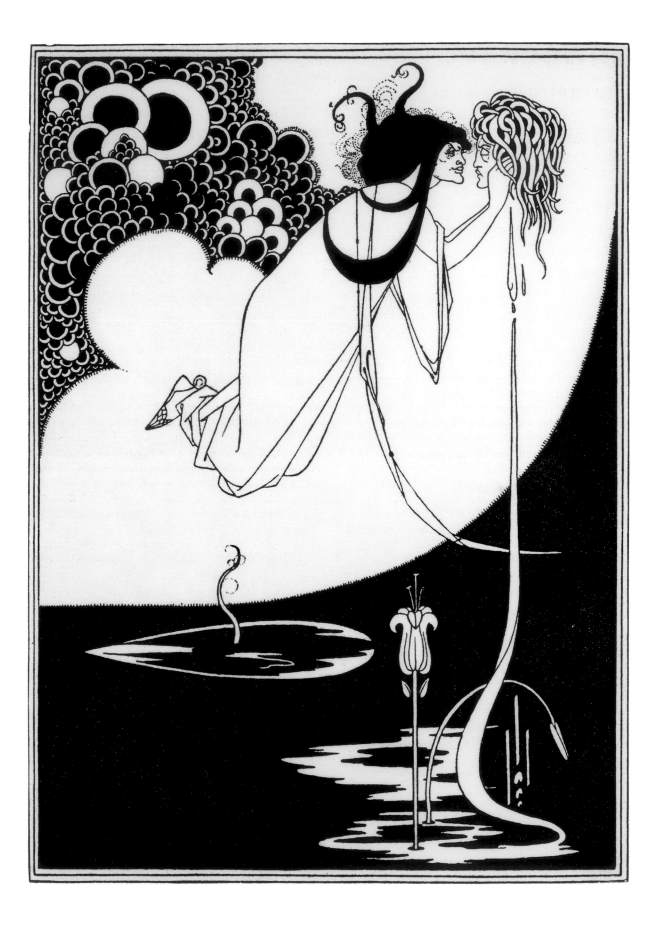

Stilwechsel

Illustration ist unsterblich

von Steven Heller

Leider war ich töricht genug, jeden neuen Band von *Illustration Now!* als Abgesang der Illustration zu bezeichnen. Und jedes Mal, wenn ein gewichtiger neuer Band erscheint, also alljährlich, zeiht mein innerer Nostradamus mich mit unfreundlichen Worten der Kurzsichtigkeit. Nie wieder werde ich, ob mündlich oder schriftlich, den Satz äußern: „Die Illustration ist tot." Hier und jetzt schwöre ich, dass die Illustration nie sterben wird. Das ist meine Art, das Gesicht zu wahren.

Aber Moment mal! Meine Prophezeiung vom Tod der Illustration mag ja tatsächlich voreilig gewesen sein, trotzdem haben sich die Branche und ihre Werktätigen durch Neuerungen in den Massenmedien stark verändert. Nun sind Veränderungen natürlich kein Grund, Trauer zu tragen, doch sind sie für die Zukunft von Bedeutung, und *Illustration Now!* repräsentiert die soeben vergangene und ummittelbar bevorstehende Zukunft.

Werfen wir zunächst einmal einen Blick in die fernere Vergangenheit. Bereits im 15. Jahrhundert führte die Erfindung der Druckmaschine zu technischen, wirtschaftlichen und gar philosophischen Veränderungen in der damaligen „Medienwelt" und damit auch in der Kunst der Illustration. Durch Gutenbergs Wundermaschine erübrigte es sich, religiöse Manuskripte von Hand zu kopieren und zu illuminieren. Jahrhunderte später wurden die Methoden und Stile der Illustration durch die Möglichkeit, radierte und gravierte Bilder zu drucken, auf den Kopf gestellt. Anfang des 19. Jahrhunderts dann stieg durch Friedrich Koenigs dampfbetriebene Zylinderdruckmaschine die Zahl der Veröffentlichungen – Bücher, Zeitungen und Zeitschriften –, was Illustratoren schier unbegrenzte Möglichkeiten des Publizierens eröffnete. Als Georg Meisenbach 1882 das Rasterverfahren erfand, mit dessen Hilfe Fotos wiedergegeben werden konnten, wurde die Illustration von einem realistischen Dokument zu einer impressionistischen, narrativen Kunstform. Und in unserer Zeit beeinflussen die digitalen Errungenschaften wiederum die Optik, wenn nicht gar den Inhalt der Illustration. Veränderung und Erneuerung allenthalben. In den zehn Jahren seit Erscheinen des ersten Bands

von *Illustration Now!* hat die Illustration immer eklektischere Höhen erreicht, es gibt derart viele Stile und stilisierte Künstler, dass ihr wohl niemand mehr (geschweige denn ich) etwas anderes als eine sonnige, verheißungsvolle Zukunft prophezeien kann.

Die heutige Illustration unterscheidet sich wie Tag und Nacht vom Stil der 30er-, 40er- und 50er-Jahre, doch setzte sie ihren Siegeszug ungehindert fort. Als der populistische romantische Realismus durch den strengen Expressionismus abgelöst wurde, verlor die Illustration die maßgebliche Rolle, die sie in Zeitschriften gespielt hatte, aber deshalb ging die Welt nicht unter. Als der expressionistische Konzeptualismus der 70er-, 80er- und 90er-Jahre durch den von mir so genannten Neo-Narrativismus ersetzt wurde, blieben Illustratoren trotzdem gefragt, schlicht weil Illustrationen im Gegensatz zu anderen Bildgenres eine Interaktion mit dem Betrachter ermöglichen.

In der gegenwärtigen neo-narrativen Illustration sind nicht mehr aggressive konzeptuelle „Statements" angesagt, vielmehr geht der Trend hin zu geistreichen visuellen Storys (für den Fall, dass Sie das noch nicht wussten: „Storytelling" ist in der Kunst und im Design das ultimative neue Schlagwort), und das verlangt sowohl gegenständliche als auch impressionistische und expressionistische Methoden – paritätisch gemischt oder in unterschiedlichen Dosen. Diese künstlerischen Methoden sind zwar nicht neu, doch insgesamt hat die Praxis der narrativen Illustration einen völlig neuen Weg eingeschlagen. Es ist nämlich so:

Ehe die Fotografie in den 50er-Jahren zum führenden visuellen Medium aufstieg, hatte diese Rolle der Illustration oblegen. Ihre Aufgabe war es gewesen, dem Leser zu helfen, ein inneres Bild des von den Worten vermittelten „Gehalts" zu sehen, zu idealisieren oder zu konkretisieren. Zu dem Zweck gestalteten die Illustratoren bildlich eine Zeile oder einen Absatz des Textes nach. Man sah, was man las. Der Leser brauchte sich das bewusste Sujet nicht vorzustellen, der Illustrator gab ihm vor, was er denken und sehen sollte. Die Illustration war also buchstäblich eine Wiedergabe. Das veränderte sich ansatzweise erst, als eine bestimmte

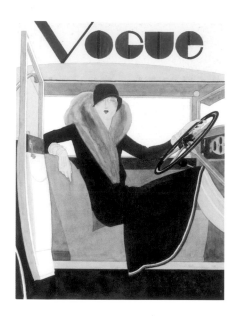

Pierre Mourgue, 1929
Vogue, cover March 1929

→ **J. Howard Miller, 1943**
We Can Do It, war-time propaganda
poster for Westinghouse Electric

p.14 **Aubrey Beardsley, 1893**
The Climax, final scene of Oscar Wilde's
play Salome; line-block print

Leserschaft es vorzog, eigene Bilder heraufzubeschwören, anstatt sehen zu müssen, wie sie sich etwas vorzustellen habe.

Heute besteht die Aufgabe einer Illustration eher darin, im narrativen Kontext eine Interpretation zu liefern. Sie soll nicht das vor Augen führen, was bereits anschaulich in Worten beschrieben wird, sondern alternative Perspektiven aufzeigen, die die erzählte Geschichte bereichern und einer Zeitschriftenseite – oder worum es sich auch handeln mag – eine weitere Dimension verleihen.

Viele Illustratoren sind insofern an einem Konzept ausgerichtet, als sie Symbole, Allegorien und Metaphern verwenden, um eine Botschaft zu vermitteln, hier repräsentiert von Sue Coe mit ihrer beißenden Kritik (S. 110), dem betörenden Ben Wiseman (S. 432) und Noma Bar mit seiner verblüffenden Schlichtheit (S. 46). Diese Illustrationen habe inhärent eine Bedeutung, sie erzählen eine Geschichte, was immer sie auch bebildern mögen. Die neo-narrative Illustration ist eine Mischung aus jedem Einfall, jedem Tropus, jeder Methode und jeder Technik, die einem Künstler heute zur Verfügung stehen. Und doch kann man das nicht als „Sampling" bezeichnen, denn jeder Illustrator beschränkt sich, den Einflüssen vieler Vorgänger zum Trotz, auf sein eigenes Feld im großen Patchwork.

Diese Vielfalt ist ein Markenzeichen von *Illustration Now! 5*. Allerdings gibt es in dieser Auswahl einige grafische Ähnlichkeiten, die vielleicht den Anfang (oder das Ende) eines kleinen Trends darstellen. (Um ehrlich zu sein, betrachte ich zwei oder mehr Illustratoren mit ähnlichen Stilelementen als einen Trend.) Nachfolgend in alphabetischer Ordnung die Charakteristika, die mir in diesem Band ins Auge fielen:

Absurditäten Das Nebeneinander von unerklärlichen oder beliebigen Objekten: Mattias Adolfsson, Jonathan Bartlett, Pablo Bernasconi

Beardsleysquerien Beardsley'sche Ringel- und Lockenfrisuren: Toril Bækmark, Sarah Egbert Eiersholt, Leonardo Gauna, Katy Smail

Cleverositäten Geistreiche Gegenüberstellungen, die den Betrachter stutzen lassen: Christopher Brown, David de Ramón

Colorphilie Überraschende, gefällige Farbpaarungen: Moa Bartling, Erik Jones

Comic Book Revival Gegenständliche Darstellungen, die sich ans Goldene Zeitalter der Liebes- und Actioncomics anlehnen: Rafael Alvarez, Dominic Bugatto, Nathan Fox, Agata Nowicka

Flora und Fauna Grafische Wälder, Gärten und Dschungel (à la Rousseau): Ricardo Fumanal, Sarah Jackson, Junior Lopes, Malin Rosenqvist, Bożka Rydlewska

Geometrische Schlichtheit Einfache Formen, kontrastarme Farben und rechte Winkel: Katarzyna Bogucka, Lucie Clement, Craig & Karl

Goofy Liebenswert trottelig: Jon Burgerman, Jules Le Barazer

Ikonische Ikonen Logoartige Piktogramme und Glyphen: Oscar Bolton Green, Ricardo Gimenes

Legere Lockerheit Transparent, lässig, aquarellig: Paul Cox, Paolo Galetto, Conrad Roset

Magischer Realismus Surrealistische Fantasy-Welten: Marc Burckhardt, Dan Craig, Rory Kurtz

Noir light in Farbe Edward Hoppers des 21. Jahrhunderts: Thomas Ehretsmann, Primary Hughes

Vignettierte Sinfonik Orchestrierte Miniaturen: Nik Neves, Zé Otavio, Patrick Vale

Das sind, zugegebenermaßen, recht persönliche Kategorien, und viele der Grafiken in *Illustration Now! 5* entziehen sich dieser etwas erzwungenen Taxonomie. Trotzdem macht es Spaß, solche Beziehungen herzustellen, denn so werde Stile bestimmt. Und wenn es in *Illustration Now! 5* um etwas geht, dann um Stile im Fluss. Jetzt, wo ich weiß, dass die Illustration unsterblich ist, kann ich den nächsten Band kaum erwarten.

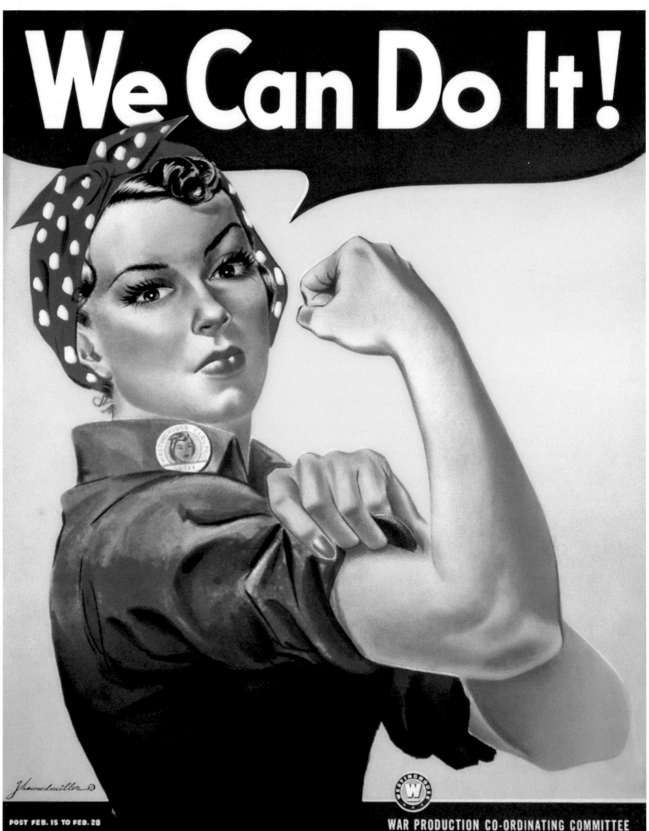

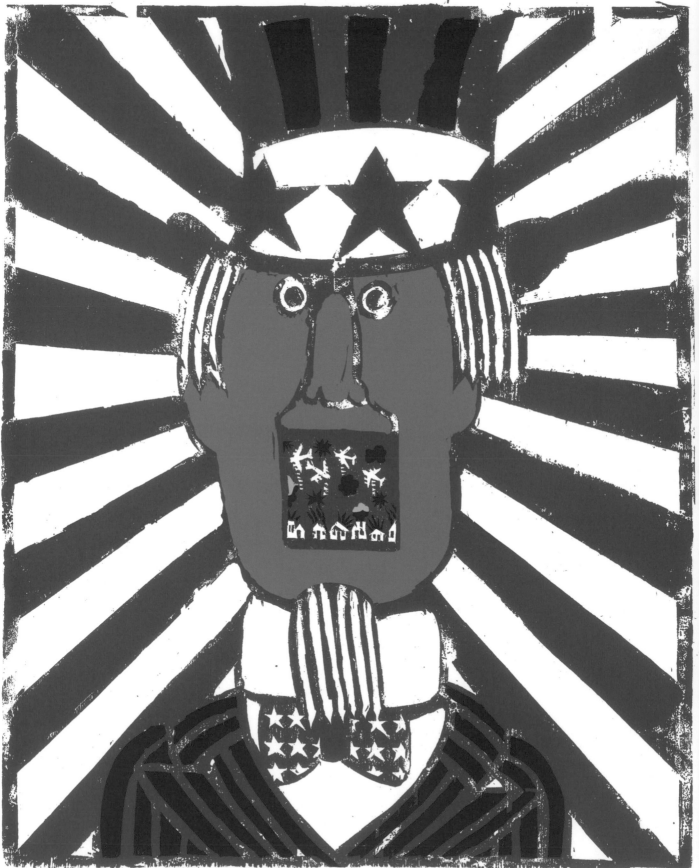

Seymour Chwast

End Bad Breath.

Styles en transition

L'illustration ne mourra jamais

par Steven Heller

J'ai régulièrement prédit que chaque édition d'*Illustration Now!* marquait le dernier soubresaut de l'illustration. Quelle stupidité. Pourtant, chaque année, lorsqu'un nouveau lourd volume est publié, le Nostradamus que je porte en moi me rappelle avec sévérité à quel point j'ai la vue courte. Plus jamais je n'écrirai ni ne prononcerai la phrase « L'illustration est morte. » Alors, ici et maintenant, je jure que l'illustration ne mourra *jamais*. C'est ma façon de sauver la face.

Mais attendez ! Ma prédiction du trépas de l'illustration est effectivement prématurée, mais il est indéniable que les mass media ont connu des changements qui ont définitivement bouleversé ce secteur et ses praticiens. Il ne faut bien sûr pas considérer le changement comme forcément négatif, mais il a des conséquences pour l'avenir, et *Illustration Now!* représente le futur récent et imminent.

Mais tout d'abord, regardons un peu vers le passé : au XVe siècle, l'invention de la presse à imprimer déclencha une révolution technologique, économique et même philosophique qui transforma l'art de l'illustration. La merveilleuse machine de Gutenberg dispensait de devoir écrire et illuminer les manuscrits sacrés à la main. Des siècles plus tard, la possibilité d'imprimer des images lithographiques et gravées modifièrent les méthodes et les styles de l'illustration. Au début du XIXe siècle, les presses à imprimer rotatives à vapeur de Friedrich Koenig augmentèrent le nombre global de publications – livres, journaux et magazines – et donnèrent aux illustrateurs des opportunités pratiquement illimitées. En 1882, lorsque Georg Meisenbach breveta la trame de similigravure pour reproduire fidèlement les photographies, l'illustration cessa d'être un moyen de documentation réaliste pour devenir une forme artistique de narration impressionniste. Et aujourd'hui, les avancées du numérique influencent le style visuel, voire les contenus de l'illustration. Le changement et le renouvellement sont fréquents et récurrents. Pendant la décennie qui s'est écoulée depuis la parution du premier volume d'*Illustration Now!*, l'illustration est entrée dans un royaume de plus en plus éclectique, avec tant de styles et d'artistes stylés entre lesquels choisir, qu'il serait difficile pour n'importe qui, surtout pour moi, de prédire à ce secteur un avenir autre que radieux.

Entre l'illustration d'aujourd'hui et celle des années 1930, 1940 et 1950, c'est le jour et la nuit, mais l'illustration n'a jamais cessé de prospérer. Lorsque le réalisme romantique populiste fut remplacé par un expressionisme tranchant, l'illustration perdit son rôle central dans les magazines, mais ce ne fut pas la fin du monde. Lorsque le conceptualisme expressionniste des années 1970, 1980 et 1990 fut usurpé par ce que j'appelle le néo-narrativisme actuel, la demande en illustrateurs resta inchangée, parce que l'illustration donne lieu à une interaction avec le public que les autres types de visuels n'atteignent pas.

La nouvelle cuvée d'illustration néo-narrative ne fait pas de grandes « déclarations » conceptuelles agressives. La tendance actuelle est plutôt à la narration visuelle pleine d'esprit (et, au cas où vous ne le saviez pas, la *narration* est le nouveau mot d'ordre dans l'art et le design) qui combine méthodes représen-tationnelles, impressionnistes et expressionnistes – toutes à la fois ou en divers dosages. Ces méthodes artistiques ne sont pas nouvelles, mais dans l'ensemble, la pratique de l'illustration narrative emprunte un tout nouveau chemin. Voici comment :

Lorsque l'illustration était le support visuel principal, avant que la photographie ne devienne prédominante dans les années 1950, son rôle était d'aider le public à réaliser, idéaliser ou concrétiser une vision interne du « contenu » que véhiculaient les mots. Pour ce faire, les illustrateurs traduisaient en image une phrase ou un passage du texte. Ce que vous lisiez était ce que vous voyiez. Alors, plutôt que d'imaginer ce à quoi un sujet ressemblait, l'illustrateur disait au lecteur quoi penser et quoi voir – son llustration était une représentation littérale. Cela changea lorsque certains publics commencèrent à refuser qu'on leur indique quoi imaginer, et décidèrent de choisir leurs propres images.

Mirko Ilić, 2008
Cold War on the Internet,
Der Spiegel, March 29, 2010,
Art Direction: Stefan Kifer; digital

p.18 Seymour Chwast, 1967
End Bad Breath; poster protesting
against the Vietnam War; offset
lithograph

p.22 Yann Kebbi, 2013
Falling in Love with Cement,
Dorade; pencil

La mission actuelle de l'illustration est donc plus interprétative dans un contexte narratif. Plutôt que de montrer ce qui a déjà été décrit avec éloquence par des mots, l'illustration présente d'autres perspectives qui complètent l'expérience narrative en ajoutant une dimension à la page, ou au support quel qu'il soit.

De nombreux illustrateurs se centrent sur le concept, dans la mesure où ils utilisent les symboles, les allégories et les métaphores pour transmettre un message. Ils sont représentés ici par l'acerbe Sue Coe (p.110), l'envoûtant Ben Wiseman (p.432) et l'enchanteur Noma Bar (p.46). Leurs illustrations ont des significations intégrales – elles racontent une histoire indépendante de ce qu'elles illustrent. L'illustration néo-narrative est un amalgame de tous les trucs, concepts, méthodes et techniques dont les illustrateurs disposent aujourd'hui. Et pourtant, ce n'est pas tout à fait de « l'échantillonnage », puisque chaque illustrateur individuel se concentre sur son carré du patchwork, mais est influencé par de nombreux prédécesseurs.

La diversité est une marque de fabrique d'*Illustration Now! 5*. Il existe cependant certaines similarités graphiques dans cette sélection qui indiquent ce qui pourrait être le début (ou la fin) de petites tendances. (Franchement, pour moi, il suffit de deux illustrateurs présentant des attributs similaires pour constituer une tendance.) J'énumère ci-dessous les curieuses caractéristiques que j'ai remarquées dans ce volume, rangées par ordre alphabétique.

Absurdation La juxtaposition d'objets inexplicables ou aléatoires : Mattias Adolfsson, Jonathan Bartlett, Pablo Bernasconi

Astuciosité Juxtapositions humoristiques qui déclenchent une réaction à retardement : Christopher Brown, David de Ramón

Beardsleyquismes Inclusion d'enjolivures pour des chevelures à la Beardsley : Toril Bækmark, Sarah Egbert Eiersholt, Leonardo Gauna, Katy Smail

Chromophilie Combinaisons de couleurs inattendues et apaisantes : Moa Bartling, Erik Jones

Farfelu Tout simplement farfelu : Jon Burgerman, Jules Le Barazer

Faune et flore Forêts, jardins et jungles graphiques (style Rousseau) : Ricardo Fumanal, Sarah Jackson, Junior Lopes, Malin Rosenqvist, Bożka Rydlewska

Flou liquide Aquarelles opulentes, veloutées et sinueuses : Paul Cox, Paolo Galetto, Conrad Roset

Iconolâtrie Pictogrammes qui évoquent des logos et des glyphes : Oscar Bolton Green, Ricardo Gimenes

Noir allégé en couleur Edward Hoppers du XXIᵉ siècle : Thomas Ehretsmann, Primary Hughes

Réalisme magique Mondes imaginaires surréalistes : Marc Burckhardt, Dan Craig, Rory Kurtz

Revival BD Rendus représentationnels qui évoquent l'âge d'or des BD de romance et d'action : Rafael Alvarez, Dominic Bugatto, Nathan Fox, Agata Nowicka

Simplicité géométrique Formes simples, aplats de couleur et angles droits : Katarzyna Bogucka, Lucie Clement, Craig & Karl

Symphonie de miniatures Vignettes orchestrées : Nik Neves, Zé Otavio, Patrick Vale

Bien entendu, il s'agit de mes catégories personnelles, et une grande partie du contenu d'*Illustration Now! 5* ne rentre pas dans ma taxonomie contrainte. Tout de même, c'est amusant d'établir ce type de relations, car c'est ainsi que les styles se définissent. Et après tout, *Illustration Now! 5* est un ouvrage qui traite de styles en transition. J'ai hâte de voir paraître le prochain volume, maintenant que je sais que l'illustration ne mourra jamais.

Brad Holland, 1983
New York Times Magazine, cover; acrylic

Esther Aarts

1971 born in Brabant, Netherlands | lives and works in Nijmegen, Netherlands
www.estheraarts.nl

CLIENTS
Hello!Lucky, Target, BNN, Heijmans,
Threadless, Makro, Chocomel,
Verkade, Ben & Jerry's, Wired, BBC

EXHIBITIONS
Ltd. Edition, group show, Designer's Club, Kunstraum Walcheturm, Zürich, 2013
Grenzeloos, Contemporary illustration, group show, Gemeentemuseum, Kampen, NL, 2011
Gelders Balkon 9, Illustration and Animation, group show, MMKA, Arnhem, NL, 2010

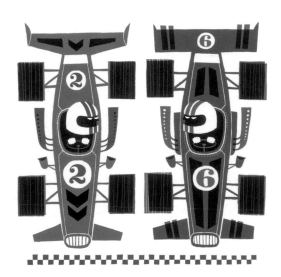

"I have a soft spot for people and
the way they present themselves
in everyday situations."

„Ich habe eine Schwäche für Menschen und
die Art, wie sie sich im Alltag darstellen."

«J'ai une faiblesse pour les gens, et pour
la façon dont ils se présentent dans les
situations quotidiennes.»

Racecars, 2012
Personal work; digital

→ How Connected Do You
Want to Be?, 2013
Blink, Denmark; digital

→→ Perpetuum Mobile
of Summer, 2013
Personal work; digital

Youssef Abdelké

1951 born in Qameshli, Syria | lives and works in Damascus

CLIENTS
Tate Gallery, Claude Lemand Collection, Jarrah Collection, Kuwait Museum, Atassi Collection

EXHIBITIONS
New Works, solo show, Galerie Tanit, Beirut, 2014
Solo show, Akhnatoun, Cairo, 2004
Solo show, Al Chaab exhibition space, Damascus, 1978

AGENTS
Galerie Tanit, Beirut, Lebanon
Galerie Claude Lemand, France
Mashrabia Art Gallery, Egypt

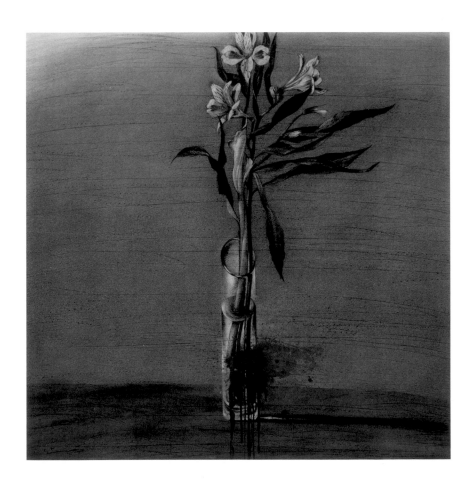

"Everything but ease and skill. I want to engage the eye of the viewer in conversation with the work, because it's the other, because it's me."

„Man muss über Leichtigkeit und reines Können hinausgehen. Ich möchte, dass das Auge mit dem Werk in Kommunikation tritt. Das Auge repräsentiert das Andere, aber auch mich."

« Il est important d'aller au-delà de la facilité et du pur talent. Je veux que l'œil entre en dialogue avec le travail. L'œil représente l'autre, et il me représente moi. »

Vase, 2013
Personal work, courtesy of Galerie Tanit, Beirut and the artist; charcoal on paper

→ Martyr's Mother, 2012
Personal work, courtesy of Galerie Tanit, Beirut, and the artist; charcoal on paper

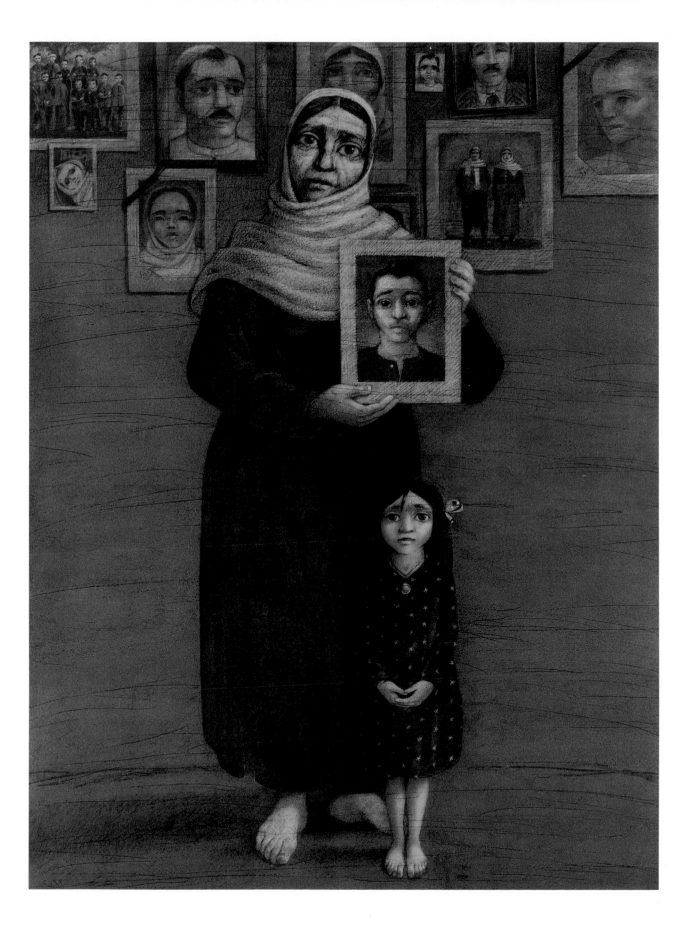

Fish, 2011
Personal work, courtesy of
Galerie Tanit, Beirut and
the artist; charcoal on paper

→ Knife and Bird, 2010
Courtesy of Khatib Collection;
charcoal on paper

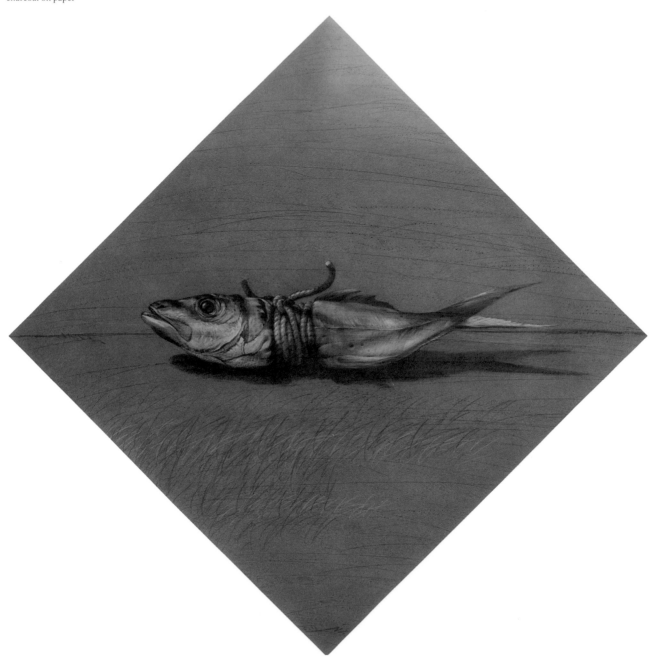

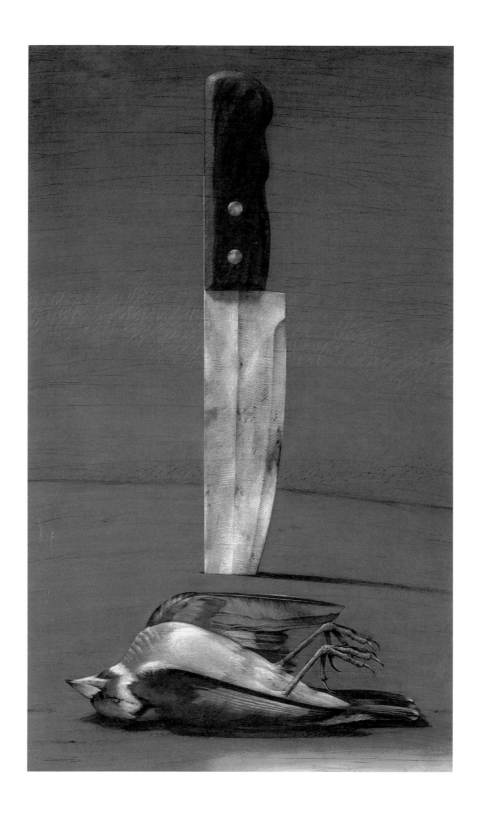

Mattias Adolfsson

1965 born in Göteborg, Sweden | lives and works in Sigtuna, Sweden
www.mattiasadolfsson.com

CLIENTS
The New York Times, Arnold,
McSweeney's, Nickelodeon, Wired,
The Walt Disney Company

EXHIBITIONS
Space, the gallery show, group show, Gallery 1988, Los Angeles, 2013
A Saga in the Stars, group show, Gallery Nucleus, Alhambra, USA, 2013
Not in Kansas anymore, group show, Gallery Nucleus, Alhambra, USA, 2013

AGENT
Söderberg Agentur, Sweden

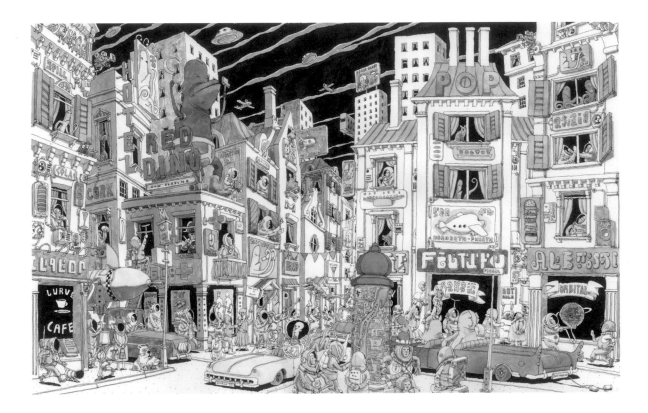

"Many of my drawings evolve rather than get planned, starting
in one corner I let the drawing take me on a journey."

„Viele meiner Zeichnungen entstehen aus sich selbst heraus, ohne dass
ich sie plane. Ich fange in einer Ecke an und lasse mich von der Zeichnung
auf eine Reise mitnehmen."

« En général, mes dessins ne sont pas planifiés, ils évoluent.
Je commence dans un coin et je laisse le dessin
m'emmener en voyage. »

Red Dino, 2013
Personal work; ink and watercolor

→ The Onion, 2013
Personal work; ink and watercolor

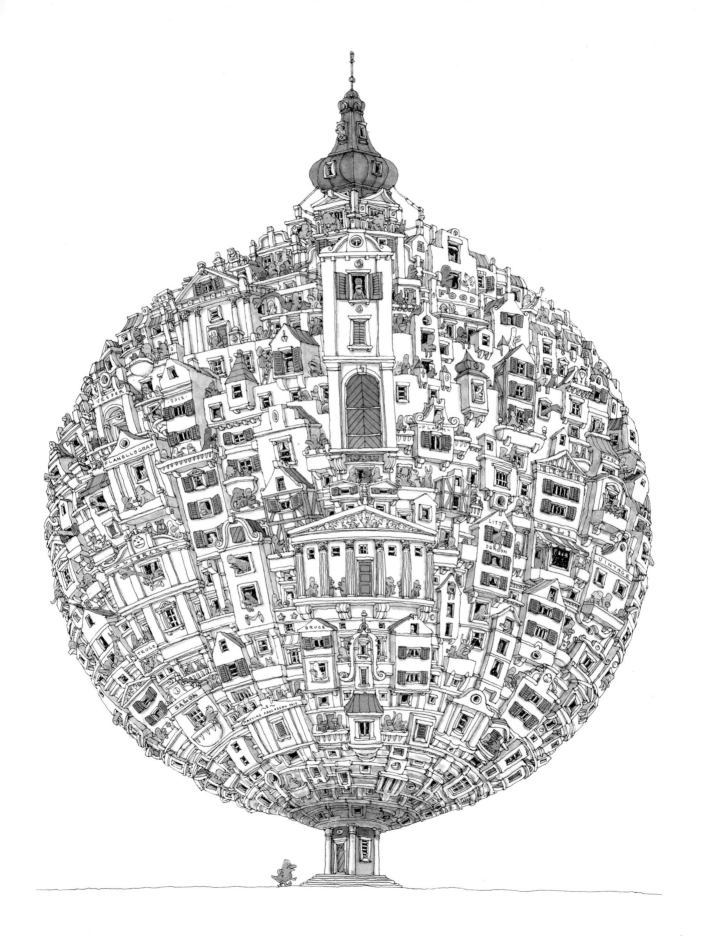

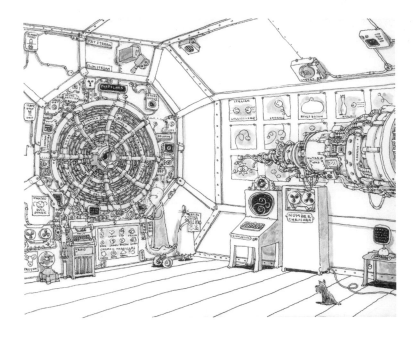

→ Collider, 2012
Personal work; ink and watercolor

→→ 30 January 1969, 2012
Exhibition All Together Now:
A Tribute to the Beatles, Gallery
Nucleus, Alhambra, USA; ink
and watercolor

↓ Pedestrians, 2012
Personal work; ink and watercolor

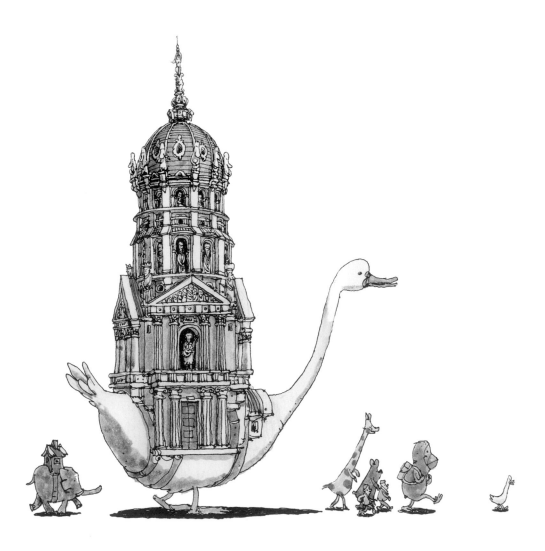

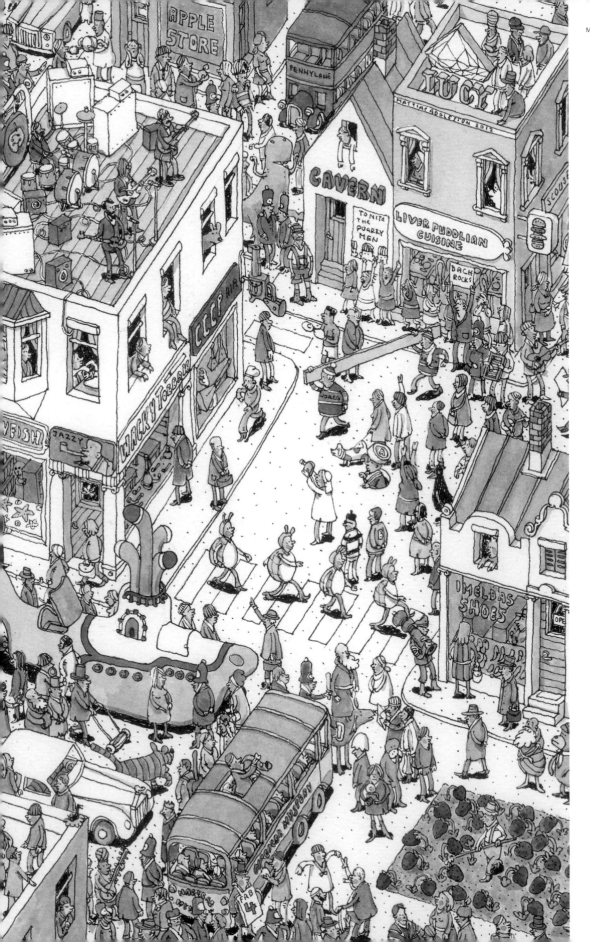

Yanneth Albornoz

1977 born in Panama | lives and works in Berlin and Ho Chi Minh, Vietnam
www.yannethalbornoz.wordpress.com

CLIENTS
Custo Barcelona, Kaltblut Magazine,
Salsipuedes Tropical, Sensa Nostra

EXHIBITIONS
Ibero-American Design Biennial, group show, Museu da Casa Brasileira, São Paulo, 2013
Ibero-American Design Biennial, group show, Matadero de Madrid, Spain, 2012
Ibero-American Design Biennial, group show, Matadero de Madrid, Spain, 2010

"I cultivate the art of mistakes, experimentation and curiosity. I love creating a more sophisticated context for Latin-American pop art from the streets."

„Ich pflege die Kunst der Fehler, der Experimente, der Neugier. Es macht mir Spaß, der lateinamerikanischen Straßen-Pop-Art einen anspruchsvolleren Rahmen zu geben."

« Je cultive l'art des erreurs, de l'expérimentation et de la curiosité. J'aime créer un contexte plus sophistiqué pour l'art populaire latino-américain de la rue. »

Tropicstickers, 2010
Personal work, exhibition Panama
Gráfico Biennial 2010; ink on paper
and digital

→ Cobra, 2010
Custo Barcelona, T-shirt design;
ink on paper and digital

→→ Chica Electropiano, 2011
Tantalo Hotel; ink on paper and digital

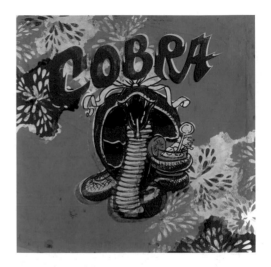

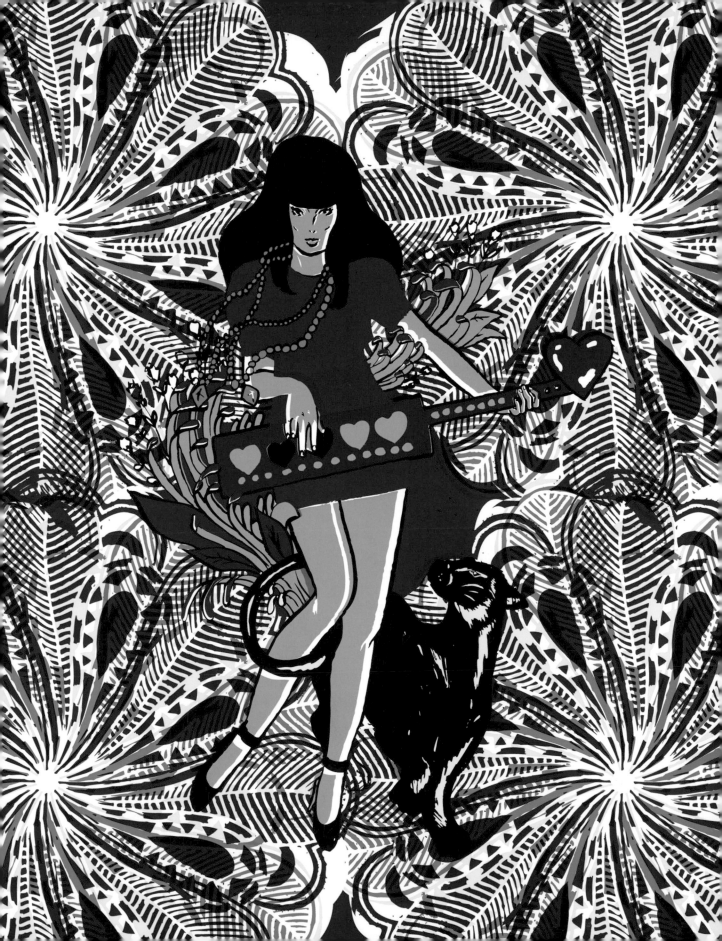

Clara Aldén

1988 born in Falun, Sweden | lives and works in Stockholm
www.claraalden.se

CLIENTS
Rodeo, Plaza Deco, Barncancerfonden,
Médecins Sans Frontières Sweden, Nöjesguiden

AGENT
Agent Bauer, Sweden

"Multi-colored realism!"

The Day After, 2013
Personal work; pencil

→ Theresa, 2011
Rodeo, website; pencil

→→ Untitled, 2013
Personal work; pencil

**Getting Ready for
a Costume Party, 2013**
Personal work; pencil

← **Working out
on Instagram, 2013**
Personal work; pencil

↓ **Untitled 2012**
Plaza Deco; pencil

Rafael Alvarez

1978 born in Madrid | lives and works in Brooklyn and Berlin
www.alvarezrafa.com

CLIENTS

The New York Times, Süddeutsche Zeitung, Playboy,
American Express, Grand Central, Sixpoint Brewery,
UnaMono Fashion Brand, Paramount Pictures

EXHIBITIONS

Illustrative Berlin, group show, Direktorenhaus, Berlin, 2013
The Thesis Show, group show, SVA Gallery, New York, 2012
Girls: Fact or Fiction, group show, Light Grey Art Lab, Minneapolis, 2012

"I like my illustrations to tell stories with a certain sense
of humor and a foreshadowing to make the viewer
spend some time looking at the details."

„Meine Illustrationen sollen eine Geschichte erzählen, mit etwas Humor,
aber auch voller Andeutungen, damit der Betrachter sich die Details
genauer ansieht."

« J'aime que mes illustrations racontent des histoires avec
un certain humour et qu'elles aient un pouvoir de suggestion
pour que l'on prenne le temps d'examiner les détails. »

You Again, 2012
Personal work, e-book Hotel
Pandemonium; pen, ink and digital

→ **After the Storm, 2013**
Personal work; pen, ink and digital

A Familiar Face, 2012
Personal work, e-book Hotel
Pandemonium; pen, ink and digital

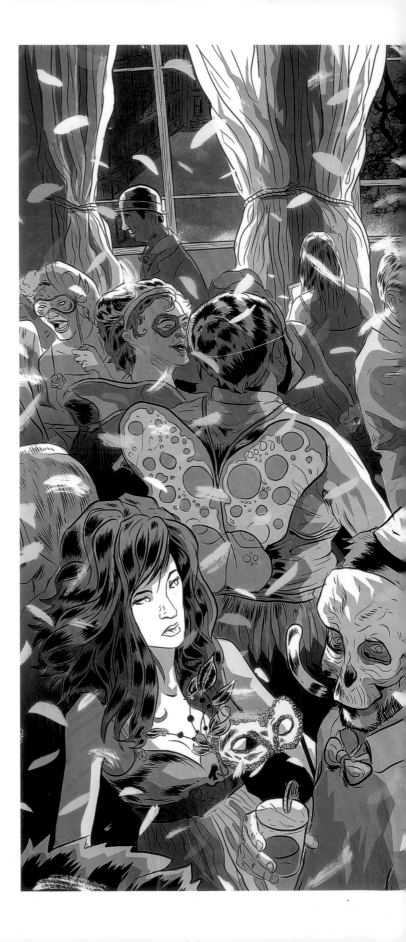

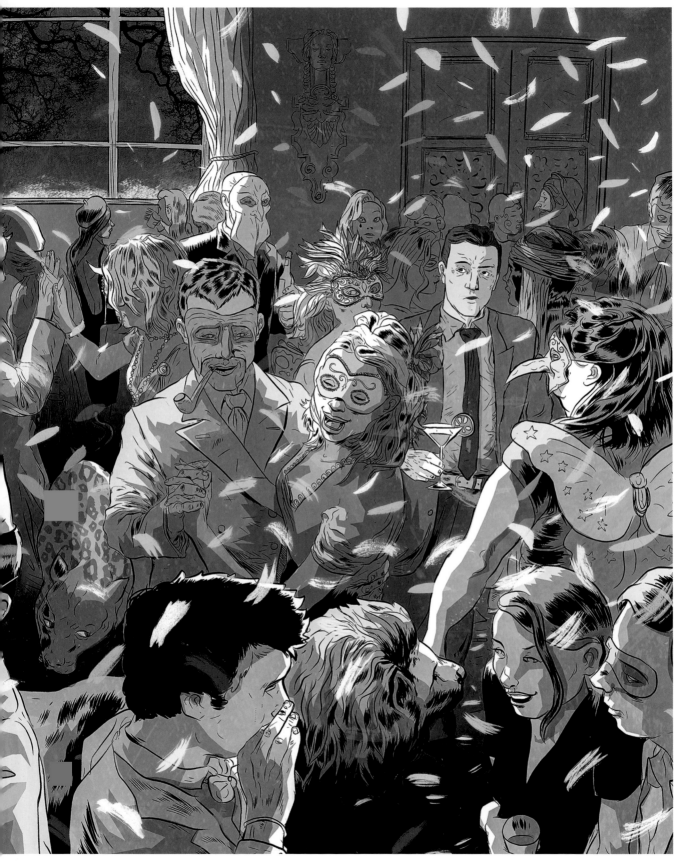

Toril Bækmark

1966 born in Ølstykke, Denmark | lives and works in Copenhagen
www.torilbaekmark.com

CLIENTS
Coca-Cola, Elle DK, Cles, Queensberry
Fine Printing, Munthe plus Simonsen, Aarhus
Theater, Discover & Deliver, Magasin du Nord

EXHIBITIONS
Beak and Claws, group show, Gallery CMYK, Copenhagen, 2013
Someplace, group show, Gallery CMYK, Copenhagen, 2013

AGENT
Hilde Agency, France

"To lose myself in the rhythm and the quality of the line...
the splash of the watercolor. To free myself in the
expression of the image—I love it!"

„Im Rhythmus und in der Qualität des Strichs aufzugehen … hingetupfte
Wasserfarben. Mich im Ausdruck eines Bilds zu befreien – genial!"

« Me perdre dans le rythme et la qualité du trait …
les éclaboussures de l'aquarelle. Me libérer dans
l'expression de l'image – j'adore ça ! »

Head Garments by Blossfeldt, 2010
Personal work; ink and digital

→ Seaweed, 2013
Personal work; pencil, ink and digital

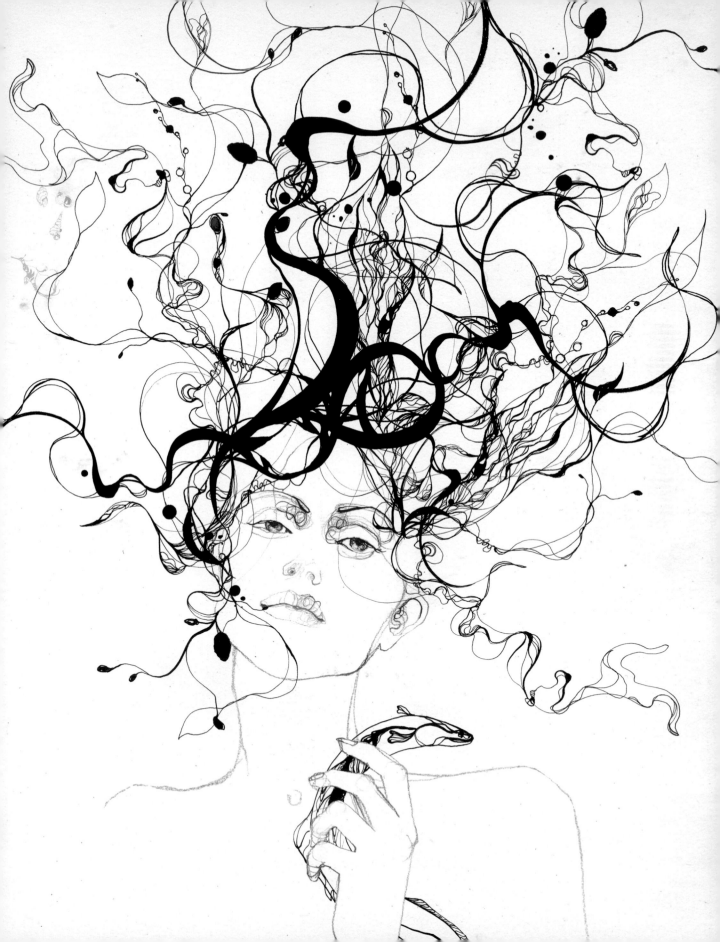

Noma Bar

1973 born in Afoola, Israel | lives and works in London
www.facebook.com/NomaBar

CLIENTS
The Economist, The New York Times, Google, The Guardian, Wired,
GQ, Time, Sony, Wallpaper*, The New Yorker, IBM, Volkswagen,
Channel 4, Nike, Adidas, Penguin, Vodafone, V&A

EXHIBITIONS
Cut the Conflict, solo show, Rook & Raven Gallery, London, 2013
Design of the Year 2012, solo show, Design Museum, London, 2012
Noma Bar, solo show, Gallery Seven, New York, 2011

AGENT
Dutch Uncle, UK

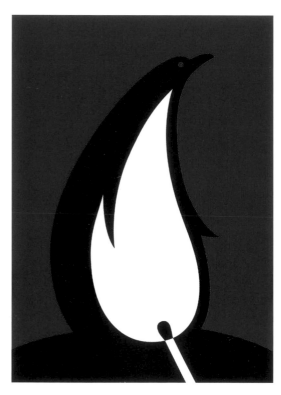

"Maximum communication with minimum elements, and turn negative space into positive space."

„Maximale Kommunikation durch minimalste Elemente, negativen Raum in positiven Raum verwandeln."

« Une communication maximale avec un minimum d'éléments, et transformer l'espace négatif en espace positif. »

The Last Emperor, 2012
Personal work; screenprint

→ Ouch, 2012
Personal work; screenprint

→→ Double Bill, 2013
Personal work; screenprint

Jonathan Bartlett

1984 born in Camp Hill, USA | lives and works in Brooklyn
www.bartlettstudio.com

CLIENTS
The New York Times, Random House,
WW Norton, The Atlantic, Plansponsor,
Wired, Fortune, New York MTA

"Go for broke...
every single time."

„Alles auf eine Karte
setzen – jedes Mal wieder!"

« Jouer le tout pour le tout ...
à chaque fois ! »

Tweed Run, 2012
Personal work; mixed media

→ Fahrenheit 451, 2013
Simon & Schuster, book cover,
unpublished; mixed media

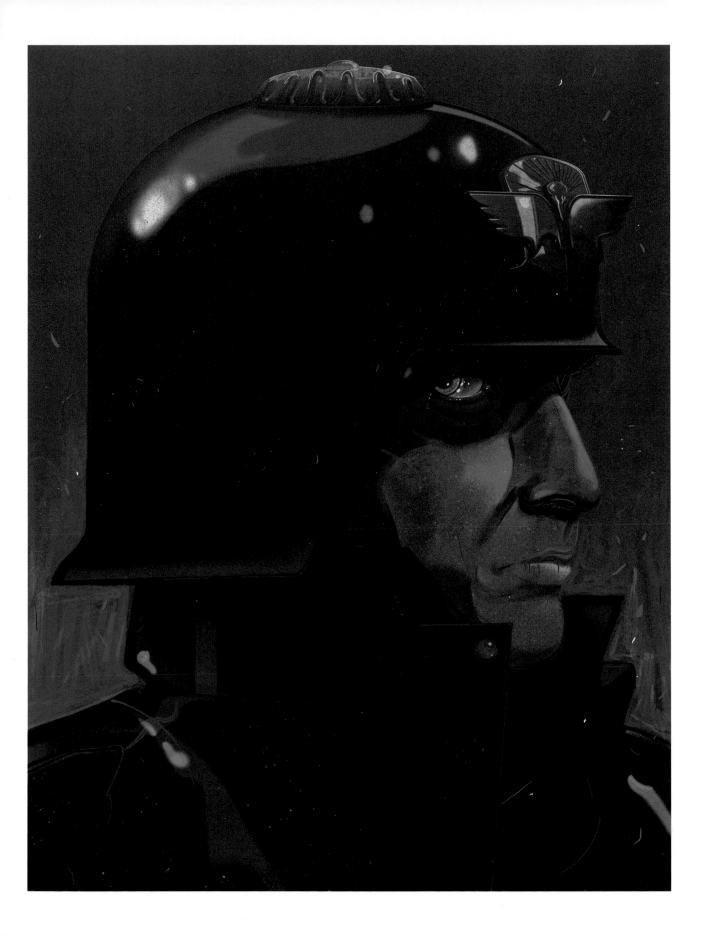

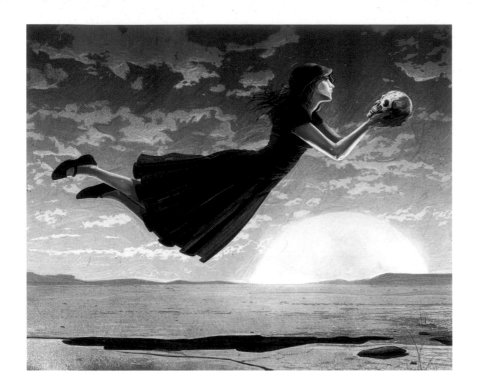

You Only Die Once, 2013
Christianity Today, Art Direction:
Alecia Sharp; mixed media

→ Love is Like…, 2012
El Malpensante, magazine cover, Art
Direction: Angel Unfried; mixed media

↙ Year of The Dragon, 2012
The Atlantic, ongoing Lunar New
Year series; mixed media

↓ Year of The Snake, 2013
The Atlantic, ongoing Lunar New
Year series; mixed media

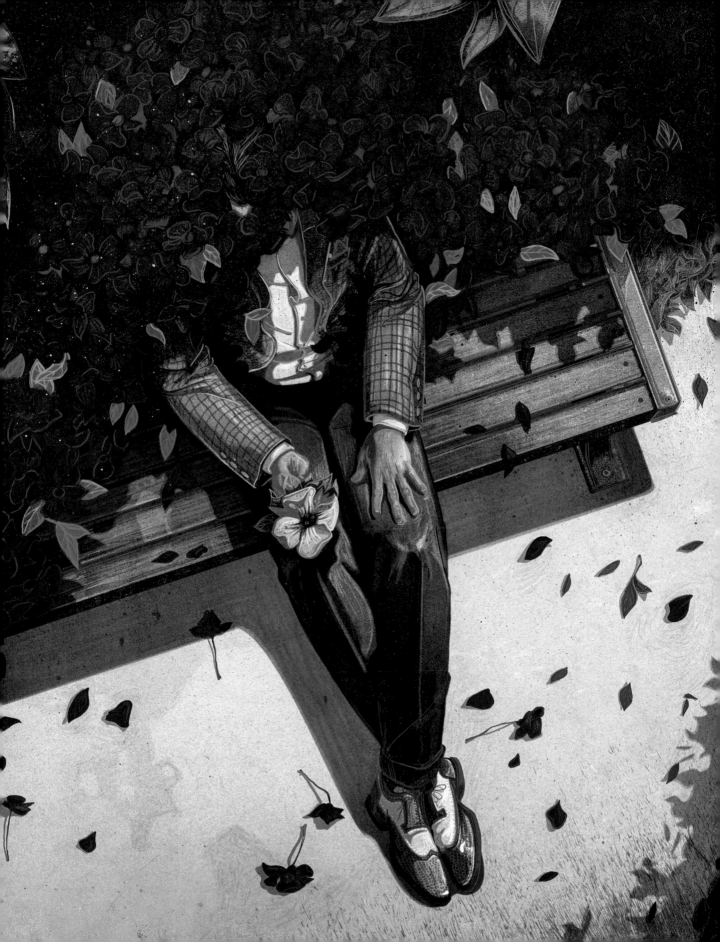

Moa Bartling

1978 born in Stockholm | lives and works in Stockholm
www.moabartling.com

CLIENTS

H&M, Acne, Elle Sweden, Cosmopolitan Russia,
Marie Claire, Christian Lacroix, NK, Nordiska
Galleriet, Oriflame, Burglar. Co., Ltd, Gourmet

EXHIBITIONS

Nordiska Galleriet, solo show, Stockholm, 2012
PA&CO-Större än en Kokbok, solo show, Stockholm, 2011
Restaurang 1900, solo show, Stockholm, 2010

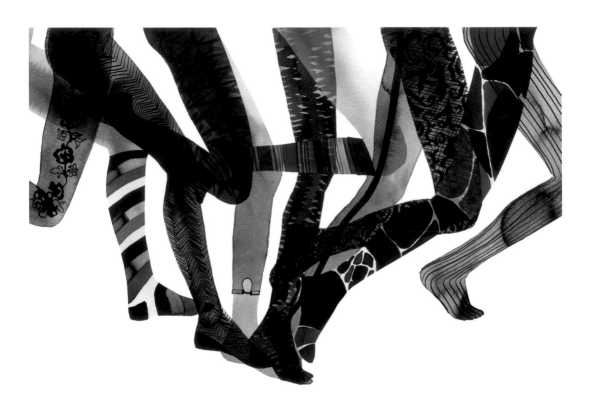

"My basics are watercolors and the simplicity of using as
few strokes as possible, to create an attractive picture."

„Mein Ausgangspunkt sind Wasserfarben und Schlichtheit, so wenig Striche
wie möglich und daraus ein ansprechendes Bild machen."

« Mes ingrédients de base sont l'aquarelle et la simplicité, utiliser aussi
peu de coups de pinceaux que possible pour créer une image séduisante. »

Untitled, 2005
NK, advertising; watercolor

→ Untitled, 2010
Personal work, exhibition; watercolor

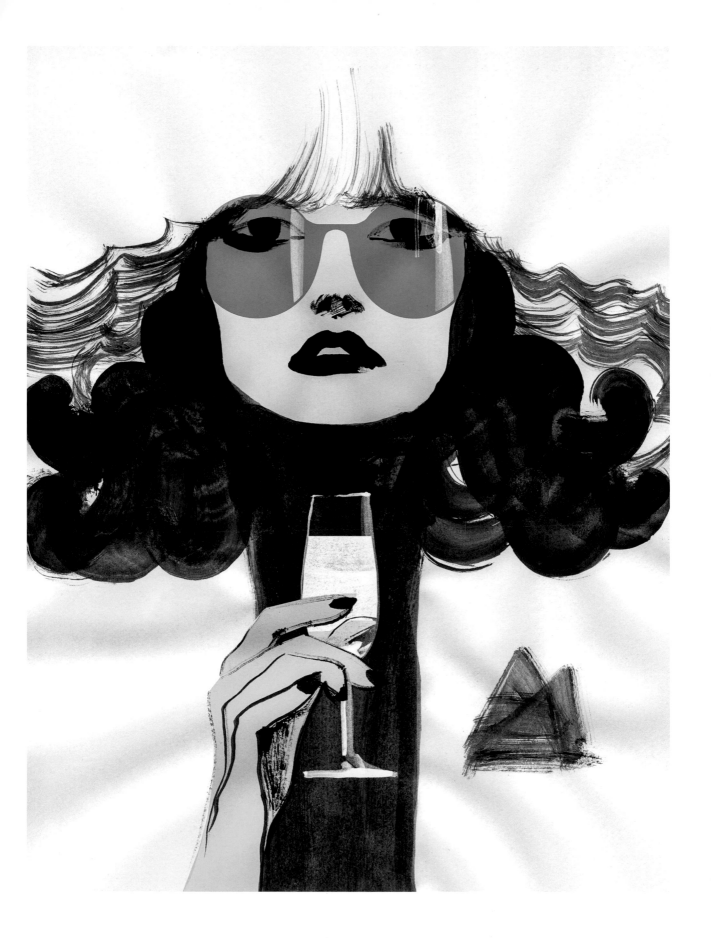

Pablo Bernasconi

1973 born in Buenos Aires | lives and works in Bariloche, Argentina
www.pablobernasconi.blogspot.com

CLIENTS
Rolling Stone, Wall Street Journal, The Times,
The Walt Disney Company, Nokia, BBDO, Movistar,
Coca-Cola, Saatchi & Saatchi, Bloomsbury

EXHIBITIONS
Pensamientos Ilustrados, solo show, Bariloche, Argentina, 2013
Bologna Book Fair, group show, Bologna, 2010
Society of Illustrators, group show, New York, 2007

AGENTS
Shannon Associates, USA
Début Art, UK

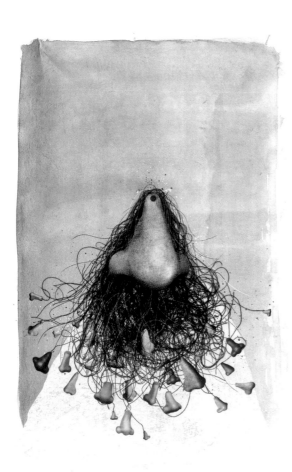

"I believe in the soul of every object.
I try to build the illustrations from
the inside to the outside, taking special
care with their internal vitality."

„Ich glaube, dass jeder Gegenstand eine Seele
hat. Ich versuche, Illustrationen von innen nach
außen aufzubauen, und achte besonders auf
ihre innere Vitalität."

« Je crois que chaque objet a une âme. J'essaie
de construire mes illustrations de l'intérieur
vers l'extérieur, en prenant grand soin
de leur vitalité interne. »

Ravi Shankar, 2011
Diario La Nación, Art Direction:
Ana Gueller; mixed media

→　Edgar Allan Poe, 2008
Personal work, book Retratos;
mixed media

→→　Crisis, 2010
Personal work, book Bifocal;
mixed media

Rocky Balboa, 2008
Personal work, book Retratos;
mixed media

← The Old Man and the Sea, 2012
Personal work, book Finales;
mixed media

↓ Joey Ramone, 2008
Personal work, book Retratos;
mixed media

Ricardo Bessa

1989 born in Paredes, Portugal | lives and works in London and Penafiel, Portugal
www.ricardobessa.com

CLIENTS
Lenovo, Pfeiffer Wines,
Boom Magazine, Zizzi,
Bulletin

EXHIBITIONS
Role Models, group show, Light Grey Art Lab, Minneapolis, 2013
Uivo 2, group show, Fórum da Maia, Porto, 2013
Ice & Fire, group show, Dernier bar avant la fin du monde, Paris, 2013

AGENTS
Rocket Sloth, Canada
Folio, UK

"Even though the digital component is pretty much essential
to my work process, I always start out with traditional
media. The result is usually a mix."

„Das Digitale ist für meinen Arbeitsprozess absolut wichtig,
trotzdem fange ich immer mit herkömmlichen Medien an.
Das Ergebnis ist meist eine Mischung aus beidem."

« Bien que la composante numérique soit assez essentielle,
je commence toujours avec un support traditionnel.
Le résultat est généralement un mélange. »

Little White Flowers, 2013
Curzon Cinemas, postcard; pencil
on paper and digital

→ The Kill List, 2013
Personal work, exhibition Ice & Fire:
Game of Thrones Tribute Artworks,
Geek-Art; pencil on paper and digital

Lisa Billvik

1980 born in Arboga, Sweden | lives and works in Stockholm
www.lisabillvik.com

CLIENTS
Selfridges, Urban Outfitters, Part Two,
Amelia's Magazine, Nylon Magazine,
Habit, Catwalk Studio, Synk Casting

AGENTS
Peppercookies, UK
Snyder & The Swedes, USA

"It's all about creativity. Everything is possible
and there are no rules. I'm inspired by people
and life stories from reality or fiction."

„Kreativität ist alles. Alles ist möglich, es gibt keine Vorschriften.
Ich lasse mich von Menschen und Lebensgeschichten anregen,
ob tatsächlichen oder fiktiven."

« Il s'agit avant tout de créativité. Tout est possible et il n'y a
pas de règles. Je m'inspire des gens et d'histoires réelles
ou fictionnelles. »

Untitled, 2013
MindFull / M&C Saatchi London;
pencil and ink

→ Untitled, 2010
Personal work; pencil and digital

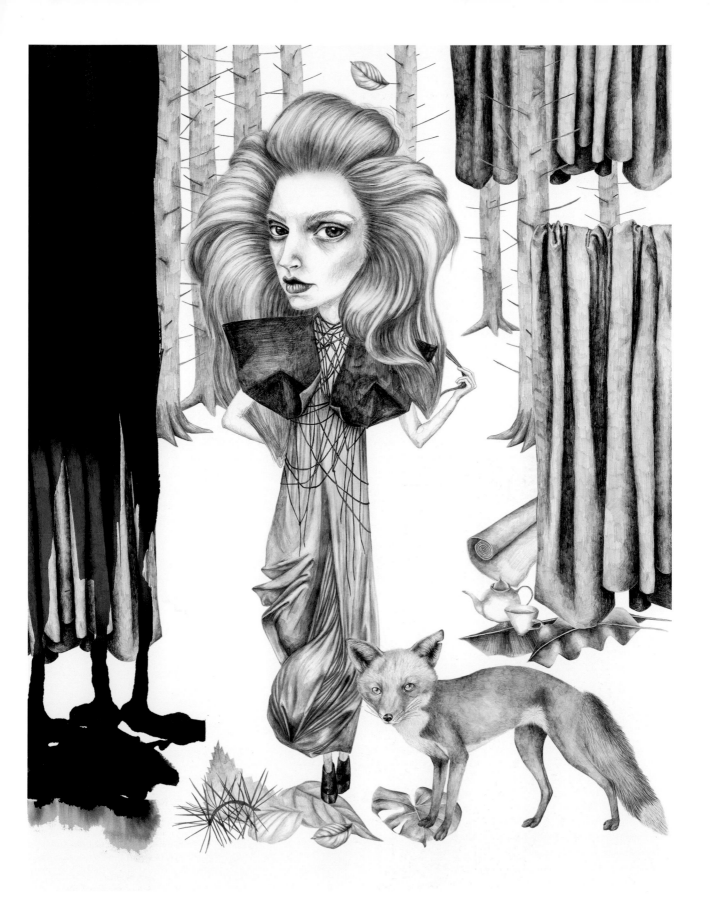

Lina Bodén

born in Stockholm | lives and works in Stockholm
www.linaboden.se

CLIENTS
Whyred, Weekday, Monki, H&M, Ikea,
Vogue Japan, Show Studio, Way Out West

AGENTS
Agent Molly & Co., Sweden
CWC-Tokyo, Japan
Peppercookies, UK

"In my work I strive to build up an imaginary visual world of my
own, located in the space between dreams and reality. A place where
objects come to life and anything could happen."

„Ich möchte in meiner Arbeit eine ganz eigene imaginäre visuelle Welt schaffen,
angesiedelt zwischen Traum und Realität. Ein Raum, in dem Gegenstände
zum Leben erweckt werden und alles möglich ist."

« Dans mon travail, je m'efforce de construire mon propre monde
visuel imaginaire, situé entre le rêve et la réalité. Un lieu où les objets
prennent vie et où tout pourrait arriver. »

Through the Looking Glass, 2010
Personal work; hand-drawn and digital

→ The Cocktail Zoo, 2010
Exhibition; hand-drawn

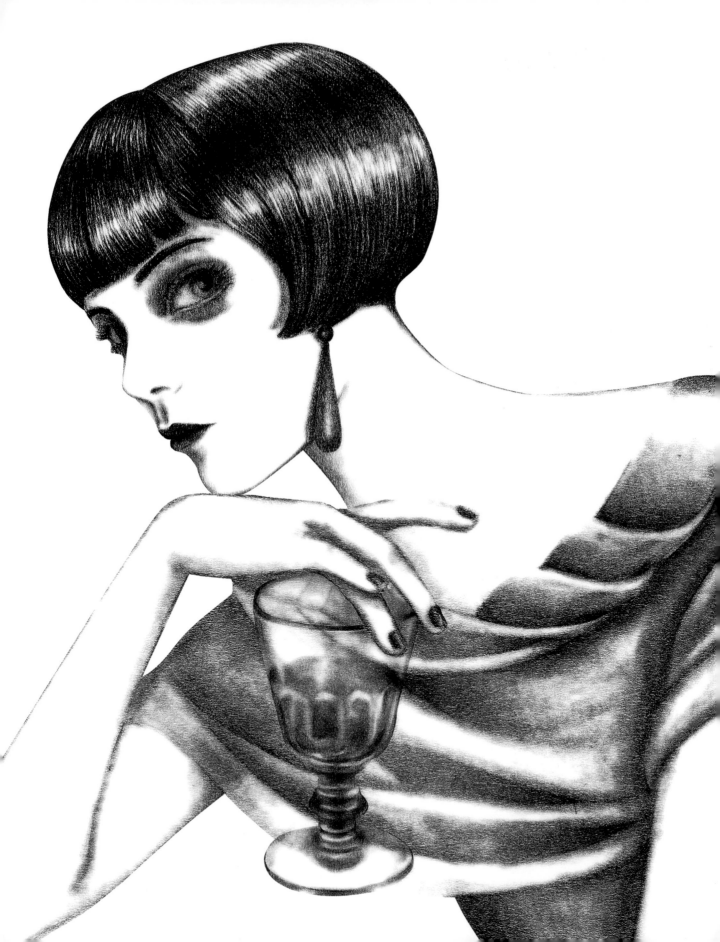

Katarzyna Bogucka

1985 born in Lomza, Poland | lives and works in Warsaw
www.nioska.com

CLIENTS
Nenukko, Twoj Styl, Wytwornia,
Dwie Siostry, Pantuniestal,
Tatarak, Ladne Halo

"I started designing patterns for my
own needs. I still like to make up new
projects. Putting realistic elements
into geometric abstraction is fun."

„Zuerst habe ich für meine eigenen Zwecke Muster
entworfen. Ich entwickle noch immer gerne
neue Projekte. Realistische Elemente geometrisch
abstrakt umzusetzen macht mir Spaß."

« J'ai commencé à dessiner des motifs pour mes
propres besoins. J'aime toujours imaginer de
nouveaux projets. C'est amusant de transformer des
éléments réalistes en abstractions géométriques. »

Forest, 2013
Personal work, wallpaper; digital

→ Beach, 2013
Personal work, paper pattern; digital

→→ Polish Birds, 2013
Personal work, wallpaper; digital

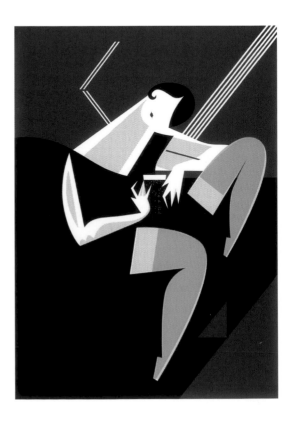

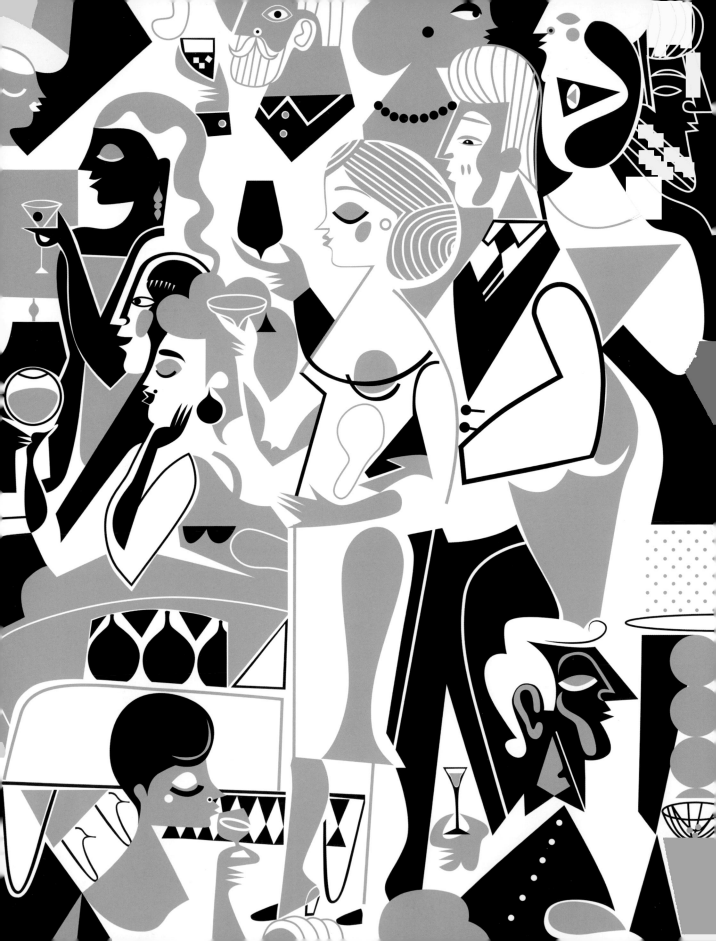

Oscar Bolton Green

1988 born in London | lives and works in London
www.oscarboltongreen.com

CLIENTS
American Express, Nike, Rolling Stone, MTV,
The New York Times, Bloomberg, Little White Lies,
Corraini, It's Nice That

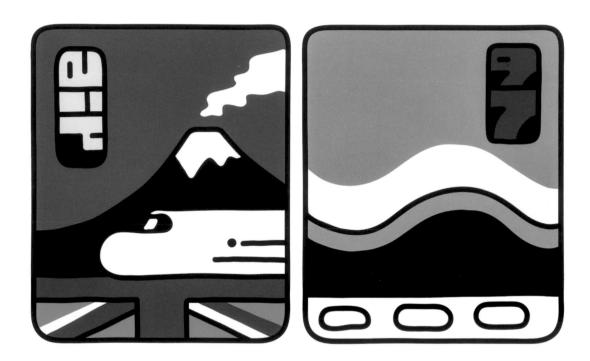

"I feel like I am only at the start. I still have a lot to learn.
But for me it's always been about drawing and the
enjoyment you get from it."

„Ich habe das Gefühl, dass ich noch ganz am Anfang stehe.
Ich muss noch viel lernen. Aber mir geht es einfach ums Zeichnen
und um die Freude, die ich dabei empfinde."

« J'ai l'impression que je ne fais que commencer. J'ai encore
beaucoup à apprendre. Mais l›important a toujours été
le dessin, et le plaisir que j'en retire. »

**Air Max 25th Anniversary
#1, #2 and #3, 2013**
Nike; digital

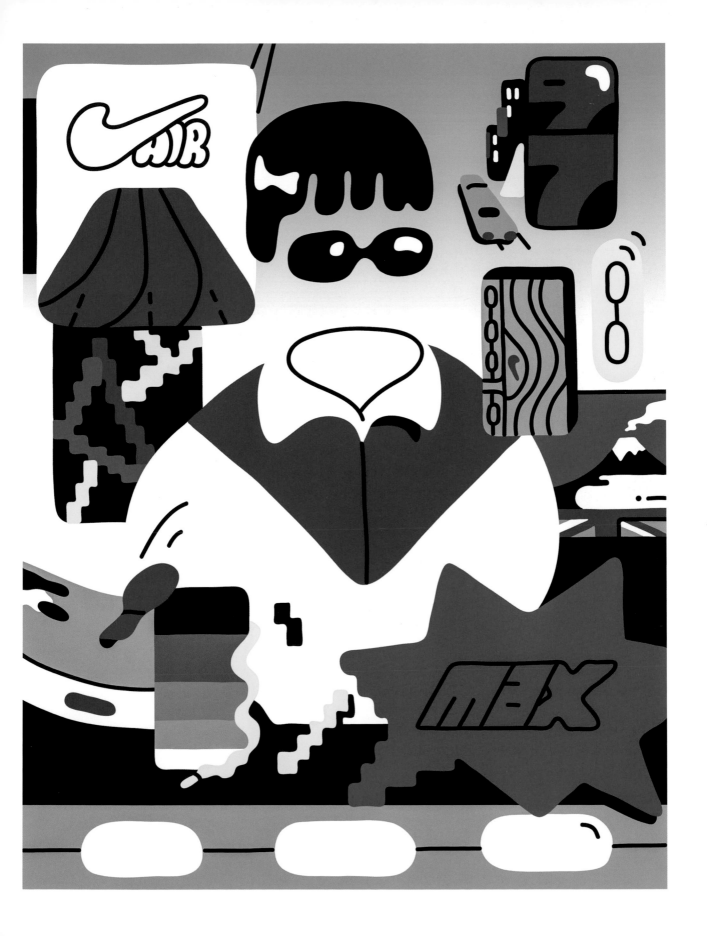

Beata Boucht

1979 born in Stockholm | lives and works in Stockholm
www.beataboucht.com

CLIENTS
Acne, H&M, The New Yorker, Monki, Factory, Nylon Magazine, Peak Performance, National Post Service, Stockholm Fashion Week, Great Works/Electrolux

EXHIBITIONS
Kollaborit, group show, WOS, Stockholm, 2013
Draw a Line, group show, Teckningsmuseet Laholm, 2012
Beata Boucht, solo show, Eskilstuna Konstmuseum, 2011

AGENT
NU Agency, Sweden

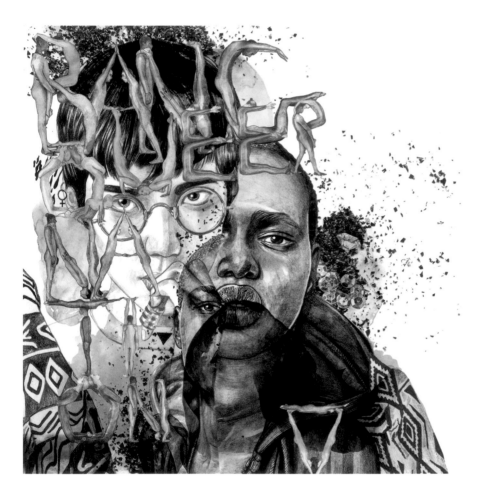

"Illustration has the power to change the way we view the world. It is my voice, and my heart, and it beholds my wildest dreams of the future."

„Illustration kann unsere Sicht der Welt verändern. Sie ist meine Stimme und mein Herz, in ihr stecken meine kühnsten Zukunftsträume."

« L'illustration arrive à modifier notre façon de voir le monde. C'est ma voix, et mon cœur, et elle renferme mes rêves d'avenir les plus fous. »

Queer Nation, 2012
Bang Magazine; graphite pen, watercolors and digital

→ Valentine, 2013
The New Yorker; graphite pen, watercolors and digital

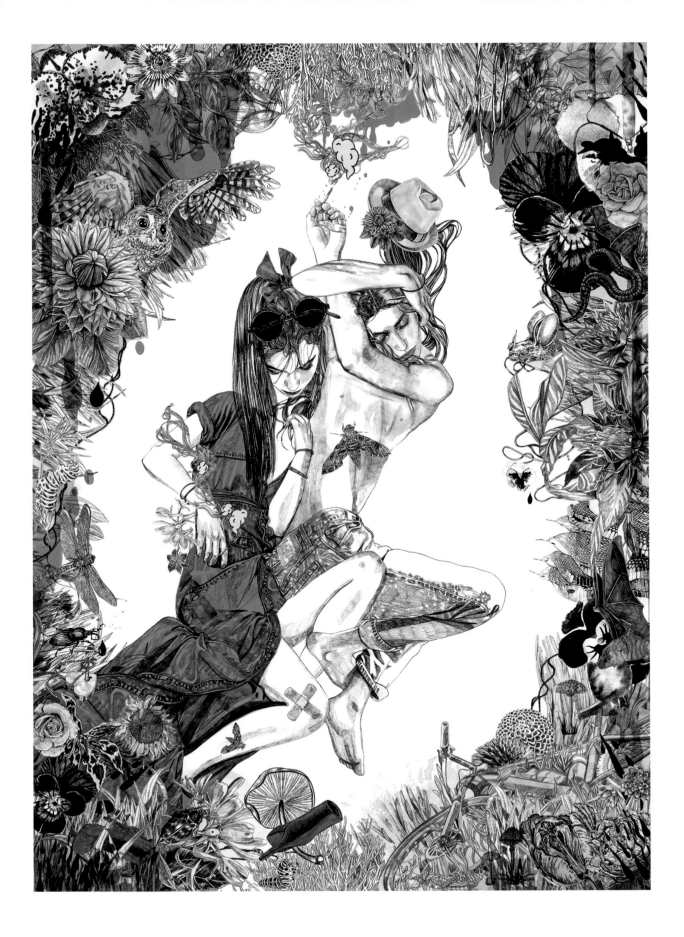

All about Magazines, 2013
Allt om Tidskrifter; graphite pen,
watercolors and digital

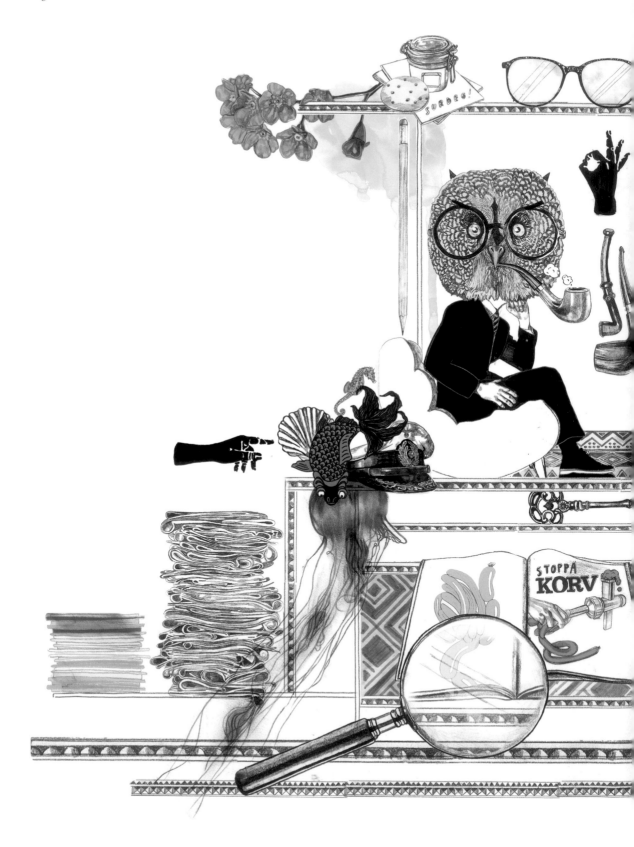

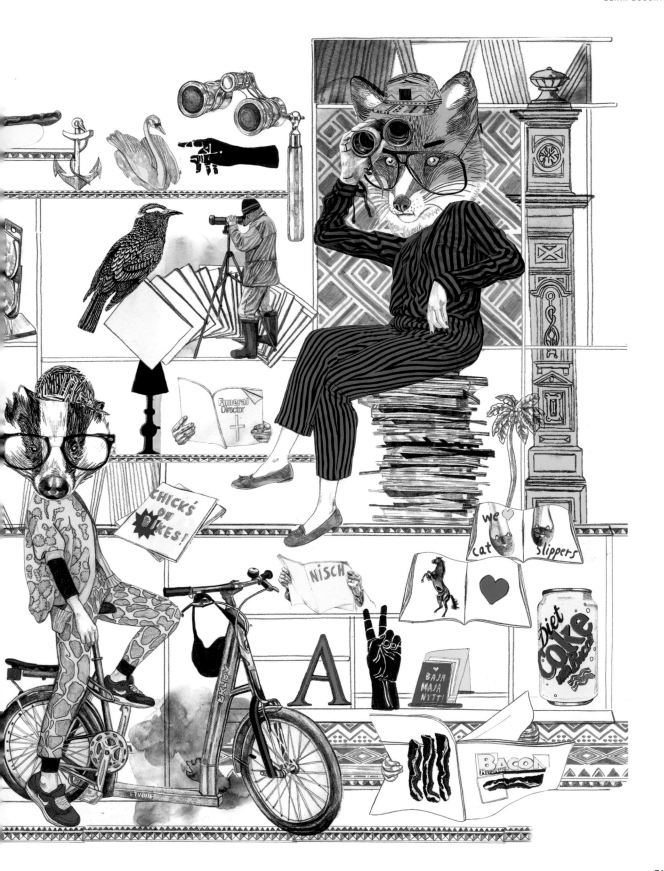

Christopher Brown

1953 born in London | lives and works in London
www.mrchristopherbrown.com

CLIENTS
The Folio Society, Merrell, Webb & Webb, Carluccio's, Hand & Eye, The New Yorker, The Sunday Times, Bay Tree Food Company, SAS, Faber & Faber

EXHIBITIONS
Ten Printmakers, group show, The Scottish Gallery, Edinburgh, 2013
An Alphabet of London, solo show, Central St. Martins, London, 2012
East Coasting, solo show, St. Jude's Gallery, Norfolk, England, 2009

AGENT
Central Illustration Agency, UK

"It's good to look back at yesterday but today is more important and tomorrow is to be looked forward to."

„Es ist gut, einen Blick zurück zu werfen, aber das Heute ist wichtiger, und auf das Morgen darf man sich freuen."

« Il est bon de regarder vers le passé, mais le présent est plus important et il faut aussi regarder vers le futur avec enthousiasme. »

Letter W, 2012
Merrell Publishers, book An Alphabet of London, Art Direction: Nicola Bailey; linocut

→ Art Fund, 2010
The Art Fund, tote bag, Product Manager: Cathy Colby; line drawing and digital

Bourneville and Avebury, 2013
Book project proposal, An Alphabet
of England, Art Direction: Nicola
Bailey; linocut

Yelena Bryksenkova

1988 born in Saint Petersburg, Russia | lives and works in New Haven, USA
yelenabryksenkova.com

CLIENTS
Real Simple, The New York Times, Urban Outfitters, Anorak Magazine, Macmillan, American Greetings, Random House UK, Red Cap Cards, Penguin India

EXHIBITIONS
Enormous Tiny Art Show, solo show, Nahcotta Gallery, Portsmouth, UK, 2013
BookExpo America, solo show, Javits Center, New York, 2013
Fall Arts Festival, solo show, Main Street, Woodbury, USA, 2013

AGENT
Magnet Reps, USA

"I'm curious and organized, inspired by textiles, folk art and travel, and I always begin with research. My tools: Leningrad cake watercolors and gouache."

„Ich bin neugierig und gut organisiert. Mich inspirieren Stoffe, Volkskunst und Reisen, und am Anfang jeder Arbeit steht die Recherche. Meine Werkzeuge: Leningrad Wasserfarben und Gouache."

« Je suis curieux et organisé, inspiré par les textiles, l'art populaire et les voyages, et je commence toujours par faire des recherches. Mes outils : aquarelle Leningrad et gouache. »

L'inconnue, 2013
Personal work; watercolor

→ Socks & Mittens, 2012
Personal work; watercolor

→→ Siamese Cat, 2013
Red Cap Cards; pen, watercolor and ink on paper

Solitaire, 2013
Personal work; pen, ink,
watercolor and on paper

→ **Unicorn, 2013**
Red Cap Cards; watercolor

↓ **Cat Nap, 2012**
Personal work; watercolor
and gouache

Dominic Bugatto

1966 born in Bradford, UK | lives and works in Toronto
www.bugattoillustration.tumblr.com

"Film noir of the 1940s, vintage comic strips, hot rods,
psychobilly, rockabilly and jazz are continual
sources of inspiration for my work."

„Inspirationsquellen sind für mich immer wieder der Film noir der
40er-Jahre, alte Comics, Hotrods, Psychobilly, Rockabilly und Jazz."

« Films noirs des années 1940, bandes dessinées vintage,
hot rods, psychobilly, rockabilly et jazz sont de continuelles
sources d'inspiration pour mon travail. »

Rollin, 2013
Avenue Magazine; ink and digital

→ **Maras, 2012**
California Magazine; ink and digital

Marc Burckhardt

1962 born in Rüsselsheim, Germany | lives and works in Austin, USA and Leipzig, Germany
www.marcburckhardt.com

CLIENTS
Time, Rolling Stone, Playboy, Sony, Pentagram,
Honda, ITV, Simon & Schuster, Random House,
Ogilvy & Mather, Wieden+Kennedy

EXHIBITIONS
Fables & Natural Wonders: The Art of Marc Burckhardt, solo show, PCAD, Lancaster, PA, 2012
Art Basel, group show, Mindy Solomon Gallery, Art Basel, 2011
Art Against the War, group show, Art Students League, New York, 2008

"In my work I combine historical genres, themes and techniques
with contemporary conceptual ideas and subject matter."

„In meiner Arbeit verbinde ich historische Genres, Themen und Techniken
mit zeitgenössischen Stoffen und Konzeptideen."

« Dans mon travail j'essaie de combiner les genres, thèmes et
techniques historiques avec des idées conceptuelles
et des sujets contemporains. »

Abacus, 2012
Private commission; acrylic and
oil on wood panel

→ Overfishing, 2012
Men's Health, Art Direction:
Dena Vedesca and Robert Festino;
acrylic and oil on wood panel

Monstrum Marinum, 2012
Last Gasp Publishing, book Art
for BLAB! vol 3, Editor: Monte
Beauchamp; acrylic and oil on wood

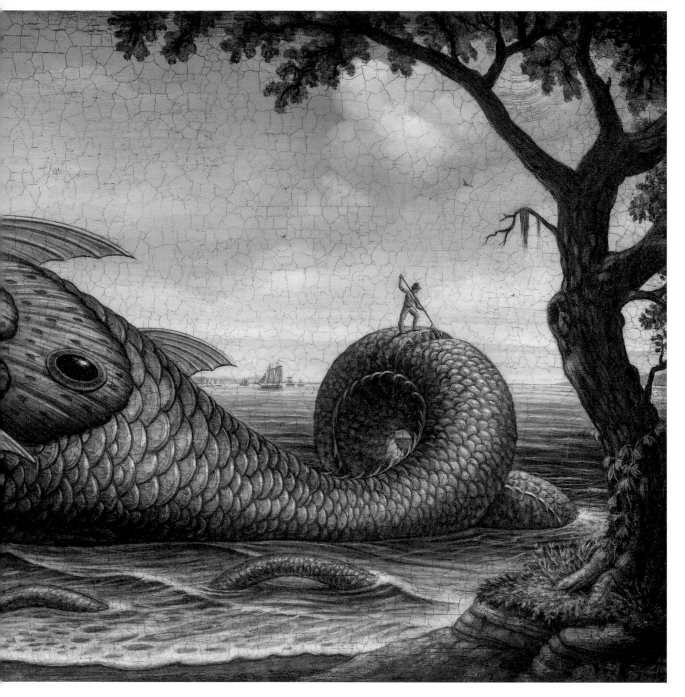

Jon Burgerman

1979 born in the UK | lives and works in New York
www.jonburgerman.com

CLIENTS
Lush, Pepsi, Coca-Cola, Nike, Sony, Sky, Kidrobot,
Puma, Nintendo, MTV, Levi's, 55DSL, Miss Sixty,
AOL, Size?, BBC, Rip Curl, Virgin

EXHIBITIONS
On!, group show, CAC Museum, Cincinnati, 2013
The Hungry Games, solo show, Pawn Works Gallery, Chicago, 2012
V&A Museum Street Art in Print, touring exhibition, group show, V&A, London, 2011

"I create hyper-kinetic images in pen and paint that deal
with the inadequacies of modern existence and my
resulting failings as a human being."

„Ich schaffe mit Feder und Farbe hyperkinetische Bilder, die sich
mit den Unzulänglichkeiten des heutigen Daseins und meinen daraus
erwachsenden menschlichen Schwächen beschäftigen."

« Je crée au stylo et au pinceau des images hypercinétiques
qui traitent des carences de la vie moderne et de mes échecs
en tant qu'être humain. »

Extruded Head #1, #3 and #2, 2013
Personal work, exhibition
A Failure of Judgement, Ink-d
Gallery, Brighton; marker

→ Alien, 2013
Personal work, 1xRun, Detroit;
screenprint

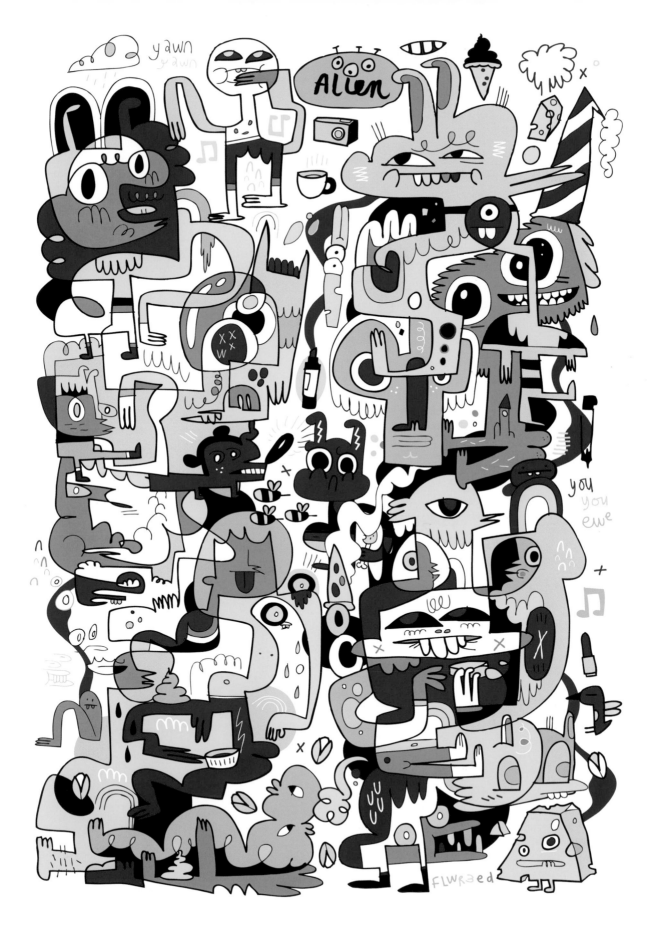

Cachetejack

2010 founded in Valencia | live and work in London and Valencia
www.cachetejack.com

CLIENTS
Hermès, Oslo Screen Festival, Henkelhield, Georges, Wrap, Flamingo, Anorak Magazine

EXHIBITIONS
Elcaf, group show, Illustration Festival, London, 2013
That's Life, solo show, AID Berlin, 2012
Pick Me Up, group show, Somerset House, London, 2012

AGENT
Agent 002, France
Margarethe Hubauer, Germany
The Illustration Room, Australia

"Colors, energy, humor and irony form our universe."

„Unser Universum besteht aus Farben, Energie, Humor und Ironie.“

« Les couleurs, l'énergie, l'humour et l'ironie forment notre univers. »

Aeroport Pirigrins, 2013
Personal work; mixed media

→ Sucks, 2013
L'atelier des jeunes; mixed media

→→ Girls on Wheels, 2013
Girls on Wheels; mixed media

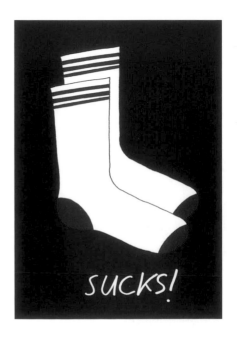

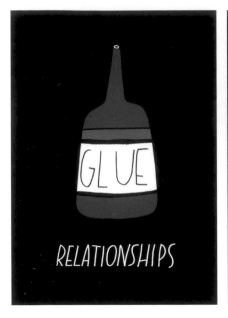

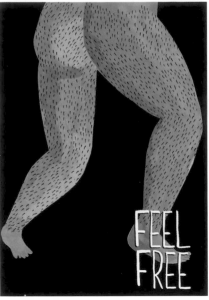

Feel Free, 2012
Personal work; mixed media

← Relationships, 2012
Personal work; mixed media

↓ Cachetejack Deep on
 Working, 2013
Flamingo; mixed media

Wrap, 2013
Wrap; mixed media

Jill Calder

1970 born in Dundee, UK | lives and works in Cellardyke, UK
www.jillcalder.com

CLIENTS
Billabong, Visa, First Great Western,
Elle, Penguin, The New Yorker,
The National Museum of Scotland

EXHIBITIONS
Pittenweem Arts Festival, solo show, Funky Scottish Gallery, Pittenweem, 2013
Working Drawings, group show, London Gallery West, London, 2012
V&A Illustration Awards, group show, V&A, London, 2011

AGENTS
Central Illustration Agency, UK
Friend + Johnson, USA

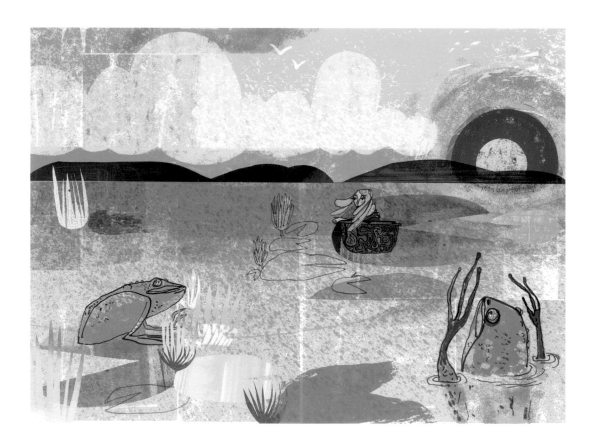

"I love drawing, ideas, color, ink, pixels, typography, narrative, sketchbooks and yes, deadlines. I like mixing them all up together!"

„Mir gefallen Zeichnen, Ideen, Farbe, Tusche, Pixel, Typografie, Erzählung, Skizzenbücher und, doch, Abgabetermine. Und es gefällt mir, das alles einmal kräftig durchzuschütteln!"

« J'aime dessiner, les idées, la couleur, l'encre, les pixels, la typographie, les histoires, les carnets de croquis et, oui, les délais. J'aime mélanger tout ça ensemble ! »

Poucette, 2011
Les Editions des Braques, Paris,
unpublished, Art Direction:
Mathilde Frenay; ink and digital

→ White Hot Summer:
Beautiful, 2013
Friend + Johnson, Art Direction:
Coco Connolly; ink and digital

beautiful

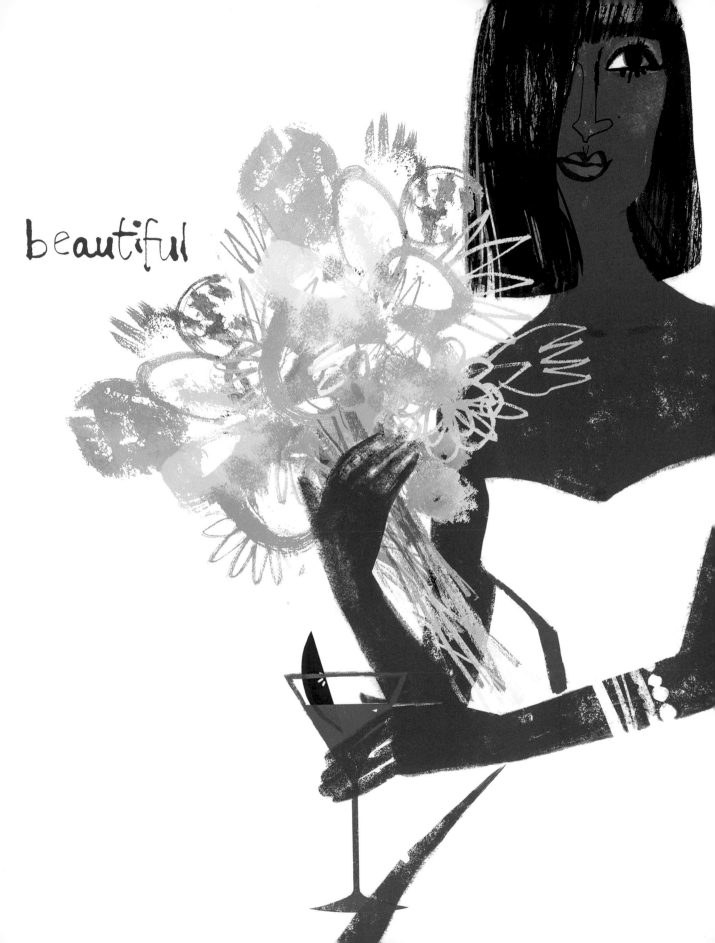

Marjolein Caljouw

1984 born in Middelburg, Netherlands | lives and works in Utrecht, Netherlands
www.marjoleincaljouw.com

CLIENTS
Oilily, Playboy, Esprit, Hotel Bloom, DJ Broadcast, Vertigo Games, Chocolate & Foam

EXHIBITIONS
Animal Kingdom, group show, Nucleus Gallery, Alhambra, USA, 2013
We are Bored, group show, Void Gallery, Amsterdam, 2013
Artlab, group show, Streetlab, Amsterdam, 2009

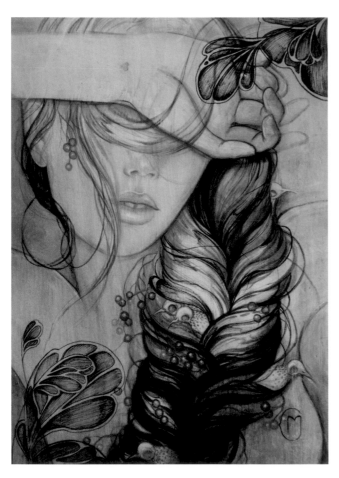

"Although I'm my own worst critic, I love development in every challenge I get, whether it's making a small illustration or a big wall-design."

„Niemand kann mich so gut kritisieren wie ich mich selbst. Trotzdem macht es mir großen Spaß, mich mit jeder neuen Aufgabe zu entwickeln, sei es nun eine kleine Illustration oder ein Entwurf für die Wand."

«Bien je sois mon critique le plus sévère, j'aime évoluer à travers chaque défi, que ce soit une petite illustration ou un grand mural.»

Bird Braid, 2013
Personal work; acrylic, ink and graphite on paper

→ **Hedgehog, 2013**
Personal work; acrylic and ink on wood

→→ **Golden Gloves, 2014**
Personal work; acrylic, graphite, stickers, gold and ink on paper

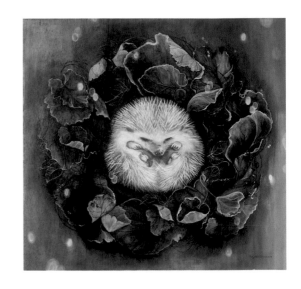

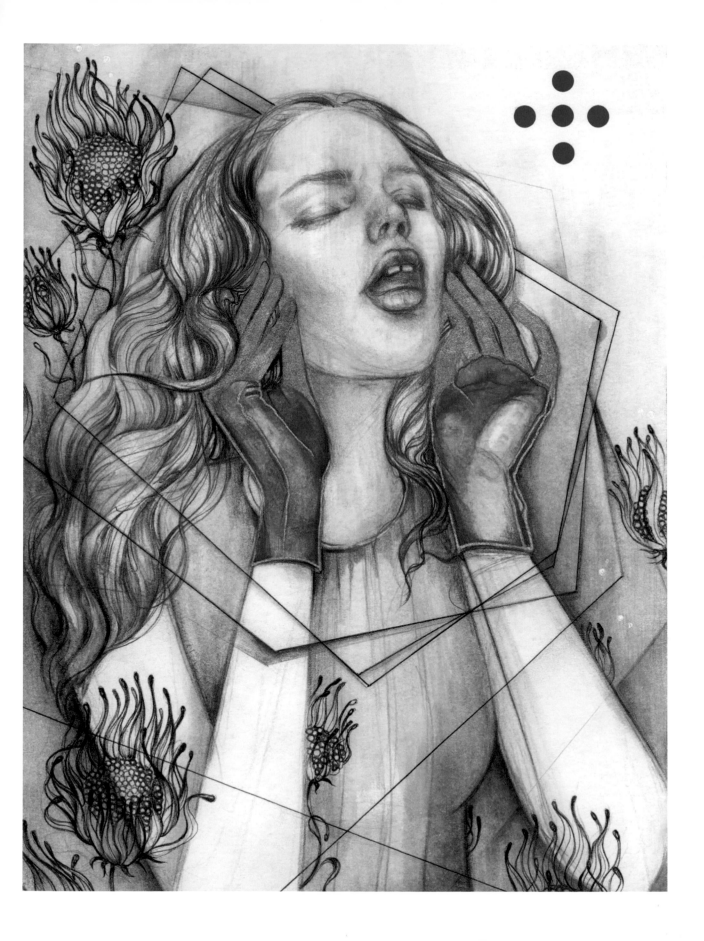

Natsuki Camino

1979 born in Nara, Japan | lives and works in Tokyo
www.cammino.jp/top

CLIENTS
Barneys New York, Harper's Bazaar, Signature,
Anan Magazine, Madame Figaro Japan,
Hobo Nikkan Itoi Shinbun

EXHIBITIONS
Japanese Trend-setting Female Creators, group show, Claska, Tokyo, 2011
Paper Trip, solo show, HB Gallery, Tokyo, 2010
RED Original Art Book Exhibition, solo show, Dazzle, Tokyo, 2009

AGENT
Taiko & Associates,
Japan

"Torn colored paper—I've been making chigiri-e work since 2007."

„Zerrissenes farbiges Papier – ich mache Chigiri-e-Arbeiten seit 2007."

« Du papier de couleur déchiré – je fais du chigiri-e depuis 2007. »

George, 2010
Hobo Nikkan Itoi Shinbun, book cover;
chigiri-e collage

→ **Paper Trip 2, 2010**
Personal work; chigiri-e collage

Kyodo Corty, 2011
Odakyu Agency; chigiri-e collage

→ **Soto-jazz, 2012**
King Records; chigiri-e collage

Gwénola Carrère

1977 born in Geneva | lives and works in Brussels
gwenola.ultra-book.org

CLIENTS
Thierry Magnier, XXI, Dada, Tate Gallery, Plan B, Creative Review, Nobrow Press, Topipittori, Albin Michel, Nokia, Bayard, Financial Times, Agenda

EXHIBITIONS
Gwénola Carrère, solo show, Zoo, Bologna, 2013
Pick Me Up, group show, Somerset House, London, 2011
Aller-retour, group show, Maison des Métallos, Paris, 2010

AGENTS
Illustrissimo, France

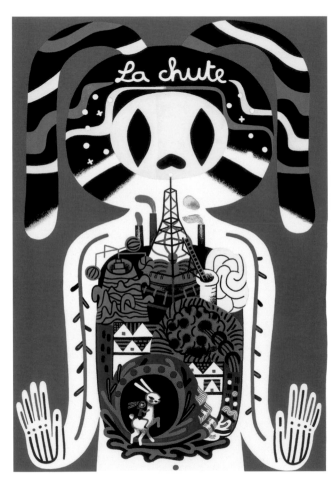

La chute, 2011–12
Canal+; acrylic

→ Eloise Decazes,
Eric Chenaux, 2012
Okraina Records; pencil, pen,
indian ink and acrylic

→→ Re-Création II, 2013
Théâtre de la vie; pencil,
acrylic, pen and indian ink

"A joyful battle between computer
and hand, control and no control,
head and body, space and time,
ending up in screenprinting,
hand drawing or painting."

„Ein spielerischer Kampf zwischen Computer
und Hand, Kontrolle und Kontrolllosigkeit,
Kopf und Bauch, Raum und Zeit, aus dem
ein Siebdruck, eine Zeichnung oder
ein Gemälde entsteht.“

« Une bataille joyeuse entre ordinateur
et main, contrôle et absence de
contrôle, tête et corps, espace et temps,
qui se traduit par de la sérigraphie,
du dessin à la main ou de la peinture. »

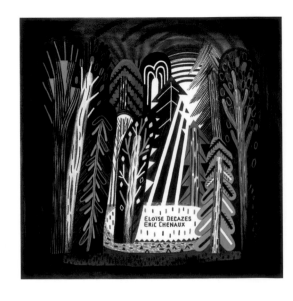

Stanley Chow

1974 born in Manchester | lives and works in Manchester
www.stanleychowillustration.com

CLIENTS
The New Yorker, Variety, Vanity Fair,
McDonald's, Volkswagen, Vodafone,
The Washington Post, GQ, Boston Globe

AGENTS
Bernstein & Andriulli, USA
Central Illustration Agency, UK

"Since the age of four I always knew
that I wanted to be an illustrator.
All that I can say is that I feel very
lucky that my hobby is my job."

„Dass ich Illustrator werden will, wusste
ich schon mit vier Jahren. Ich habe
wirklich großes Glück, dass mein Hobby
gleichzeitig meine Arbeit ist."

« Depuis l'âge de quatre ans, j'ai toujours
su que je voulais être illustrateur.
Tout ce que je peux dire, c'est que j'ai
de la chance que ma passion soit
aussi mon travail. »

Beach, 2013
Personal work; digital

→ Mad Men as Bat Man, 2012
Huffington Post; digital

→→ 'The Third Man'
Novak Djokovic, 2013
The New Yorker, Art Direction:
Chris Curry; digital

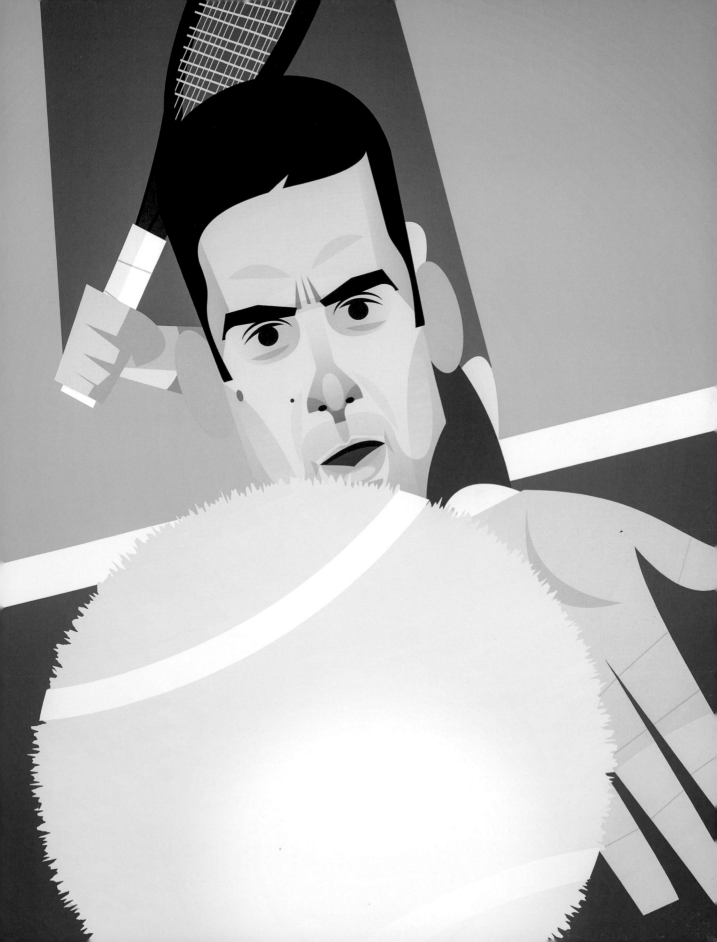

Lucie Clement

1987 born in Tours, France | lives and works in Paris
www.lucieclement.fr

"With graphic studies, my work is based on
simple shapes, symmetry, texture and colors.
I'm fascinated by the ambiguity between
the sensuality of women and greed…"

„Bei grafischen Studien arbeite ich mit einfachen Formen,
Symmetrie, Textur und Farben. Mich fasziniert die Unschärfe
zwischen der Sinnlichkeit von Frauen und Gier…"

« Avec des études de graphisme, mon travail se base sur
les formes simples, la symétrie, la texture et les couleurs.
Je suis fascinée par l'ambigüité entre la sensualité
des femmes et l'avidité… »

Éclair d'amour, 2013
Personal work; digital

← Coup de chaud sur
mes lèvres, 2013
Personal work; digital

→ En attendant l'été, 2014
Personal work; digital

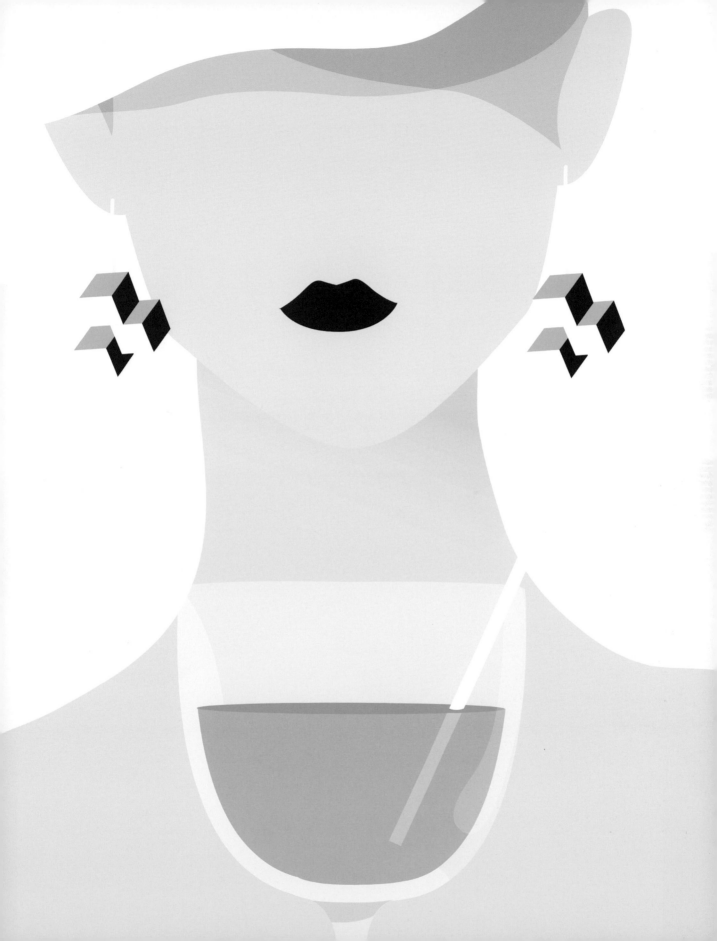

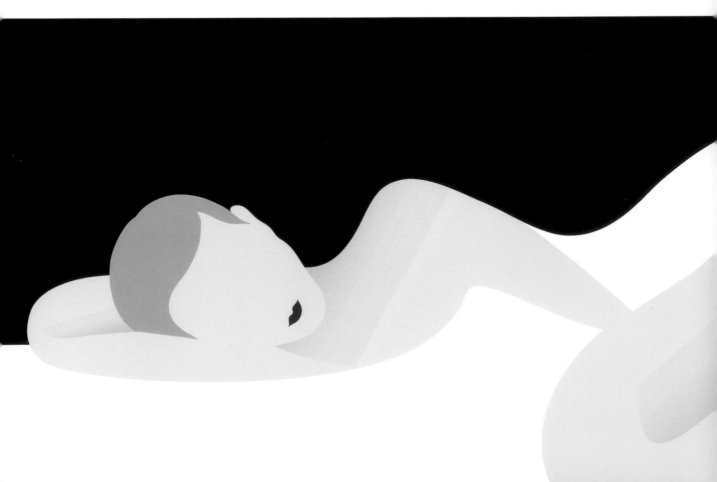

Canard à Chapeau, 2013
Personal work; digital

← Sweet Lemonade, 2013
Personal work; digital

↙ Nuit de Noël, 2013
Personal work; digital

Russell Cobb

1968 born in Letchworth, UK | lives and works in London and Privett, UK
www.russellcobb.com

CLIENTS
Royal Mail, Sir Terence Conran, UBS Bank, BBC Worldwide,
Honda, Saab, Volkswagen, The Times, The Telegraph,
Penguin, Time, DDB London, Publicis

EXHIBITIONS
The Association of Illustrators, Illustration Awards,
group show, Somerset House, London, 2013

AGENT
Début Art, UK

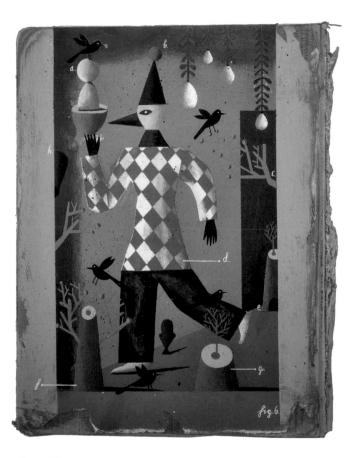

"A world of books. Drawing every day,
my paintings are formulated in
sketchbooks. The process ends with
an old book, painting on them
and in them."

„Eine Welt der Bücher. Da ich jeden Tag
male, entstehen meine Bilder zuerst
in Skizzenbüchern. Ganz am Ende male
ich dann in oder auf ein altes Buch."

« Un monde de livres. Je dessine tous
les jours, et mes peintures sont
formulées dans mes carnets de croquis.
Le processus se termine avec un
vieux livre, je peins dessus et dedans. »

Theatre Time, 2011
Personal work; acrylic on book

→ Bee Keeper, 2011
Personal work; acrylic on book

→ → Dreamscape, 2011
Personal work; acrylic on book

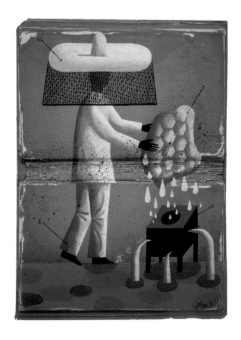

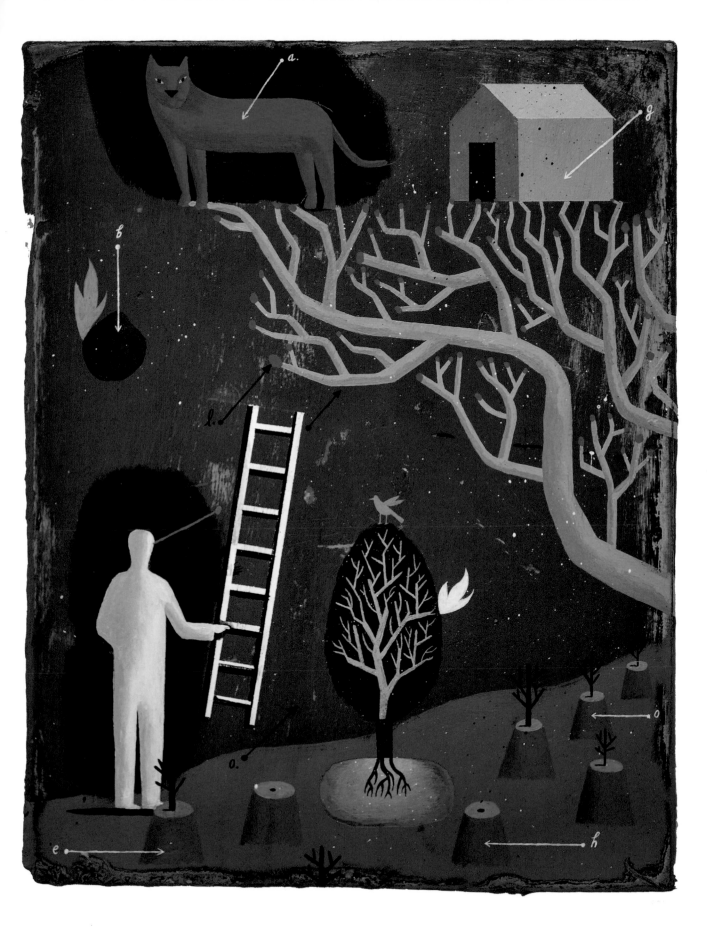

Sue Coe

1951 born in Tamworth, UK | lives and works in Deposit, USA
www.graphicwitness.org

EXHIBITIONS
The Ghosts of Our Meat, solo show, Trout Gallery, Carlisle, USA, 2014
Dead Meat, solo show, Galerie St Etienne, New York, 1996
Directions, solo show, Hirshhorn Museum, Washington, DC, 1994

AGENT
Galerie St. Etienne, USA

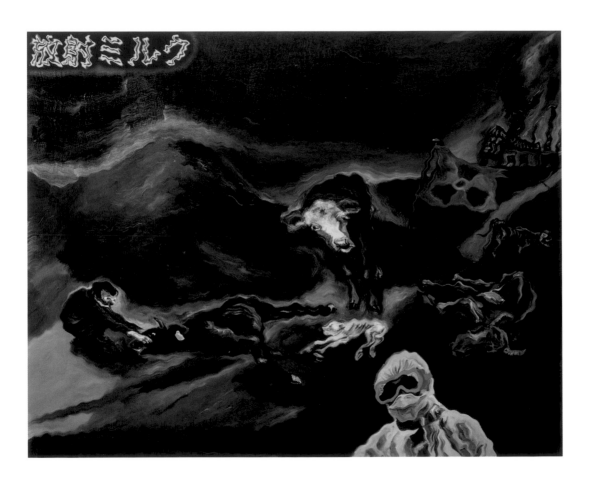

"Reportage art can have a vital role in supporting social justice movements. Art exists to change the world."

„Reportagekunst kann Bewegungen für soziale Gerechtigkeit in vieler Hinsicht sehr wirkungsvoll unterstützen. Sinn und Zweck der Kunst ist es, die Welt zu verändern."

« Le reportage art peut jouer un rôle vital dans le soutien des mouvements pour la justice sociale. L'art existe pour changer le monde. »

Fukushima, 2011
Or Books; oil on canvas

→ You Consume Their Terror, 2011
Or Books; graphite

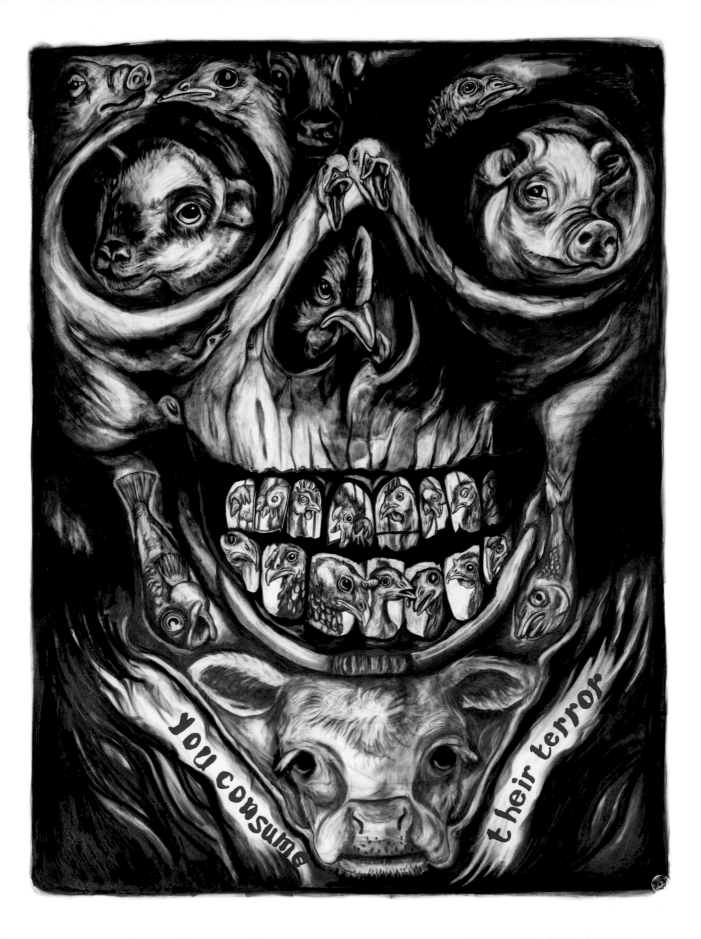

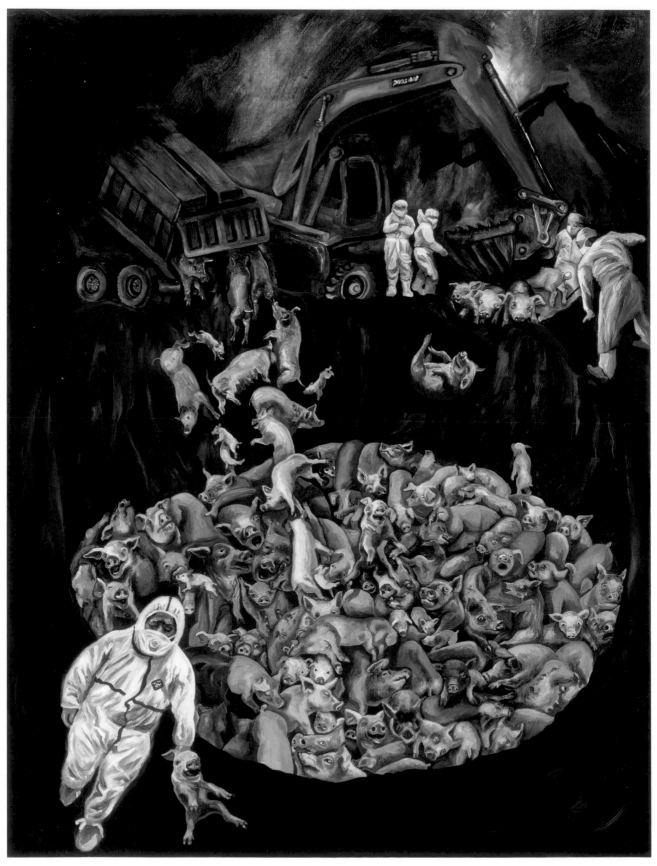

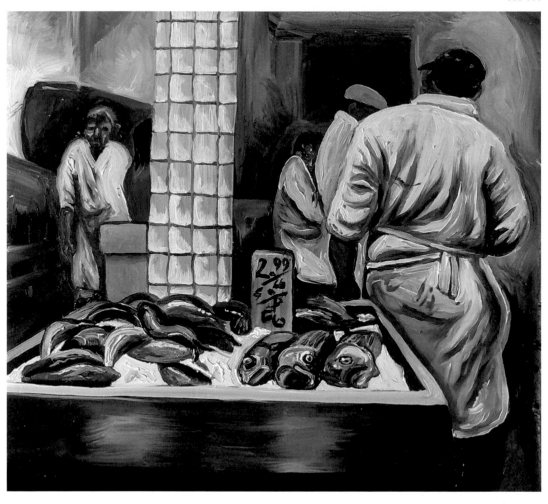

Fish Market, 2011
Or Books; oil on wood

← **Pigs Buried Alive, 2011**
Or Books; oil on canvas

Hugh Cowling

1990 born in Lincoln, UK | lives and works in Bristol
www.hughcowling.co.uk

CLIENTS
Bloomsbury, Electric Egg, Hush,
Falmouth University

EXHIBITIONS
Beginning Middle End, group show, Truro Arts Company, Truro, UK, 2013
New Designers, group show, Business Design Centre, London, 2013
D&AD New Blood, group show, Old Spitalfields Market, London, 2013

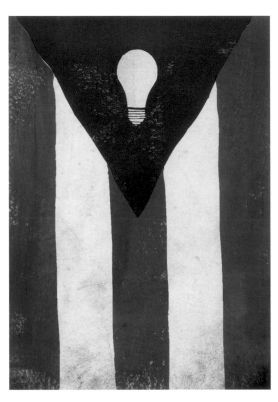

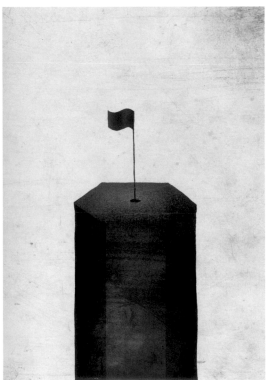

"Each new commission or idea inspires me to explore
different techniques and media. I want to continue
learning through each project I work on."

„Jeder neue Auftrag, jede neue Idee ist für mich ein Anreiz, neue
Techniken und Medien auszuprobieren. Ich möchte bei jedem
Projekt, an dem ich arbeite, etwas lernen."

«Chaque nouvelle commande ou idée me pousse à explorer
des techniques et supports différents. Je veux continuer
à apprendre à travers chaque projet.»

National Trust Attempts
to Block £100m Giant's Causeway
Golf Course, 2013
Personal work; pencil and digital

← Entrepreneurs Lead Cuba's
New Revolution, 2013
Personal work; pencil, gouache
and digital

→ Tuna Threatened by
Overfishing, 2011
Personal work; pencil, watercolor,
gouache, etching and digital

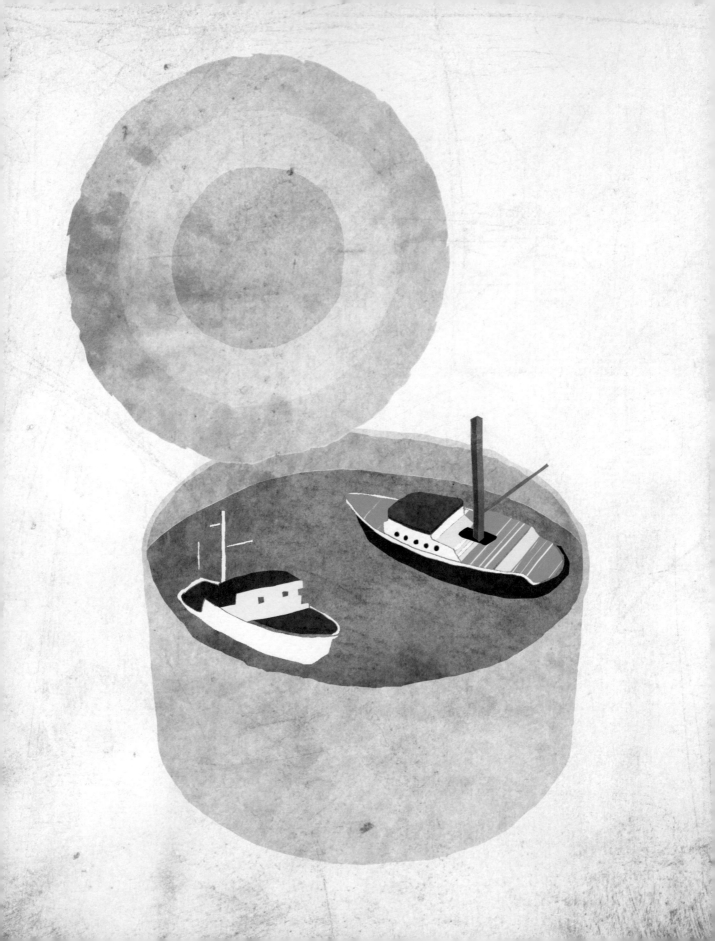

Paul Cox

1957 born in London | lives and works in London
www.paulcoxartist.com

CLIENTS
Folio Society, Penguin, Vanity Fair, The Telegraph,
Country Living, The Sunday Times, Esquire,
GQ, Town & Country, The New York Observer,
The Guardian, The Times, Veuve Clicquot

EXHIBITIONS
Paul Cox, A Journey Through His Art, major retrospective,
Chris Beetles Gallery, London, 2013
Solo Retrospective, Chris Beetles Gallery, London, 2001
Solo exhibition, Illustrators Gallery, London, 1985

AGENTS
Alison Eldred, UK
Richard Solomon, USA

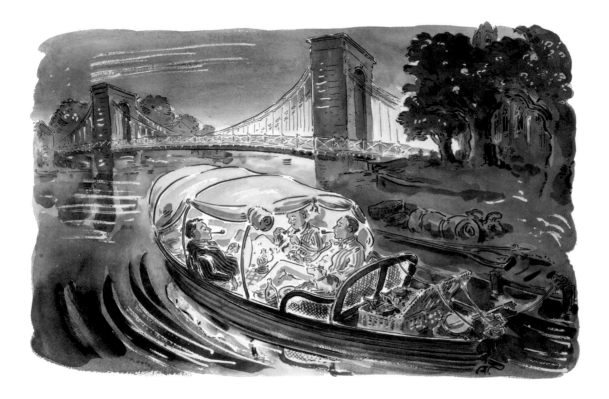

"Illustration should connect with the viewer's emotional
relationship with the text and belong to it. Both text and image
should be mutually enhancing, making something that is
unique, that each on their own would not achieve."

„Illustrationen sollten die emotionale Beziehung des Lesers zum Text ansprechen
und einen Teil von ihr darstellen. Text und Bild sollten sich ergänzen und etwas
Einmaliges entstehen lassen, was sie allein nie schaffen würden.“

« L'illustration doit entrer en résonance avec la relation émotionnelle
que le lecteur entretient avec le texte. L'image et le texte doivent
se compléter, et créer quelque chose d'unique, qu'ils ne
pourraient pas atteindre chacun de son côté. »

Three Men in a Boat,
Evening by Marlow Bridge, 2009
Client, Pizza Express, originally
Pavilion Books 1989; watercolor

→ Paris News Kiosk, 2007
Personal work; watercolor

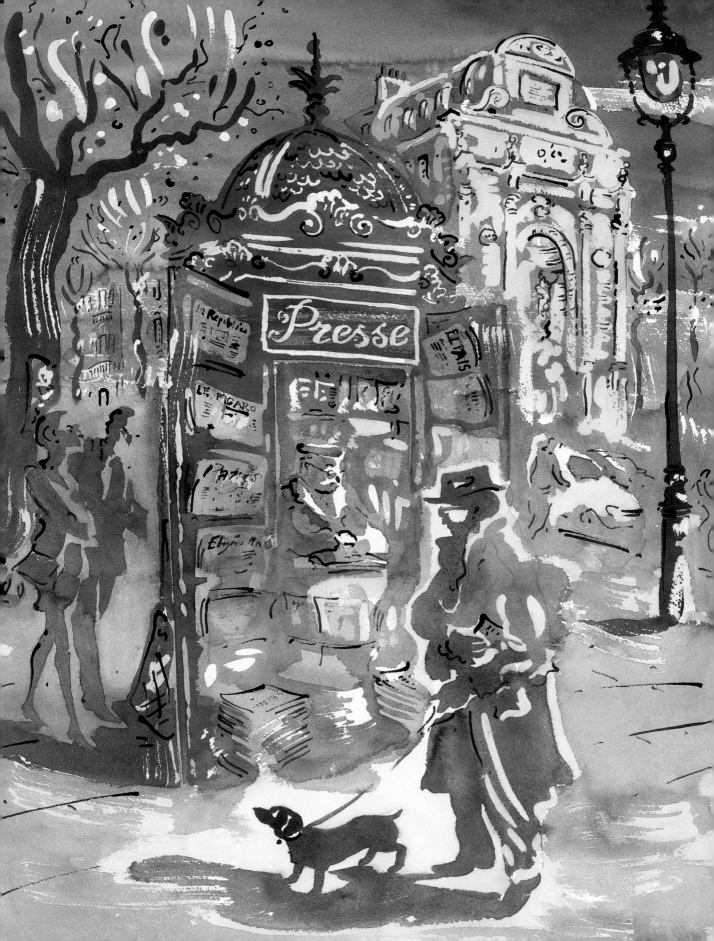

Dan Craig

1957 born in Mankato, USA | lives in Saint Paul and works in Minneapolis

CLIENTS

Nike, Toyota, Smucker's, ESPN, Minnesota Zoo, Stern, Der Spiegel, The Washington Post, Morgan Stanley, Land Rover, Birds Eye, Penguin, Random House

EXHIBITIONS

Group show, Society of Illustrators, New York, 2011
Fifty Years of Der Spiegel, traveling group show, Hamburg, 2004

AGENT

Bernstein & Andriulli, USA

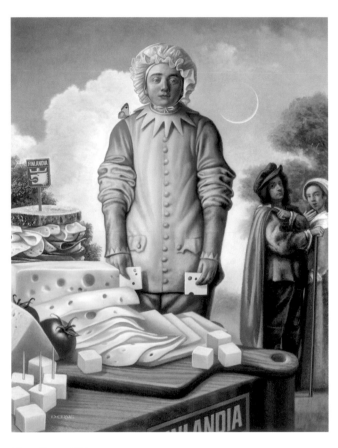

Cheese Dunce, 2013
Finlandia; digital

→ Quail Hunt, 2009
Captain Birdseye, series of print ads
A Better Class of Fish, Art Direction:
Colin Jones, AMV BBDO London;
digital

→→ Girl with Parakeets, 2003
Personal work; digital

"I am fascinated by detail, structure and the subtleties of color and shadow. I try to be true to nature but enjoy and have fun with its visual form."

„Mich faszinieren Details, Strukturen und die Nuancen von Farben und Schatten. Ich versuche, naturgetreu zu arbeiten, spiele aber gern mit den visuellen Formen der Natur."

« Je suis fasciné par les détails, la structure et les subtilités de la couleur et de l'ombre. J'essaie de rester fidèle à la nature, mais j'aime m'amuser avec sa forme visuelle. »

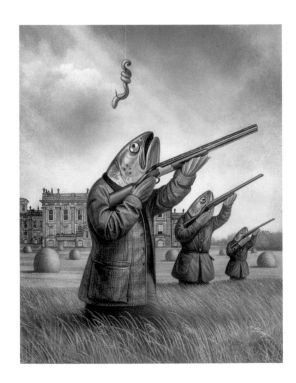

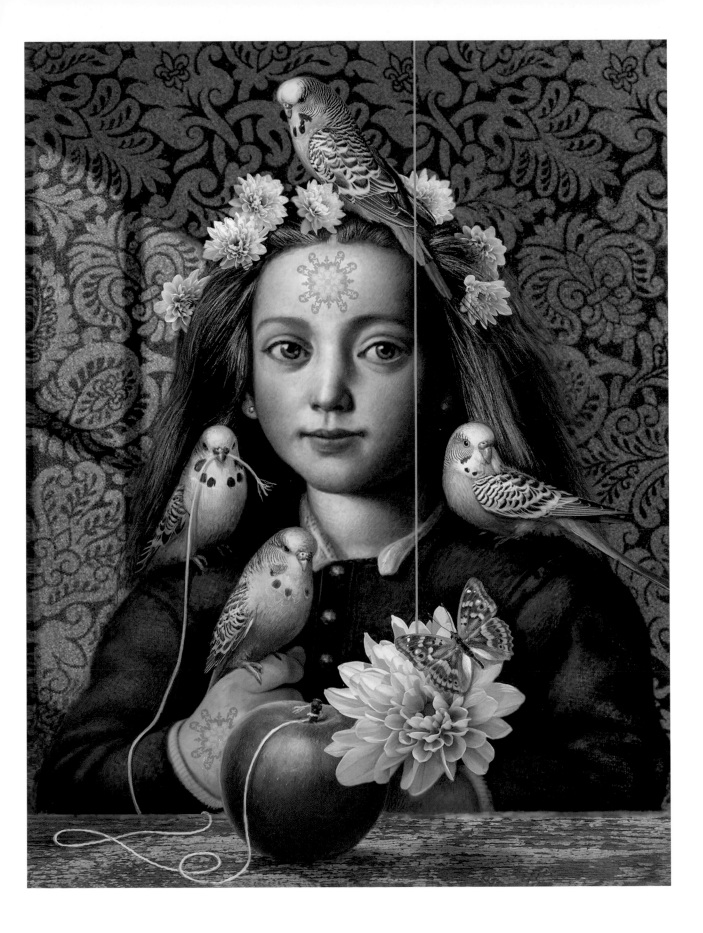

Tortoise and Hare, 2002
Scott Foresman, Art Director:
Janet Hill; digital

→ The Red Beret, 2007
Random House, book cover, Art
Direction: Paolo Pepe; digital

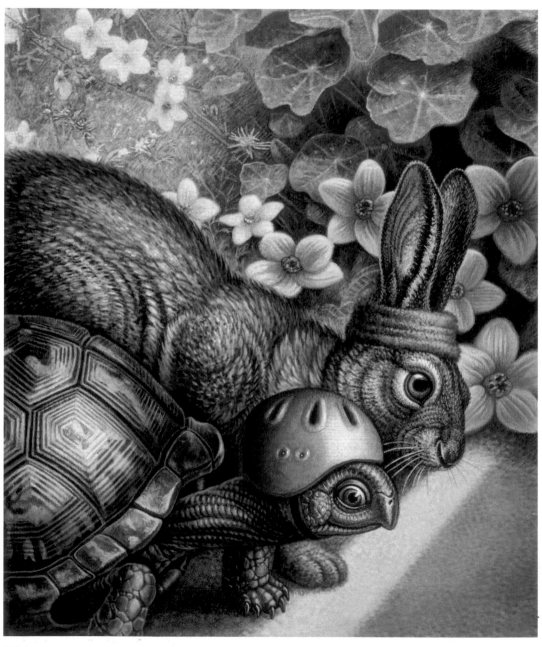

Craig & Karl

2011 born in New York and London | live and work in New York and London
www.craigandkarl.com

CLIENTS
LVMH, Google,
Nike, Apple, Vogue,
The New York Times

EXHIBITIONS
Drones of New York, group show, Museum of the Moving Image, New York, 2013
Fashionable Ones, solo show, I.T., Hong Kong, 2012
150/15, solo show, Colette, Paris, 2012

"We live in different parts of the world but collaborate
daily to create work that is filled with simple messages
executed in thoughtful ways."

„Wir leben auf unterschiedlichen Kontinenten, kommunizieren
aber jeden Tag, um überlegt ausgeführte Grafiken mit
einfachen Botschaften zu machen."

«Nous vivons dans différentes régions du monde,
mais nous collaborons tous les jours pour
créer un travail qui transmet des messages
simples, exécutés avec soin.»

Chris Paul and
Carmelo Anthony, 2013
Nike, apparel; digital

→ Outside Pass, 2013
Personal work; digital

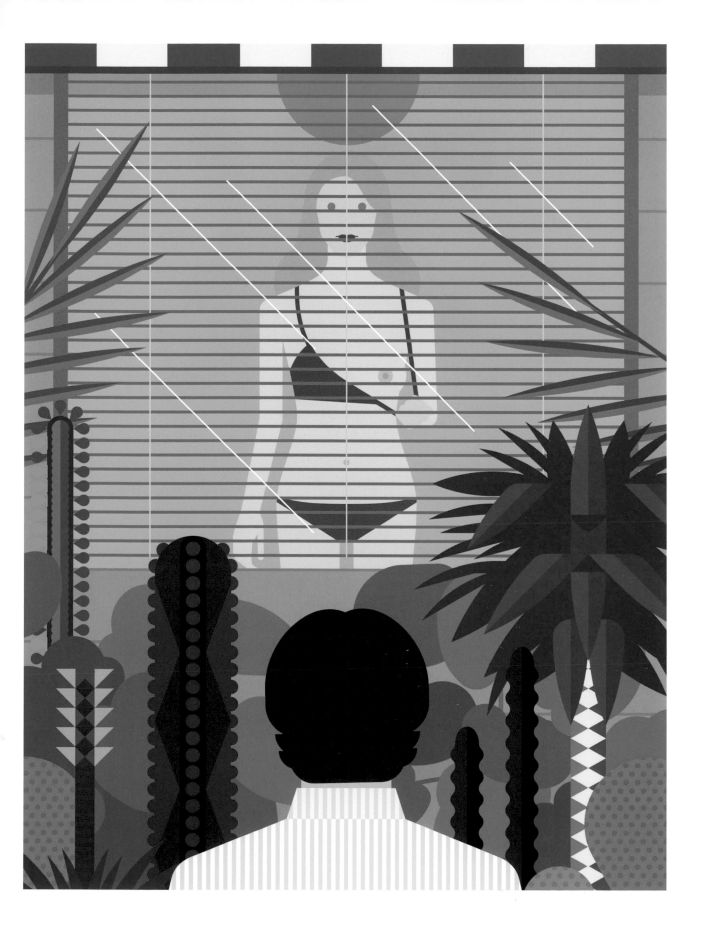

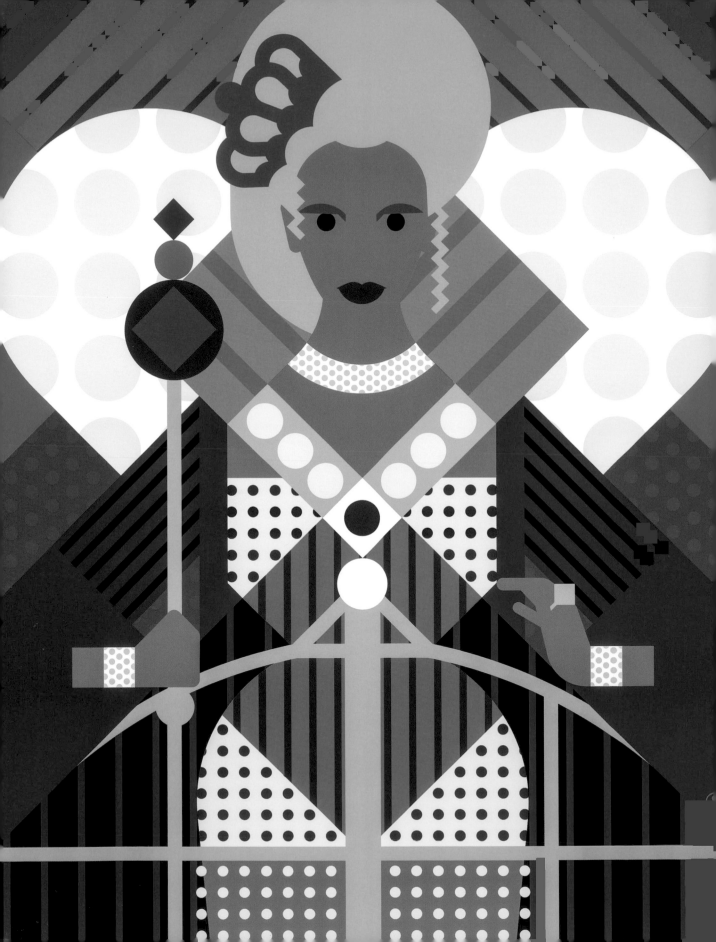

Hansel and Gretel, Rigoletto,
Written on Skin and Babylon, 2013
Bayerische Staatsoper, Design:
Mirko Borsche; digital

← **Beyonce**, 2013
British Vogue; digital

Deedee Cheriel

1970 born in Eugene, USA | lives and works in Los Angeles
www.deedeecheriel.com

EXHIBITIONS
Unnatural – Natural History, group show, Royal West Academy, Bristol, 2012
Just Passing Through, solo show, Andenken Gallery, Amsterdam, 2012
Deedee Cheriel New Work, group show, Subliminal Projects, Los Angeles, 2010

AGENTS
Coates and Scarry, UK
Merry Karnowsky Gallery, USA

"The dramas of my everyday life find comedic remedy
in my narratives. I draw stories about my life."

„Meine alltäglichen Dramen lösen sich in meinen Darstellungen
humorvoll auf. Ich zeichne Geschichten über mein Leben."

« Les drames de ma vie quotidienne trouvent un remède
humoristique dans mes récits. Je dessine des
histoires à propos de ma vie. »

Desire, 2012
Personal work; spray paint, latex and
acrylic on wood panel

→ Taming the Tiger Within, 2012
Personal work; spray paint, latex and
acrylic on wood panel

Peter Donnelly

1967 born in Dublin | lives and works in Dublin
www.donnellyillustration.com

CLIENTS

Rothco, Leo Burnett, McCann Erickson, DDFHB,
Ogilvy & Mather, Cawley Nea, Chemistry, Young Euro,
The Brand Union, The New York Observer

EXHIBITIONS

Art of Superstition, group show, Copper House Gallery, Dublin, 2013
The Illustrated Beatles, group show, Oh Yeah Centre, Belfast, 2012
Illustration @ Fire, group show, Copper House Gallery, Dublin, 2012

AGENTS

John Brewster Creative, USA
Red Ape Design, Australia

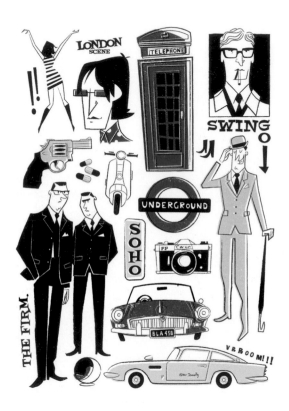

"I like to create lots of rhythm in
my work, always pushing the design
until I feel I've finally captured
a sense of movement."

„Meine Arbeiten sollen richtig Rhythmus haben.
Ich entwickle einen Entwurf immer weiter,
bis ich schließlich das Gefühl von Bewegung
eingefangen habe."

« J'aime créer beaucoup de rythme dans mon
travail, en poussant le concept jusqu'à ce que
j'arrive à saisir une impression de mouvement. »

London Scene, 2013
Personal work; pencil and digital

→ Tudor House, 2012
Personal work; pencil and digital

→→ Seaways, 2013
Personal work, exhibition The Art of
Superstition, Copper House Gallery,
Dublin; pencil and digital

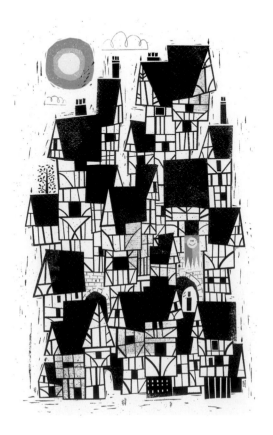

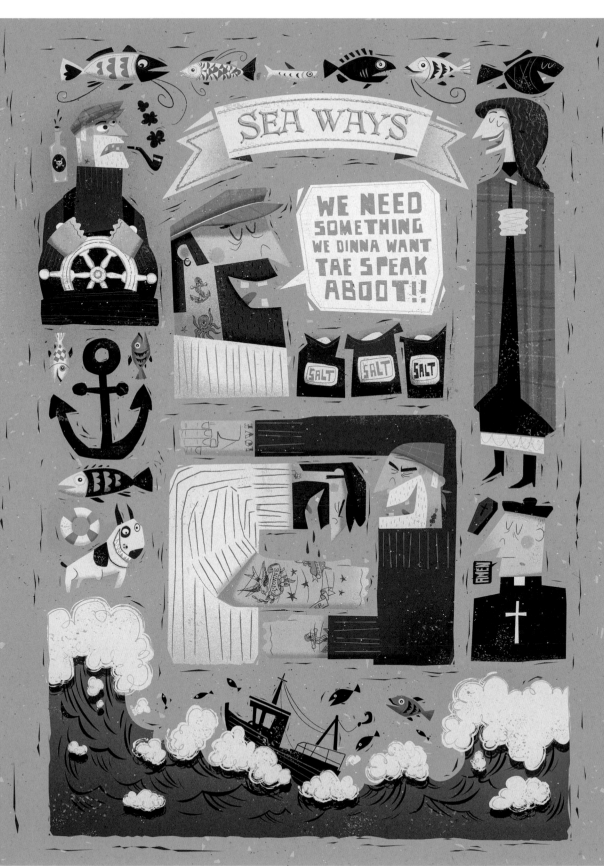

Elzo Durt

1980 born in Brussels | lives and works in Brussels
www.elzodurt.com

CLIENTS
Born Bad Records, Lacoste, Carhartt, Le Monde,
Flip Skateboards, Rome Snowboards, Salomon,
Teenage Menopause Records

EXHIBITIONS
Solo show, Doppelgaenger, Bari, Italy, 2013
Hey! Modern Art & Pop Culture Art Show, group show, Halle St-Pierre, Paris, 2011
Elzo Exhibition Tour for Carhartt, solo show, various Carhartt shops, 2009

AGENTS
Central Illustration
Agency, UK
La Superette, France

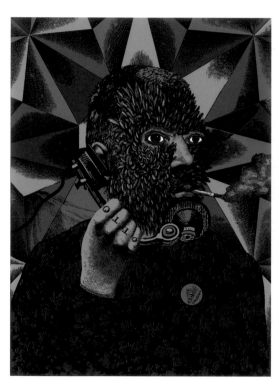

"My illustrations are done as computer-assisted collage.
I look for source material in old engravings, comics and photos,
then put it together and give it form and color."

„Meine Illustrationen sind computergestützte Collagen. Mein Ausgangsmaterial
sind alte Radierungen, Comics und Fotos, das stelle ich dann zusammen
und gebe ihm Form und Farbe."

« Mes illustrations sont des collages assistés par ordinateur.
Je cherche mes sources dans de vieilles gravures, BD et photos,
je les assemble et je leur donne forme et couleur. »

Stephanovitch, 2009
Personal work; mixed media,
screenprint

← Autoportrait, 2010
Personal work; mixed media,
screenprint

→ 7 Sins, 2011
Personal work; mixed media,
screenprint

Sarah Egbert Eiersholt

1985 born in Copenhagen | lives and works in Copenhagen
www.sarahegberteiersholt.com

CLIENTS
The Independent on Sunday, Sturm und Drang,
Die Presse, Miss, Bulletin, Fleisch Magazine, Brand8

AGENTS
Caroline Seidler, Austria
Peppercookies, UK

"I am interested in combining opposites—finding a certain pattern, color or character in an environment where they do not belong."

„Mir gefällt es, Gegensätze zu verbinden – ein Muster, eine Farbe oder einen Charakter in eine völlig unpassende Umgebung einzubauen."

« Ce qui m'intéresse c'est combiner les contraires, trouver un motif, une couleur ou un personnage dans un environnement qui lui est étranger. »

Good Times, 2013
Personal work; pencil and digital

→ Monkey, 2013
Personal work; pencil and digital

→→ Nothing But Hair, 2013
Personal work; pencil and digital

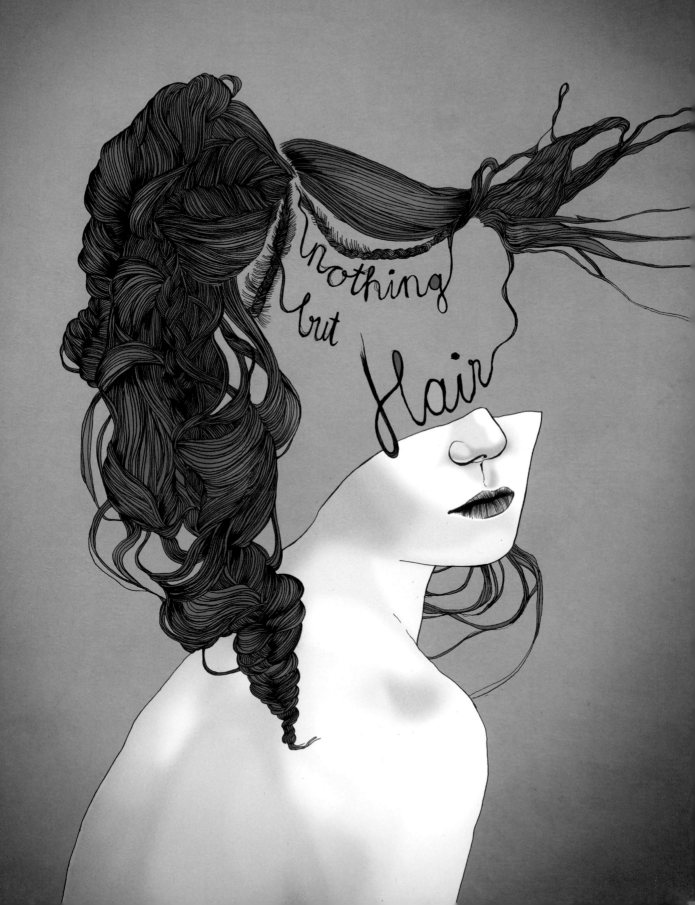

Thomas Ehretsmann

1974 born in Mulhouse, France | lives and works in Strasbourg
www.thomas-ehretsmann.com

CLIENTS
Elle, The New Yorker, Rolling Stone, Salani,
Delcourt, Penguin, Bloomsbury, Mondadori,
Flammarion, Bayard, DTV, Hachette

EXHIBITIONS
Odd Nerdrum's Students Exhibition, Gallery L'Oeil du Prince, Paris, 2013
Portraits Exhibition, group show, Gallery Brûlée, Strasbourg, 2011

AGENT
Richard Solomon, USA

"Painting is a constant effort to link
technique to emotional content,
the goal being for each illustration
to have a life of its own."

„Beim Malen geht es ständig darum, Technik
mit emotionalem Gehalt zu verbinden. Am Ende
soll jede Illustration ein Eigenleben haben."

«Peindre est un effort constant pour relier
technique et contenu émotionnel, l'objectif
étant que chaque illustration ait une vie
qui lui est propre.»

David Bowie, 2013
Rolling Stone; acrylic on paper

→ Murder Inc., 2008
Editions Delcourt, graphic novel cover
Mafia Story, volume 3; acrylic on paper

→ SDF, 2008
Elle; acrylic on paper

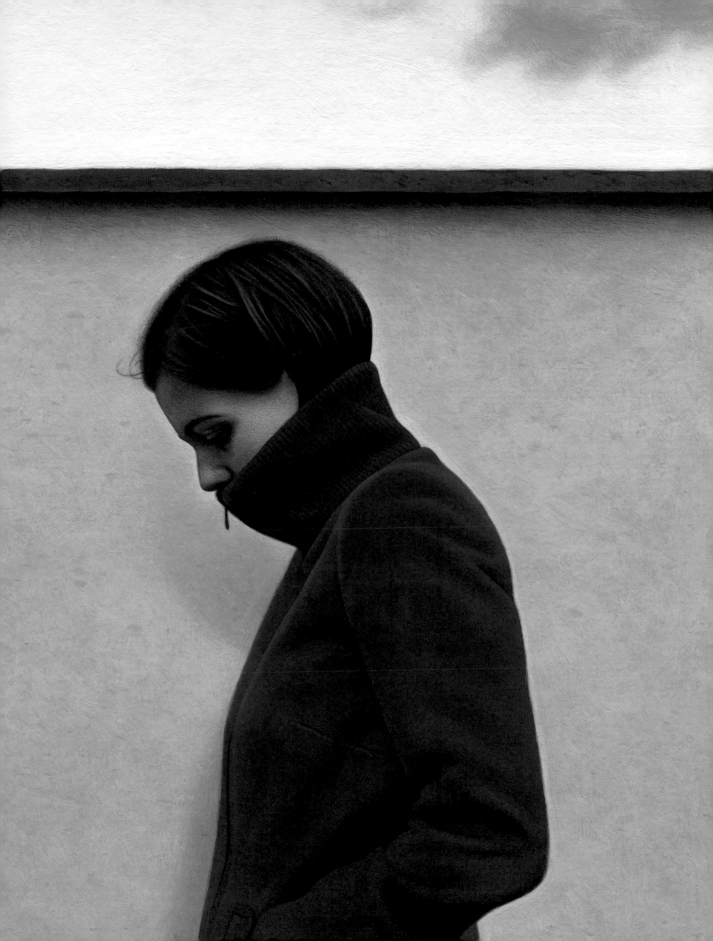

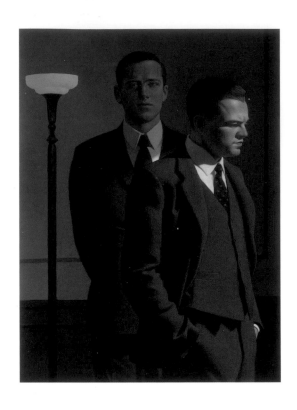

J. Edgar, 2011
The New Yorker; acrylic on paper

→ Nu, 2013
Galerie L'Oeil du Prince, Paris;
acrylic on cardboard

↓ Elle, 2004
Elle; acrylic on paper

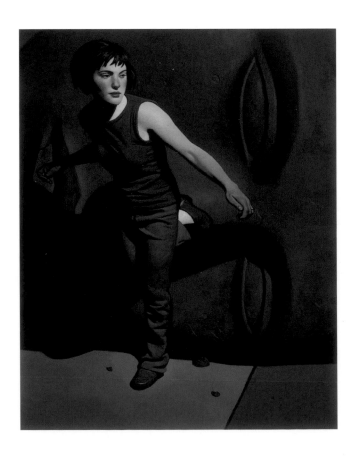

Shimrit Elkanati

1980 born in Haifa | lives and works in Givataim, Israel
www.flickr.com/photos/shimritelkanati/

CLIENTS
The New York Times, Nobrow, Am Oved, Scrawl,
Inbal Pinto & Avshalom Pollak Dance Company,
The Israeli Cartoon Museum

EXHIBITIONS
HaMizrahi'eem (The Orientals), group show, Dov Hoz Street Gallery, Holon, 2013
Art-Trek, group show, Galerie Mekanik, Antwerp, 2012
Childhood Memories, group show, Kunst und Kultur e.V. 2025 Gallery, Hamburg, 2012

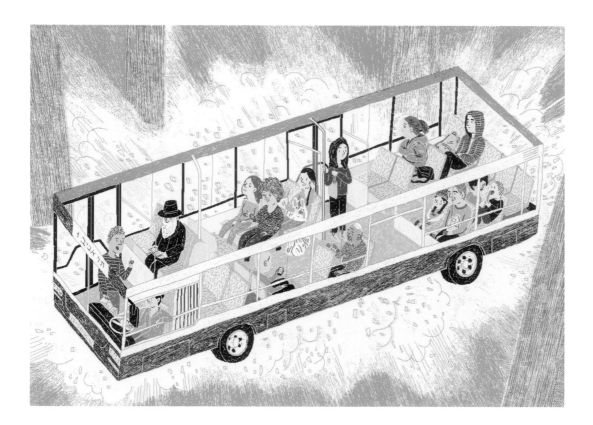

"Drawing is work and therapy wrapped up together.
More than anything I just love making marks."

„Zeichnen ist Arbeit und Therapie in einem. Das mache ich wirklich
am liebsten: Dinge zu Papier bringen."

« Dessiner, c'est à la fois travailler et faire une thérapie.
Mais surtout, j'adore laisser des traces sur le papier. »

Untitled, 2013
Nobrow Press; digital

→ Grandpa Mountain &
Ermoza, 2011
Personal work, comic book; digital

Ellakookoo

1985 born in Haifa | lives and works in Tel Aviv and Berlin
www.ellakookoo.com

CLIENTS
Wrap, The New York Times, Eight,
Wall Street Journal, I Heart Magazine,
EasyJet, Time Out Tel Aviv, Oh Comely

EXHIBITIONS
Illustrators 55, group show, Museum of American Illustration, New York, 2013
Illustrative 2013, group show, Direktorenhaus, Berlin, 2013
Ordinary, group show, Lorber Gallery, Shenkar, Tel Aviv, 2012

AGENTS
Folio, UK
La Suite, France

"Illustration is my way of communicating ideas and feelings with the world. I'm inspired by everything and everyone I see and meet along the way."

„Illustrationen sind meine Art, der Welt Ideen und Gefühle zu vermitteln.
Ich lasse mich von allem und jedem inspirieren, dem ich unterwegs begegne."

« L'illustration, c'est ma façon de communiquer des idées et des émotions.
Je m'inspire de tout et de toutes les personnes que je rencontre. »

The Homecoming, 2012
Thesis; digital

→ I Heart TLV, 2013
I Heart Magazine, editorial;
digital

Miguel Endara

1983 born in Los Angeles | lives and works in Miami
www.miguelendara.com

EXHIBITIONS
Handheld Exhibition, group show, The LAB Miami, 2012
Sofi Magazine Art Basel Show, group show, South of Fifth, Miami, 2010
Grafuck 3 Book Release Art Show, group show, Gallery Nucleus, Alhambra, USA, 2007

"Becoming a more patient person
with each illustration is more important
than the illustration itself."

„Mit jeder Illustration an Geduld zu gewinnen
ist wichtiger als die Illustration an sich."

« Devenir une personne plus patiente
à chaque illustration est plus important
que l'illustration elle-même. »

Lily with a Pearl Earring, 2010
Personal work, self portrait with Lily
Vidal; paper, pen and ink

→ Hero, 2011
Personal work; paper, pen and ink

→→ Benjaman Kyle, 2012
Personal work; paper, pen and ink

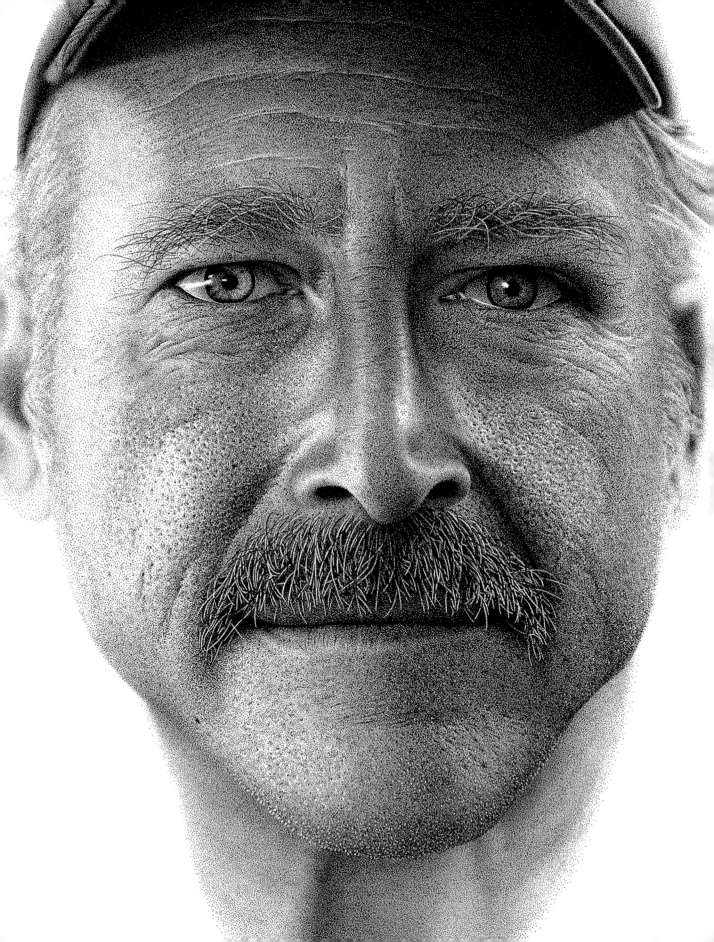

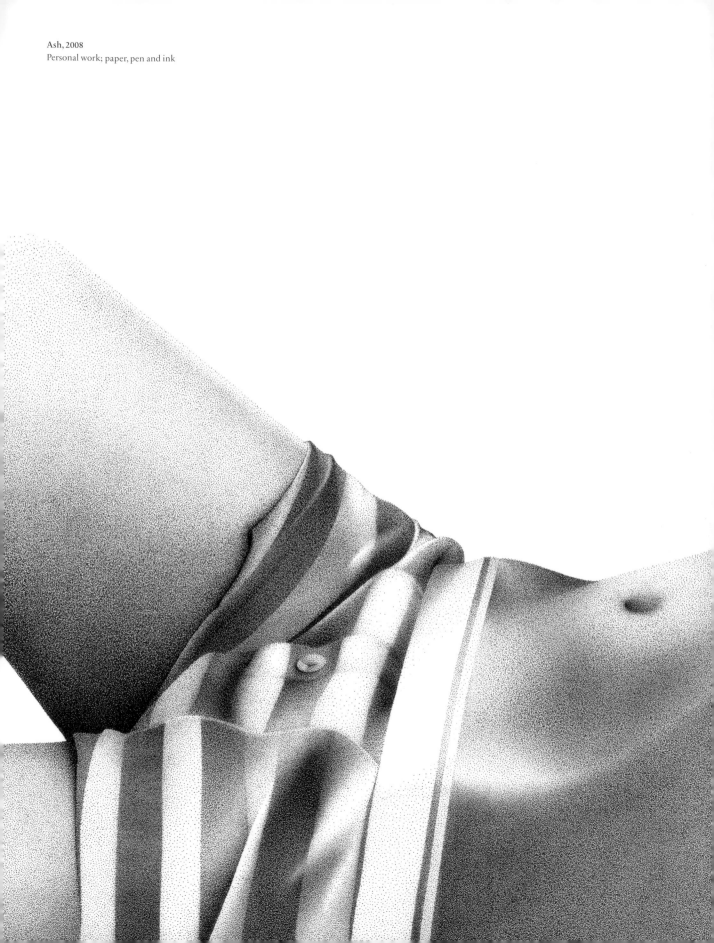

Ash, 2008
Personal work; paper, pen and ink

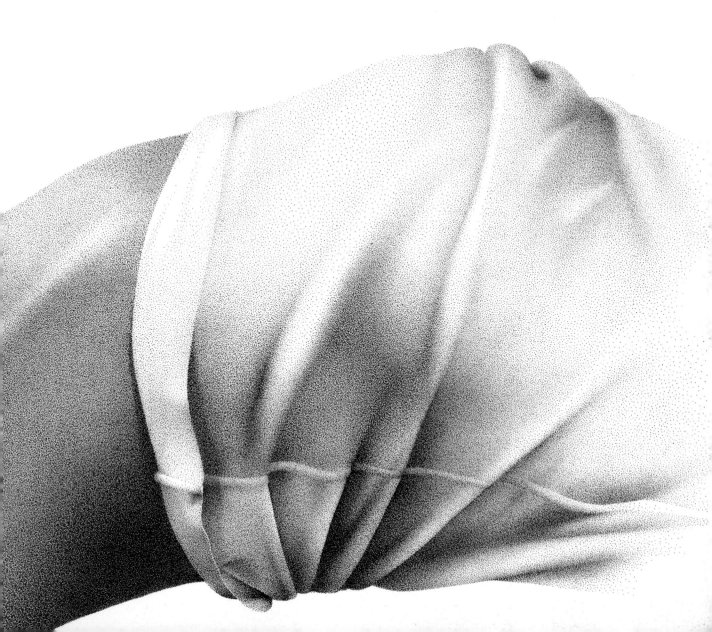

Maren Esdar

1972 born in Bielefeld, Germany | lives and works in Hamburg
www.marenesdar.com

CLIENTS
The New York Times, Vogue, GQ, Esquire, Amica Italia, Elle, Tush, Surface, La Perla, Mercedes Benz, Neiman Marcus, British Airways, Universal Music

EXHIBITIONS
Phobia, solo show, 2agenten art-space, Berlin, 2010

AGENTS
2agenten, Germany
Traffic Creative Management, USA
Unit, Netherlands

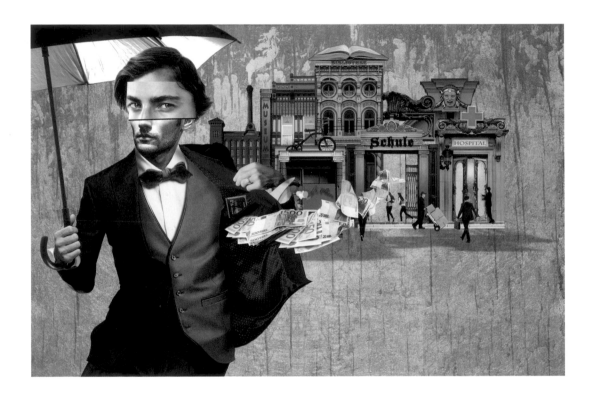

"Creating poetic dream-worlds in which sensual, sophisticated individuals invite you to take a closer look and see beauty where at first you wouldn't expect it."

„Poetische Traumwelten zu schaffen, in denen sinnliche, kultivierte Menschen einen auffordern, näher hinzusehen und Schönheit in etwas zu erkennen, wo man sie zunächst nicht erwarten würde."

« Créer des mondes oniriques et poétiques dans lesquels des individus sensuels et élégants vous invitent à regarder de plus près et voir la beauté là où vous ne l'attendez pas. »

Conscious Luxe, 2013
Manager Magazin, Art Direction: Wilde; digital

→ Psychedelic Visions, 2011
Tush, Art Direction: Reto Brunner; digital

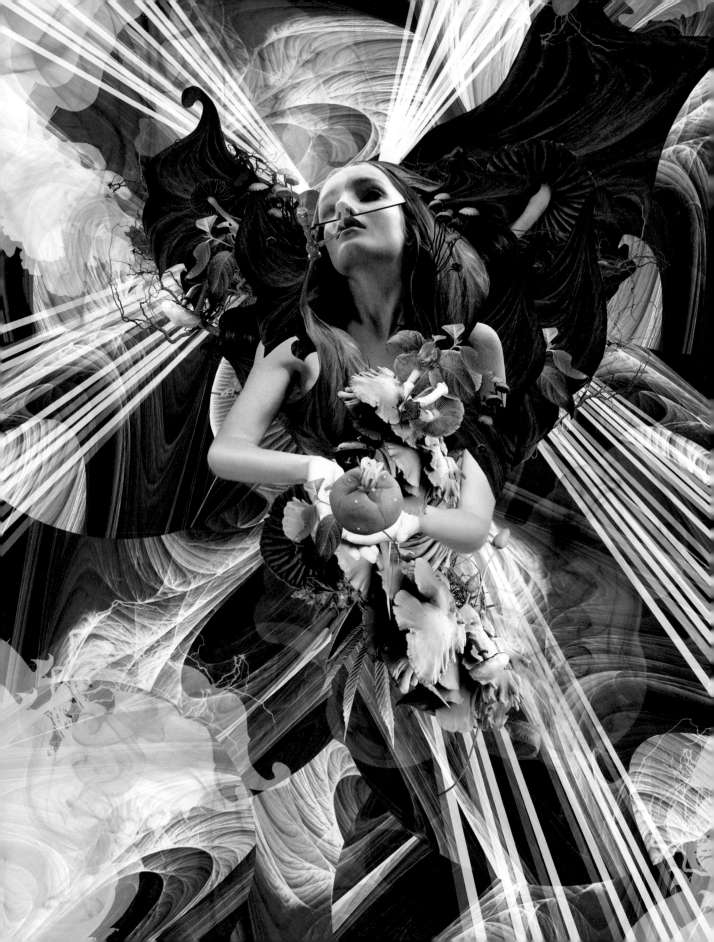

Ophelia, 2013
2agenten, booklet Inspiration; digital

→ Checkers, 2013
Flashon; digital

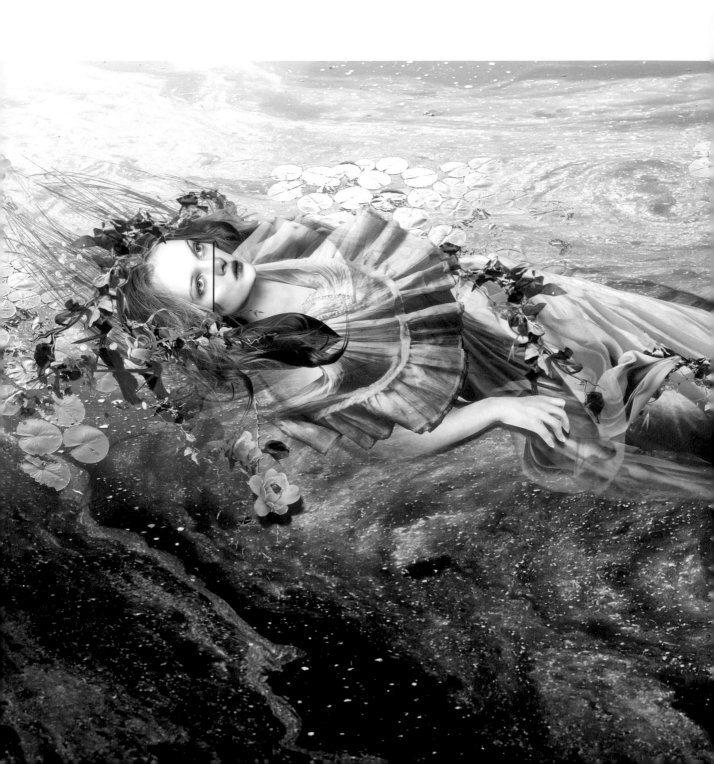

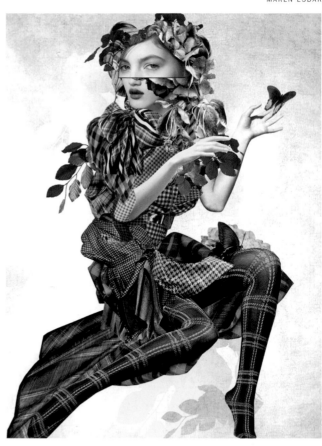

Chrigel Farner

1972 born in Schaffhausen, Germany | lives and works in Berlin
www.chrigelfarner.com

"The most important thing for me is to be drawing
as few cars as possible. For c. 20 years now I have worked
at times as an illustrator and at others as myself."

„Es geht mir hauptsächlich darum, so wenig Autos wie
möglich zu zeichnen. Ich arbeite jetzt seit ca. 20 Jahren
gelegentlich als Illustrator und als Ich."

«Pour moi, le plus important est de dessiner aussi
peu de voitures que possible. Depuis 20 ans,
je travaille parfois en tant qu'illustrateur et
parfois en tant que moi-même.»

Crazy Sky, 2010
Sirenenvogel Y; gouache on paper

→ **Fingerpoke**, 2010
Tudor Records, album artwork Neptune
Street by Fingerpoke; acrylic, pen, ink,
pencil and oil on cardboard

Die Welt, 2012
Salis-Verlag AG, book Nemorino und
das Bündel des Narren, Collaborator:
Gion Mathias Cavelty; gouache and pen

Malika Favre

1982 born in Paris | lives and works in London
www.malikafavre.com

CLIENTS
Penguin UK, Vogue UK/Japan, Gucci, Vitsœ, Vanity
Fair France, Wallpaper*, The New York Times,
Roger Vivier, Carluccio's, Heals, Orlebar Brown

EXHIBITIONS
Kama Sutra, Pick Me Up selects, solo show, Somerset House, London, 2013
Tweet-a-brief, Handsome Frank, group show, Gallery 71a, London, 2012
Hide and Seek, solo show, Kemistry Gallery, London, 2012

AGENT
Handsome Frank, UK

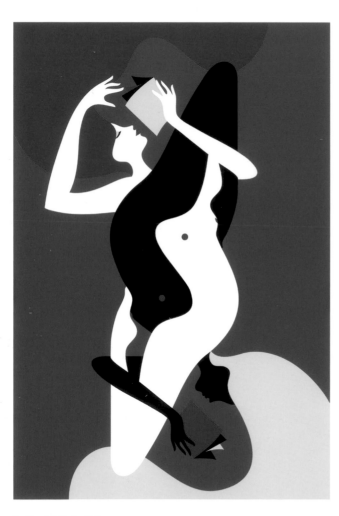

"I am all about colorful minimalism.
I aim to use as few lines and colors
as are needed to convey the core
of the idea. Less is definitely more."

„Für mich ist farbenfroher Minimalismus alles.
Ich möchte den Gehalt eines Gedankens mit
so wenigen Strichen und Farben wie möglich
vermitteln. Weniger ist eindeutig mehr."

« Mon truc à moi c'est le minimalisme coloré.
J'essaie d'utiliser le minimum nécessaire
de traits et de couleurs pour exprimer
l'essence de l'idée. »

Justine et Juliette, 2013
Personal work; screenprint

→ **Le Plaisir, 2013**
The New York Times, cover; digital

→→ **Russian Beauty, 2013**
Marie Claire Russia, cover; digital

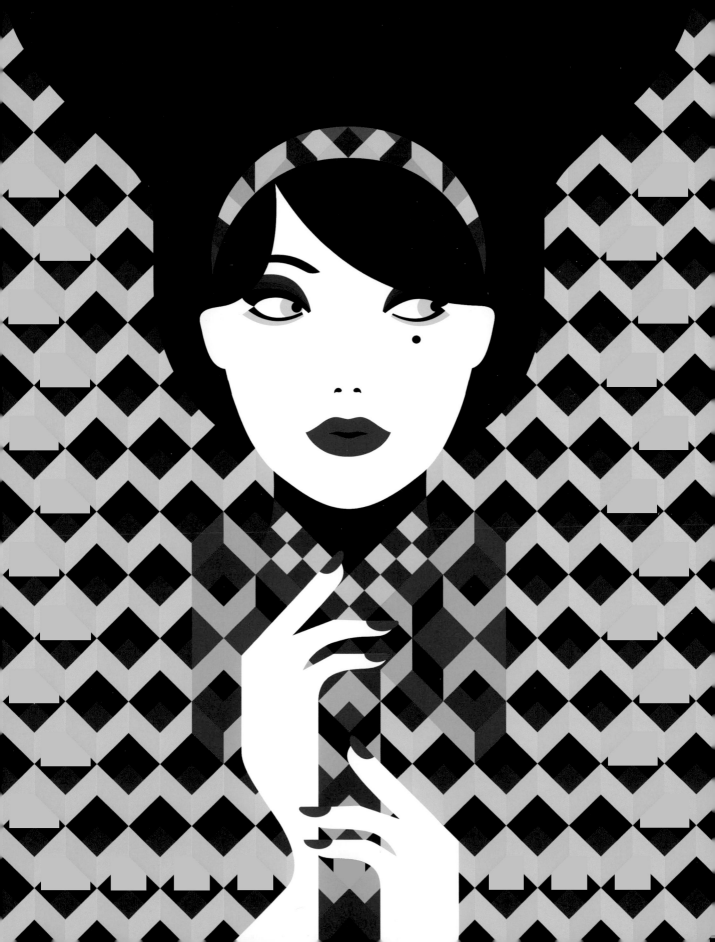

Nathan Fox

1975 born in Washington, DC | lives and works in New York
www.foxnathan.com

CLIENTS
Rolling Stone, Wieden + Kennedy, Nike, Burton, Wired,
The New York Times, Chronicle Books, Scholastic,
Playboy, GQ, Esquire, DC/Vertigo, Marvel, Image

EXHIBITIONS
Group show, Society of Illustrators, New York, 2014
American Illustration, group show, Angel Orensanz Foundation,
New York, 2012 and 2013

AGENT
Bernstein & Andriulli, USA

"I try and tell a story with every illustration, establishing
movement and character with the marks I make in
an effort to engage, inform and entertain."

„Ich versuche, mit jeder Illustration eine Geschichte zu erzählen und
durch die Zeichen, die ich mache, eine Bewegung und einen Charakter
darzustellen, die den Betrachter bannt, informiert und unterhält. "

« J'essaie de raconter une histoire à chaque illustration, en créant
du mouvement et un personnage avec mes traits pour intriguer,
informer et amuser. »

My Blonde Zombie, 2011
The Atlantic, Art Direction: Jason Treat;
brush and ink on bristol and digital

→ Red Dead Redemption, 2011
Entertainment Weekly, Art Direction:
Jennie Chang; ink wash on bristol
and digital

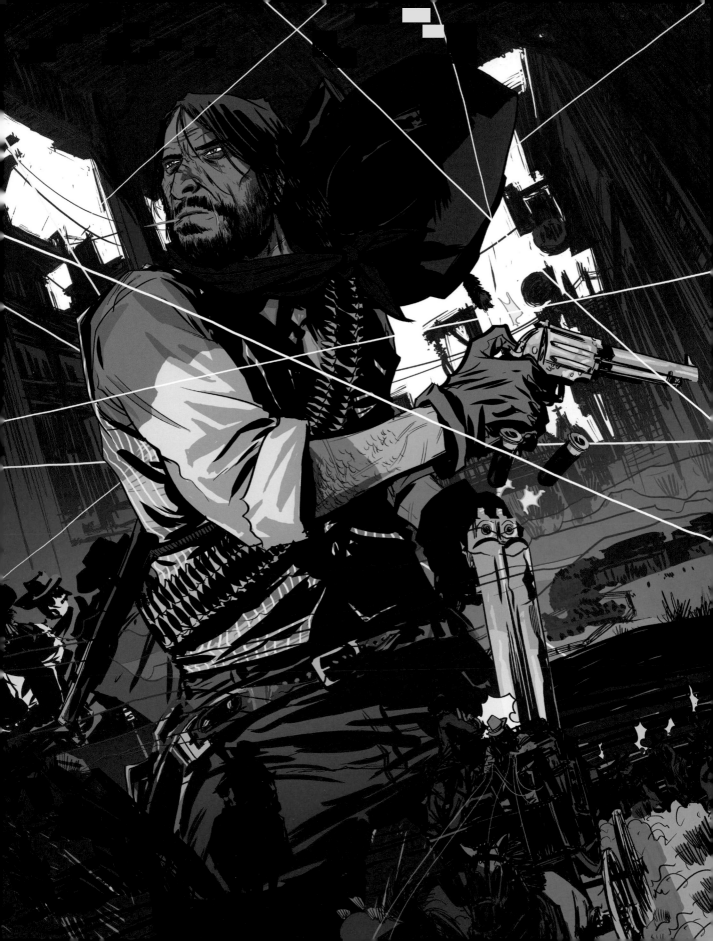

Jonna Fransson

1984 born in Stockholm | lives and works in Stockholm
www.jonnafransson.com

AGENT
NU Agency, Sweden

"I think my realistic style and favorite
motifs reflect a longing for something
beyond opinions about right and
wrong, trends and hierarchies.
Something that stays the same over
time. Just like nature."

„Ich finde, mein realistischer Stil und meine
Lieblingsmotive zeigen ein Verlangen nach etwas,
das über Meinungen zu richtig und falsch, über Trends
und Hierarchien hinausweist. Etwas, das sich über
den Lauf der Zeit hinweg treu bleibt. Wie die Natur."

« Je pense que mon style réaliste et mes motifs
de prédilection reflètent l'envie de quelque chose
qui dépasse les opinions sur le bien et le mal,
les tendances et les hiérarchies. Quelque chose
qui ne change pas. Comme la nature. »

Portrait, 2012
Behind the Scenes, Arvinius Förlag,
book illustration; pencil and digital

→　Seeds, 2012
Personal work; pencil and digital

Shannon Freshwater

1977 born in Las Vegas | lives and works in Los Angeles
www.shannonfreshwater.com

CLIENTS
The New York Times, Scientific American, Playboy,
Farrar, Straus & Giroux, Little, Brown & Co., Knopf,
Le Monde, Stanford Social Innovation Review

EXHIBITIONS
50 Books/50 Covers, group show, AIGA National Design Center, New York, 2011
That's What She Said, group show, Subtext Gallery, San Diego, 2011
True Self, group show, Jonathan LeVine Gallery, New York, 2009

A Maggot, 2012
Little, Brown & Co., book cover,
unpublished, Art Direction: Keith
Hayes; collage

→ **Alzheimers, 2010**
The New York Times, Art Direction:
Aviva Michaelov; collage

→→ **Old Time Radio in LA, 2011**
The Playboy Jazz Festival, Art Direction:
Fred Fehlau; collage

"I continually strive to create arresting
work that captures an emotional
and psychological mood, with interests
in the mysterious and unknown."

„Ich versuche immer, packende Bilder zu machen,
die eine emotionale und psychologische Stimmung
vermitteln, aber auch etwas Geheimnisvolles
und Unbekanntes einfangen."

« J'essaie constamment de créer des images
frappantes qui saisissent une atmosphère
émotionnelle et psychologique, avec une
tendance pour le mystère et l'inconnu.»

Carla Fuentes

1986 born in Valencia | lives and works in Madrid
www.littleisdrawing.com

EXHIBITIONS
Exhibition About a Trip, solo show, Ó! Galeria, Porto, 2013
Drawings 2010–2012, solo show, Do Design, Madrid, 2012

El Chico del Pelo Rojo, 2012
Personal work; gouache, color
pencil, pencil and ink

→ **Nick Cave Tribute, 2010**
Personal work; ink and color pencil

→→ **Botanical Girl, 2012**
Personal work; gouache, color
pencil, pencil and ink

"Illustration is perfect, it combines
with all the disciplines, is simple
and complete."

„Illustration ist perfekt: Sie passt sich
allen Disziplinen an, ist schlicht und in
sich geschlossen."

« L'illustration est parfaite, elle combine
toutes les disciplines, elle est simple
et complète. »

162

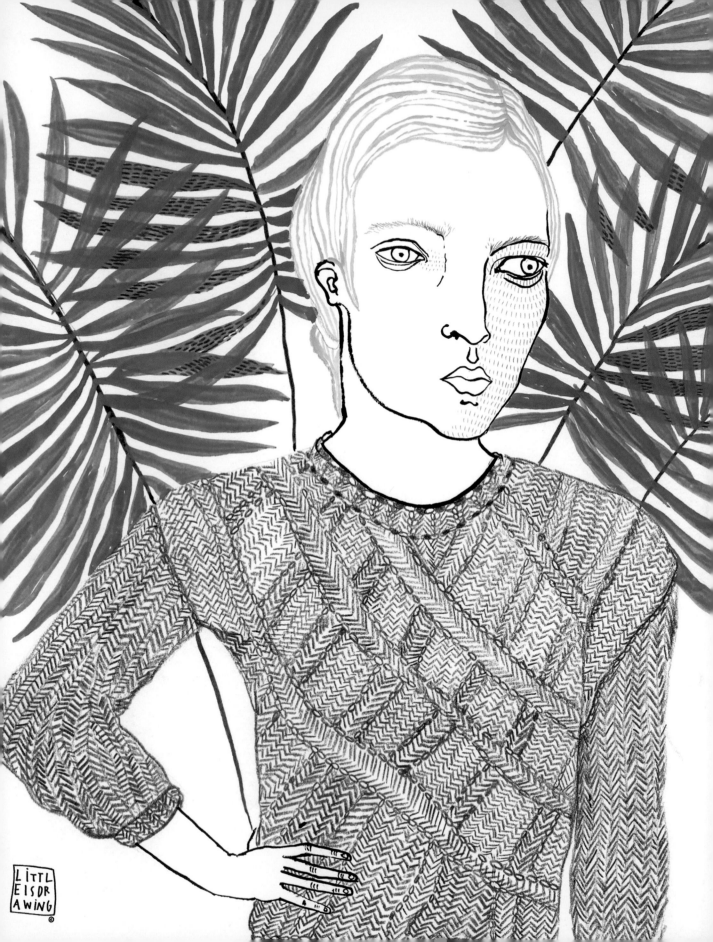

Ricardo Fumanal

1984 born in Huesca, Spain | lives and works in Berlin and London
www.ricardofumanal.com

CLIENTS
Harper's Bazaar Australia, Lou Dalton, Mango,
Vogue Hommes Japan, Dazed & Confused, Fred Perry,
Apartamento, Richard Nicholl, Wallpaper*

"I work with images from various sources.
My illustrations start from photographic
collage, then I render them in my own
style in pen and pencil."

„Ich arbeite mit Bildern aus verschiedenen Quellen.
Am Anfang einer Illustration steht eine Fotocollage,
die ich dann mit Tusche und Bleistift in meinem
eigenen Stil wiedergebe. "

« Je travaille avec des images de différentes
sources. Mes illustrations partent du collage
photographique, puis je leur donne mon
propre style au crayon et au stylo. »

Automatic Lover, 2008
Hercules, Photography: Nacho Alegre,
Fashion Editor: David Vivirido; ink
and pencil on paper

→ Untitled, 2013
Negarin, showroom decoration;
mixed media

Justin Gabbard

1981 born in San Francisco | lives and works in San Francisco
www.justingabbard.com

CLIENTS
Brand New School, Ben & Jerry's, Wired, The New Yorker, New York Magazine, The New York Times, Newsweek, Businessweek, Out Magazine, Departures, Kiehl's, Spin, JWT, Microsoft, Scion, Harvard Business Review, Stanford University

AGENT
The Loud Cloud, USA

Moving in with Your Partner, 2011
Out; gouache and digital

→ Cheetah, 2012
Personal work; gouache and
xylene transfer

→→ Biomarkers, 2012
Proto; gouache

"Drawing inspiration from pop music, New York storefront signs, bright colors and loud people."

„Meine Inspirationen: Popmusik, die Schilder an Ladenfronten in New York, leuchtende Farben und laute Menschen."

« Je m'inspire de la musique pop, des enseignes new-yorkaises, des couleurs vives et des gens bruyants. »

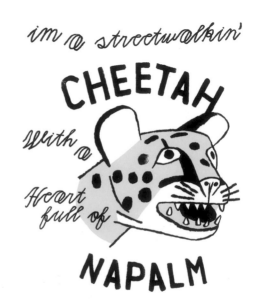

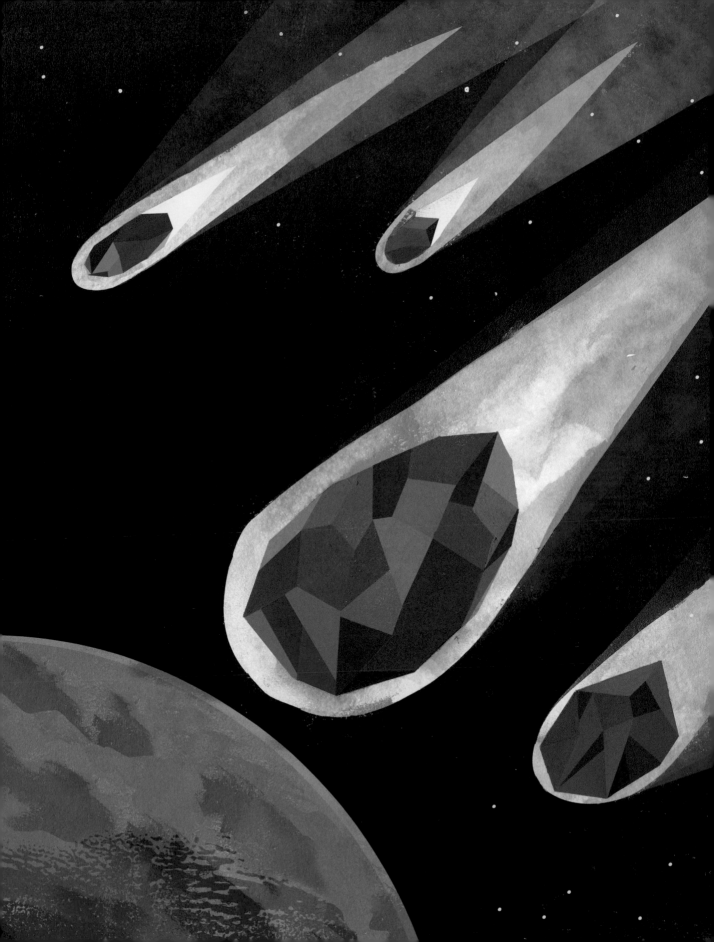

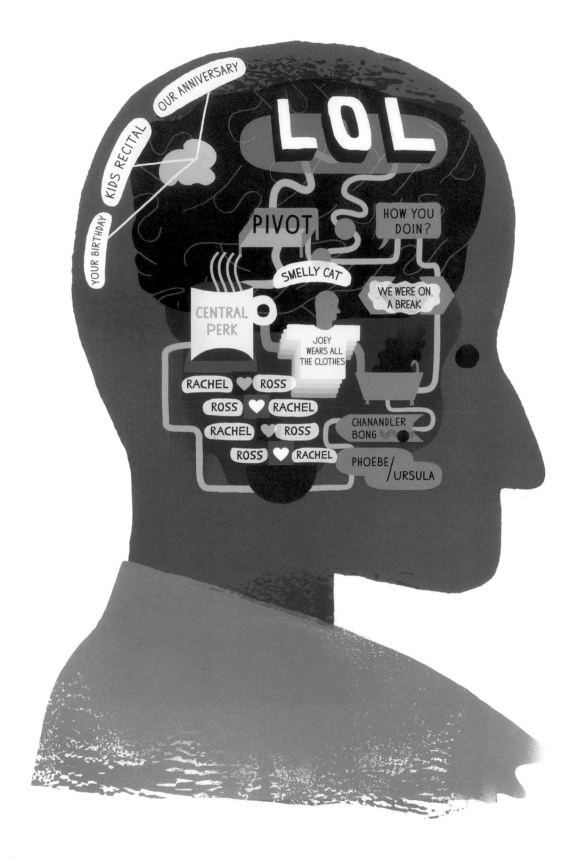

I Am the Cosmos, 2012
Personal work; gouache and
xylene transfer

← Useless Information, 2012
Print magazine; gouache and digital

↓ Women in the Corporate
World, 2012
Newsweek; gouache

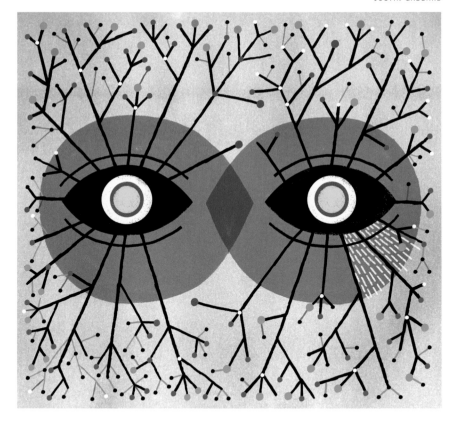

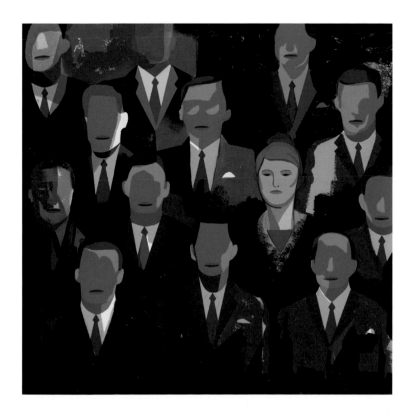

Paolo Galetto

1962 born in Turin | lives and works in Turin and Paris
www.paologaletto.blogspot.it

CLIENTS

Vogue Italia, Vogue.it, Condé Nast, Miroglio Group,
Caractère, Psychologies, La Stampa, Maria Rinaldi,
Max Mara Group, Pennyblack

EXHIBITIONS

Portraits, solo show, Chiesa di San Domenico, Alba, Italy, 2013
Vogue Fashion Night Out, solo show, McArthur Glen, Milan, 2012
Walking in My Shoes, solo show, Space 12, Milan, 2011

"I love drawing. The transformation of reality
in drawing is love. To see is to love."

„Zeichnen ist meine große Liebe. Die Realität in eine Zeichnung
umzusetzen ist Liebe. Zu sehen heißt zu lieben."

« J'adore dessiner. Transformer la réalité en dessin,
c'est de l'amour. Voir, c'est aimer. »

Waiting at the Airport, 2013
Personal work; watercolor on paper

→ **Portrait of Sonia Sieff, 2011**
Vogue Italia, vogue.it: Voguette by
Paolo Galetto, Editor-in-chief: Franca
Sozzani, Photo Editor: Alessia
Glaviano; watercolor on paper

Portrait of Emilie Foullioux, 2013
Vogue Italia, vogue.it: Voguette by
Paolo Galetto, Editor-in-chief: Franca
Sozzani, Photo Editor: Alessia
Glaviano; watercolor on paper

← **Portrait of Anna Klossowski
de la Rola, 2011**
Vogue Italia, vogue.it: Voguette by
Paolo Galetto, Editor-in-chief: Franca
Sozzani, Photo Editor: Alessia
Glaviano; watercolor on paper

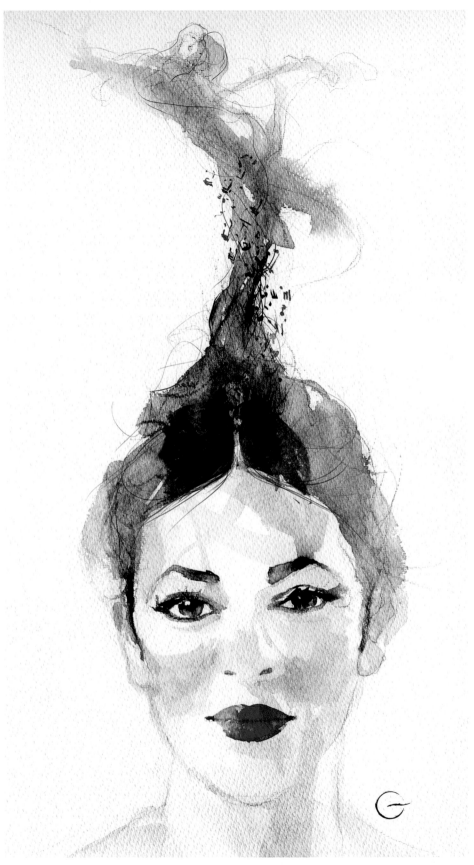

Paul Garland

1968 born in Taunton, UK | lives and works in Sheffield, UK
www.paul-garland.com

CLIENTS
Amnesty International, IPC Media, Saveur, Worth,
Financial Times, Fine Cooking, Currents, American
Lawyer, USTA

EXHIBITIONS
Serco Prize for Illustration, group show, London Transport Museum, 2014
3x3 ProShow, group show, New York, 2011
Association of Illustrators. Images, group show, Mall Galleries, London, 2009

AGENT
Morgan Gaynin Inc., USA

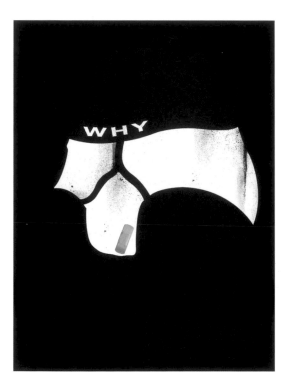

"I strive for a minimalist, Mies van
der Rohe 'less is more' approach
in my work. This produces the
best results in a bold, graphic
and simple form."

„Ich bemühe mich um einen minimalistischen
Ansatz à la Mies van der Rohe und ‚weniger
ist mehr.' Das kommt in klaren, grafischen
und schlichten Formen am besten."

« Dans mon travail je recherche une approche
minimaliste, à la Mies van der Rohe.
Cela produit ses meilleurs résultats sous
une forme vive, graphique et simple. »

WHY Fronts, 2010
DAHRA/Subism, Memories Book,
Art Direction: Paul Garland,
Garrick Webster, Rishi Sodha,
Stuart Boyd, Antony Kitson; pencil,
gouache, printmaking and digital

→ **Amber Rose, 2011**
Personal work; pencil, gouache,
printmaking and digital

→→ **The Water's Fine, 2012**
Acc Docket, magazine cover,
Art Direction: Jamie Mitchell;
pencil, gouache, printmaking
and digital

Ugo Gattoni

1988 born in Vitry sur Seine, France | lives and works in Paris
www.ugogattoni.fr

CLIENTS
Caravan Palace, Céline, Commune de Paris, Condé Nast, Honda, Motorola, Museum of London, The New York Times, Nissan, Nobrow Press, Qhuit, Sandro, Savoir Faire & Cie, The Dudes Factory

EXHIBITIONS
Water for Elephant, solo show, The Book Club, London, 2012
Bicycle, solo show, Bicycle, London, 2012
Ultra Copains, solo show, Paris, 2012

AGENTS
Lezilus, France
Agent Pekka, Finland

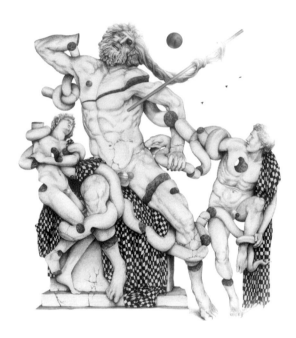

"My work is most often about details and huge-size drawing. I love the concentrated activity in making illustration."

„Bei meiner Arbeit geht es meistens um Details und um sehr große Zeichnungen. Die konzentrierte Arbeit beim Illustrieren macht mir großen Spaß."

« Mon travail se compose surtout de détails, et de dessins énormes. J'aime l'activité concentrée de l'illustration. »

Bastonnade, 2012
French Fourch; pencil on paper

→ Architecture, 2012
Salm; pencil on paper

→ → JS, 2011
Personal work; pencil on paper

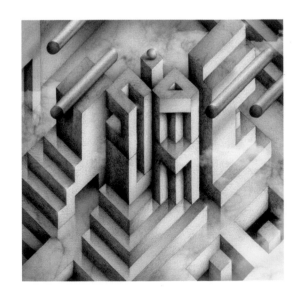

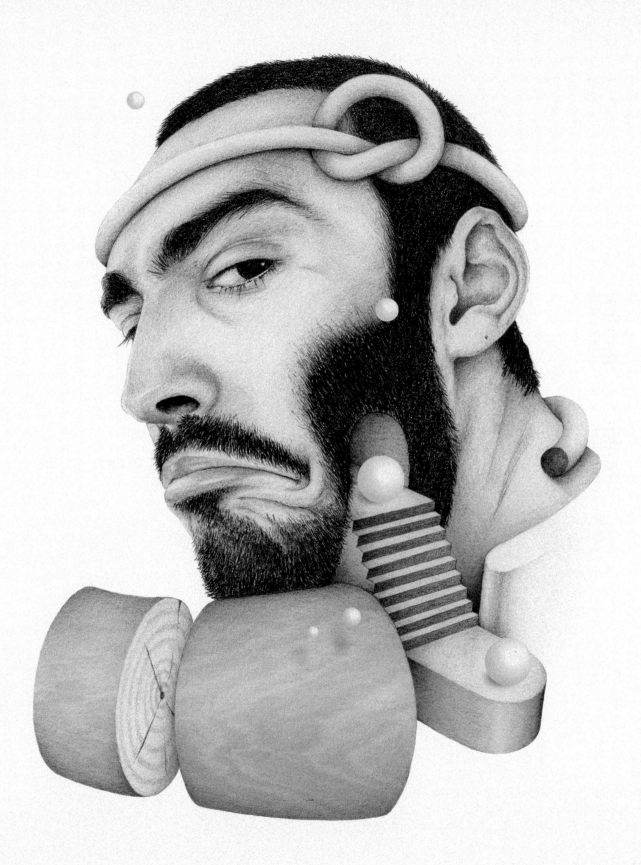

Panic, 2012
Caravan Palace; pencil on paper

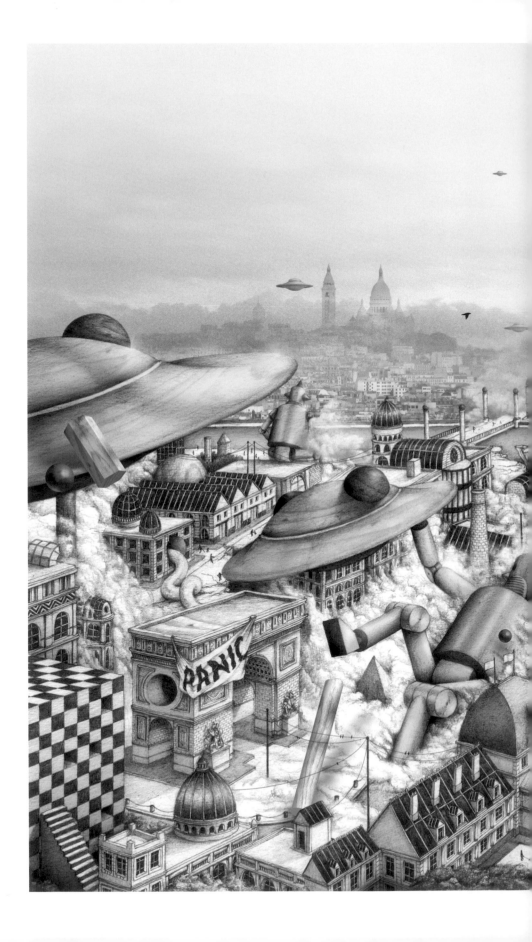

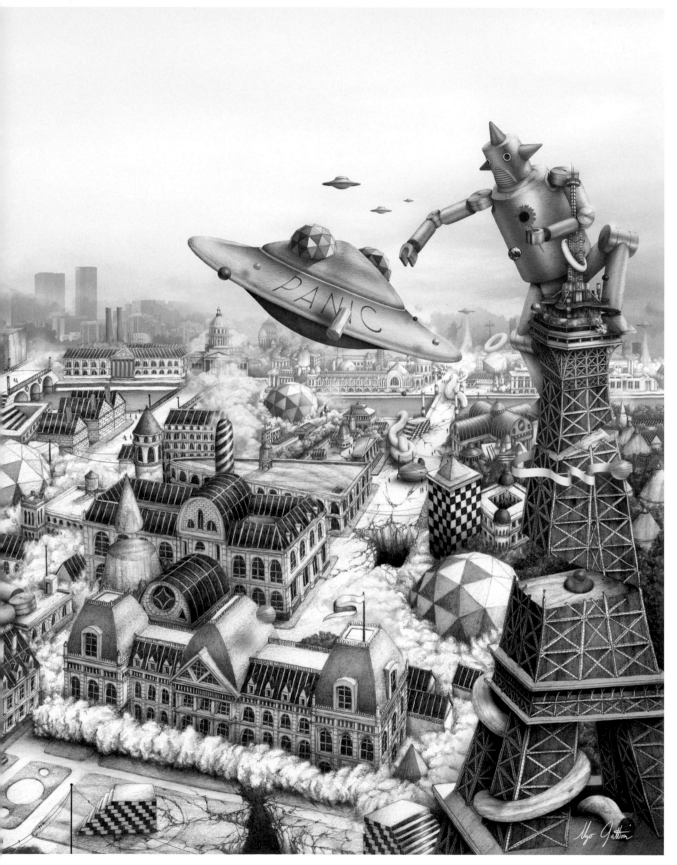

Leonardo Gauna

1984 born in Zárate, Argentina | lives and works in La Plata, Argentina
www.leogauna.blogspot.com

CLIENTS
Universidad de La Plata, FBA, Crann, Universidade
Federal de Minas Gerais, Teatro Argentino,
Caras y Caretas

EXHIBITIONS
Salón de Ilustración Latinoamericana, solo show,
Universidad de Palermo, Buenos Aires, 2011

"Illustration is my way of communicating: a medium of humor,
reflection, suggestion and dialogue. I connect with people and myself."

„Illustration ist meine Art der Kommunikation: ein Medium, das Humor, Überlegung, Andeutung
und Dialog in sich vereint. Ich stelle eine Verbindung zu anderen und zu mir selbst her."

« L'illustration, c'est ma façon de communiquer : un support pour l'humour, la réflexion,
la suggestion et le dialogue. J'établis une connexion avec les gens et avec moi-même. »

Untitled, 2011
Pasaje Cultural Dardo Rocha;
synthetic resin lacquer on glass

→ Tarde o Temprano
Van a Volar 2, 2012
Personal work; ink

Owen Gildersleeve

1986 born in Bristol | lives and works in London
www.owengildersleeve.com

CLIENTS
Ben & Jerry's, Rolex, Cadbury, The New York Times,
Wallpaper*, Royal Mail, The Guardian, Harrods,
Procter & Gamble, KPMG, Scientific American

EXHIBITIONS
ADC Young Guns 9, group show, Art Director's Club, New York, 2011
Pick Me Up, group show, Somerset House, London, 2011
Hello London, group show, Parco, Tokyo, 2010

AGENTS
MP Arts, UK
Agent Pekka, Finland

"The play with light and shadow brings my ideas to life."

„Das Spiel mit Licht und Schatten erweckt meine Ideen zum Leben."

« Le jeu avec l'ombre et la lumière donne vie à mes idées. »

Most Innovative, 2013
Fast Company; paper-cutting

→ To Climb a Mountain, 2013
Nordea Private Banking; paper-cutting

Ricardo Gimenes

1976 born in São Paulo | lives and works in São Paulo
www.ricardogimenes.com

CLIENTS
BBC, The Walt Disney Company, Nickelodeon,
SporTV, Editora Abril, Editora Globo,
Marcelo Tas, Ultraje a Rigor

"Digital mobile humor!"

Live one Life, 2013
Web show characters; digital

Bex Glover

1981 born in the UK | lives and works in Bristol
www.severnstudios.co.uk

CLIENTS
Ogilvy & Mather NY, EDF Energy, Pearson Australia,
J. Maskrey, Digital Artist, Torbay Council, Scottsville
Museum, Millington Associates

EXHIBITIONS
Selected Works, solo show, The Canteen, Bristol, 2013
Upfest, Live Painting and Public Art Exhibition, group show, North Street, Bristol, 2013
The Originals Exhibition, Artparcel.com, group show, The Square Club, Bristol, 2013

"Nature-inspired with an urban aesthetic—combining hand-rendered elements including spraypaint and watercolor, with digital techniques and finishes."

„Anregungen aus der Natur, urbane Ästhetik, von Hand bearbeitete Elemente, etwa Sprüh- und Wasserfarben, digitale Techniken und Oberflächen."

« Inspiré par la nature, avec une esthétique urbaine, en combinant les éléments faits à la main, au spray et à l'aquarelle, et les techniques et finitions numériques. »

Firebird, 2013
Personal work; watercolor, pencil,
scanned textures, spraypaint and digital

→ Geofoliage II, 2013
Personal work; watercolor, pencil,
scanned textures and digital

→→ 2 Peacocks, 2011
Personal work; watercolor, pencil,
scanned textures and digital

Neil Gower

1984 Newport, UK | lives and works in Lewes, UK
www.neilgower.com

CLIENTS
Faber & Faber, The Folio Society,
Penguin, Vanity Fair, Condé Nast
Traveler, The New Yorker, Transworld

"Hand-painted
graphic art."

Viva Lewes No. 21, 2008
Magazine cover; gouache and pencil

→ Viva Lewes No. 59, 2011
Magazine cover; gouache

Sam Green

1981 born in Shoreham, UK | lives and works in London
www.sams-place.net

CLIENTS
Random House, Esquire, Sawdust, Non-Format, Frank Ocean,
The New York Times, ESPN, Wallpaper*, Fallon, Lucas Arts,
Knight Frank, MTV, Nokia

EXHIBITIONS
This Is Now, The Best Artists in Contemporary Design, group show, TM51 Gallery, Oslo, 2012
Now Showing, Exploring the Lost 'Art' of the Film Poster, group show, Cosh Gallery, London, 2008
Fallon 'Showcase', group show, Fallon Studios, London, 2008

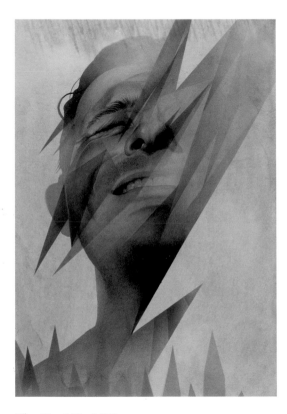

"My work is carefully planned and executed
but a strong sense of the arbitrary and
surrealism is at the heart of it."

„Ich plane meine Arbeiten sehr genau und führe sie
exakt aus, aber im Grunde haben sie etwas recht
Eigenwilliges und Surrealistisches."

« Mon travail est soigneusement planifié et
exécuté mais se nourrit d'un solide sens
de l'arbitraire et du surréalisme. »

Where Does it Hurt?, 2012
Howard Hughes Medical Institute;
pencil, paint on paper and digital

→ **Portrait of Ritzy Bryan, 2013**
Aritzia; pencil, paint on paper
and digital

→→ **Untitled, 2009**
Personal work; pencil on paper
and digital

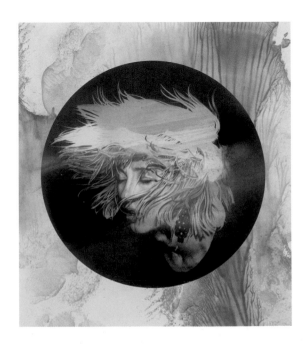

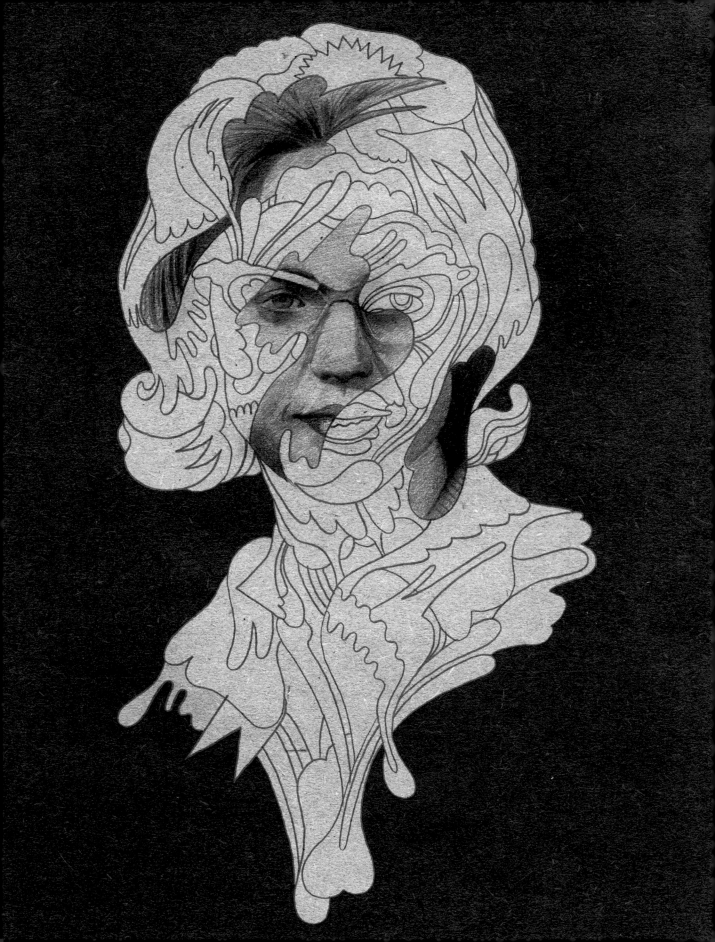

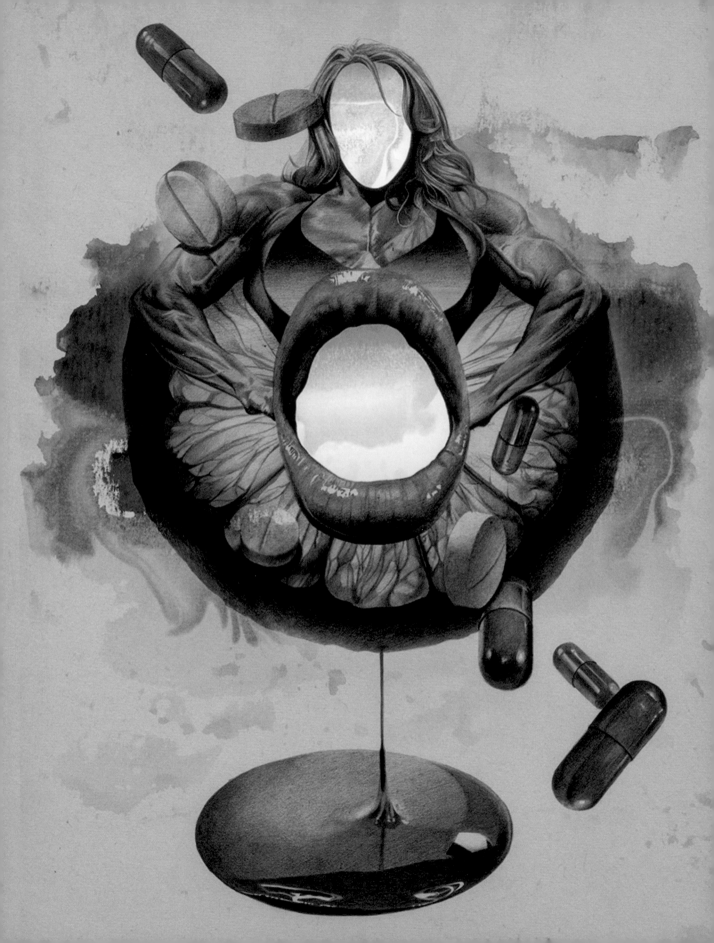

Surfacing 3, 2010
Persoanl work; pencil on paper

← **The Aftershock, 2010**
Popshot Magazine; pencil, paint on
paper and digital

↓ **Treading Water 2, 2008**
Personal work; pencil on paper

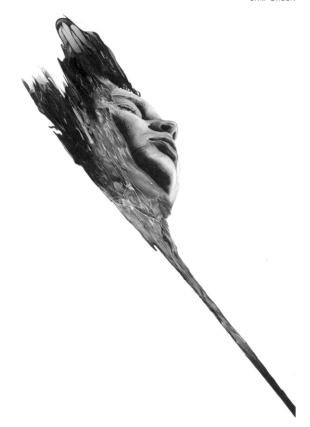

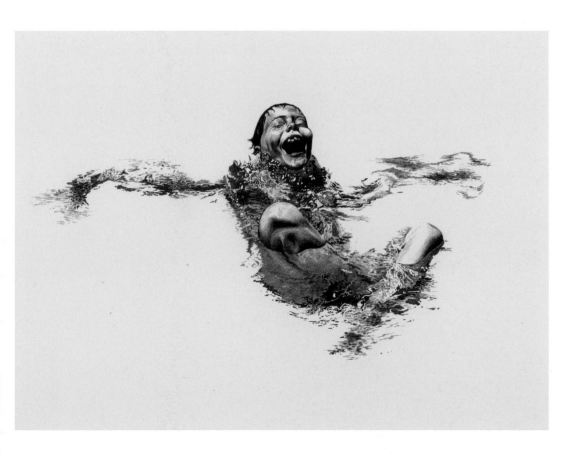

Roya Hamburger

1971 born in Rotterdam | lives and works in Amsterdam
www.royahamburger.net

CLIENTS
Albert Hein, WNF, FNV Bondgenoten, Elle,
Man Power, Ikon Broadcasting, Cosmopolitan,
Avant Garde, ABN-AMRO, British Airways

EXHIBITIONS
Steam, group show, Art Basel, Miami, 2012
New York New Wave, group show, Bowery Hotel, NY, 2011
The Elbow Room, solo show, Alley Art Gallery, Hasselt, 2011

AGENT
Kombinatrotweiss, Germany

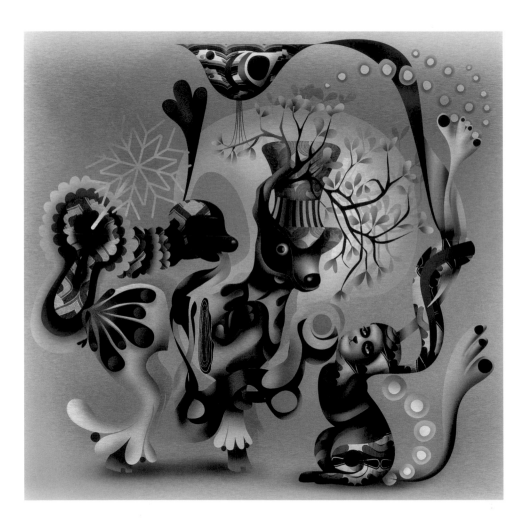

"I always start with real paper and pencil."

„Mein Ausgangspunkt sind immer ein Stift und ein Blatt Papier."

« Je commence toujours avec du papier et un crayon. »

Dear Deer, 2011
Personal work; digital

→ The Segregation, 2011
Personal work; digital

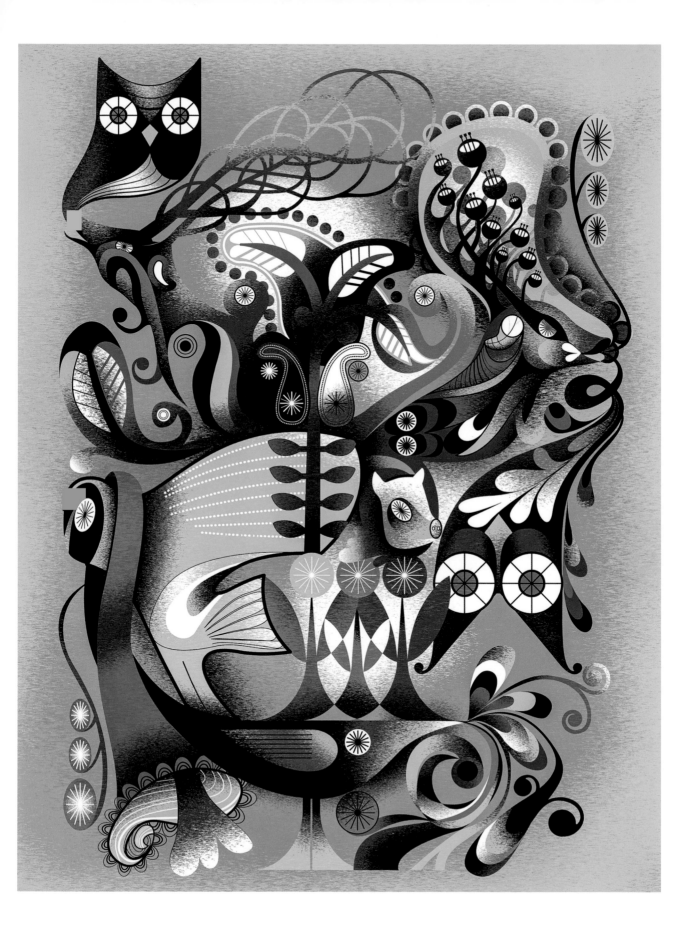

Emma Hanquist

1980 born in Visby, Sweden | lives and works in Stockholm and Hangvar, Sweden
www.emmahan.com

CLIENTS
Boston Globe Magazine, Kraft Foods,
CAP&Design, Dagens Nyheter, Fokus,
Elle Interior, Filter, Spotify, Texttalk

EXHIBITIONS
Rainy Days or Sunny Days, solo show, VOL Gallery, Stockholm, 2011
C/O Illustration, group show, Biblioteksgatan 10, Stockholm, 2011
1020 Trickery Lane, solo show, Riche, Stockholm, 2010

AGENTS
Anna Goodson, Canada
The Overall Picture, Australia

"Illustration can please both eyes and mind. A successful illustration
combines a creative idea with an inspirational form."

„Illustrationen können dem Auge ebenso gefallen wie dem Kopf. Eine überzeugende
Illustration verbindet einen kreativen Gedanken mit einer einfallsreichen Form."

« L'illustration peut satisfaire les yeux et l'esprit. Une illustration réussie
combine une idée créative avec une forme qui inspire. »

Do You Love One of Your
Children More?, 2012
Dagens Nyheter; collage and digital

→ Recycle, 2011
Slöjdforum; collage and digital

Adam Herbert

1978 born in Sheffield, UK | lives and works in London
www.adamherbert.co.uk

"I enjoy recording the world around me and working
spontaneously with different drawing materials.
I like my images to be free and simplistic."

„Mir gefällt es, meine Umwelt festzuhalten und spontan mit verschiedenen
Zeichenmaterialien zu arbeiten. Meine Bilder sollen frei und unkompliziert sein."

« J'aime garder une trace du monde qui m'entoure et travailler
spontanément avec différentes techniques. J'aime que mes images
soient libres et simples. »

Portraits, 2013
Personal work; gouache

→ Mango, Lemon, Lime, 2013
Personal work; gouache and pencil

**Indian Toy Animal Figures
from Jaipur, 2013**
Personal work; gouache

→ **London Café Kitchen
Interior, 2013**
Personal work; graphite pencil,
felt-tip pen and crayon

Maria Herreros

1983 born in Valencia | lives and works in Valencia
www.mariaherreros.es

CLIENTS

Ultrarradio, Edicions de Ponent, Norma Editorial, Culdesac,
Marina Cenacci, Turia, Analog, Birdog, Oxxo, Paiorfa, Bibi Lou,
Barba Silkscreen Atelier, Octubre CCC

EXHIBITIONS

What is Bootsbau, group show, Bootsbau, Berlin, 2013
Americana, solo show, Espai Cream, Barcelona, 2012
I am a Fan, solo show, Ò Galeria, Porto, 2012

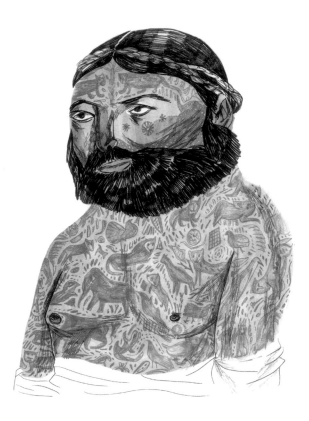

"I want to surprise, provoke and even
soften with portraits and my aim is to create
a special beauty and sensitivity."

„Ich möchte mit Porträts überraschen, provozieren und
auch anrühren. Mein Ziel ist, eine ganz besondere Schönheit
und Sensibilität hervorzurufen."

« Je veux surprendre, provoquer et même adoucir avec
mes portraits, et mon objectif est de créer une beauté
et une sensibilité spéciales. »

Prince Constantine, 2012
Edicions de Ponent, graphic novel;
watercolor and graphite

→ David Lynch, 2012
Personal work; watercolor and graphite

→→ Audrey Hepburn at a
Flower Market, 2013
Personal work; watercolor and graphite

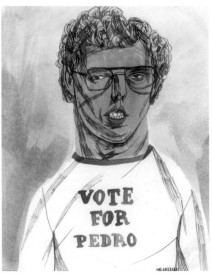

←← Women of the Future, 2013
Personal work; watercolor and graphite

← Napoleon Dynamite, 2013
Personal work; watercolor and graphite

→ Young Christina Ricci, 2012
190º The Magazine, cover; watercolor and graphite

↓ Company She Keeps, 2013
Personal work; watercolor and graphite

Jakob Hinrichs

1977 born in Düsseldorf | lives and works in Berlin
www.jakobhinrichs.com

CLIENTS
New Scientist, The Guardian, Billboard, Boston Globe Magazine, Wall Street Journal, The Washington Post, The New York Times Book Review,

EXHIBITIONS
Over My Dead Body, group show, September Gallery, Berlin, 2013
Bellevue, Avantgarde Illustration for the Printed Matter, group show, Bongout Gallery, Berlin, 2011
Annual Show, group show, Society of Illustrators New York, 2010

AGENTS
Gerald & Cullen Rapp, USA
Central Illustration Agency, UK

> "I love wood-cuts and analog printing. They've always been a great source for new ideas and artistic experimentation."

„Ich liebe Holzschnitt und analoge Drucktechniken. Sie sind wunderbare Quellen für neue Ideen und künstlerische Experimente."

« J'aime la gravure sur bois et l'impression analogique. Elles ont toujours été d›excellentes sources de nouvelles idées et d'expérimentation.»

Flex & the City, 2013
Off Duty Magazine / Wall Street Journal, Art Direction: Elena Proskurova; mixed media

→ Failing Infrastructures, 2013
Common Ground, Art Direction: Cori Canady; mixed media

Jack Hughes

1989 born in London | lives and works in London
www.jack-hughes.com

CLIENTS
Harrods, Burberry, ShortList, Wired,
Elle Decoration, Levi's, The Atlantic,
Agent Provocateur, The New York Times

EXHIBITIONS
PWEKKKA Expo, group show, Wieden+Kennedy, Amsterdam, 2013
Jiggling Atoms, group show, The Rag Factory, London, 2012
Pick Me Up, group show, Somerset House, London, 2012

AGENTS
Agent Pekka, Finland
YCN Talent Agency, UK

"So long as the work I produce is sophisticated and aspirational
with a touch of elegance then at the end of the day I'm happy."

„Solange die Grafik, die ich mache, differenziert, anspruchsvoll und
auch elegant ist, bin ich zufrieden."

« Du moment que le travail que je produis est sophistiqué et
ambitieux avec une touche d'élégance, alors je suis
content de ma journée. »

The Gentleman's Handbook, 2013
Hardie Grant Books, Art Direction:
Matt Phare; digital

→ Agent Provocetaur, 2013
The Clerkenwell Post, Art Direction:
Cai Taylor; digital

Porsche 911, 2013
Elle Decoration, Art
Direction: Rachel Wols; digital

→ Home, 2013
Harrods, Art Direction:
Kim Band; digital

↓ The Gentleman's
Handbook, 2013
Hardie Grant Books, Art
Direction: Matt Phare; digital

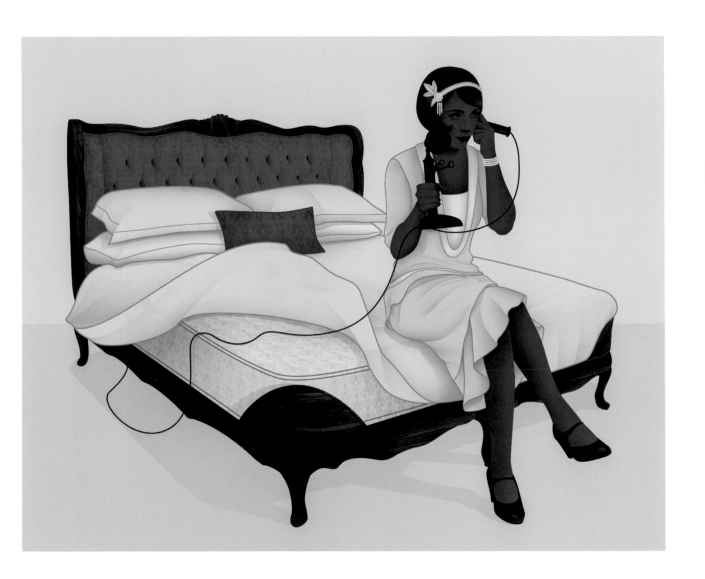

Primary Hughes

2003 born in Stow, USA | lives and works in Marquette, USA
www.primaryhughes.com

CLIENTS
American Greetings, Spoke Art Gallery, Light Grey Art Lab, Case Western Reserve University, Ohio Magazine, Cleveland Magazine, University of Dayton

EXHIBITIONS
Scorcese: An Art Show Tribute, group show, Bold Hype Gallery c/o Spoke Art Gallery, New York, 2013
The Art of Baseball, 15th Annual, group show, George Krevsky Gallery, San Francisco, 2012
Society of Illustrators 49, group show, Museum of American Illustration, New York, 2007

"By developing a deep knowledge or familiarity with the subject, I am more able to reveal it to the audience."

„Nur wenn ich mit einem Thema richtig vertraut bin und viel darüber weiß, kann ich es dem Betrachter wirklich nahebringen."

«En développant une connaissance ou familiarité profonde avec le sujet, je suis mieux à même de le révéler au public.»

Amsterdam, 2013
Personal work; acrylic

← The Butcher, 2012
Spoke Art Gallery; acrylic

→ The Waiting Room
with Russell Martin, 2010
Personal work; acrylic

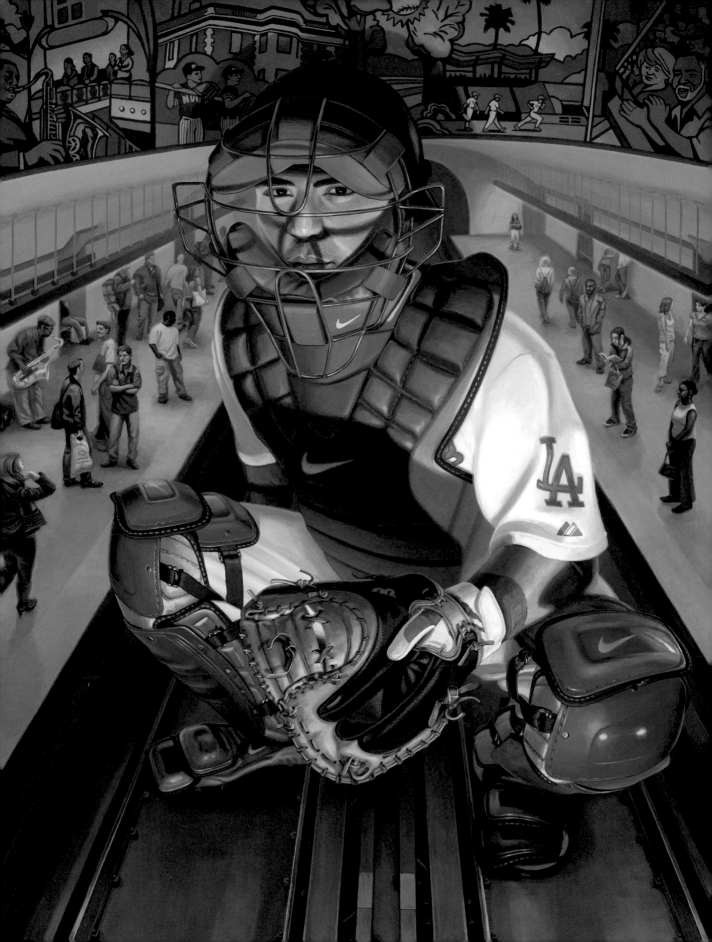

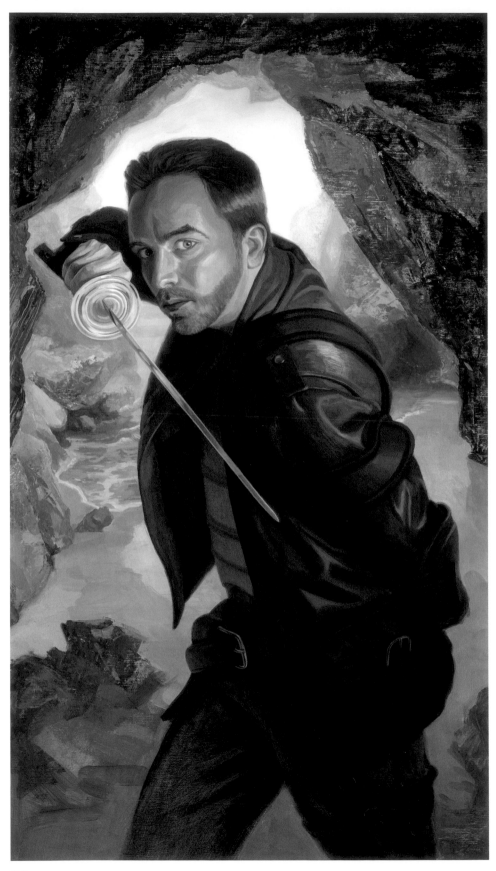

Cecropia Bot, 2012
Case Western Reserve University, Art
Direction: Lori Scheid; mixed media

← **Edward Deidrick, 2013**
Light Grey Art Lab, role-playing
card game; acrylic

↘ **Mr. Sabathia Goes to
New York, 2010**
Personal work; acrylic

↓ **Angel Rising, 2010**
Personal work; acrylic

Meg Hunt

1983 born in New London, USA | lives and works in Portland, USA
www.meghunt.com

"My focus is creating charming and colorful character-based illustrations, lettering and patterns for a variety of markets."

„Bei mir geht es vor allem darum, ansprechende, farbenfrohe, charakterstarke Illustrationen, Typografien und Muster für unterschiedliche Märkte zu machen."

« Je crée des illustrations charmantes et colorées basées sur des personnages, des lettrages et des motifs, pour différents marchés. »

Translating Another World, 2013
Plansponsor, Art Direction: SooJin Buzelli; mixed media and digital

→ Sacred Valley, 2012
Monoblock, book cover; mixed media and digital

A Way Out, 2013
Personal work; mixed media and digital

← The Builders, 2013
Plansponsor, Art Direction: SooJin
Buzelli; mixed media and digital

Sarah Jackson

1989 born in London | lives and works in Bristol and Victoria, Canada
www.sarahjacksonillustration.com

CLIENTS
Wall Street Journal, Starbucks, Shire
Hotels, Timbergram, Germanwings

EXHIBITIONS
Untitled, solo show, The Music Room, Glasgow, 2013
University College Falmouth Degree Show, group show, Falmouth University, UK, 2010
Children's Book Exhibition, group show, The Poly, Falmouth, UK, 2008

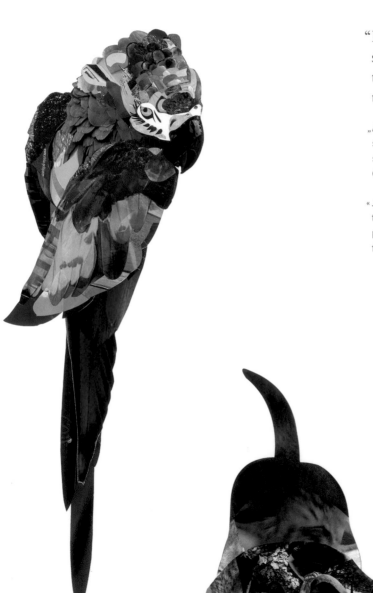

"Everything in my house has tiny
shapes cut out of it—I create
the puzzle pieces that fit
together to make the whole."

„Aus allem, was bei mir zu Hause herumsteht,
sind kleine Formen ausgeschnitten – das
sind meine Puzzlestücke, die sich zu einem
Ganzen zusammenfügen."

« Je découpe des formes minuscules dans
tout ce que j'ai chez moi, je crée des
pièces de puzzle qui s'emboitent pour
former un tout. »

Untitled, 2010
Personal work; collage

← But Boz I was…, 2013
Personal work; collage

→ Lets Go Fly, 2013
Personal work; collage and digital

David Jien

1981 born in Los Angeles, USA | lives and works in Los Angeles, USA
www.davidjien.com

CLIENTS
The New York Times, McSweeney's,
Plansponsor

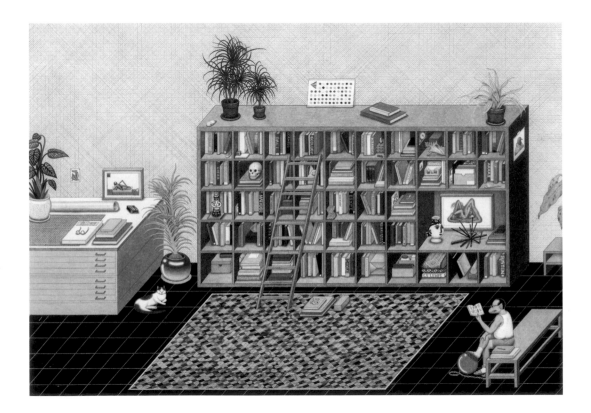

"I approach illustration like solving a puzzle, using the given pieces to come up with a desired solution."

„Eine Illustration ist für mich wie ein Puzzle: Mithilfe der vorhandenen Stücke finde ich die gewünschte Lösung."

«Pour moi l'illustration c'est comme faire un puzzle, en utilisant les pièces qu'on me donne pour trouver la solution souhaitée.»

Cubby Control, 2013
Personal work; color pencil

→ **Build High, 2013**
Plansponsor, Art Direction: SooJin
Buzelli; color pencil and watercolor

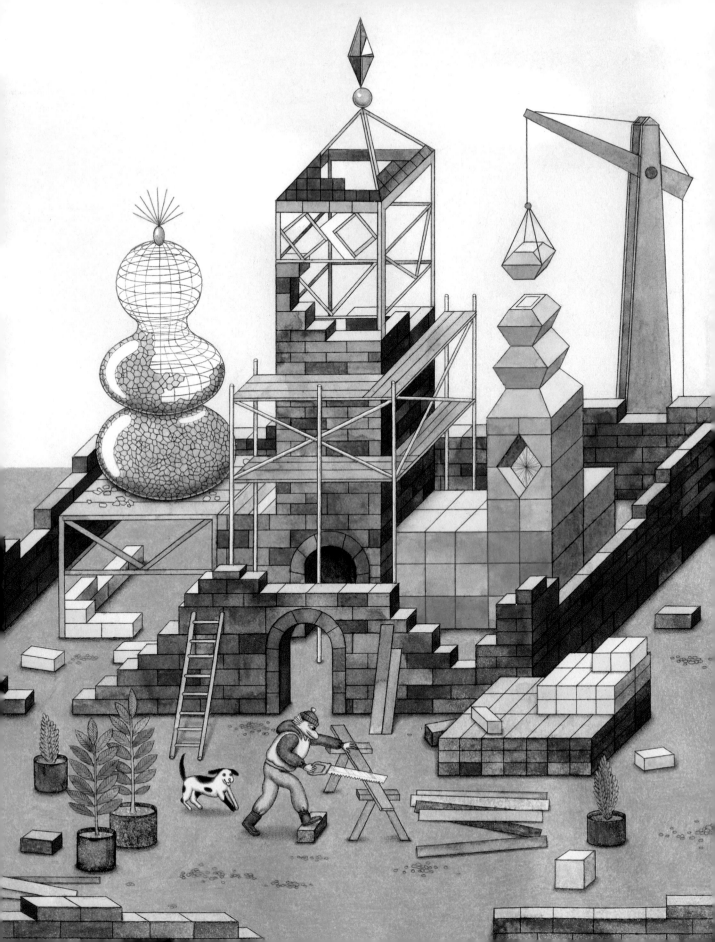

Adrian Johnson

1974 born in Liverpool | lives and works in Lewes, UK
www.adrianjohnson.co.uk

CLIENTS
Paul Smith, Adidas, Stüssy, IBM, Arkitip,
Monocle, Creative Review, Norse Projects,
Pentagram, Volkswagen, The Guardian

EXHIBITIONS
Basilicas, solo show, Kemistry Gallery, London, 2013
Insiders, Outsiders & the Middle, group show, Scion Space, Los Angeles, 2008
Happy London, group show, Paul Smith/Space Gallery, Tokyo, 2008

AGENT
Big Active, UK

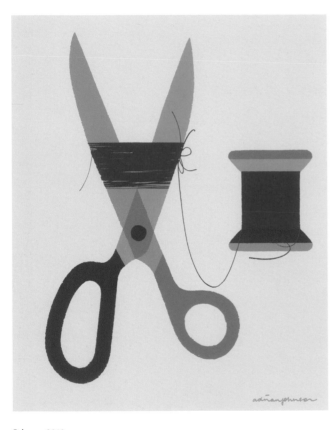

"Driving forwards. Continuously
evolving and always striving
for a balance between simplicity
and sophistication."

„Immer vorwärts. Ständiges Weiterentwickeln,
immer auf der Suche nach der Balance
zwischen schlicht und anspruchsvoll."

« Avancer. Évoluer constamment et toujours
rechercher un équilibre entre la simplicité
et la sophistication. »

Scissors, 2013
Personal work; mixed media

→ Chainsaw, 2013
Personal work; mixed media

→→ Conference, 2012
Personal work; mixed media

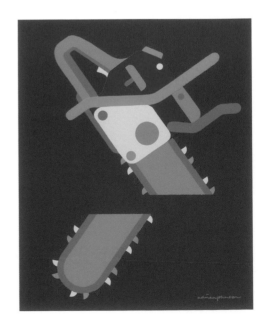

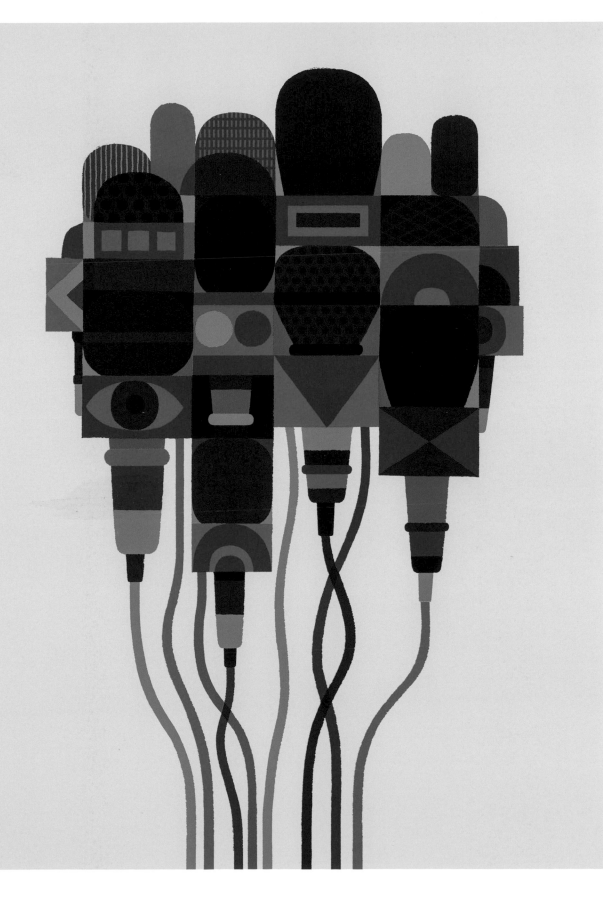

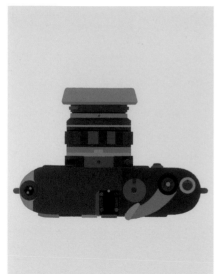

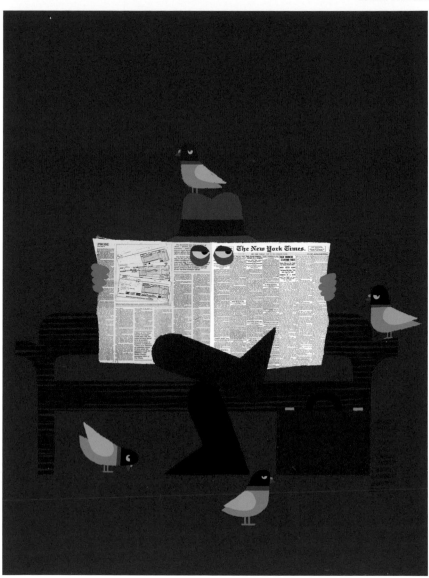

Stealth Economics, 2013
Harvard Business Review,
Art Direction: Karen Player;
mixed media

← **Leica M3, Mamiya,
Rolleiflex, Olympus Trip,
Polaroid, Linhof, Leica M9,
Leica Model 1, Hasselblad, 2013**
Personal work; mixed media

Paweł Jońca

1968 born in Warsaw | lives and works in Warsaw
www.paweljonca.com

CLIENTS
Architektura Murator, Fontlab, Niebieska Studnia,
Harvard Business Review, Malemen, Newsweek,
Przekrój, Wprost, Zwierciadło

EXHIBITIONS
Ilustracja PL 2012: O-Kupować, group show, Soho Factory, Warsaw, 2012
Ilustracja 2010, group show, Sinfonia Varsovia, Warsaw, 2010
Solo Show, Śląski Zamek Sztuki, Cieszyn, 2009

"I work on an illustration until I find
the simplest possible answer."

„Ich arbeite an einer Illustration, bis ich die denkbar
einfachste Lösung gefunden habe."

« Je travaille sur mes illustrations jusqu'à ce que
je trouve la solution la plus simple possible. »

Pride, 2013
Zwierciadło; digital

→ **BAM!, 2013**
Malemen; digital

→→ **Earth 2.0, 2010**
Przekrój; digital

Father's Day, 2013
Zwierciadło; digital

→ Social Classes, 2010
Przekrój; digital

↘ Memory Game, 2013
Zwierciadło; digital

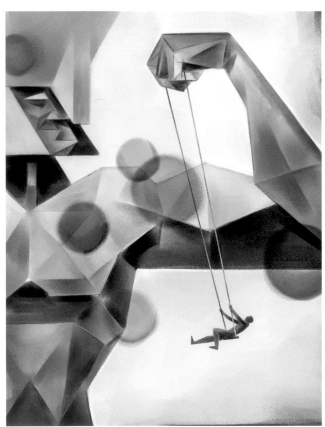

Erik Jones

1982 born in St. Petersburg, USA | lives and works in Brooklyn
www.erikjonesart.com

CLIENTS
ImagineFX, Hi-Fructose, Marvel,
Thinkspace Gallery, Spoke Art Gallery

EXHIBITIONS
Scope Art Show, group show, Spoke Art Gallery, New York, 2013
art MRKT SF, group show, Spoke Art Gallery, San Francisco, 2013
Beyond Eden, group show, Thinkspace Gallery, Los Angeles, 2013

"I approach my illustrations as if they were for fashion or
a gallery. I imagine the figures being wrapped in organic
patterns and colorful forms."

„Wenn ich an einer Illustration arbeite, stelle ich mir vor, sie wäre
ein Modeentwurf oder eine Arbeit für eine Galerie. Ich sehe die Figuren
in organische Muster und bunte Formen gehüllt vor mir."

« J'approche mes illustrations comme si elles étaient destinées
à la mode ou à une galerie. J'imagine les silhouettes enveloppées
dans des motifs organiques et des formes colorées. »

Comet: The Great Migration, 2013
Vanessa Fernandez; acrylic and wax
pastel on paper

→ Armor, 2013
Dagny+Barstow; pencil, acrylic, wax
pastel and oil on paper

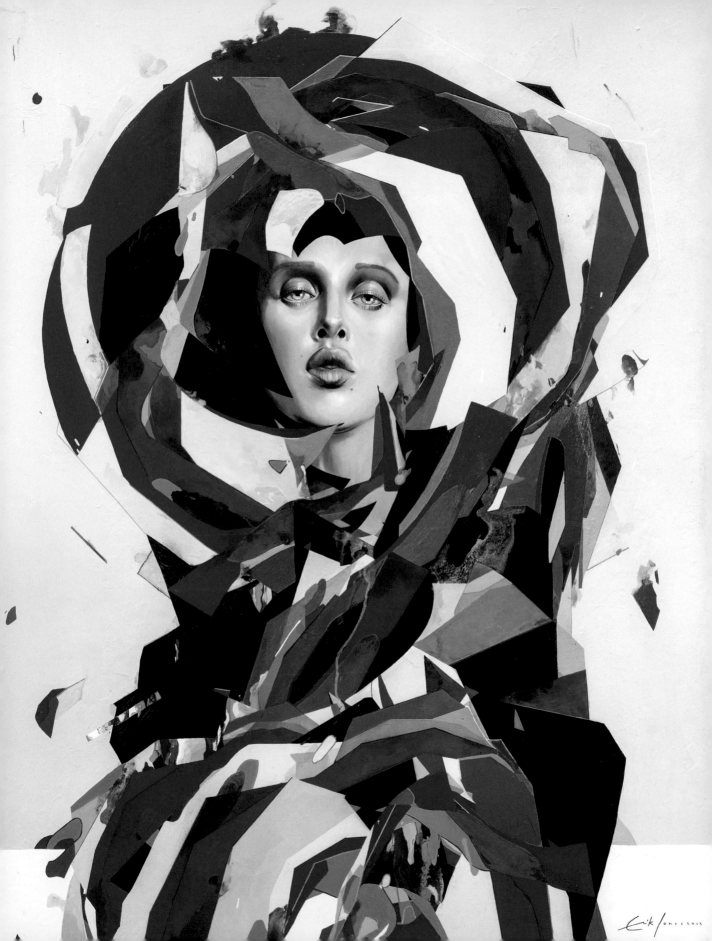

Melinda Josie

1982 born in Milton, Canada | lives and works in Toronto
www.melindajosie.com

CLIENTS
The New York Times, Time, Elle Canada,
Southwest Airlines, Air Canada, The Walrus,
New York Magazine, Real Simple

EXHIBITIONS
Untitled, solo show, Hellion Gallery, Portland, 2013
A Small Collection, solo show, Mjölk, Toronto, 2010
Le Géranium, solo show, Magic Pony Gallery, Toronto, 2009

"I render realistic imagery utilizing traditional media and methods, aspiring to the accurate depiction of the beauty I see in everyday details."

„Ich gebe eine realistische Bilderwelt mit herkömmlichen Medien und Methoden wieder und versuche, die Schönheit, die ich in banalen Kleinigkeiten sehe, genau abzubilden."

« Je travaille des images réalistes à l'aide de supports et méthodes traditionnels, et j'aspire à représenter fidèlement la beauté que je voies dans les détails quotidiens.»

Domingas, 2013
Pentagram, Client: World Wildlife
Fund Magazine, Art Direction:
Carla Delgado; watercolor

→ **Gluten-Free Pancakes, 2013**
Real Simple, Art Direction:
Cybele Grandjean; watercolor

→→ **Grover and Isha, 2012**
John Baker and Juli Daoust-Baker,
personal collection; watercolor

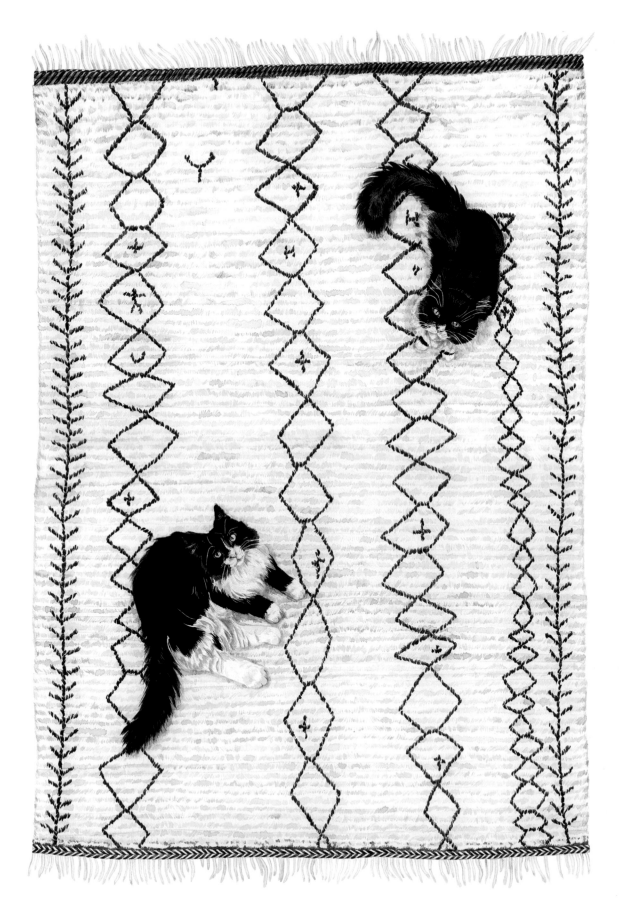

Chris Kasch

1971 born in Liverpool | lives and works in London
www.chriskasch.co.uk

CLIENTS
Saatchi & Saatchi, The Lotus F1 Team, Moretti Beer, IBM, Vogue,
Royal Mail, Rolling Stone, Mojo, Arena, GQ, Radisson Hotels,
The Times, The Guardian, The Observer

AGENT
Central Illustration Agency, UK

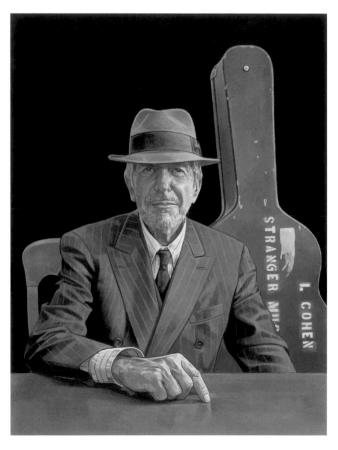

"Precision in my work is always
important but I also work hard on
finding that humanity within."

„Genauigkeit ist in meiner Arbeit natürlich wichtig,
aber ich bemühe mich auch sehr, die darin
liegende Menschlichkeit zu finden."

«Dans mon travail, la précision est toujours
importante, mais je fais aussi beaucoup
d'efforts pour trouver l'humanité.»

Leonard Cohen, 2013
Mojo; acrylic on paper

→ Lyor Cohen, 2013
Billboard; acrylic on paper

→→ Cultivate Creative, 2013
Cultivate Creative, acrylic on paper

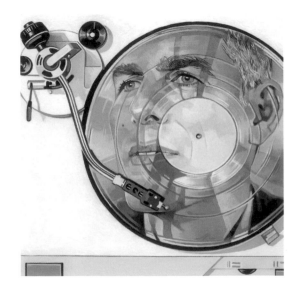

Blue, 2013
Personal work; acrylic on paper

← **Much Ado, 2012**
Wyndham's Theatre, poster Shakespeare
play Much Ado About Nothing,
David Tennant and Catherine Tate;
acrylic on paper

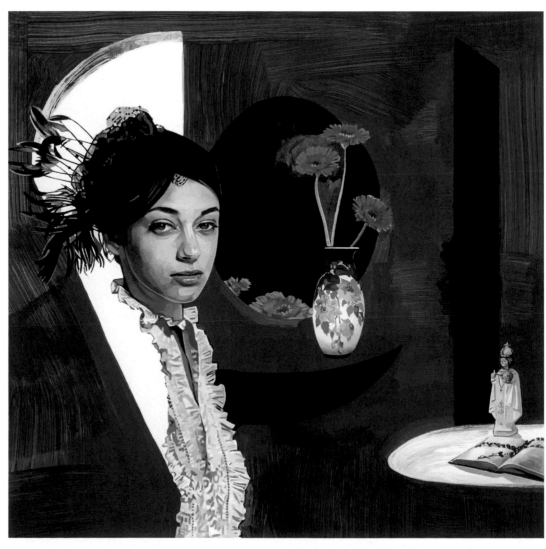

Yann Kebbi

1987 born in Paris | lives and works in Paris

CLIENTS
The New York Times, The New Yorker, Vanity
Fair France, Revue XXI, The Guardian, Telerama,
SZ-magazin, Condé Nast Traveler, Libération,

EXHIBITIONS
Americanin, solo show, Galerie Michel Lagarde, Paris, 2013
Gravures et monotypes, solo show, Galerie Michel Lagarde,
Paris, 2012

AGENTS
Illustrissimo, France
Heart, UK

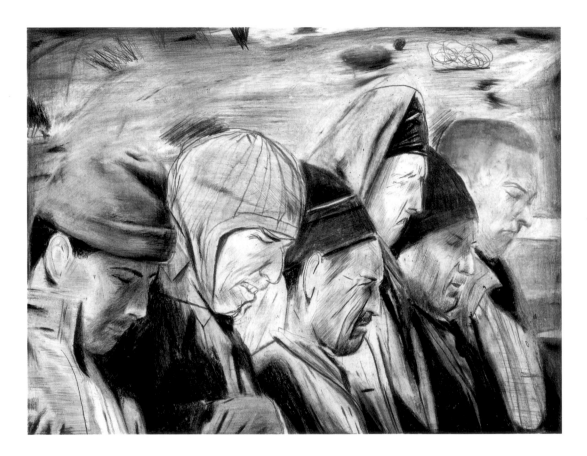

"I try in my illustrations to reach the energy, the movement and
looseness I can find in sketches. I am not there yet, but I try!"

„Ich versuche, in meinen Illustrationen die Energie, die Bewegung und
die Lockerheit einzufangen, die ich in Skizzen sehe. Ganz schaffe
ich es noch nicht, aber ich bleibe dran!"

« Dans mes illustrations, j'essaie d'atteindre l'énergie,
le mouvement et la liberté que je trouve dans les croquis.
Je n'y suis pas encore, mais j'essaie ! »

The Tea and Electricity, 2012
Revue XXI, Art Direction:
Quintin Leeds; pencil

→ **Subway Diving**, 2012
The New Yorker, Art Direction:
Chris Curry; pencil and fine line pen

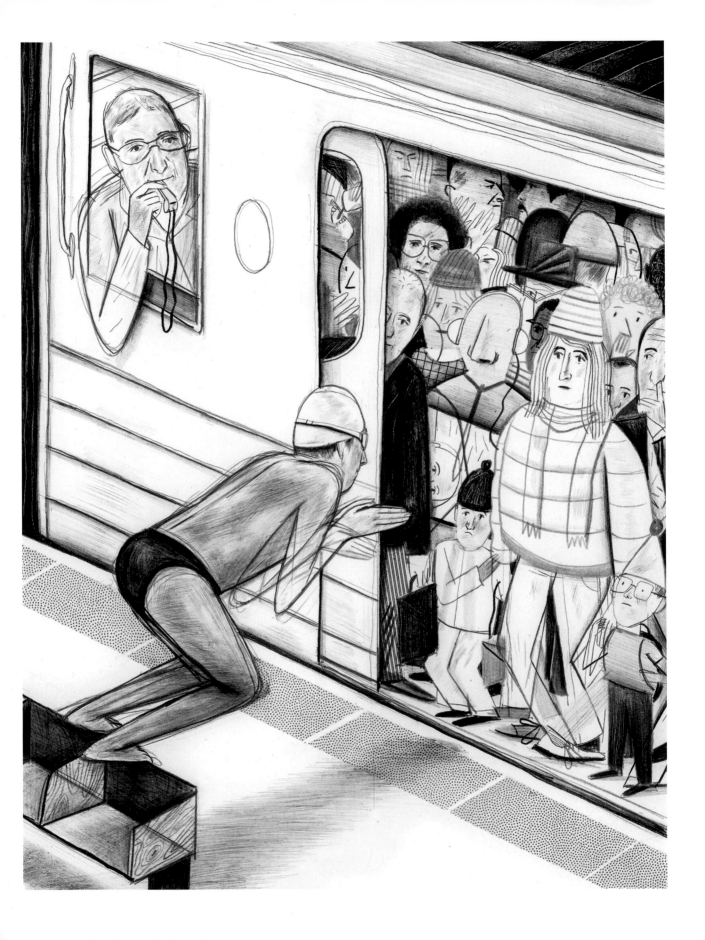

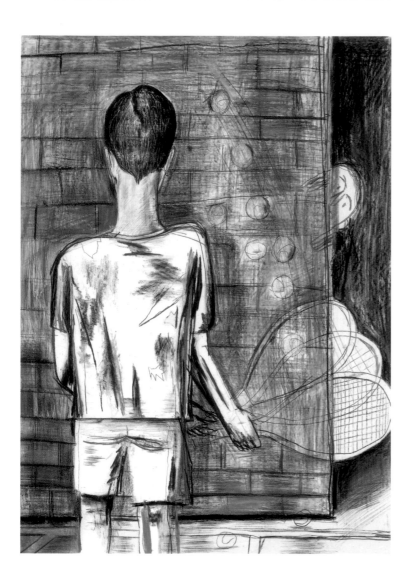

A Bartleby of the Ball, 2013
Revue Desports; pencil

↓ The Tea and Electricity, 2012
Revue XXI, Art Direction:
Quintin Leeds; pencil

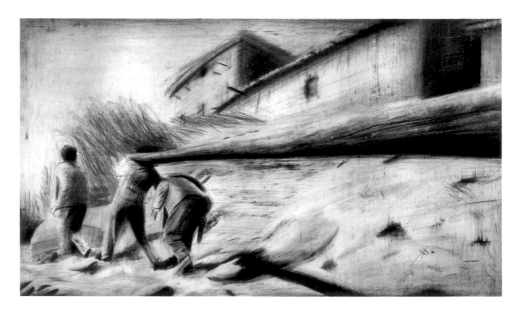

Descartes, 2013
Libération, Art Direction:
Anne Mattler; pencil

↓ Falling in Love with
Cement, 2013
Dorade; pencil

Gary Kelley

1945 born in Algona, USA | lives and works in Algona, USA
www.garykelleyonline.com

CLIENTS
Rolling Stone, Creative Editions, Playboy,
The New Yorker, Nat. Football League,
US Postal Service, Los Angeles Times

EXHIBITIONS
Once upon a Time, The Art of Creative Editions, traveling group show, USA and Europe, 2003
Poe, Tales of Mystery and Imagination, solo show, Montreuil Children's Book Fair, Paris, 1998
Art of Children's Books, group show, Norman Rockwell Museum, Stockbridge, USA, 1996

AGENT
Richard Solomon, USA

"Curiosity. Concept. Composition. Craft. Friends like Picasso, Matisse, Bonnard, Schiele, Jacob Landau, Joseph Solman, Edwin Dickinson, Felice Casorati. An enduring passion for what I do."

„Neugierde. Konzept. Komposition. Können. Freunde wie Picasso, Matisse, Bonnard, Schiele, Jacob Landau, Joseph Solman, Edwin Dickinson, Felice Casorati. Eine unbändige Leidenschaft für das, was ich tue."

«Curiosité. Concept. Composition. Savoir-faire. Des amis comme Picasso, Matisse, Bonnard, Schiele, Jacob Landau, Joseph Solman, Edwin Dickinson, Felice Casorati. Une passion durable pour ce que je fais.»

The Magician, 2013
Waterloo, Cedar Falls Symphony,
music video projection for concert:
The Planets by Holst; pastel and oil

→ Van Gogh Moon, 2006
North American Review, magazine
cover; monotype

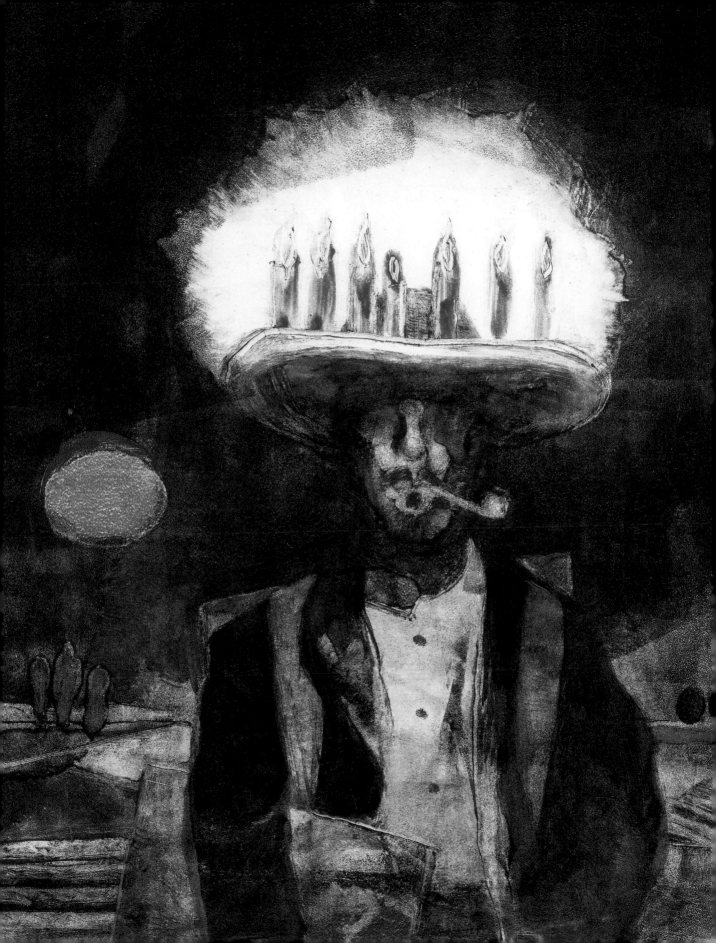

Sarah King

1985 born in London | lives and works in Whistler, Canada
www.sarahaking.com

CLIENTS

San Francisco Museum of Modern Art, National
Geographic, The Guardian, The New York Times,
Vice, Wired US, Zizzi Restaurant, Gnu Snowboards

EXHIBITIONS

Worca Fundraiser, group show, Red Bull Tower Crankworx, Whistler, Canada, 2013
State of the Art, group show, Whistler Conference Centre, Whistler, Canada, 2013
Pick Me Up, group show, Somerset House, London, 2010

"My illustrations are inspired by how I perceive the world around
me, full of nature, information and random thought."

„Die Inspiration für meine Illustrationen ist meine Wahrnehmung der Welt:
voller Natur, Informationen und zielloser Gedanken."

«Mes illustrations sont inspirées par ma perception
du monde, pleines de nature, d'informations
et de pensées aléatoires.

Baboon, 2012
National Geographic;
hand-drawn and digital

→ **Putin, 2012**
Bloomberg Businessweek;
hand-drawn

Edward Kinsella

1983 born in St. Louis, USA | lives and works in St. Louis, USA
www.edwardkinsellaillustration.com

CLIENTS
Simon & Schuster, Penguin, Rolling Stone, Wired,
Wall Street Journal, Smithsonian Magazine,
The New Yorker, The Washington Post, The Progressive

EXHIBITIONS
Yugen, group show, Ghostprint Gallery, Richmond, USA, 2012

AGENT
Richard Solomon, USA

"My work is a combination of old and new, flat and rendered, my needs and the client's needs. For me, illustration is all about balance."

„Meine Arbeiten sind eine Mischung von alt und neu, schlicht und ausgefeilt, meinen Bedürfnissen und denen des Kunden. Ausgewogenheit ist der Schlüssel einer jeden Illustration."

« Mon travail est une combinaison d'ancien et de nouveau, de plat et de texture, de mes besoins et de ceux du client. Pour moi, l'illustration est une question d'équilibre. »

Mountain Man, 2013
Personal work; ink, gouache
and etching ink on paper

→ **The Corpse Tree, 2013**
UUWorld, magazine cover, Art
Direction: Bob Delboy; ink and
gouache on paper

→→ **Bob Dylan at 70, 2011**
Richard Solomon Artist Rep.;
ink, gouache and watercolor
on paper

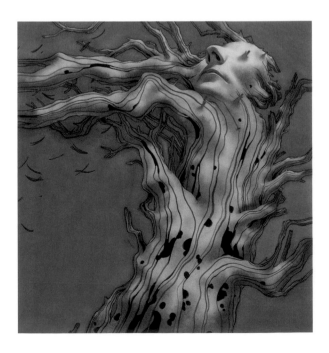

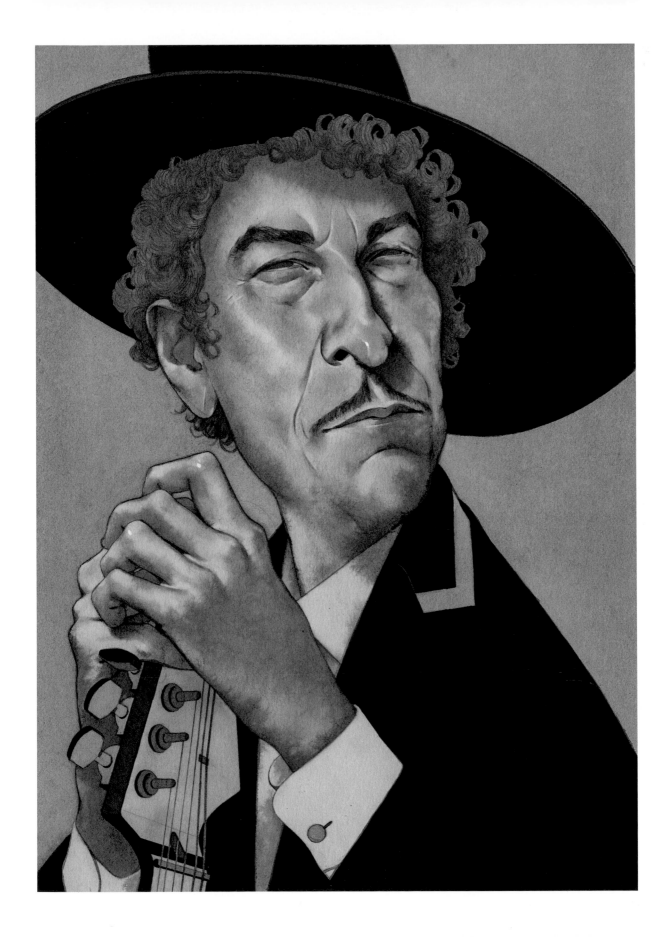

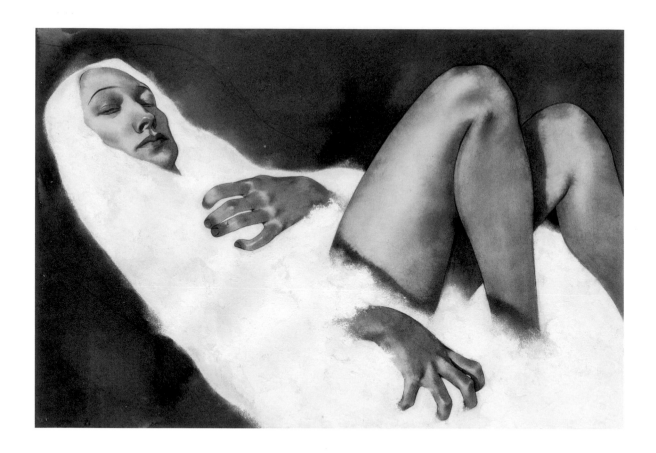

Winter I, 2010
Gallery Nucleus; ink and
gouache on paper

→ **Look Back in Anger, 2012**
The New Yorker, Art Direction:
Chris Curry; ink, gouache and
watercolor on paper

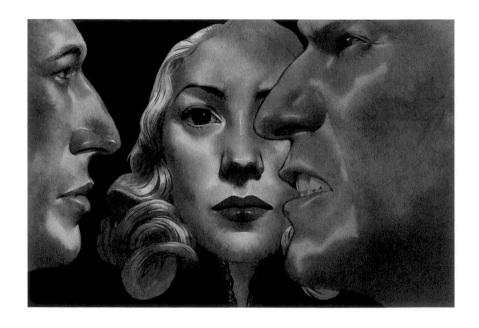

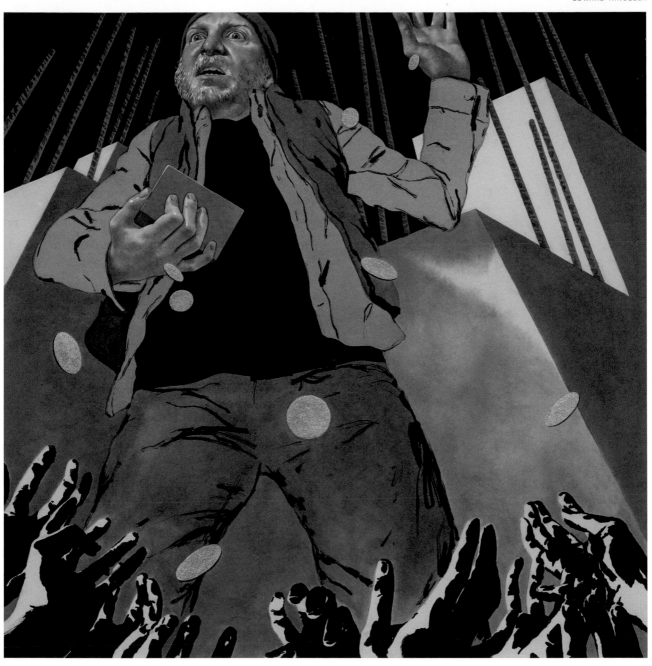

Timon of Athens, 2012
The New Yorker, Art Direction:
Chris Curry; ink, gouache and
watercolor on paper

Uli Knörzer

1975 born in Reutlingen, Germany | lives and works in Berlin
www.uliknoerzer.com

CLIENTS

AD Magazin, ADC Art Director's Club, Berghain,
Dash Magazine, GQ, Kid's Wear, KulturSPIEGEL,
Milk X Magazine, Spiegel Wissen, Die Zeit

EXHIBITIONS

Time Is Honey, solo show, Neonchocolate Gallery, Berlin, 2012
Echt? Basiert auf einer wahren Begebenheit, group show, Künstlerhaus Stuttgart, 2011
Participate, group show, Mars Gallery, Melbourne, 2011

"A central theme of my work is the human being, whose numerous emotions and fleeting expressions I aim to capture in my drawings."

„Ein zentrales Thema meiner Arbeiten ist der Mensch, dessen vielfältige Gefühle und flüchtige Gesten ich in meinen Zeichnungen einzufangen versuche."

« L'être humain est un thème central dans mon travail, j'essaie de saisir ses nombreuses émotions et expressions éphémères dans mes dessins. »

Untitled, 2012
Bobby Kolade Fall/Winter 2013–14,
textile print, Collaboration: Bobby
Kolade; pencil and screenprint

→ This Is Concrete, 2012
Jefta van Dinther, promotion for dance
piece This Is Concrete; indian ink

→→ Untitled, 2013
Bobby Kolade Fall/Winter 2013–14,
textile print, Collaboration: Bobby
Kolade; pencil and screenprint

Rory Kurtz

1979 born in Milwaukee | lives and works in Milwaukee
www.rorykurtz.com

CLIENTS
Rolling Stone, Simon & Schuster, Runner's World, Bicycle Times,
ESPN magazine, The Atlantic Monthly, Ford, Hachette Books,
Ogilvy & Mather, Vancouver Opera, The Village Voice

EXHIBITIONS
A Cry for Help, group show, Thinkspace Gallery,
Los Angeles, 2010

AGENT
Levy Creative
Management, USA

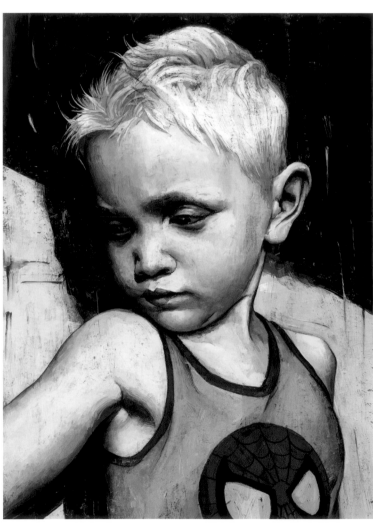

"I enjoy the craftsmanship
of illustration. There's a sense
of trying to master something
vague and subjective that
I find rewarding."

„Mir gefällt am Illustrieren der hand-
werkliche Aspekt. Für mich ist es
erfüllend zu versuchen, etwas Vages,
Subjektives zu meistern."

« J'aime l'artisanat de l'illustration.
Il y a ce sentiment d'essayer de
maîtriser quelque chose de vague et
de subjectif, que je trouve gratifiant. »

Witch Hazel Song, 2011
Popshot Magazine, Art Direction:
Jacob Denno; graphite and digital

→ Spoke Song, 2010
Bicycle Times, Art Direction: Amanda
Zimmerman; graphite
and digital

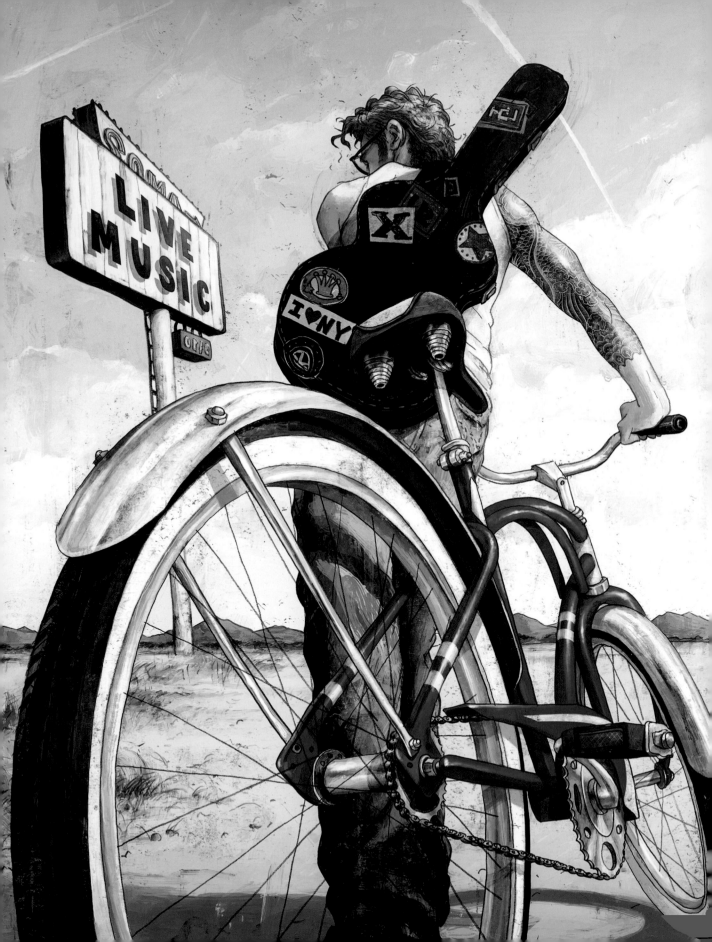

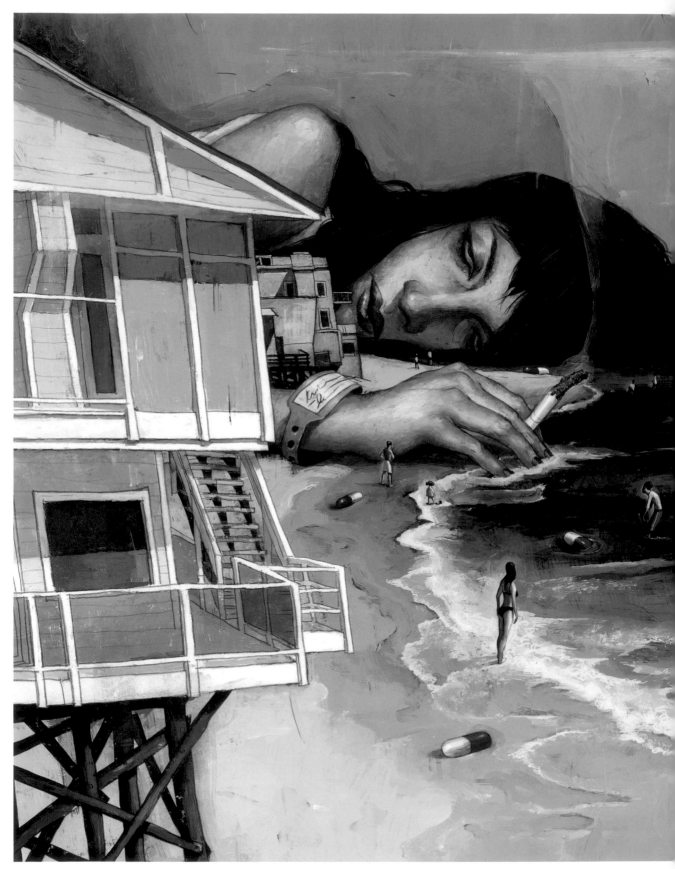

The Heart Thief, 2011
The Atlantic Monthly, Art Direction:
Katie Mathy; graphite and digital

← **Rocky Passages, Broken
Dreams, 2011**
Malibu Times, Art Direction:
Matt Ansoorian; graphite and digital

Gian Paolo La Barbera

1969 born in São Paulo | lives and works in São Paulo
www.barberaestudio.com.br

CLIENTS
Dazed & Confused, Rolling Stone,
Wax Poetics, Jazznin, Shook, Fused
Magazine, MTV Brasil, Sony Music

EXHIBITIONS
Azuldecobalt, group show, Ritter Butzke, Berlin, 2013
Soul Sketches, group show, Urban Arts Gallery, São Paulo, 2011
Design Brasileiro, Uma Mudança do Olhar, group show, Itamaraty Palace, Brasilia, 2007

"Several techniques, use of strong colors, insistent geometric
interventions, oneiric and metaphysical influences."

„Verschiedene Techniken, kraftvolle Farben, starke geometrische
Interventionen, traumartige und metaphysische Einflüsse."

«Plusieurs techniques, l'utilisation de couleurs fortes,
des interventions géométriques insistantes, des influences
oniriques et métaphysiques.»

Funky Jazz Machine, 2013
Tuto Ferraz, record sleeve; oil on paper

→ Jimi Hendrix, 2012
Personal work; oil on paper

Tim Lahan

1984 born in Pennsylvania | lives and works in New York
www.timlahan.com

CLIENTS
The New Yorker, McSweeney's,
Nike, Jack Spade, Kenzo,

EXHIBITION
This, That & the Other, solo show, Art in the Age,
Philadelphia, 2013

AGENT
Agent Pekka, Finland

"Creating images in a direct, simple and oftentimes
innately humorous fashion."

„Direkte, einfache und oft auch inhärent geistreiche Bilder zu machen."

« Créer des images d'une façon directe, simple et
souvent humoristique. »

Beach Me, 2013
Personal work; hand-drawn and digital

→ **Celebrated Summer, 2013**
Personal work; hand-drawn and digital

Poul Lange

1956 born in Copenhagen | lives and works in Los Angeles
www.poullange.com

CLIENTS
Random House, The New York Times, Time, Boston Globe,
Chicago Tribune, GQ, Hemispheres, Johns Hopkins Universtiy,
MIT Sloan, Citibank

EXHIBITIONS
Cut and Paste, group show, Tag Art Gallery, Nashville, 2007
Unbroken, group show, Denise Bibro Fine Art, New York, 2004
1998: Held together by Glue, solo show, Cast Iron Gallery, New York, 1999

Romola, 2013
Personal work; collage

→ The Moral Animal, 2003
Johns Hopkins Professional
Studies; collage

→→ Cosmopolitan, 2013
Random House, book
Storied Sips; collage

"A collage is like a cocktail: top-shelf
ingredients complement and contrast
with each other, and if the measurements
are just right, it will be delicious."

„Collagen sind wie Cocktails: Erstklassige Zutaten
ergänzen sich und kontrastieren miteinander,
und mit dem richtigen Mischungsverhältnis entsteht
daraus etwas Umwerfendes."

«Un collage, c'est comme un cocktail : les ingrédients
de qualité se complètent et créent un contraste,
et si la mesure est juste, ce sera délicieux.»

Jules Le Barazer

1984 born in Tours, France | lives and works in Paris
www.juleslebarazer.com

CLIENTS
Libération, Le Monde, Milk Magazine,
Ogilvy & Mather, Sciences-Po

AGENT
Talkie Walkie, France

"Body fluids, tics and twitches and
perishable foods are the sort of
things I get my inspiration from."

„Körperflüssigkeiten, Marotten, Macken
und verderbliche Lebensmittel – das sind
meine Inspirationsquellen."

«Je tire mon inspiration de choses comme
les fluides corporels et les tics nerveux,
ou encore les denrées périssables.»

Multitasking Smartphone, 2012
Air Le Mag; felt-tip pen
and digital

→ Future Mom, 2012
Figure; felt-tip pen
and digital

→→ Parental Control, 2013
Milk; felt-tip pen
and digital

Gwendal Le Bec

1987 born in Quimper, France | lives and works in New York
www.gwendallebec.com

CLIENTS
Albin Michel Jeunesse, Gallimard Jeunesse, Nobrow,
Le Monde, The New York Times, The New Yorker,
Wall Street Journal, Amnesty International

EXHIBITIONS
The Parisianer, group show, Galerie de la Cité Internationale des Arts,
Paris, 2013

AGENTS
Garance, USA
Illustrissimo, France

"My practice is mainly a focus on narration,
going from a single image to a book
with a strong visual impact."

„Im Mittelpunkt steht für mich meist eine Geschichte.
Ich fange mit einem einzigen Bild an und habe
zum Schluss ein Buch, das starke visuelle
Botschaften vermittelt."

« Je me concentre avant tout sur la narration,
je pars d'une seule image pour arriver à un
livre visuellement fort. »

Papua, 2012
News of the Times; indian ink
and digital

← Hunger Strike, 2013
News of the Times; cut paper,
indian ink and digital

→ Shoes, 2013
Personal work; digital

Yann Legendre

1972 born in Orléans | lives and works in Paris
www.yannlegendre.com

CLIENTS
Wall Street Journal, The New York Times,
The Guardian Magazine, Libération, Janus Films,
The Criterion Collection, Universal Music

EXHIBITIONS
The One Show Design, group show, The One Show Gallery, New York, 2013
Flesh Empire, solo show, Nakatomi Gallery, Austin, 2013
10th International Poster Biennial in Mexico, group show, 2008

AGENT
Début Art, UK

"I'm interested in illustrating every
subject for all types of media, as long
as the illustration provokes an
emotion in the viewer."

„Solange die Illustration im Betrachter ein Gefühl
hervorruft, bebildere ich jedes Thema für jedes Medium."

« Ce qui m'intéresse, c'est d'illustrer tous les sujets pour
tous types de support, du moment que l'illustration
provoque une émotion. »

Head of Passes, 2013
The Steppenwolf Theater,
poster series; digital

→ **The Bearded Man**, 2013
The Wall Street Journal; digital

→ → **The Deepweb**, 2013
Télérama; digital

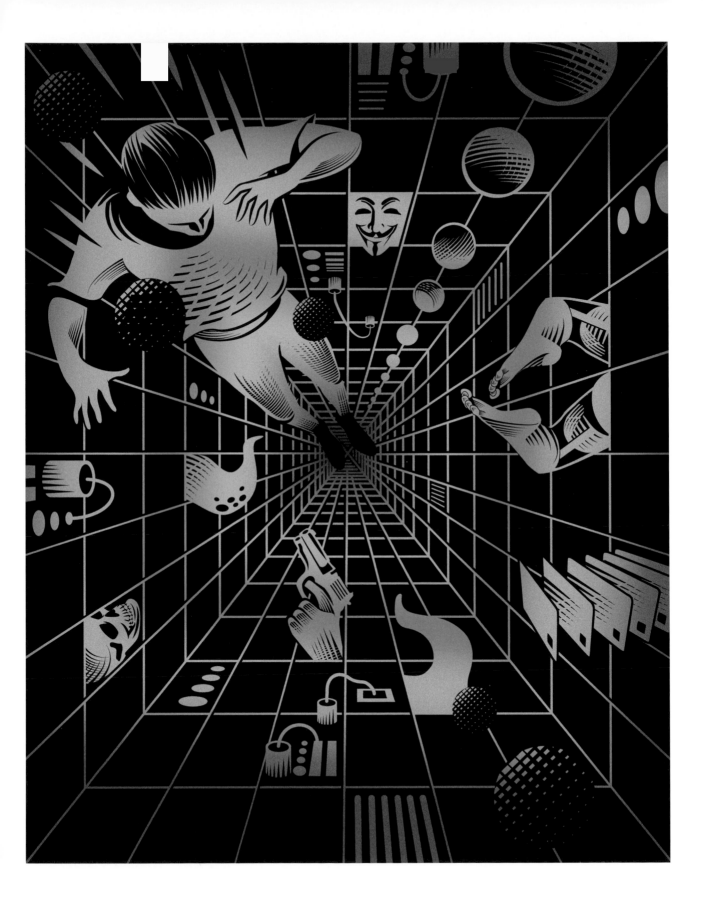

David Litchfield

1982 born in Bedford, UK | lives and works in London
www.davidlitchfieldillustration.com

CLIENTS

Metal, The Daily Telegraph, The Beano, Center Parcs,
Picturehouse Cinemas, Anorak Magazine, Rue Royale,
Wolf Clothing, We Can Create, Creaturemag

EXHIBITIONS

Vessel Collective, group show, Roosevelt 2.0, Tampa, Florida, 2012,
3 C's. Creatures, Characters & Communication, group show, APG Gallery, Sheffield, 2012
A Drawing A Day, 365 Illustrations by David Litchfield, solo show, Animal Gallery, Bedford, 2011

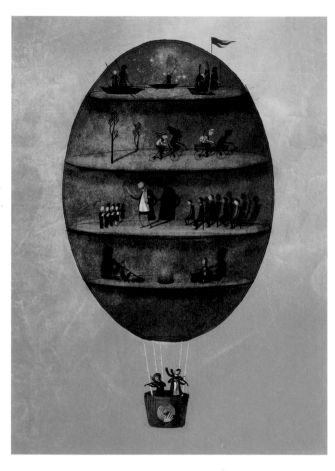

Roseability, 2013
Cambridge University Press/CAIN,
book cover; fine line pen, pencil, acrylic
and digital

→ **The Complicated Life of
Hogarth Ruuberlash, 2011**
Personal work, series Drawing A Day;
pencil

→→ **Animal Madness, 2012**
The Beano/DC Thomson; fine line pen,
watercolor, pencil crayon and digital

"If you had told me as a seven-year-old
boy that one day I would get paid
to draw monsters I would have
exploded with joy."

„Hätte jemand mir als Siebenjährigem gesagt,
dass ich eines Tages dafür bezahlt würde,
Monster zu zeichnen, wäre ich vor Freude an
die Decke gesprungen."

« Si quand j'avais sept ans on m'avait
dit qu'un jour on me paierait pour dessiner
des monstres, j'aurais explosé de joie. »

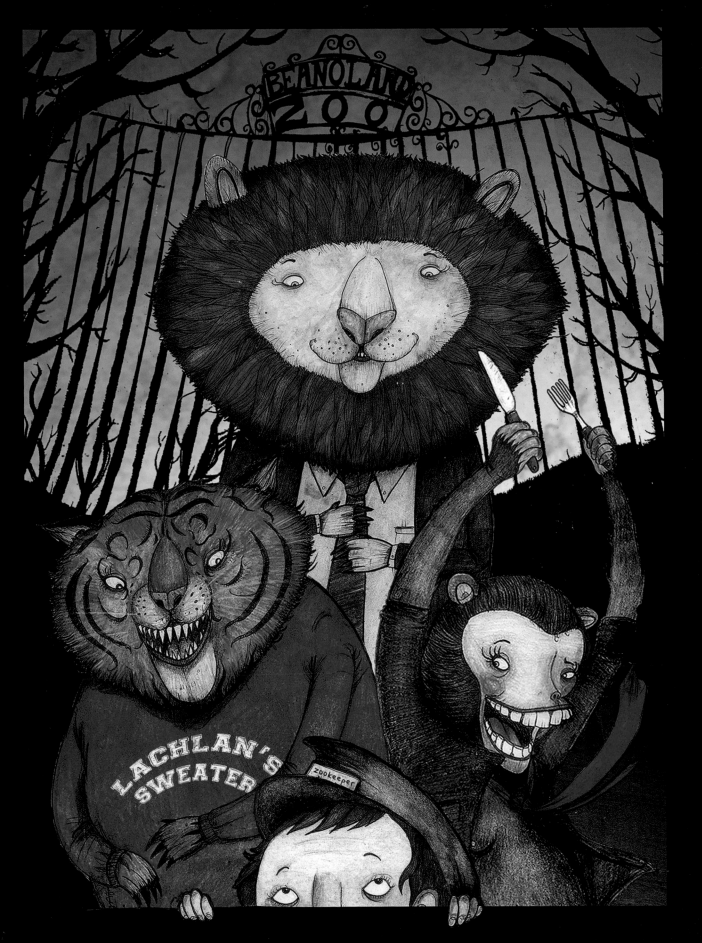

Junior Lopes

1966 born in Castanhal, Brazil | lives and works in São Paulo
www.juniorlopesillustrator.blogspot.com.br

CLIENTS
Levi's, Folha de São Paulo, Rolling
Stone Brasil, Le Monde Diplomatique,
MTV magazine

EXHIBITIONS
Terruá Pará, solo show, Instituto de Artes do Pará, Belém, 2012
International Humor Exhibition of Piracicaba, solo show, São Paulo, 2012
Centro de Estudos Brasileiros Maputo, solo show, Mozambique, 2008

"My work is always hand-crafted, made with
pieces of fabric, scissors and glue."

„Meine Arbeiten entstehen alle in Handarbeit mit Stoff,
Schere und Kleber."

«Mon travail est toujours fait à la main, avec des morceaux
de tissu, des ciseaux et de la colle.»

Django Reinhardt, 2013
Personal work; collage

→ Frida, 2012
Personal work; collage

Diogo Machado

1990 born in São Paulo | lives and works in São Paulo
www.machadodiogo.tumblr.com

CLIENTS
L'Officiel magazine, Chic.com.br,
U+Mag, FFW, Octopus Publishing,
Pug Records, MAM

EXHIBITIONS
Itsnoon + Urban Arts: Crowd Art, group show, São Paulo, 2012
Projeto Parede, group show, São Paulo Museum of Modern Art, 2011

AGENT
Urban Arts, Brazil

"My work is aggressive, emotional
and involves dialogues with
the narratives of everyday life.
Fashion and music are the main
references for building my art."

„Meine Arbeiten sind aggressiv und emotional
und greifen Geschichten aus dem Alltag auf. Die
Fixpunkte meiner Kunst sind Mode und Musik."

« Mon travail est agressif, émotionnel et établit
des dialogues avec les histoires de la vie
quotidienne. La mode et la musique sont les
principales références de mon art. »

Don't Think Twice,
It's Alright, Josefien Roderman, 2012
Personal work; pencil, watercolor
and digital

→ Carnaval, 2013
Personal work; pencil, watercolor
and digital

→→ Dries Van Noten, 2013
Personal work; pencil, gouache
and digital

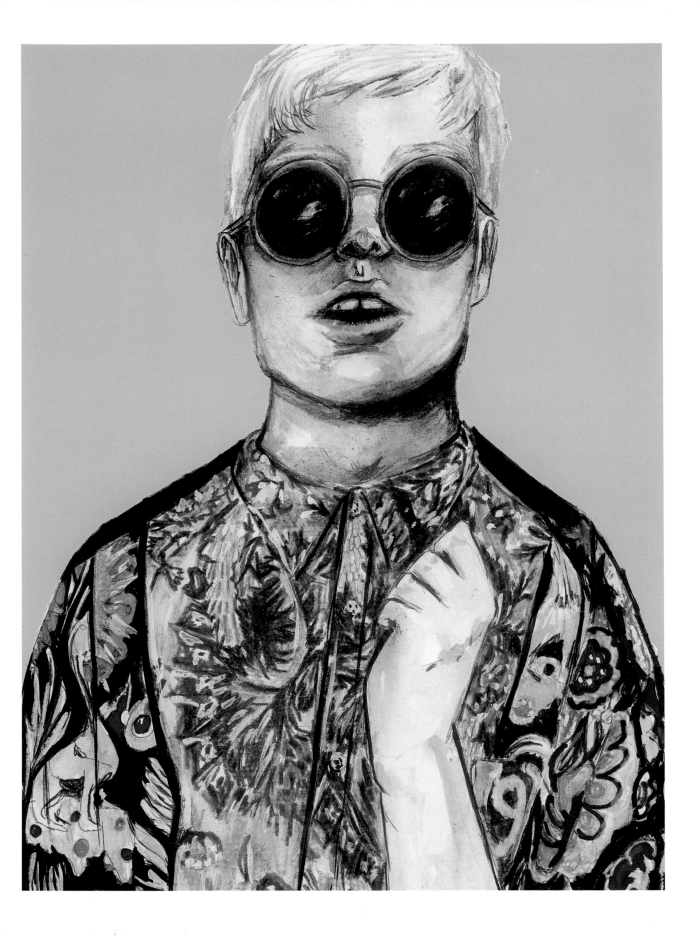

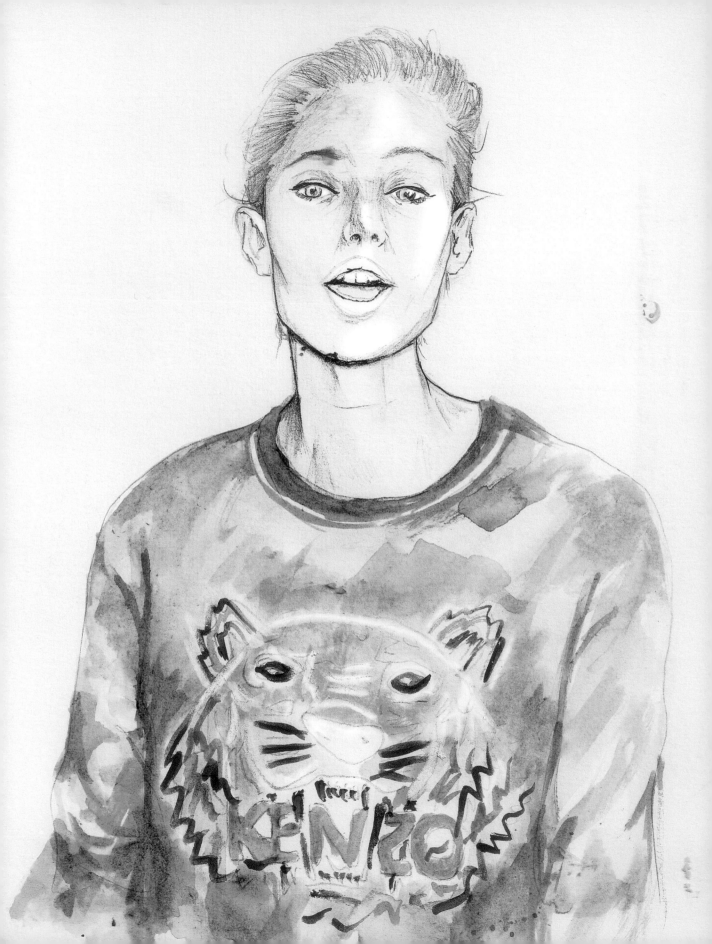

**Manual Prático de Bons Modos
em Livrarias, 2013**
Editora Seoman; gouache and digital

← **Kenzo, 2013**
Personal work; pencil, watercolor
and digital

Mágoz

1989 born in Barcelona | lives and works in Bristol
www.magoz.is

CLIENTS
The New York Times, Wall Street Journal, Adweek,
Scientific American, Wired, Medium.com, Financial
Post, Billboard, MIT Technology Review

EXHIBITIONS
3x3 Professional Show, group show, 631 Vanderbilt Street, New York, 2013
Artaq Awards, group show, 40 rue de la Folie Regnault, Paris, 2012
Society of Illustrators, group show, New York, 2011

AGENT
Anna Goodson,
Canada

"Using few elements and colors,
I play with images, focusing on the
conceptual value."

„Wichtig ist für mich vor allem der konzeptuelle
Wert, ich spiele mit Bildern und verwende dabei
wenige Elemente und Farben."

« J'utilise un nombre restreint d'éléments et
de couleurs pour jouer avec les images,
en me concentrant sur la valeur conceptuelle. »

Media Censorship, 2013
Pacific Standard; digital

→ Corruption in Football, 2014
La Marea; digital

→→ Growth of Jewellery Industry
in Brazil, 2013
Vioro Magazine; digital

Sea Activities During the Winter, 2012
Descobrir; digital

← Replicate This, 2013
Pacific Standard; digital

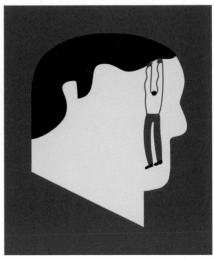

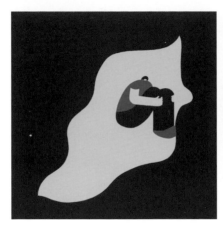

Fear of Happiness, 2013
Scientific American; digital

→ Mental Illness and
Depression, 2012
Austin Monthly; digital

↓ Prosperity, 2013
Personal work; digital

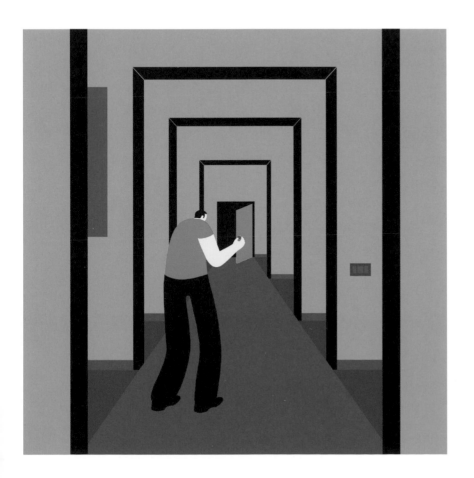

Gregory Manchess

1955 born in Fort Thomas, USA | lives and works in Portland
www.manchess.com

CLIENTS
Time, National Geographic, Smithsonian, Fedex,
The New Yorker, Tor Books, Random House,
US Postal Service, Rand Corporation

EXHIBITIONS
Society of Illustrators, solo show, New York, 2013
The Figure, solo show, Witham Gallery, Ohio, 1997

AGENT
Richard Solomon, USA

"I enjoy narrative oil painting.
My approach is to achieve
a timeless look that goes
beyond the assignment and
can hang on a wall."

„Mir gefallen narrative Ölbilder. Es geht
mir um einen zeitlosen Look, der über
den Auftrag hinausweist und auch
an der Wand hängen kann."

« J'aime la peinture à l'huile narrative.
Je veux atteindre un style intemporel
qui dépasse la mission et aurait sa
place accroché à un mur. »

Gina Rinehart, 2013
The New Yorker; oil on linen

→ Gladiator, 2013
Personal work; oil on board

→→ Astronaut 5, 2012
Personal work; oil on board

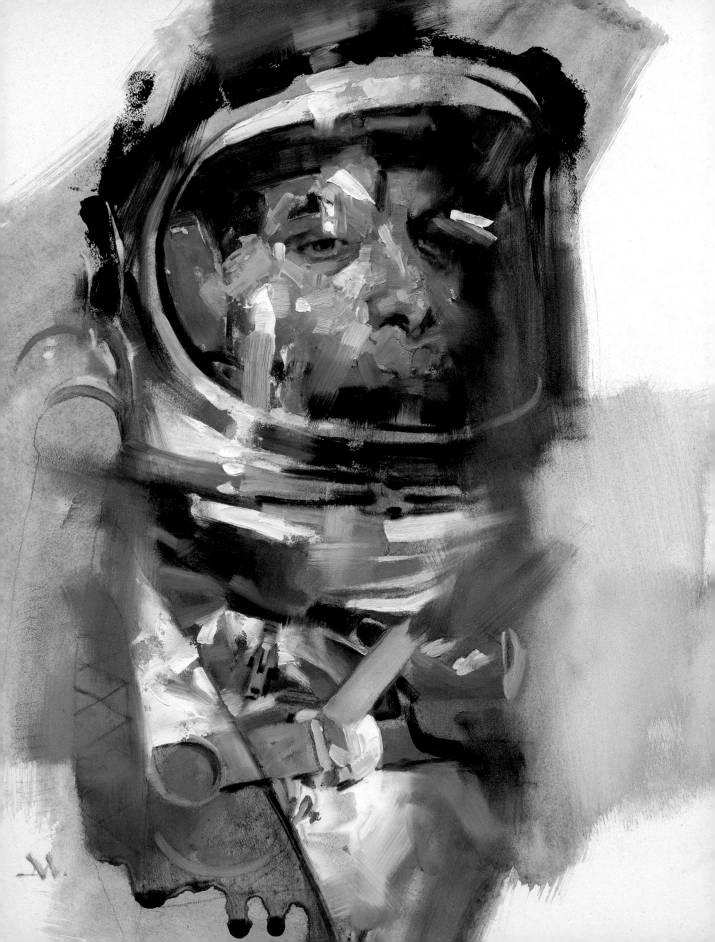

Above the Timberline, 2009
Massive Black Video, how-to video;
oil on linen

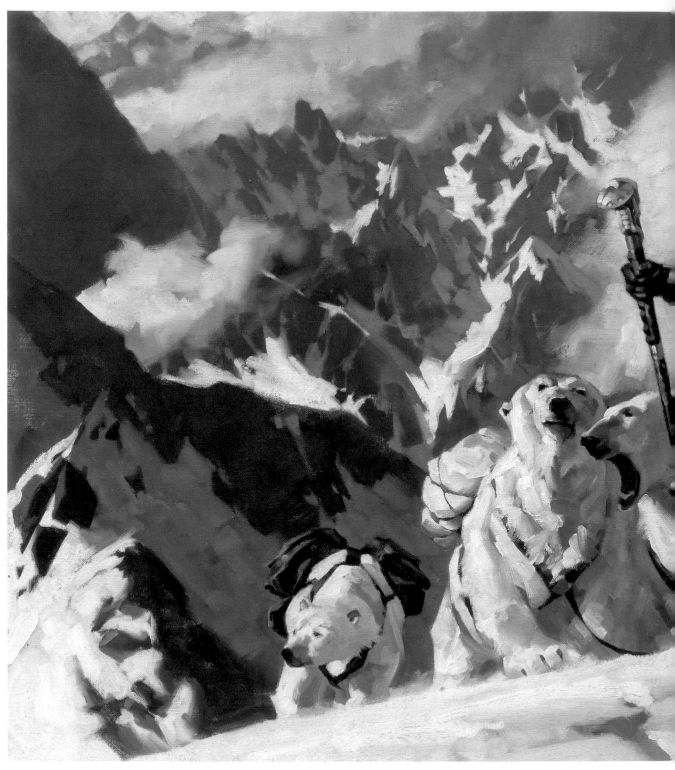

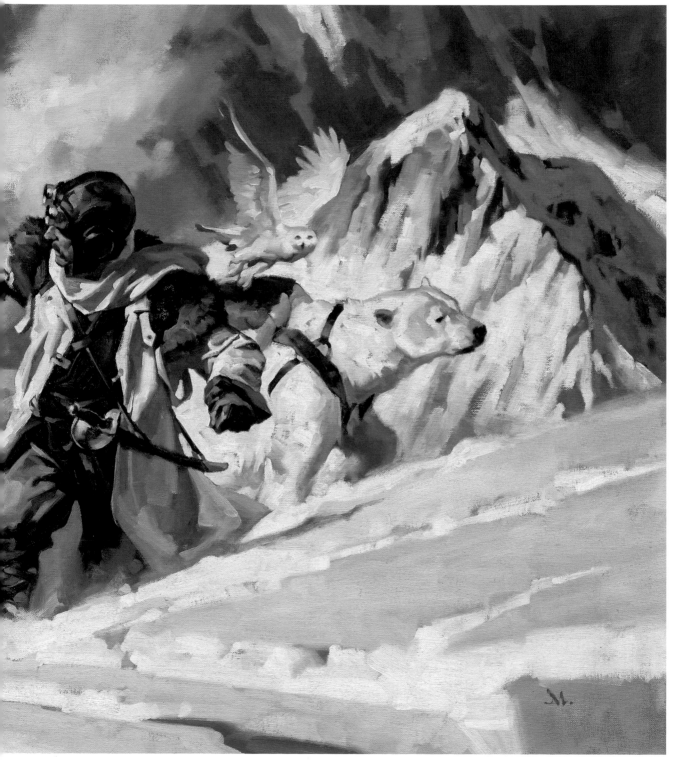

James McMullan

1934 born in Tsinatai, China | lives and works in Saq Harbour, USA
www.jamesmcmullan.com

CLIENTS
Lincoln Center Theater, Esquire,
New York Magazine, Algonquin Press,
The New York Times Magazine,
HarperCollins Publishers

EXHIBITIONS
The Masters Series: James McMullan, solo show, School of Visual Arts, New York, 2012
McMullan Posters, Gesture as Design, solo show, Vineert Astor Gallery, New York, 2011
The Theater Posters of James McMullan, solo show, Art Center College of Design,
Willamson Gallery, Pasadena, 2001

AGENT
Pippin Properties, USA

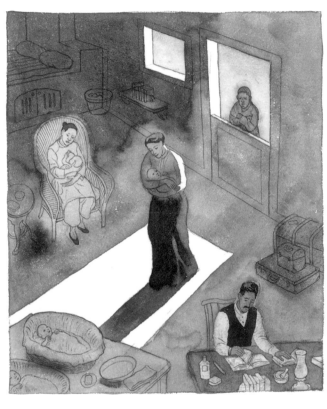

Saving the Babies, 2013
Algonquin Press, book Leaving China;
watercolor

→ The Road Blockades, 2013
Algonquin Press, book Leaving China;
watercolor

→→ My Father at the Piano, 2012
Algonquin Press, book Leaving China;
watercolor

"By drawing my images with
a great deal of risk and intuitive
simplification I hope to be able
to convey emotional ideas
through my figures."

„Ich zeichne meine Bilder mit viel Risiko
und intuitiver Vereinfachung und hoffe,
mit meinen Figuren emotionale Ideen
zu vermitteln."

« En dessinant mes images avec une
bonne dose de risque et de simplification
intuitive, j'espère arriver à véhiculer
des idées émotionnelles. »

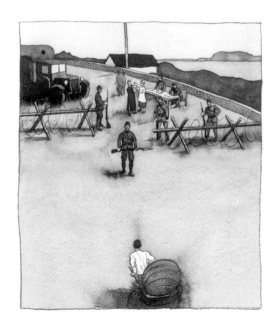

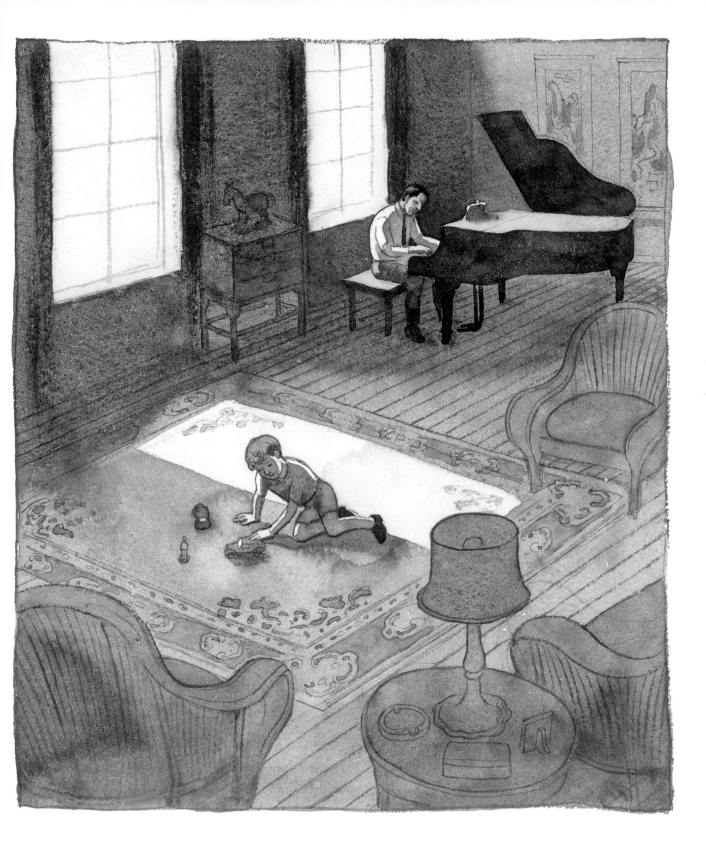

Carlo Miccio

1965 born in Florence | lives and works in Rome
www.microcolica.com

EXHIBITIONS

Propaganda, solo show, Howtan Space, Rome, 2013
Temporary Autonomous Art, group show, London, 2010
Pornosemiotika, solo show, Piermario & Co. Art Gallery, Latina, Italy, 2008

"I sample visuals from the net and digitally recycle them into
new shapes and meanings: a balancing act on the thin
line linking Dada to hip hop."

„Ich sample Bilder aus dem Internet und gebe ihnen digital neue Formen und Inhalte:
ein Balanceakt auf dem schmalen Grat zwischen Dada und Hip-Hop."

« Je trouve des images sur Internet et je les recycle numériquement en leur donnant
de nouvelles formes et significations : un exercice de funambulisme entre
le dada et le hip hop. »

War of the Worlds, 2008
Personal work, series
Pornosemiotika; digital

→ Feelings Require, 2012
Personal work, series
Propaganda; digital

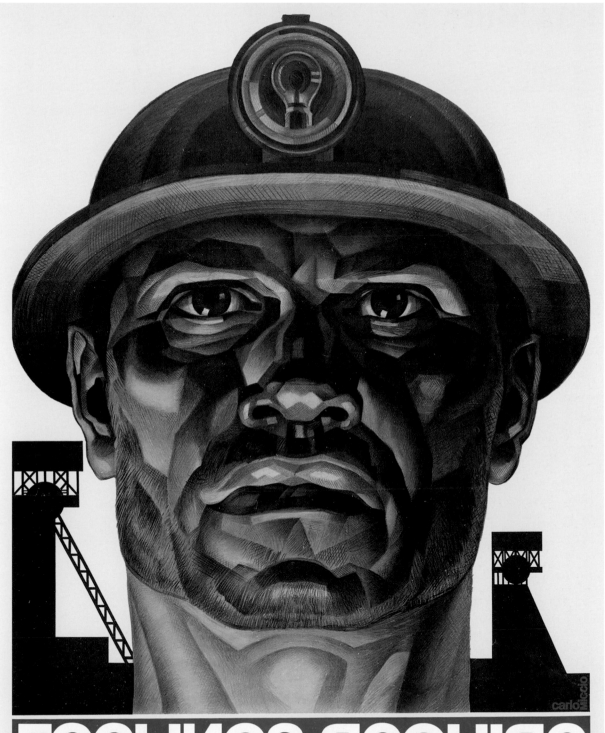

Russ Mills

1971 born in Exeter, UK | lives and works in Hassocks, UK
www.byroglyphics.com

CLIENTS
Ubisoft, Adidas, Future Publishing,
Tru Thoughts Recordings,
Royal Court Theatre

EXHIBITIONS
Always the Son, solo show, Red Propeller Gallery, Devon, 2010
Domestic Science, solo show, Signal Gallery, London, 2009
Ridiculum Vitae, solo show, Red Propeller Gallery, Devon, 2008

AGENT
Red Propeller, UK

"My work occupies an inter-dimensional space, never entirely seated in reality."

„Meine Arbeiten existieren im interdimensionalen Raum, sie sind nie ganz in der Realität verortet."

« Mon travail occupe un espace interdimensionnel, qui n'a jamais les deux pieds dans la réalité. »

Flat Earth, 2012
Personal work; digital

← Animus, 2010
Personal work, solo show
Subsidiary, Signal Gallery,
London; digital

→ Fries to Go, 2009
Personal work, Red Propeller
Gallery; digital

Dyna Moe

1978 born in Washington, DC | lives and works in New York
www.nobodyssweethheart.com

CLIENTS
Mad Men—AMC Networks,
Marc Jacobs, Penguin,
UCB Theatre

EXHIBITIONS
Solo Show, Leeds College of Art, Leeds, UK, 2013
Crazy 4 Cult, group show, Gallery 1988, Los Angeles/New York, 2012
These Are Their Stories, group show, Meltdown Gallery, Los Angeles, 2010

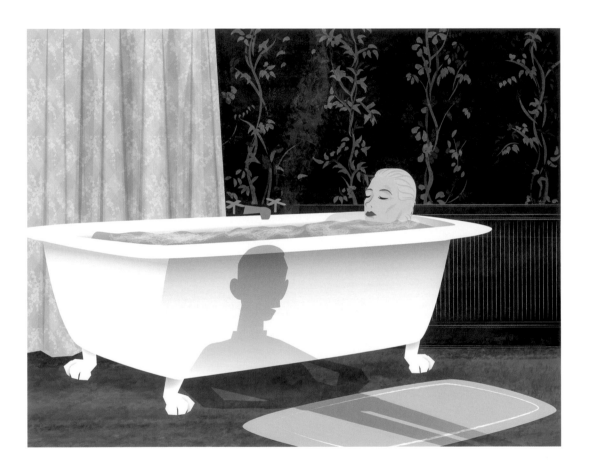

"Untouched by disgusting human hands. 100% digital and germ-free."

„Unberührt von abstoßenden menschlichen Händen. 100-prozentig digital und keimfrei."

«Vierge de tout contact avec les dégoûtantes mains humaines. 100 % numérique et sans microbes.»

Bath, 2012
Dinosaur Robot; digital

→ Hipster Animal: Ocelot, 2012
Personal work; digital

Narges "Hasmik" Mohammadi

1985 born in Mashad, Iran | lives and works in Tehran
www.narges-mohammadi.blogspot.com

CLIENTS
Soremehr Publishing House, Cheke Publishing House, Soroush
Publishing House, Afraz Publishing House, Sorush magazine,
Koshesh magazine, Keyhanbacheha magazine, Badbadak newspaper

EXHIBITIONS
Group show, Agapito Miniucchi, Rieti, Italy, 2013
Fajr Festival Illustration Exhibition, group show, Imam Ali Muzem, Tehran, 2012
Group Illustration Exhibition, group show, Momayez Gallery, Tehran, 2009

"Illustration is like a breath of fresh air in my life. Like sunshine for
the dark periods and like a melody for my private moments."

„Illustrieren ist für mich wie eine frische Brise. Wie Sonnenschein in dunklen Zeiten,
wie eine Melodie für meine persönlichen Momente."

« L'illustration est une bouffée d'air frais dans ma vie. Un rayon de soleil pour
les périodes sombres, et une mélodie pour mes instants privés. »

Untitled, 2013
Personal work; mixed media

→ Story of Moms and Children, 2013
Daneshnegar, book; mixed media

Untitled, 2013
Personal work; mixed media

Anette Moi

1984 born in Stavanger, Norway | lives and works in Stavanger
www.anettemoi.com

EXHIBITIONS
The Good Life, solo show, Tou Scene, Stavanger, 2013
Stars, solo show, Nordic Black Theatre, Oslo, 2013
Funfair, solo show, Reedprojects Gallery, Stavanger, 2012

"Fun. Colorful. Bold."

Lykke, 2013
Natt&Dag; hand-drawn and digital

→ Hockeypulver, 2013
Personal work; hand-drawn and digital

T. Dylan Moore

1990 born in Maryland, USA | lives and works in Charlotte, USA
www.tdylanmoore.com

CLIENTS
Centers for Disease Control and
Prevention, Children's Theatre of
Charlotte, SP Televisão

EXHIBITIONS
Metamorphoses, group show, Twenty-Two, Charlotte, 2014
Hungry, group show, Twenty-Two, Charlotte, 2013
Robot Apocalypse, group show, Genome Gallery, Charlotte, 2012

AGENT
Illo Zoo, USA

"I balance textural rendering with selective abstraction, and wrap it all around a concise concept in an attempt to elicit an emotional response."

„Ich ergänze innerhalb eines detaillierten Konzepts die strukturelle Darstellung mit einer selektiven Abstraktion und hoffe, dadurch eine emotionale Reaktion auszulösen."

« Je marie le rendu de texture et l'abstraction sélective, et je m'en sers pour emballer un concept concis afin de provoquer une réponse émotionnelle. »

Hushpuppy, 2012
Personal work; graphite and gouache

→ Separation Anxiety:
Or, Why Did I Stay So Still?, 2013
Personal work; graphite

→→ Francis, 2013
Personal work; watercolor, colored
pencil, gouache and acrylic

Like a Forest Scorched,
I Will Be Reborn, 2013
Personal work; graphite

← **Awake My Body, 2012**
Personal work; oil on board

Caleb Morris

1980 born in Gulfport, USA | lives and works in Atlanta
www.calebmorris.net

CLIENTS
Nickelodeon, How Magazine,
Diesel Fragrance, Georgia Pacific

EXHIBITIONS
Ten By Ten, group show, Mobile Arts Council, Mobile, USA, 2013
1942, group show, Orange County Great Park, Irvine, USA, 2012
Home Coming, solo show, Brad Robertson Gallery, Mobile, USA, 2011

"Strong concepts, interesting characters, unique point of view, watercolor, pen and ink and caffeine = visual problem solved."

„Starke Konzepte, interessante Figuren, individueller Blickwinkel, Wasserfarben, Stift, Tusche plus Koffein = Lösung des visuellen Problems."

«Concepts forts, personnages intéressants, point de vue unique, aquarelle, stylo, encre et caféine = problème visuel résolu.»

Entangled, 2013
Mobile Arts Council; watercolor
and gouache

→ Underwood, 2012
Orange County Great Park;
acrylic on paper

→→ The Sea is my Brother, 2013
Personal work; screenprint

Dust Bowl, 2012
Personal work; watercolor

→ Family Tree, 2013
Mobile Arts Council; watercolor,
gouache, pen and ink

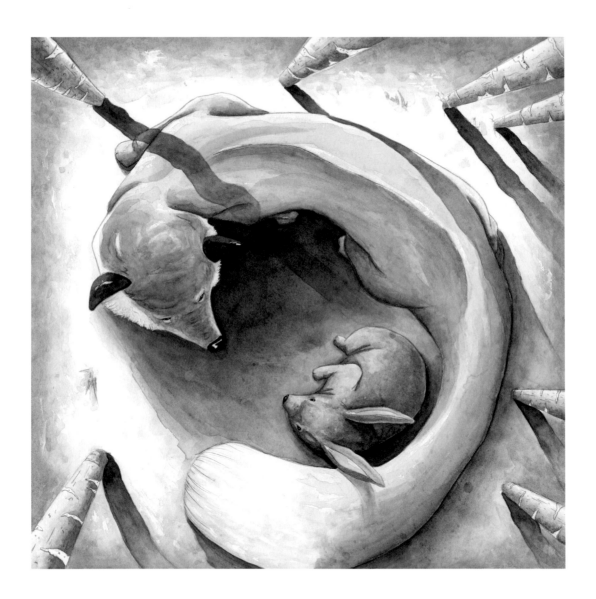

The Hunt, 2013
Mobile Arts Council Exhibit;
watercolor and gouache

Nik Neves

1976 born in Porto Alegre, Brazil | lives and works in Porto Alegre, Brazil
www.nikneves.com

CLIENTS

Brooklyn Industries, Lonely Planet, Inspirato,
Rolling Stone, Descobrir Catalunya, Strapazin, Playboy,
Runners, TAM Airlines, Hearst Corporation

"Working outdoors transformed my drawing into something
more fluid and spontaneous. The tools that respond to
this mobility have direct influence on my illustrations."

„Durch das Arbeiten im Freien zeichne ich flüssiger und spontaner.
Die Hilfsmittel, die dieser Mobilität entsprechen, haben unmittelbaren
Einfluss auf meine Illustrationen."

« Travailler dehors a donné fluidité et spontanéité à mon dessin.
Les outils qui répondent à cette mobilité ont une influence
directe sur mes illustrations.

Earwax, Williamsburg,
Brooklyn Sketchbooks, 2012
Personal work, published article in
Lola; pen, brush, ink and digital

→ Marina Sleeping
Like a Koala, 2011
Personal work; pen, ink and digital

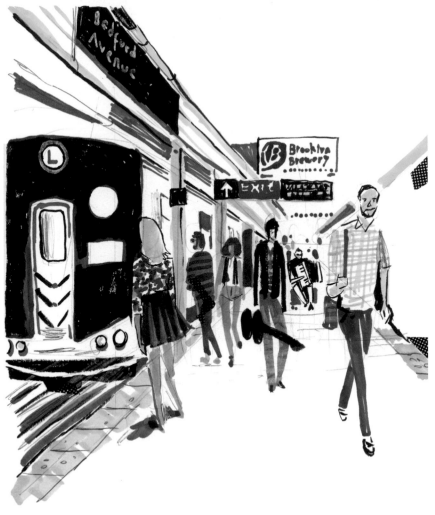

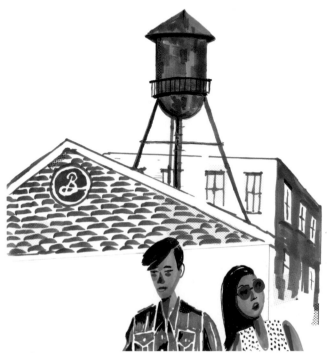

L Train, Brooklyn Sketchbooks, 2012
Personal work, published article in
Lola; pen, brush, ink and digital

← Weekend at
Ibirapuera Park, 2012
Guia, Folha de São Paulo, magazine
cover; pen, brush, ink and digital

→ The Brewery, Brooklyn
Sketchbooks, 2012
Personal work, published article in
Lola; pen, brush, ink and digital

Robert Nippoldt

1977 born in Kranenburg, Germany | lives and works in Münster, Germany
www.nippoldt.de

CLIENTS
Gerstenberg Verlag, Taschen, Mare, ZEITmagazin,
Büchergilde Gutenberg, Bear Family Records,
Deutsche Bahn, Apollo Theater, Pentagram, Aida

EXHIBITIONS
Jazz, solo show, La Central de Callao, Madrid, 2013
Jazz, solo show, Jazzclub Unterfahrt, Munich, 2007
Gangster, solo show, Burgdorfer Krimitage, Burgdorf, Germany, 2006

AGENT
Fabulous Noble, UK

"I love interesting perspectives, a precise setting of light and
shadow and an interaction between illustration and typography."

„Ich habe eine Vorliebe für interessante Perspektiven, wohlüberlegtes Setzen von
Licht und Schatten und eine Interaktion von Illustration und Typografie."

« J'aime les perspectives intéressantes, un mélange bien précis d'ombre et
de lumière, et l'interaction entre l'illustration et la typographie. »

Jazz: New York in the Roaring
Twenties, 2007
Gerstenberg; drawing pen, ink, brush,
pencil, watercolor, marker and tablet

← Hollywood in the 30s, 2012
Gerstenberg; drawing pen, ink, brush,
pencil, watercolor, marker and tablet

→ Gangster, 2010
Gerstenberg, book Hollywood in the
30s; drawing pen, ink, brush, pencil,
watercolor, marker and tablet

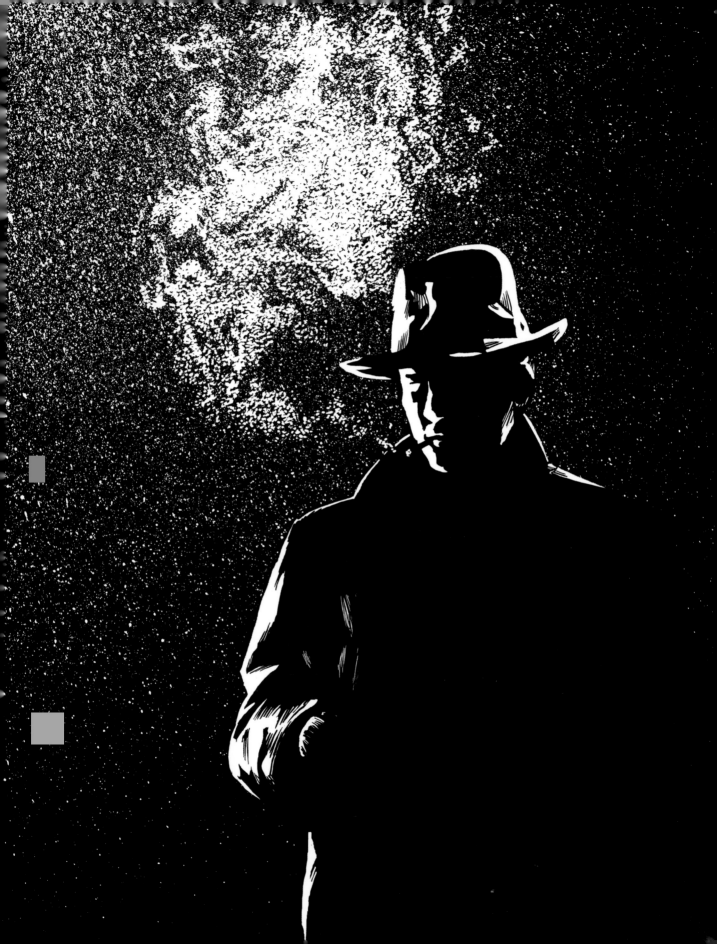

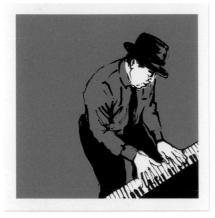

The Little Instruments, 2007
Bear Family and Büchergilde
Gutenberg, book Der Jazz in
Deutschland; drawing pen, ink, brush,
pencil, watercolor, marker and tablet

Spotlight, 2007
Gerstenberg, book Jazz: New York in the Roaring Twenties; drawing pen, ink, brush, pencil, watercolor, marker and tablet

↓ **New York at Night**, 2007
Gerstenberg, book Jazz: New York in the Roaring Twenties; drawing pen, ink, brush, pencil, watercolor, marker and tablet

Nomoco

1976 born in Fukuoka, Japan | lives and works in London
www.kazukonomoto.com

EXHIBITIONS
Small Picture Story, solo show, Vertigo Galeria, Mexico City, 2012
Museum of Small Things, group show, Selfridges, London, 2009
Solo show, Asylum Gallery, Singapore, 2005

AGENTS
Pocko, UK
Bernstein & Andriulli, USA

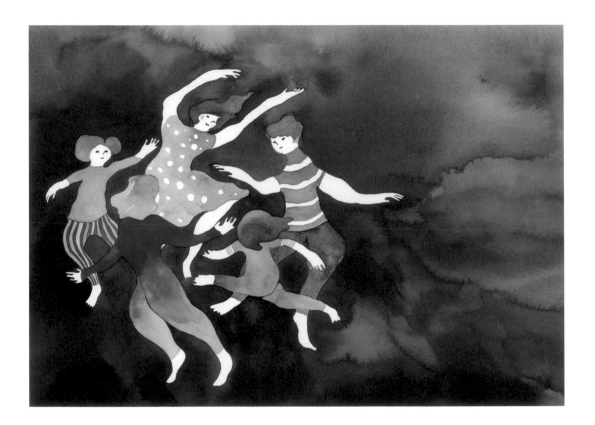

"I enjoy playing with ink and its organic movement.
It is a combination of logic and emotion. I try to follow
my instinct, I find that very helpful."

„Mir macht es Spaß, mit Tusche und ihrer organischen Bewegung
zu spielen – eine Mischung von Logik und Gefühl. Außerdem hilft es mir,
wenn ich meinem Instinkt folge."

« J'aime jouer avec l'encre et son mouvement organique.
C'est une combinaison de logique et d'émotion. J'essaie de
suivre mon instinct, je trouve que ça m'aide beaucoup. »

Dancing in a Circle, 2013
Mindful Magazine, Art Direction:
Jessica von Handorf; ink on paper

→ Peacock, 2010
Kellogg's; ink on paper

Untitled, 2012
Personal work, exhibition Small
Picture Story, Vertigo Galeria, Mexico;
ink on paper

→ Pink Blue Brown, 2012
Personal work; ink on paper

↓ Tights, 2003
Personal work, series Memory
Collector; ink on paper

Nomono

1977 born in Arica, Chile | lives and works in Berlin
www.artnomono.com

CLIENTS
The New York Times, Taschen, Martini,
International Herald Tribune, Random House,
Le Monde Diplomatique

EXHIBITIONS
Wie das Leben so Spielt, group show, Neurotitan, Berlin, 2011
Ein Haus für immer, group show, Neonchocolate, Berlin, 2011
Nomono Works, solo show, Baum Shop, Barcelona, 2008

"Fail again, fail better."

„Wieder scheitern, besser scheitern."

«Échouer encore, échouer mieux.»

Museum, 2012
Neue Zürcher Zeitung;
collage and digital

→ **Cover Special Report, 2013**
The New York Times; collage
and digital

→→ **Baku, 2013**
Baku Magazine; collage
and digital

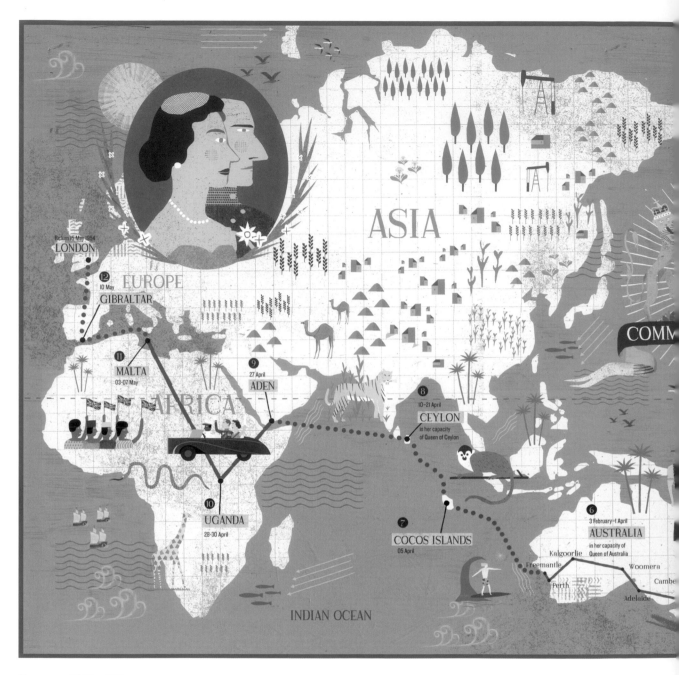

Commonwealth Map, 2012
Taschen; collage and digital

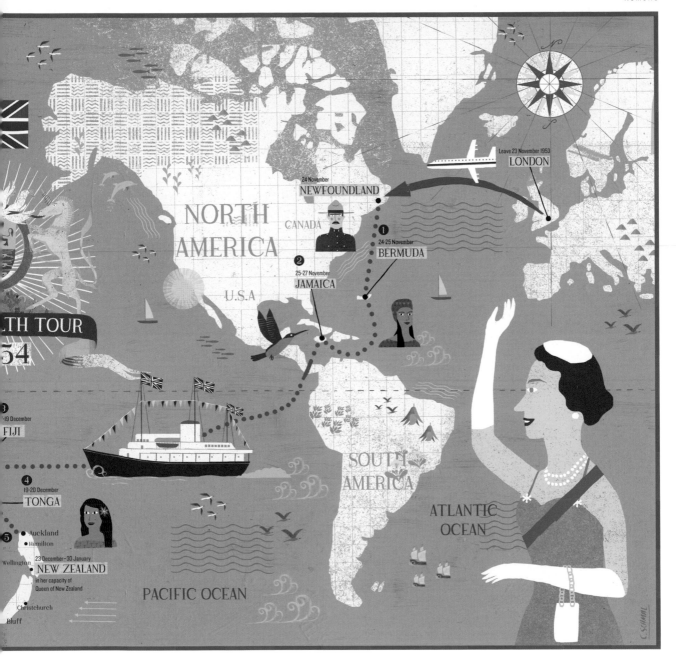

NORTH AMERICA

CANADA

U.S.A

...LTH TOUR
...54

Leave 23 November 1953
LONDON

24 November
NEWFOUNDLAND

① 24-25 November
BERMUDA

② 25-27 November
JAMAICA

SOUTH AMERICA

ATLANTIC OCEAN

...-19 December
FIJI

④ 19-20 December
TONGA

Auckland
Hamilton
Wellington
⑤ 23 December–30 January
NEW ZEALAND
in her capacity of
Queen of New Zealand

Christchurch
Bluff

PACIFIC OCEAN

C.SCHMIDT

Agata Nowicka

1976 born in Gdańsk, Poland | lives and works in Warsaw
www.agatanowicka.com

CLIENTS
Absolut Vodka, Alfa Romeo, Elle, Gala, Glamour, GQ, Newsweek, Metro International, Reebok, Museum of Modern Art in Warsaw, The New Yorker, The New York Times, The Washington Post

EXHIBITIONS
Illustrative Berlin, group show, Direktorenhaus, Berlin, 2013
Debt, group show, Living Theatre, New York, 2012
Design for Freedom/Freedom in Design, group show, Claska Gallery, Tokyo, 2011

AGENTS
Illo, Poland
Marlena Agency, USA

Where's my Money Transfer?, 2012
Przekrój, magazine cover; digital

→ Shame, 2012
Wysokie Obcasy, magazine cover; digital

→→ Robert Kuśmirowski, 2009
Lampa, editorial, cover image; digital

"I like the pixelated, 1980s computer graphics as well as editorial illustration from the 1950s-1960s, but it's the idea, not the décor that is important to me."

„Mir gefallen die pixeligen Computergrafiken der 80er-, aber auch die redaktionellen Illustrationen der 50er- und 60er-Jahre. Wichtig ist für mich allerdings die Idee, nicht die Kulisse."

« J'aime les graphismes informatiques pixélisés des années 1980 ainsi que l'illustration rédactionnelle des années 1950-60, mais c'est l'idée qui importe vraiment, et non le décor. »

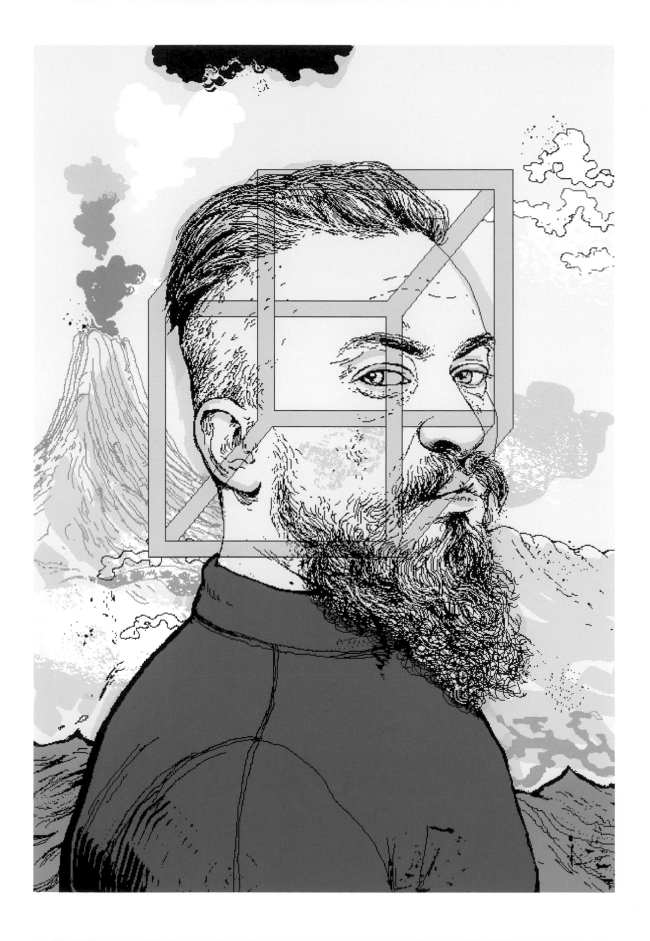

Mila and I, 2009
Fubon Art Foundation; digital

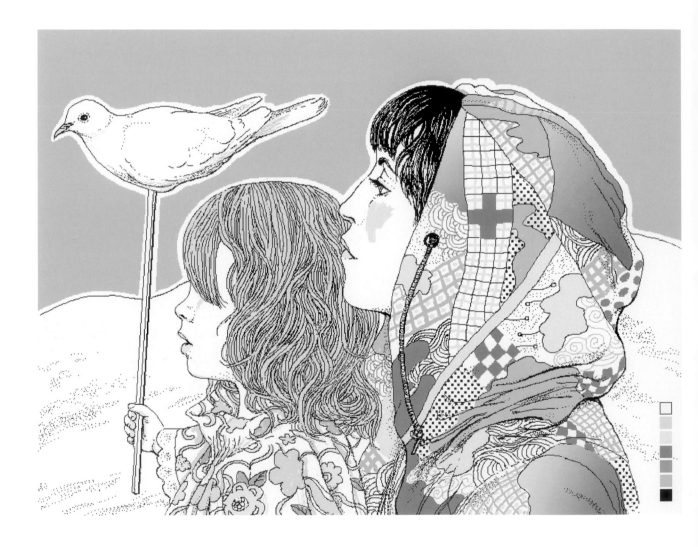

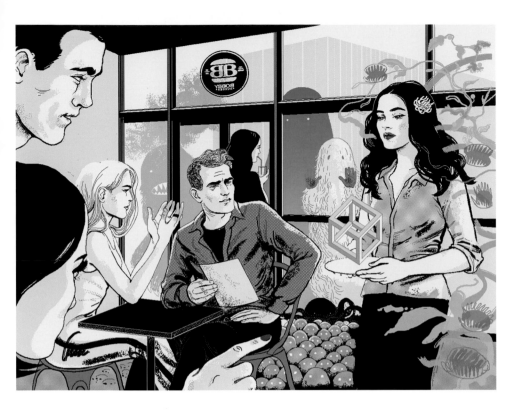

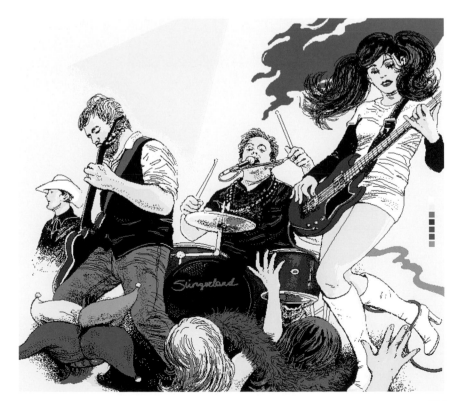

Untitled, 2013
Bobby Burger, wallpaper; digital

→ Cowboy Mouth's Mardi
Gras Special, 2010
The New Yorker, Art Direction:
Max Bode; digital

Eiko Ojala

1982 born in Tallinn, Estonia | lives and works in Tallinn
www.ploom.tv

CLIENTS
Wired, The New York Times, V&A,
Ebony, Harvard Business Review

EXHIBITIONS
Whispering Walls, group show, The Wallpaper museum, Mézières, 2013
Teine Lõige (Second Cut), solo show, Von Krahl, Tallinn, 2011

AGENTS
EW Agency, UK
La Suite, France

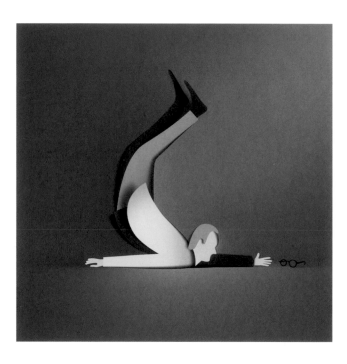

"I like to study the forms of shapes, and to work closely with light and shadow—keeping the illustrations minimal."

„Ich schaue mir die Konturen von Formen genau an und arbeite viel mit Licht und Schatten. Die Illustrationen sollen möglichst minimalistisch sein."

« J'aime étudier les formes, et travailler de près avec l'ombre et la lumière, tout en conservant le minimalisme de mes illustrations. »

Reachers #1 and #2, 2013
Personal work; paper-cutting
and digital

→→ Treeman, 2013
Personal work; paper-cutting
and digital

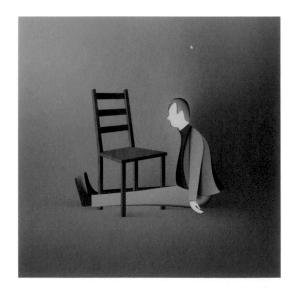

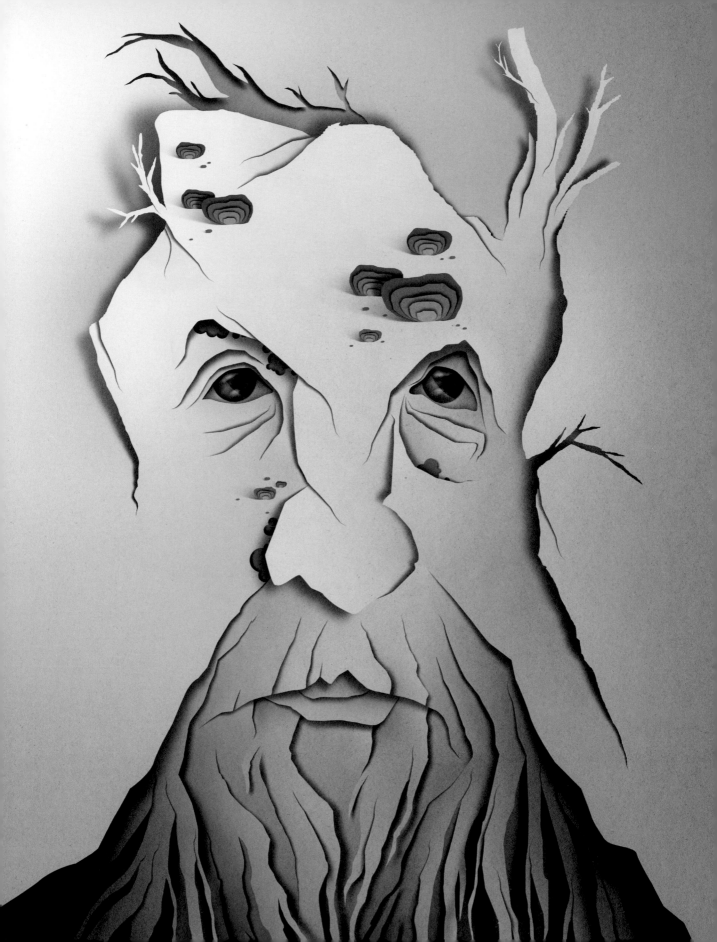

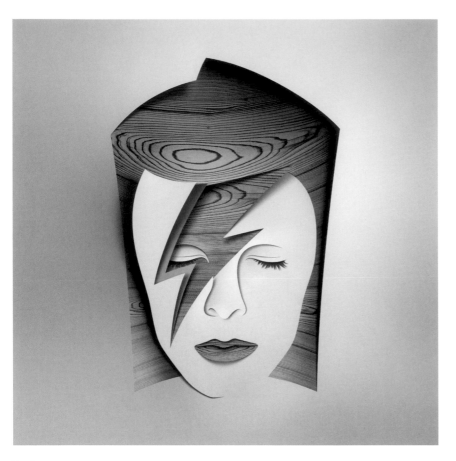

Bowie, 2013
La Suite; paper-cut and digital

→ **New York, 2013**
Affinia Manhattan Hotel; paper-cut
and digital

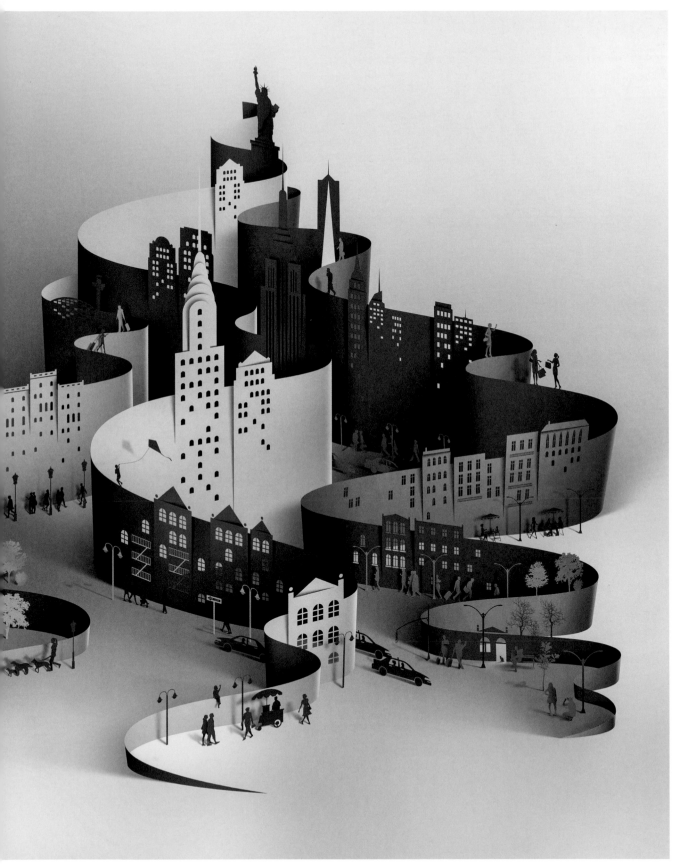

Luigi Olivadoti

1983 born in Mauren, Liechtenstein | lives and works in Berlin
www.luigiolivadoti.li

CLIENTS

Fantoche – International Animation Festival,
Das Magazin, Tschuttiheftli

EXHIBITIONS

Illustrative Berlin, group show, Direktorenhaus, Berlin, 2013
Fumetto, International Comix Festival, solo show, Lucerne, 2013
Alte Post. Es haut sie hin und her in dieser Welt, group show, Schaan, Liechtenstein, 2012

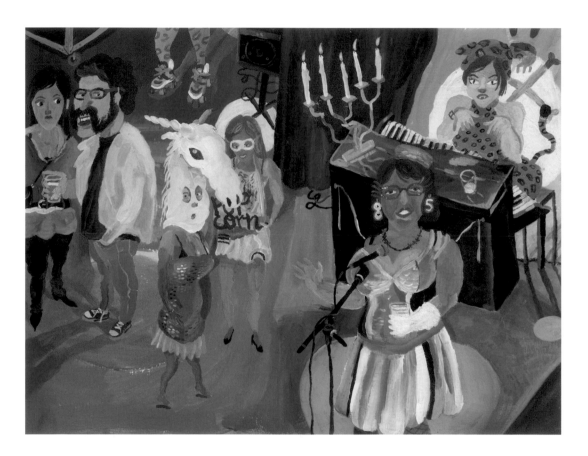

"Illustrate what you see, not what you look at."

„Illustriere das, was du siehst, und nicht das, was du ansiehst."

« Illustrez ce que vous voyez, et non ce que vous regardez. »

Fürsten der Nachtn, Nachtbar, 2010
Personal work; acrylic on paper

→ Fürsten der Nacht, Hubraum
Halbstarke, 2010
Personal work; acrylic on paper

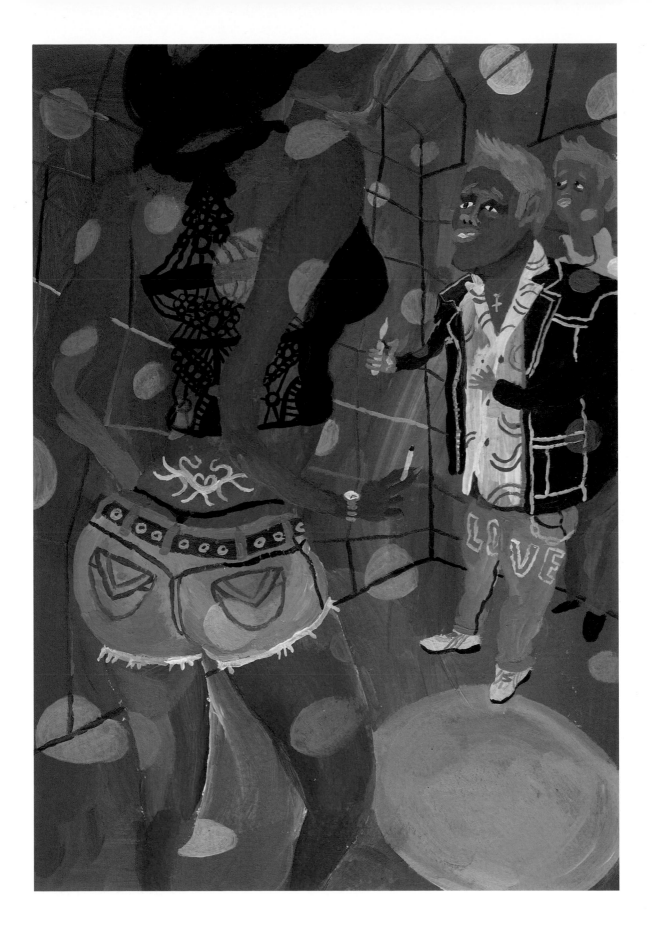

Fürsten der Nacht, Hubraum
Halbstarke, 2010
Personal work; acrylic on paper

↑ Antonio, Antonio, 2012
Schichtwechsel.li; acrylic on paper

↗ Tschuttibildli, Mario Balotelli,
2012
Tschuttibildli; acrylic on paper

→ Antonio, la Moto di Francesco,
2012
Schichtwechsel.li; acrylic on paper

Zé Otavio

1983 born in Olimpia, Brazil | lives and works in Olimpia, Brasil
www.zeotavio.com

CLIENTS
GQ Brazil, Elle Brazil, Companhia das Letras, How Magazine, Briefings, Car and Driver,

EXHIBITIONS
Vanitas, group show, Plus Gallery, Goiania, Brazil 2012
E(FEMME)RA, group show, Urban Arts, São Paulo, 2012
Magioska, group show, Pop Gallery, São Paulo, 2010

AGENT
Levy Creative Management, USA

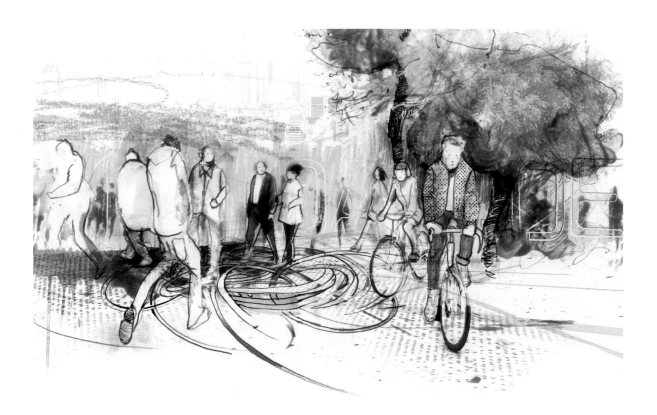

"Always looking for the perfect line."

„Auf der ewigen Suche nach dem perfekten Strich.“

« Toujours à la recherche du trait parfait. »

Wires out of Place, 2013
Audi Magazine; mixed media and digital

→ Carmen Miranda, 2013
Personal work; mixed media and digital

Essence, 2013
Audi Magazine; mixed media
and digital

← Anna meets Gloria <3, 2013
Personal work, series Femme Fatale;
mixed media and digital

→ Morrissey, 2012
Personal work, ongoing series Violent
Dreams; mixed media and digital

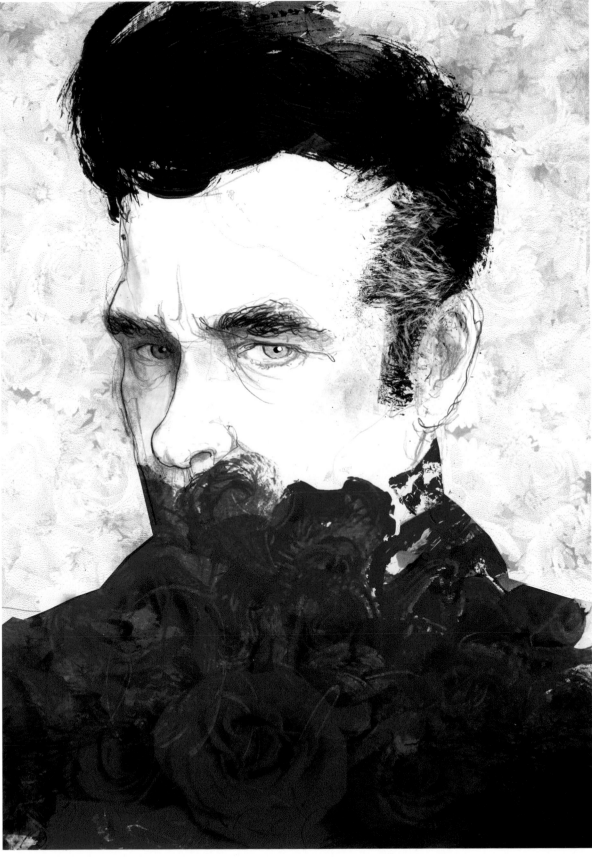

Otto

1966 born in Germany | lives and works in Bath, UK
www.ottographic.co.uk

CLIENTS

The Guardian, Times Educational Supplement, Der Freitag,
The Economist, The Independent, Le Monde, Libération,
Courrier International, The New York Times

EXHIBITIONS

London Art Book Fair, group show, Whitechapel Gallery, London, 2013
Press and Release, group show, Phoenix Gallery, Brighton, 2013
The NY Art Book Fair, group show, Moma PS1, New York, 2012

"Screenprinting is a pivotal tool for me, whether it is layers
of ink on a print or layers of meaning in an illustration."

„Siebdruck ist für mich ein ganz wichtiges Werkzeug, ob nun Farbschichten
auf einem Druck oder Bedeutungsebenen in einer Illustration."

« La sérigraphie est un outil capital pour moi, qu'il s'agisse de
couches de couleur sur une impression, ou de strates
de sens dans une illustration. »

Science, 2013
Libération, Art Direction:
Anne Mattler; digital

→ Tax Haven, 2013
Der Freitag, Art Direction: Felix
Velasco; digital

Simón Prades

1985 born in Breisach, Germany | lives and works in Saarbrücken, Germany
www.simonprades.com

CLIENTS
The New York Times, Nike, Vice,
The New Republic, New Statesman,
Serviceplan, Y&R, Joyce

EXHIBITIONS
Simon Prades trifft Horst Janssen, solo show, Neosyne, Trier, Germany, 2011
Ansichten, solo show, Neonchocolate, Berlin, 2011
Fingerprints, group show, Komturei Tobel, Tobel, Switzerland, 2010

"For me, good illustration is the perfect balance
between an idea that surprises me and an execution
that shows its creator's abandon."

„Für mich ist eine gute Illustration das absolute Gleichgewicht
zwischen einer Idee, die mich verblüfft, und einer Ausführung,
der man die Hingabe des Ausführenden ansieht."

«Pour moi, une bonne illustration est l'équilibre parfait entre
une idée qui me surprend et une exécution qui
trahit l'abandon de son créateur.»

Loup, l'été, 2013
Personal work; ink on paper and digital

→ Breeders in Rio, 2013
Queremos!, show The Breeders,
Rio de Janeiro, poster; pencil on paper
and digital

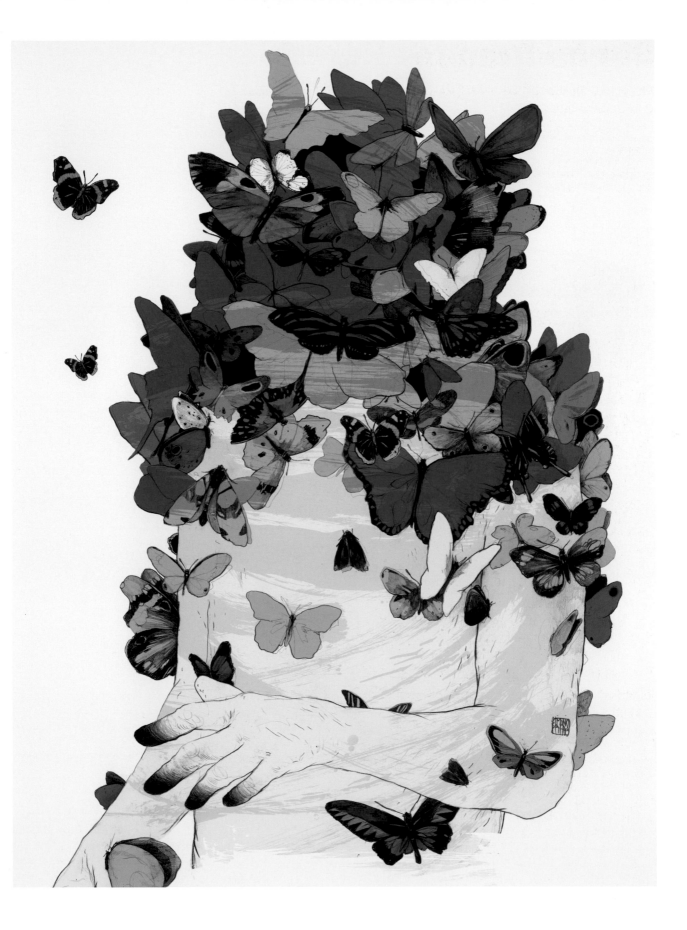

Daniel Ramirez Perez

1987 born in Hutthurm, Germany | lives and works in Berlin
www.danielramirezperez.com

CLIENTS

Deutsche Bahn, Volksbühne Berlin, Handelsblatt,
Vivienne Westwood, Kinki, Fräulein, Cicero, Enorm,
Business Punk, Financial Times

"After years of working in the fashion and graphic design industry, I realized drawing is the initial reason I chose the creative path—so I focused on that."

„Nachdem ich jahrelang in der Modeindustrie und der Grafik gearbeitet hatte, ging mir auf, dass ich eigentlich wegen des Zeichnens einen kreativen Beruf ergreifen wollte. Also habe ich mich darauf verlegt."

« Après plusieurs années de travail dans la mode et le graphisme, j'ai réalisé que c'est à cause du dessin que j'ai choisi une voie créative, alors je me suis concentré là-dessus. »

October, 2011
Personal work; marker and digital

→ Cool Pool, 2012
Personal work; digital

→→ Lips, 2011
Personal work; pencil and marker

David de Ramón

1968 born in Don Benito, Spain | lives and works in Madrid
www.davidderamon.com

CLIENTS

Volkswagen, Fiat, GQ, American Express, QUO,
El País, El Economista, Training & Development
Digest, Focus, Movistar, Canal+

AGENTS

The Mushroom Co., Spain
The Overall Picture, Australia
Illo Zoo, USA

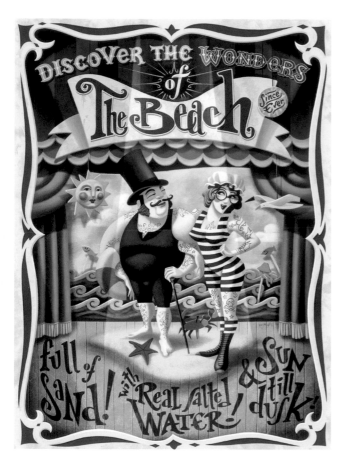

The Beach, 2013
Personal work; digital

→ Untitled, 2008
Editorial Everest, book cover, Art
Direction: Ana Mª García; digital

→ → Therapy, 2013
Personal work, published wallpaper
at wetransfer.com; digital

"The best images, like the best
stories, are those that require
the participation of those who
look at them."

„Wie die besten Geschichten erfordern
auch die besten Bilder die Mitarbeit
des Betrachters."

« Les meilleures images, comme les
meilleures histoires, sont celles
qui requièrent la participation de
ceux qui les regardent. »

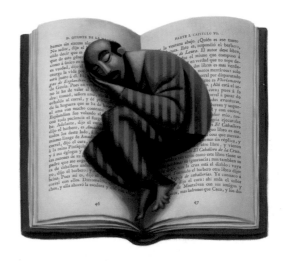

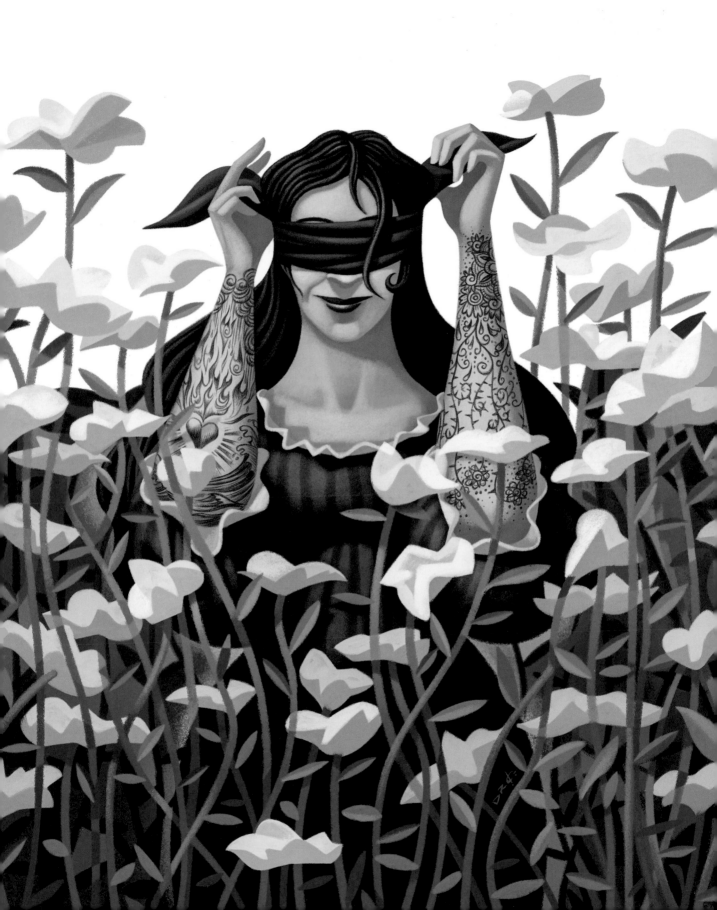

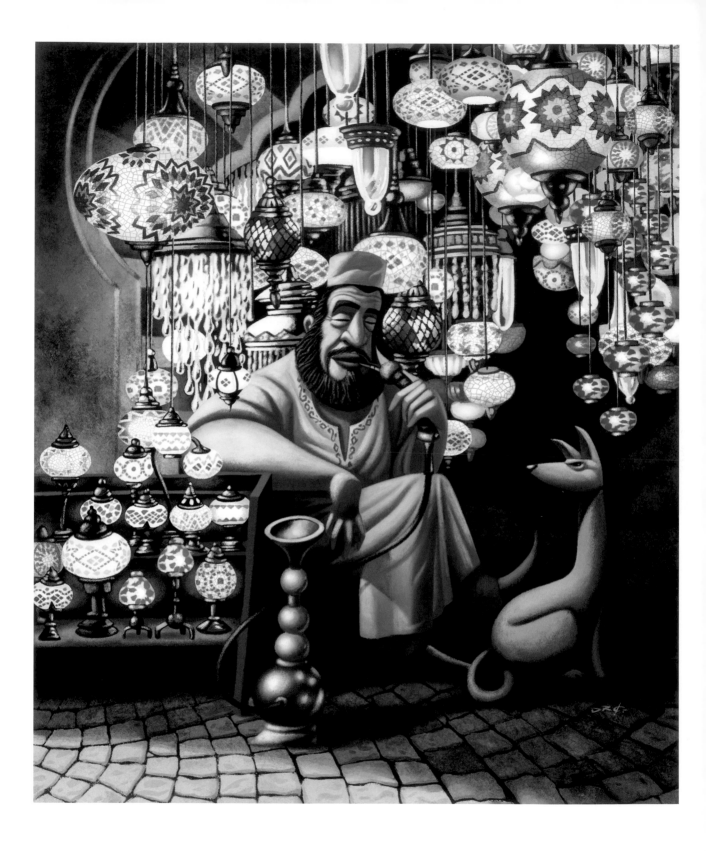

Untitled, 2012
Da Nicola restaurant,
mural, Art Direction:
Carlo Ferrando; digital

←　Arab Markets, 2011
Siete Leguas, El Mundo,
magazine cover, Art Direction:
Fernando Baeta; digital

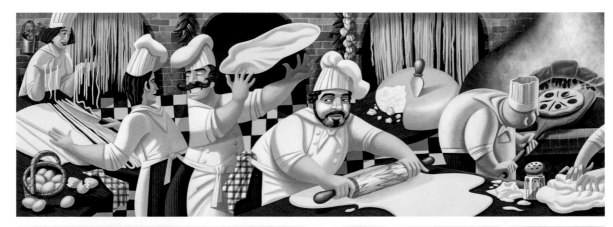

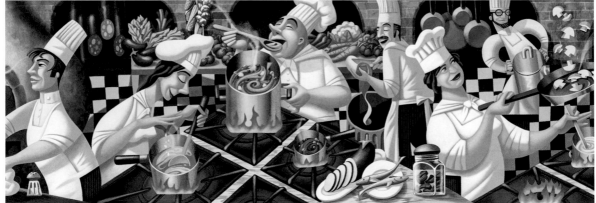

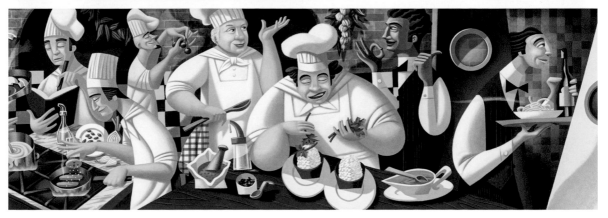

Sophie Robert

1981 born in Vienne, France | lives and works in Biarritz, France
www.agent002.com/#/illustrateurs/sophie_robert/portfolio/

CLIENTS
Édition du Chêne, Bayard Presse, Boucheron,
Undiz, Agence Malherbe Paris, Petra, L'Officiel Japan

EXHIBITIONS
Aquarelles, solo show, Galerie Artazart, Paris, 2007

AGENT
Agent 002, France

"I'm inspired by French and Italian art-house cinema.
Using different inks I create my illustration as if it were
a sensual glimpse into a movie scene."

„Mich inspirieren das französische und das italienische Autorenkino.
Meine Illustrationen, die ich mit verschiedenen Tuschen mache,
sind wie ein sinnlicher Blick auf eine Filmszene."

« Je suis inspirée par le cinéma d'art et d'essai français et italien.
À l'aide de différentes encres, je crée mes illustrations
comme si elles étaient un aperçu sensuel d'une scène de film. »

Italian Woman on the Raspail Boulevard, 2013
Personal work; indian ink

→ **Japanese Land**, 2013
Personal work; indian ink and
japanese gouache

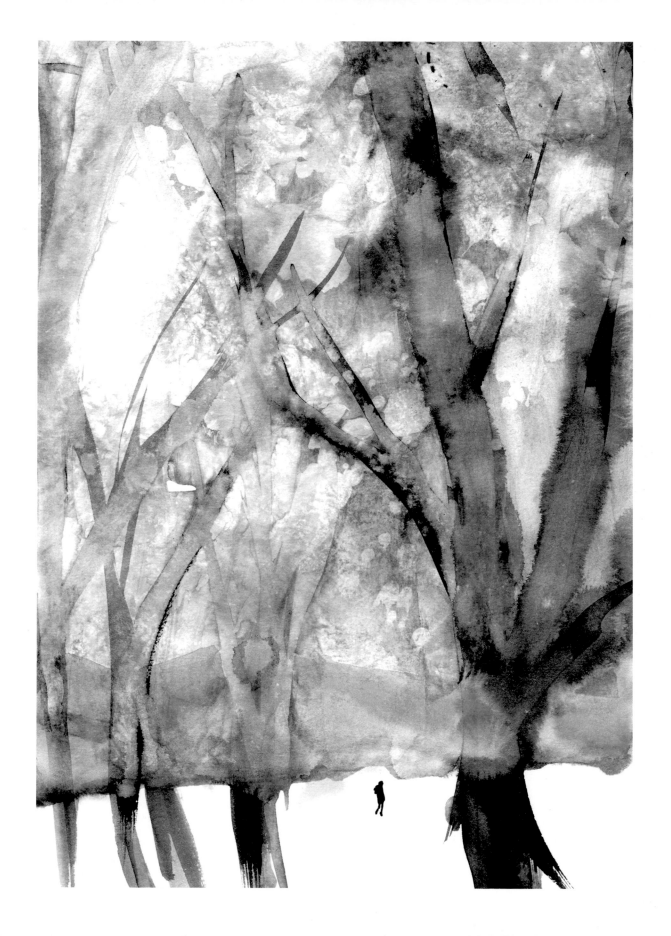

Jeff Rogers

1979 born in Dallas | lives and works in Brooklyn
www.howdyjeff.com

CLIENTS
Google, Nike, Urban Outfitters, Ford,
Ace Hotel, The New York Times, Nickelodeon,
McDonald's, DreamWorks, Purina

"I try my best to make my work, usually in the form
of illustrative lettering, joyful, fun, whimsical and colorful
in order to make people feel happy."

„Ich tue mein Bestes, damit meine Arbeiten – meist illustrative Typografien – fröhlich,
witzig, skurril und bunt sind und die Leute sich freuen, wenn sie sie sehen."

« Je fais de mon mieux pour que mon travail, généralement des lettres illustratives,
soit joyeux, fantasque et coloré, pour rendre les gens heureux. »

Just Their Type, 2013
Abilene Christian University,
Art Direction: Ron Hadfield,
Copytext: Katie Noah Gibson;
acrylic on raw canvas

→ **Jersey Strong, 2011**
Workout World, mural;
acrylic on board

Jungyeon Roh

1982 born in Seoul | lives and works in New York
www.jungyeonroh.com

CLIENTS
GQ, The New York Times, The New Yorker,
Bloomberg Businessweek, Kiehl's, McSweeney's,
The Village Voice, Priest+Grace

EXHIBITIONS
Waves of Change, Sea Shepherd Conservation Society, group
show, Hasted Kraeutler Art Gallery, New York, 2013
Townies, group show, The New York Times Gallery 7, New York, 2013
New Prints 2011/ Summer, group show, IPCNY, New York, 2011

AGENT
Magnet Reps, USA

"How I am different as a Korean woman living in America,
and the way in which I can show these honest differences through
the humor of my drawings."

„Durch was ich mich als Koreanerin hier in Amerika unterscheide und wie ich
diese Unterschiede durch den Witz meiner Zeichnungen am besten rüberbringe."

« Ma différence en tant que Coréenne vivant aux États-Unis,
et comment je peux montrer ces différences honnêtes à travers
l'humour de mes dessins. »

**Miss Eggplant's American
Boys, Broadway, 2010**
Personal work, book, Art Direction:
Marshall Arisman, Carl Titolo;
screenprint and digital

→ **A Modest Proposal, 2012**
McSweeney's, Lucky Peach, Art
Direction: Walter Green; digital

Catell Ronca

1974 born in Basel | lives and works in Lucerne
www.catellronca.com

CLIENTS
New York Botanical Gardens, Compendium Inc.,
Cricket Magazine, Royal Mail, Penguin UK,
Faber & Faber, Editions Thierry Magnier

AGENTS
Magnet Reps, USA
b.m-r fotografen, Switzerland

"I attempt to create emotive and evocative images, hand-made and intuitive in approach, drawing from fantastical sources."

„Ausgehend von fantastischen Quellen, versuche ich, emotionale und atmosphärische Bilder zu machen, und zwar von Hand und intuitiv."

« J'essaie de créer des images émotives et évocatrices, faites à la main dans une démarche intuitive, en m'inspirant de sources fantastiques. »

Ice Box, 2013
Vivai, Migros; gouache and
printed paper collage

→　How Much of Human
Behavior is Predetermined?, 2012
Chronicle Books, book The Where,
the Why and the How; gouache,
chinese ink, collage and digital

→→　Moral Dilemma, 2012
Hohe Luft; gouache, colored
paper and digital

Forest Tales, Waldgeist, 2013
Personal work; gouache painting,
paper cut-outs and digital

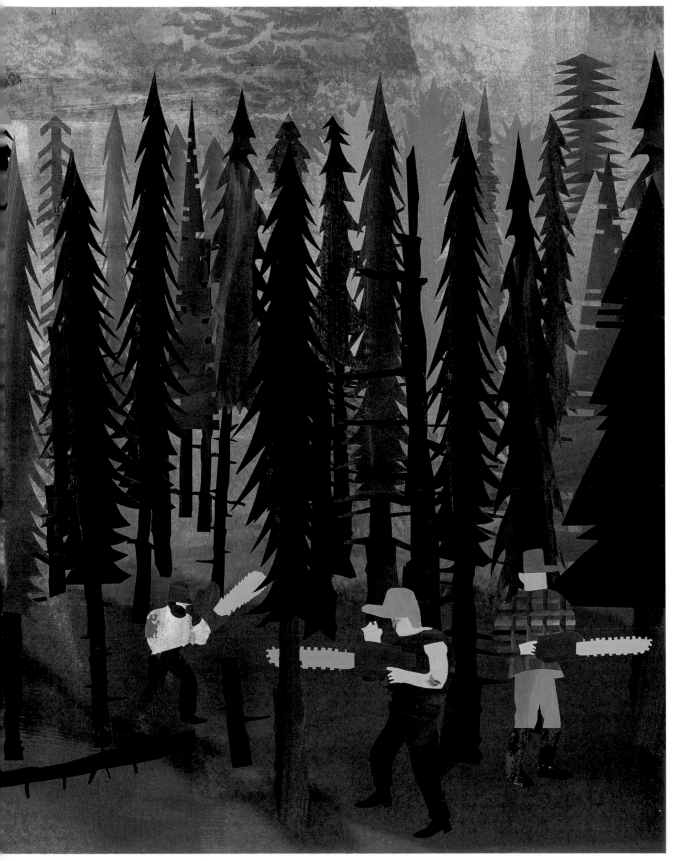

Malin Rosenqvist

1978 born in Braunfels, Germany | lives and works in Solna, Sweden
www.malinrosenqvist.com

CLIENTS
SWE, Vi Läser, Dwell, Mindful Magazine, Myself,
Annabelle, Bonnier Carlsen, Doubleday Books,
Alacarte, Form, Apoteket, Wienerin, Maxi, Kupé

EXHIBITIONS
Malin Rosenqvist, solo show, Equator, Stockholm, 2012
Fumetto, satellite exhibition, group show, Lucerne, 2011

AGENT
Agent Molly & Co., Sweden

"When you draw by hand small errors
and irregularities occur, which give
the images more life than if you were
to create them in the computer."

„Wenn man von Hand zeichnet, sind kleine Fehler
und Unregelmäßigkeiten nicht zu vermeiden, und
dadurch wirken die Bilder lebendiger, als wenn
man sie am Computer generiert hätte."

« Quand on dessine à la main il se produit
de petites erreurs et irrégularités qui donnent
aux images plus de vie que si on les avait
créées sur ordinateur. »

Starving Authors, 2012
Vi Läser, Art Direction: Johanna
Jonsson; pen

→ Vatten, 2013
Personal work; pen and digital

→→ Birds, 2012
Personal work; pen

Conrad Roset

1984 born in Terrassa, Spain | lives and works in Barcelona
www.conradroset.com

CLIENTS
Adidas, Nouvelle Vague, Coca-Cola, Mango,
Mulberry, Skoda, Unnim, Umberto Giannini, Vice,
Zurich, Zara, Random House, Mondadori, Elle

EXHIBITIONS
SE12, solo show, Spoke Art, San Francisco, 2013
I Like Soup, group show, MOCA Virginia, Virginia, 2012
Intimate Things, solo show, Miscelanea Gallery, Barcelona, 2011

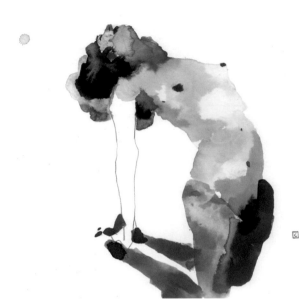

"When you start to draw you try to show the world that you know how, but then there comes a point where this doesn't matter to you. I try to make the the most beautiful things possible."

„Beim Zeichnen versucht man zuerst, die Welt zu zeigen, die man kennt, aber dann kommt man an einen Punkt, von dem ab das nicht mehr wichtig ist. Ich versuche, die schönsten Dinge überhaupt zu machen."

« Quand on commence à dessiner on essaie de prouver qu'on sait manier le crayon, mais après il arrive un moment où cela n'a plus d'importance. J'essaie de faire les choses les plus belles possibles. »

Muse #507, 2012
Personal work; indian ink and
anilines on paper

→ Muse #558, 2013
Personal work; acrylic on paper

→→ Muse #498, 2012
Personal work; indian ink and
anilines on paper

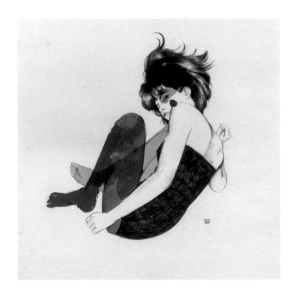

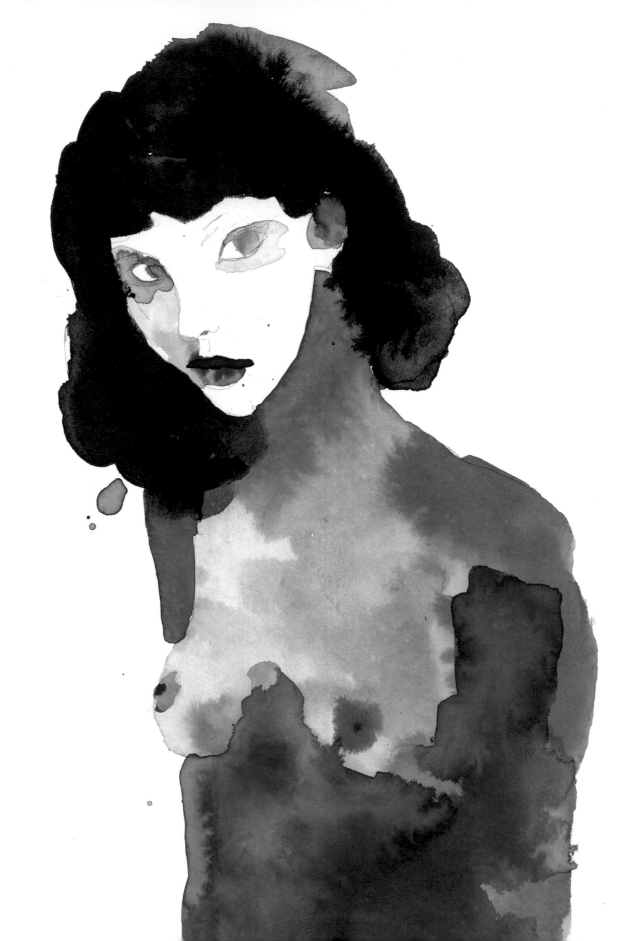

Stacey Rozich

1987 born in Seattle | lives and works in Seattle
www.staceyrozich.com

CLIENTS
Starbucks, Red Bull, Random House UK,
The Experience Music Project, Sub Pop Records,
Southern Lord Records

EXHIBITIONS
Within Without Me, solo show, Roq La Rue Gallery, Seattle, 2013
This Must Be the Place, solo show, Cuas Gallery, Chicago, 2012
The Last Wave, solo show, Flatcolor Gallery, Seattle, 2012

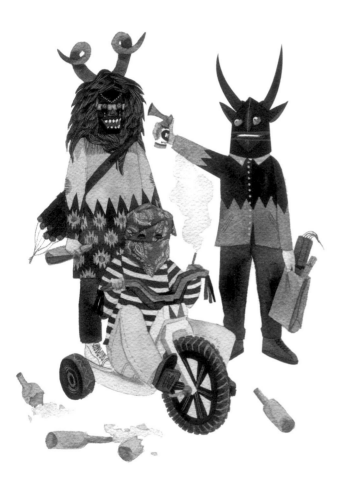

"Working in watercolor I create situational vignettes that are inspired by world folk art, textiles, childhood memories, television and pop culture."

„Ich arbeite mit Wasserfarben und schaffe, ausgehend von globaler Volkskunst, Textilien, Kindheitserinnerungen, Fernsehen und Popkultur, situative Vignetten."

« Je crée en aquarelle des scènes inspirées par l'art populaire du monde, les textiles, les souvenirs d'enfance, la télévision et la culture pop. »

Big Wheel Keeps on Turnin, 2012
Personal work, solo show This Must
Be the Place, Cuas Gallery, Chicago;
watercolor and gouache

→ **La Medusa, 2011**
Fader, Art Direction: Justin Thomas
Kay; watercolor and gouache

→→ **The King is Dead, 2013**
Personal work, solo show Within
Without Me, Roq La Rue Gallery,
Seattle; watercolor and gouache

Bożka Rydlewska

1977 born in Krakow | lives and works in Warsaw
www.bozka.com

CLIENTS

DeLaneau, Leo Burnett, Empik, Futu, G7, Dr Irena Eris,
Element One Custom Publishing, White Cat Studio,
Kristoff Porcelain, Sentemo, TVP Kultura, Arctic Paper

EXHIBITIONS

Illustrative Festival, group show, Direktorenhaus, Berlin, 2013
New Botany, solo show, Flying Gallery Foundation, Warsaw, 2012
Ilustracja PL, group show, Soho Factory, Warsaw, 2012

"I dream of new smells, forms and colors, unknown zoological and
botanical hybrids, imperfect symmetries—the landscape on the other
side of the mirror."

„Ich träume von neuen Düften, Formen und Farben, unbekannten zoologischen und botanischen
Hybriden, unvollkommenen Symmetrien – die Landschaft auf der Rückseite des Spiegels."

« Je rêve de nouvelles senteurs, formes et couleurs, d'hybrides zoologiques et botaniques
inconnus, de symétries imparfaites – le paysage de l'autre côté du miroir. »

The Looking-glass, 2011
Personal work, series New Botany;
mixed media

→ Book of Birds, 2011
Personal work, series New Botany;
mixed media

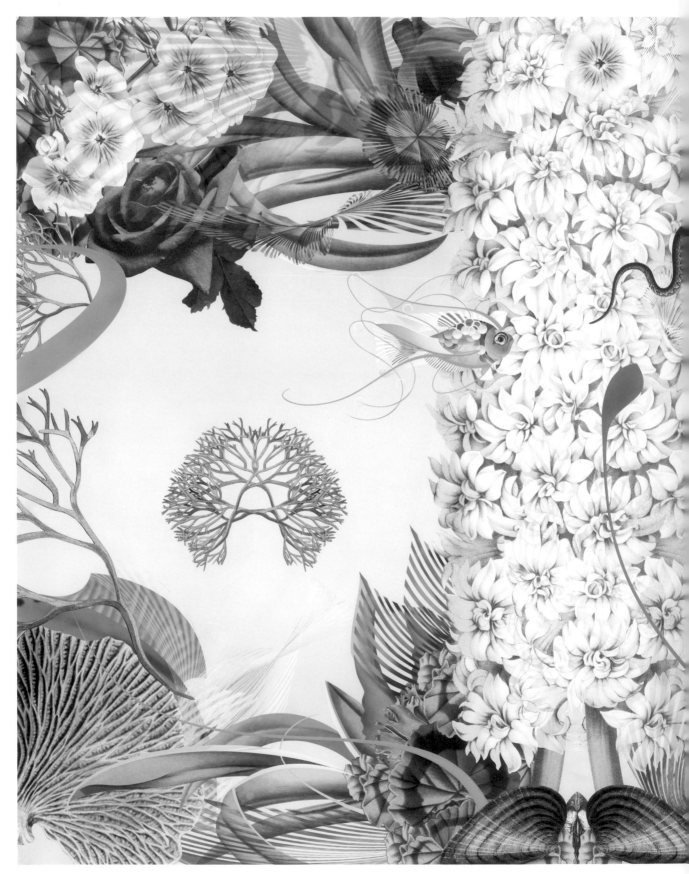

Koi, 2010
Personal work, series New Botany;
mixed media

Sac Magique

2000 founded in London | lives and works in Helsinki
www.sacmagique.net

CLIENTS
H&M, Nokia, Nordiska Kompaniet, Hartwall,
Helsinki Festival, Lux, A-lehdet, Minimarket, Nike

EXHIBITIONS
Autofestival, group show, Mudam, Luxembourg, 2010

AGENT
Agent Pekka, Finland
Woo Agentur, Sweden

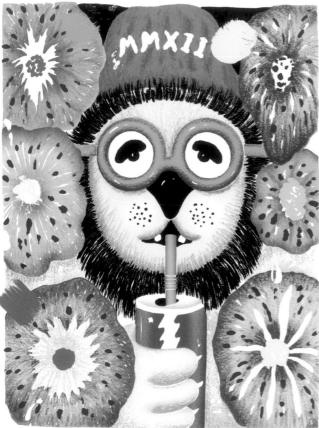

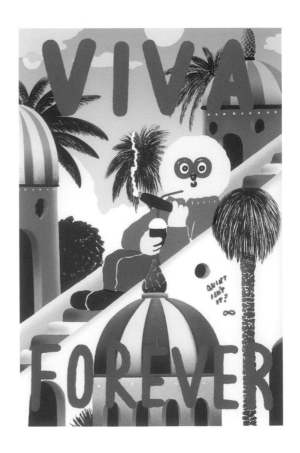

"Materials inspire me: a nice brush,
the smell of gouache, the feel of an
air-brush in my hand, the smoothness
of a Wacom pen on a tablet…"

„Materialien inspirieren mich: ein schöner Pinsel, der
Geruch von Gouache, eine Spritzpistole in der Hand,
die Leichtigkeit eines Wacom-Stifts auf dem Tablet …"

« Les matériaux m'inspirent : un bon pinceau, l'odeur de
la gouache, le poids d'un aérographe dans ma main,
le glissement d'un stylet Wacom sur une tablette … »

Secret Sipper, 2012
Personal work; gouache, felt-tip pen,
airbrush and digital

→ Viva Forever, 2013
Personal work; gouache, felt-tip pen,
airbrush and digital

→→ I Love …, 2010
Tiphaine; gouache, block print,
airbrush and digital

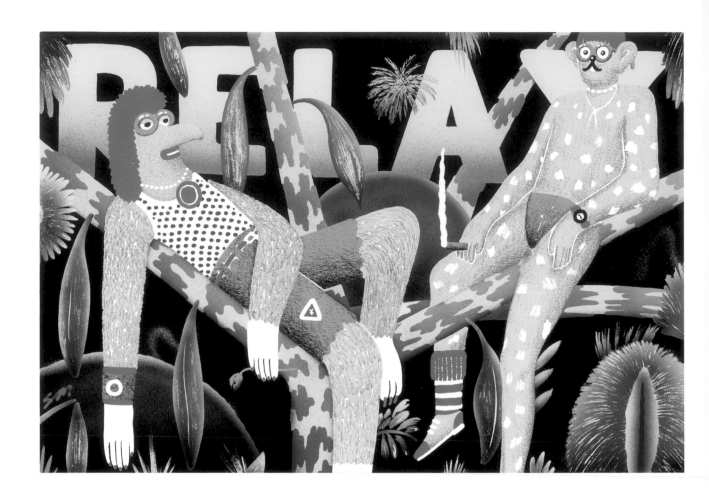

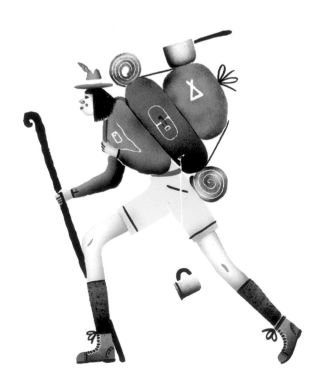

Relax, 2013
Personal work; gouache, felt-tip,
pen, airbrush and digital

← Rambling, 2011
Gloria; gouache, airbrush
and digital

Semi-ironic, 2011
Image; gouache, airbrush
and digital

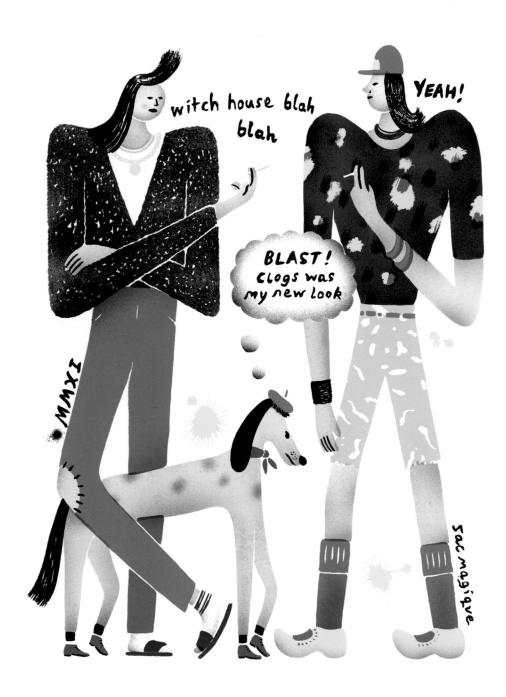

Jérémy Schneider

1986 born in Metz, France | lives and works in Paris
www.jeremyschneider.fr

CLIENTS
AMI, National Orchestra of Lorraine, Le Fooding, Commune de Paris, Le Coq Sportif, Influencia, XXI, Feuilleton, French Trotters

EXHIBITIONS
Paperworks, group show, Galerie LJ, Paris, 2014
Condensed, group show, Espace Beaurepaire, Paris, 2013
Autofestival, group show, Mudam, Luxembourg, 2010

AGENT
Garance, USA
Talkie Walkie, France

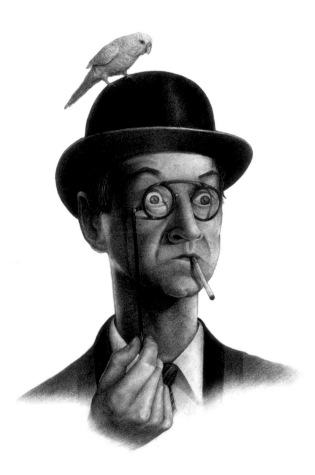

"History and philosophy—quite a few of my characters come straight out of French history or from books by Nietzsche, Fourier or Schopenhauer."

„Geschichte und Philosophie – viele meiner Figuren entspringen der französischen Geschichte oder Büchern von Nietzsche, Fourier und Schopenhauer."

« Histoire et philosophie – bon nombre de mes personnages sortent tout droit de l'histoire de France ou des livres de Nietzsche, Fourier ou Schopenhauer. »

La Surprise, 2010
Personal work; black chalk on paper

→ Bourgeoise, 2012
Commune de Paris; black chalk on paper

→→ Le Gorille, 2013
AMI Autumn/Winter 2014; pencil on paper

Jared Schorr

1982 born in Fresno, USA | lives and works in Montclair, USA
www.jaredandrewschorr.com

CLIENTS
The Walt Disney Company, The New York Times,
Ebony, Wired, Good, Houghton Mifflin Harcourt,
The Washington Post, NPR, The New Yorker, Poketo

EXHIBITIONS
Yesterday's Tomorrow, group show, Gallery Nucleus, Alhambra, USA, 2013
WonderGround, group show, Disney's WonderGround, Anaheim, USA, 2012
The Untold Want, group show, Gallery Nucleus, Alhambra, USA, 2011

AGENT
Heflinreps, USA

"I make art because I want to
create something I hope will make
people happy, and I cut paper
because it makes me happy."

„Ich mache Kunst, weil ich etwas schaffen
möchte, das den Menschen Freude macht, und
ich schneide Papier, weil das mir Freude macht."

« Je fais de l'art en espérant créer quelque
chose qui rendra les gens heureux, parce que
c'est ce qui me rend heureux. »

Bless This Hut, 2011
Personal work, exhibition The Untold
Want, Gallery Nucleus, Alhambra,
USA; paper-cutting

→ **Tricera Tops of the Trees, 2013**
Personal work, exhibition A Magical
Land Presented by Crowded Teeth and
Friends, Leanna Lin's Wonderland,
Los Angeles; paper-cutting

→→ **Diagon Alley, 2012**
Personal work; paper-cutting

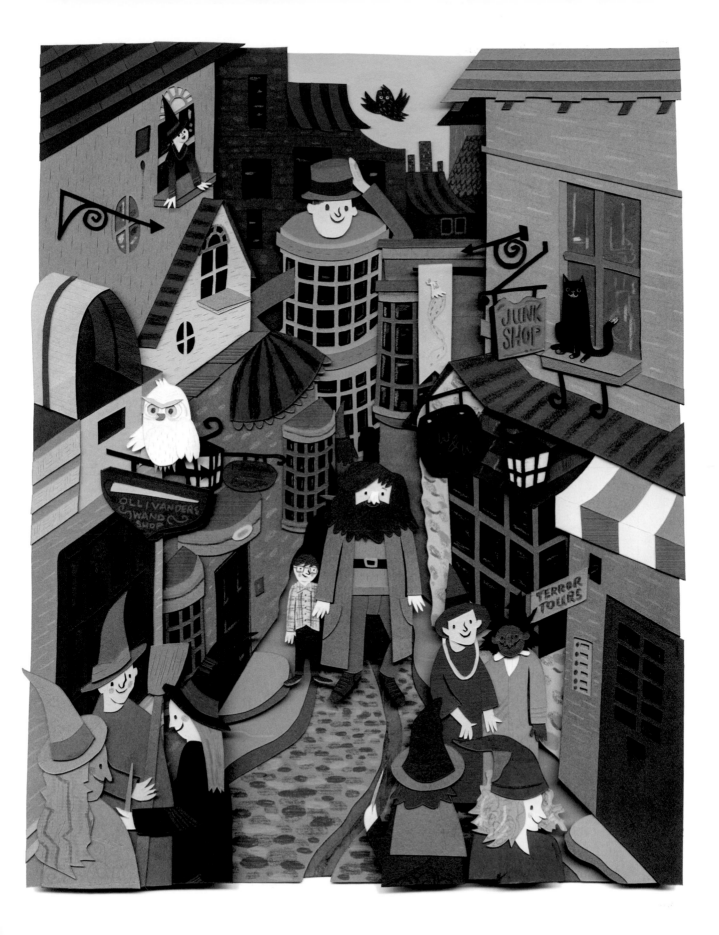

Carmen Segovia

1978 born in Barcelona | lives and works in Barcelona
www.carmensegovia.net

CLIENTS
FAZ, Wall Street Journal, El País, Le Monde,
Cosmopolitan, The New Yorker, La Vanguardia,
El Mundo, SCPF, Lamosca, Anaya, Glénat, Sterling

EXHIBITIONS
Hasta Mostla, group show, Centro Cultural de España, traveling exhibition, 2012
Moss Men, Poison Ivy, solo show, Vértigo Gallery, Mexico, 2010
The Original Art, group show, Museum of American Illustration, New York, 2010

AGENTS
2agenten, Germany
Marlena Agency, USA

"Illustration is such a great medium for telling stories.
Each project is an opportunity to create new characters,
places, narratives, shapes and compositions."

„Illustration eignet sich wunderbar, um Geschichten zu erzählen.
Jedes Projekt bietet mir die Chance, neue Charaktere, Orte, Geschichten,
Formen und Kompositionen zu erfinden."

« L'illustration est un support fantastique pour raconter des histoires.
Chaque projet est une opportunité de créer de nouveaux
personnages, lieux, récits, formes et compositions. »

White Fang, 2008
P'tit Glénat; acrylic

→ Untitled, 2012
Personal work; acrylic

Matthias Seifarth

1980 born in Warendorf, Germany | lives and works in Berlin
www.matthias-seifarth.com

CLIENTS
Rolling Stone, Die Zeit, McCann, Jung von Matt,
J'N'C, Frontline, Business Punk, KNSK,
Indie, King, SZ-Magazin

AGENT
Kombinatrotweiss, Germany
Illo Zoo, USA

Disconaut, 2013
Personal work; pencil and digital

→ Bitch on Coffin, 2013
Personal work; pencil and digital

→→ Untitled, 2012
Personal work; pencil and digital

"The fine line between beauty and imperfection is the place where my characters begin to tell their own story."

„Die Grenze zwischen Schönheit und Unvollkommenheit ist der Ort, an dem meine Figuren ihre eigene Geschichte erzählen."

«La frontière ténue entre la beauté et l'imperfection, c'est là que mes personnages commencent à raconter leur propre histoire.»

Untitled, 2012
Personal work; pencil and digital

← Untitled, 2014
Personal work; pencil and digital

Adam Simpson

1981 born in Leicester, UK | lives and works in London
www.adsimpson.com

CLIENTS
Bafta, Time, The New York Times, BBH, Conran,
The New Yorker, Los Angeles Times, Royal Mail,
National Geographic, The Folio Society, Omega

EXHIBITIONS
Art Directors Club, Young Guns, group show, New York, 2009
Show Two, group show, The Royal College of Art, London, 2006
The Best of all Possible Worlds, group show, Circus Gallery, London, 2006

AGENT
Heart, UK

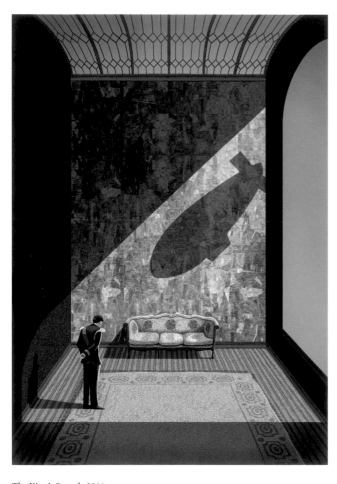

The King's Speech, 2011
Bafta, booklet cover and wall
decoration, Agency: Studio Small;
hand-drawn and digital

→ Imagination Building, 2010
Wallpaper*; hand-drawn and digital

→→ The Hand of Kong, 2012
Omega; hand-drawn and digital

"Each project presents an opportunity
to explore and evolve. I absorb the
subject matter, sketch intensively,
then decide on a direction to head in."

„Jedes Projekt bietet die Möglichkeit, etwas
zu erforschen und zu entwickeln. Ich absorbiere
das Thema, mache viele Skizzen und
entscheide mich dann, in welche Richtung
ich gehen will."

« Chaque projet présente une occasion
d'explorer et d'évoluer. J'absorbe le thème,
je fais de nombreux croquis, puis je
décide d'une direction à suivre. »

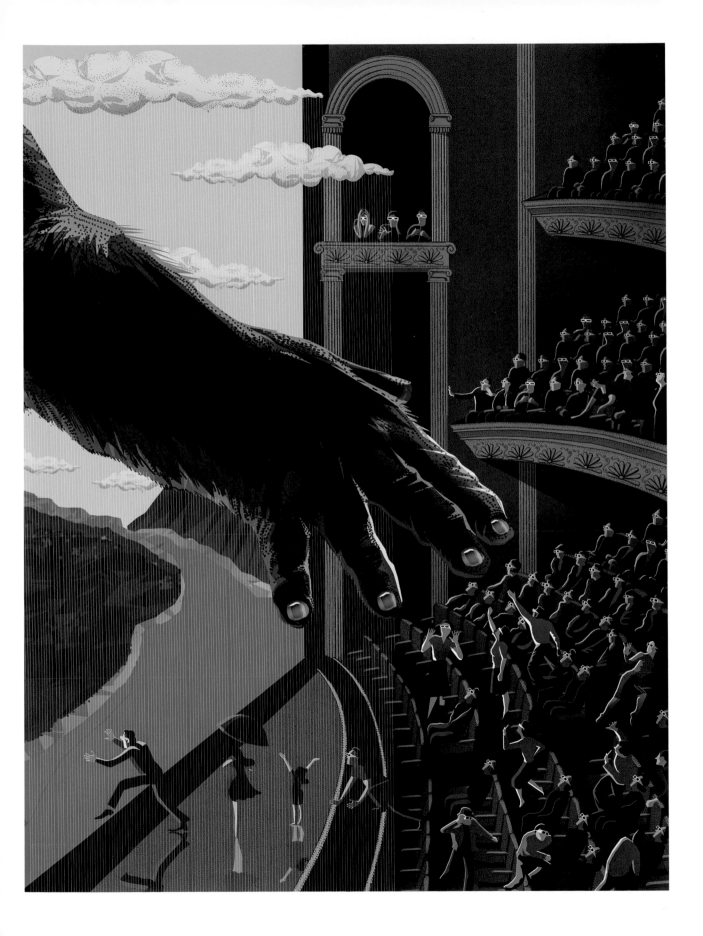

La Défense, Tal Coat, 2013
Nowness; hand-drawn and digital

→ Boundaries, 2009
Conran, mural, Boundary Hotel,
London; hand-drawn and digital

↓ Tents, 2011
Magma; hand-drawn and digital

Katy Smail

1986 born in Edinburgh | lives and works in Brookyln
www.whatktdoes.com

CLIENTS
Seventeen, Macy's, Land's End, Soft Gallery, Material Girl magazine, Culture magazine, Converse, Papier Mache, Grazia Italia

EXHIBITIONS
Flora & Fauna, solo show, Nights & Weekends, New York, 2012

AGENT
Kate Ryan, USA

> "Magical, feminine, poetic. Stories told in hand-drawn layers of winding botanicals, dreamy maidens and delicate patterns."

„Magisch, feminin, poetisch. Geschichten, die durch handgezeichnete verschlungene Pflanzenschichten, verträumte Mädchen und feine Muster erzählt werden."

« Magiques, féminines, poétiques. Des histoires racontées en strates dessinées à la main de végétaux sinueux, de jeunes filles rêveuses et de motifs délicats. »

Dreamy, 2013
Soft Gallery, T-shirt print; pen, ink and paper collage

→ **Anna, 2012**
Personal work; ink and acrylic

→→ **Suvi, 2013**
Personal work; pen and ink

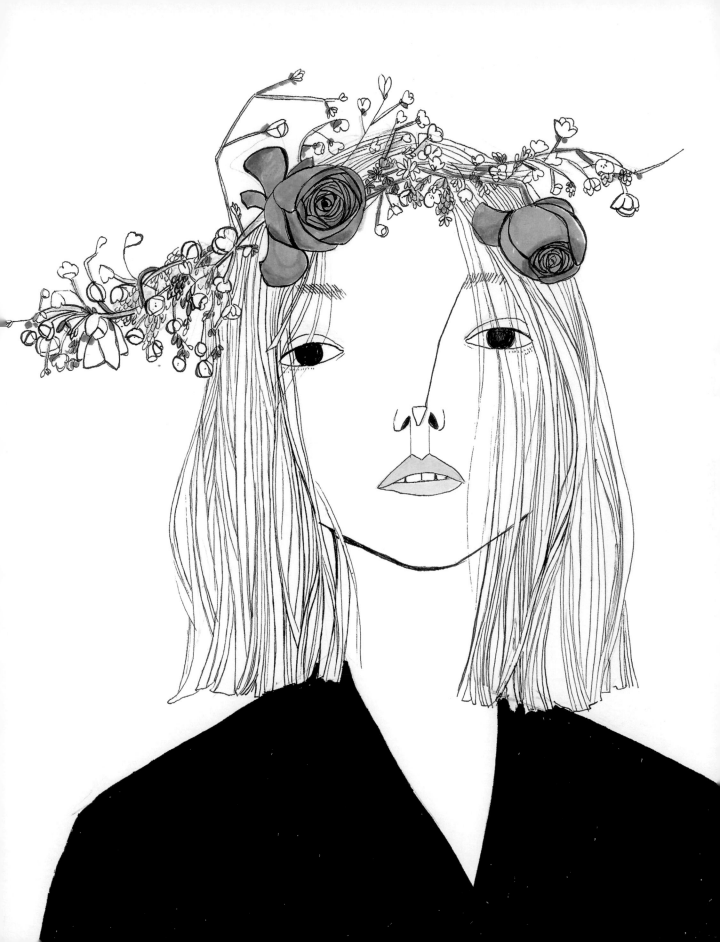

Mark T. Smith

1968 born in Wilmington, USA | lives and works in New York and Miami
www.marktsmith.com

CLIENTS
MTV, Pepsi, AT&T, Budweiser, VH-1, Taco Bell,
The Walt Disney Company, Absolut Vodka, Chrysler,
Make It Right Foundation

EXHIBITIONS
Group show, Frederick Holmes and Company Gallery, Seattle, 2013
Solo show, Contessa Gallery Gallery, Cleveland, 2010
Solo show, Contessa Gallery Gallery, Cleveland, 2009

AGENT
Richard Solomon, USA

King, 2013
Personal work; acrylic on canvas

→ 2008 Beijing Olympic Poster
for the US Olympic Team, 2008
Acrylic on canvas

"Flourishing at the intersection of Art and Commerce."

„Am Schnittpunkt von Kunst und Kommerz zu reüssieren."

«Florissant à l'intersection de l'Art et du Commerce.»

Véronique Stohrer

1977 born in Stuttgart | lives and works in Stuttgart
www.veronique-stohrer.com

CLIENTS
Grey, Gruner+Jahr, Jahreszeitenverlag, Burda, Bauer Media Group, KircherBurkhardt,
Audiomax Medien, Rewe International AG Wien, Südtirol Marketing Verlag, Mare,
Chrismon Verlag, Blonde, Stadt Stuttgart, Ritter Sport

"What really excites me about collage
is the possibility of making something
new and unexpected out of already
existing material."

„Was mich an der Collage besonders reizt,
ist die Möglichkeit, aus schon vorhandenem
Bildmaterial neues Unerwartetes
zu schaffen."

« Ce qui m'intéresse vraiment dans le
collage, c'est la possibilité de faire quelque
chose de nouveau et d'inattendu à partir
de ce qui existe déjà. »

Looking for What, 2011
Personal work; watercolor and digital

→ Wyoa, 2011
Personal work; aquarell, pen and digital

→→ Destination Blue, 2013
Arte online, displayed in Ars Electric
light box, wallpaper; collage, paint
and digital

Kera Till

1981 born in Munich | lives and works in Munich
www.keratill.com

CLIENTS
Ladurée, Vogue, Hermès, Arte,
Mercedes Benz, Tatler, Dallmayr,
Museum Villa Stuck, Biotherm, Prantl

AGENTS
Taiko & Associates, Japan
Thorsten Osterberger, Germany

"The collection of curiosities assembled by my family over the years is my most precious source of inspiration."

„Die wertvollste Inspirationsquelle ist für mich die Kuriositätensammlung, die meine Familie im Lauf der Jahre zusammengetragen hat."

« La collection de curiosités assemblée par ma famille au cours des années est ma source d'inspiration la plus précieuse. »

Amerika, 2012
Frankfurter Allgemeine
Sonntagszeitung, editorial;
digital, ink, watercolor and marker

→ Maharadscha, 2012
Prantl Stationery; marker and ink

→ → Léopard en voyage, 2012
Personal work; ink, watercolor
and digital

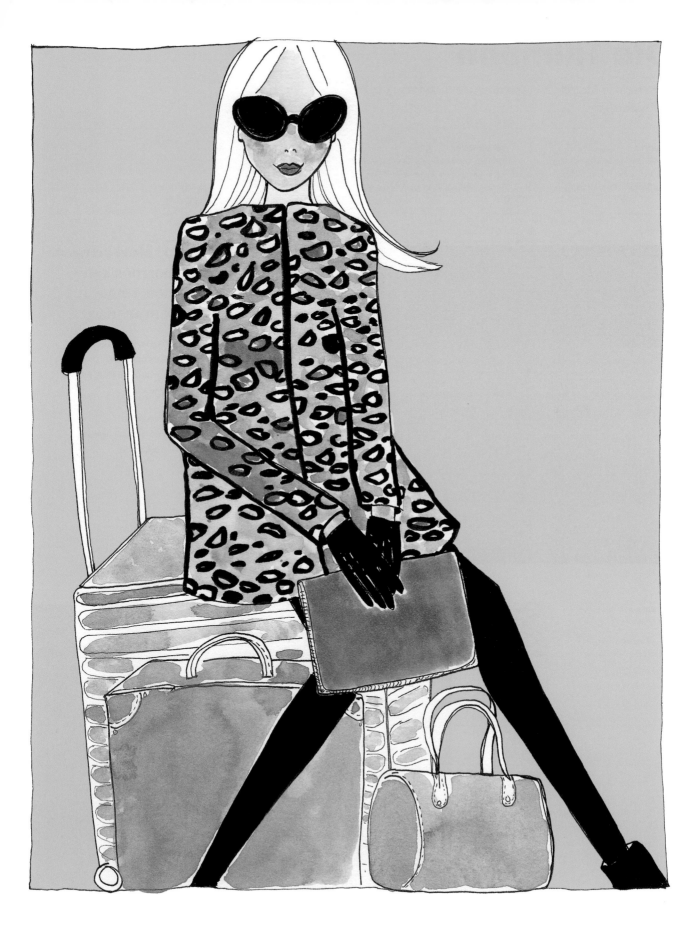

Ole Tillmann

1988 born in Meerbusch, Germany | lives and works in Providence and Berlin
www.ole-t.de

CLIENTS
Chronicle Books, Stern-Verlag,
WDR, Big New Ideas, Todd Oldham,
The Walt Disney Company

EXHIBITIONS
Wünsch Dir 'was, group show, Kulturreich Galerie, Hamburg, 2012
SILA, group show, Illustration West 49, Los Angeles, 2011
Society of Illustrators, group show, New York, 2011

"Illustration is a good blend between storytelling, collaboration and obsessive observation. I enjoy it when I can get lost in an image."

„Illustration ist eine gute Mischung von Geschichtenerzählen, Zusammenarbeit und leidenschaftlichem Beobachten. Ich mag es, mich in einem Bild zu verlieren."

« L'illustration est un bon mélange de narration, de collaboration et d'observation obsessive. J'aime quand je peux me perdre dans une image. »

Automaten Casino, 2013
Personal work; digital

→ Leviathan, 2011
Personal work; digital

→→ Phytosteroids, 2012
Chronicle Books; digital

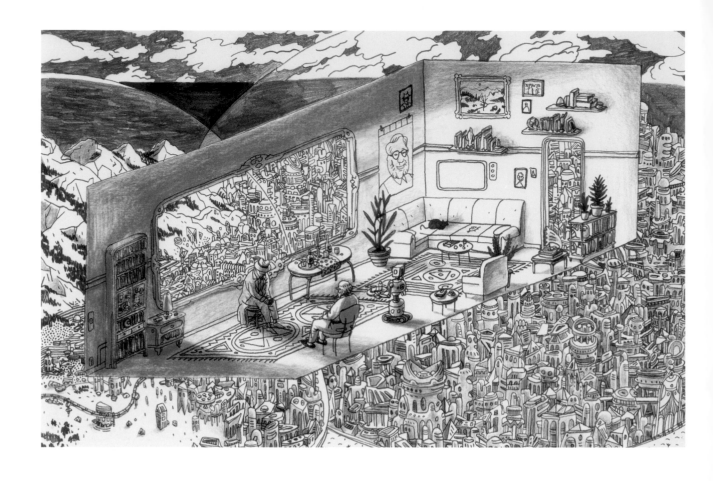

Star City 2070, 2012
Local Quarterly; digital

→ Mutter, 2013
Personal work; digital

Narcolepsy, 2012
Personal work; digital

Robert Tirado

1977 born in Caracas | lives and works in Madrid
www.roberttiradoart.com

CLIENTS
Adobe, Chivas, Harper's Bazaar Spain, Fossil,
The Telegraph, Glamour, Playboy, Oh My Cut!

EXHIBITIONS
Those Who Dream by Day, group show, Strychnin Gallery, Berlin, 2013
Line of Style—Fashion Illustration, group show, Gallery Nucleus, Alhambra, 2010
Candy Coated Canvas, group show, London Miles Gallery, London, 2009

"I'm always searching for new tools
that will give me the opportunity
to express myself as an artist willing
to reinvent myself through
experimentation."

„Ich bin ständig auf der Suche nach neuen
Mitteln, mit denen ich mich als ein Künstler
zum Ausdruck bringen kann, der sich durch
Experimentieren neu erfindet."

« Je cherche toujours de nouveaux outils
qui me permettront de m'exprimer
en tant qu'artiste prêt à me réinventer
à travers l'expérimentation. »

Blumen Schal, 2013
Personal work; watercolor,
pencil and digital

→ Life/Death, 2012
Personal work; watercolor,
pencil, collage and digital

→→ Untitled, 2013
Personal work; pencil,
watercolor, digital
and marker

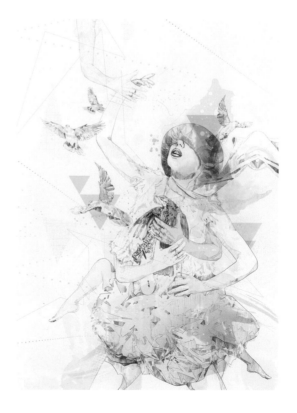

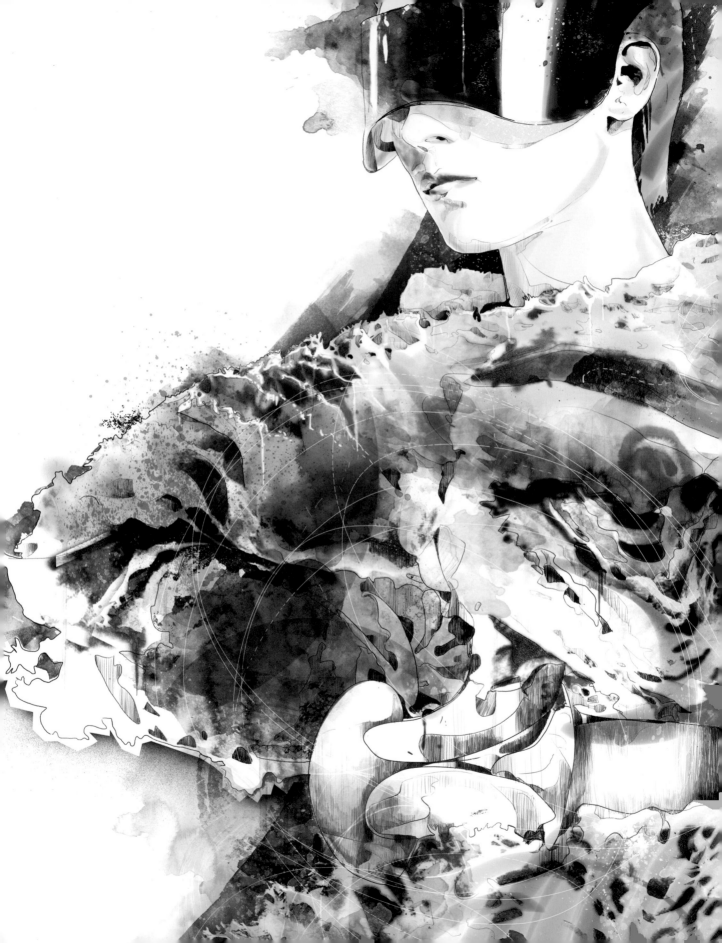

Saurabh Turakhia

1979 born in Mumbai | lives and works in Mumbai
www.heartatart.blogspot.com

CLIENT
JumboKing

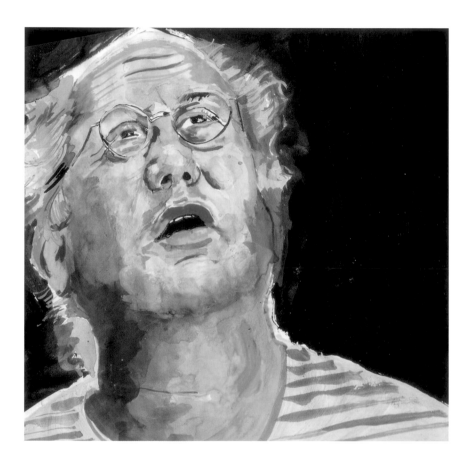

"The only belief that drives me to illustrate something
is that if I can see something, I can also replicate it.
I don't follow any method as of now."

„Mein einziges Motiv, etwas zu illustrieren, besteht darin, dass ich etwas,
das ich sehe, auch nachbilden kann. Momentan folge ich keiner
bestimmten Methode."

« La seule conviction qui me pousse à illustrer quelque chose c'est
que si je peux voir cette chose, je peux aussi la reproduire.
Je ne suis aucune méthode pour le moment. »

Why?, 2013
Personal work; watercolor

→ Maquisards, 2012
Personal work; ink

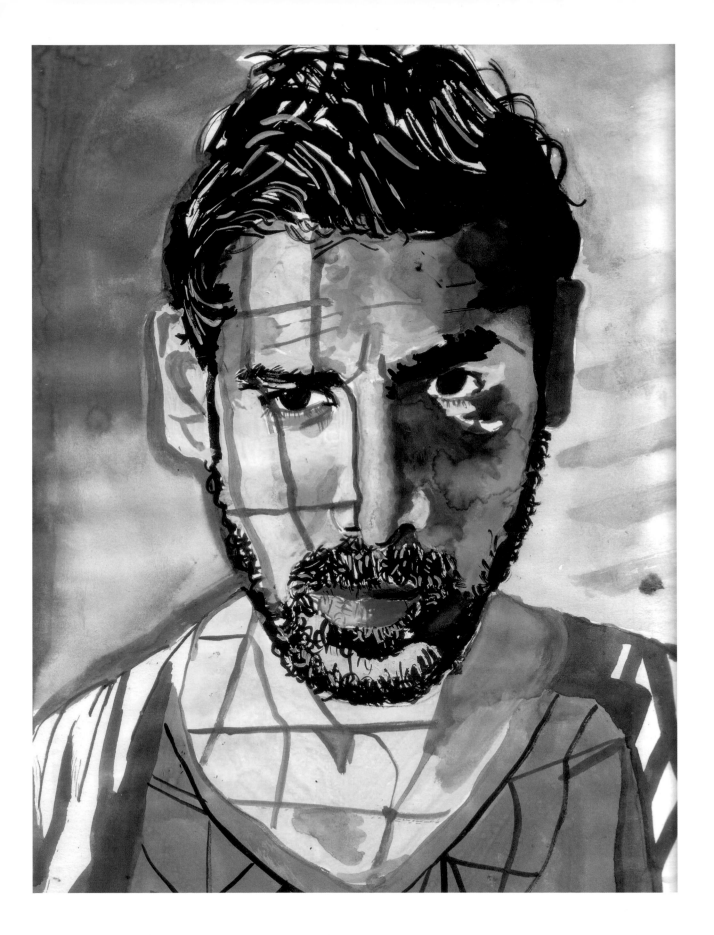

Patrick Vale

1980 born in Kingston, UK | lives and works in London
www.patrickvale.co.uk

CLIENTS
Samsung, Lexus, Fortune, Volkswagen,
Royal Institute of British Architects, BBC,
Eurostar, Virgin, The Arts Council

EXHIBITIONS
City Lines, solo show, Coningsby Gallery,
London, 2013

AGENT
Début Art, UK, USA

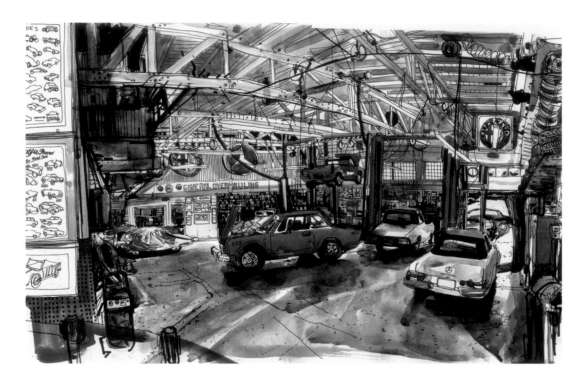

"I make work about the world around me, especially the urban environment.
I draw completely freehand and build up layer upon layer, usually with ink."

„Meine Bilder handeln von der Welt, die mich umgibt, insbesondere die urbane Welt.
Ich zeichne nur freihändig und lege eine Schicht auf die andere, meist mit Tusche."

« Mon travail traite du monde qui m'entoure, particulièrement
l'environnement urbain. Je dessine complètement à main levée et
je superpose les strates, généralement à l'encre. »

Garage, San Francisco, 2013
Personal work; ink and wash

→　Trafalgar Square, London, 2011
Personal work; ink and wash

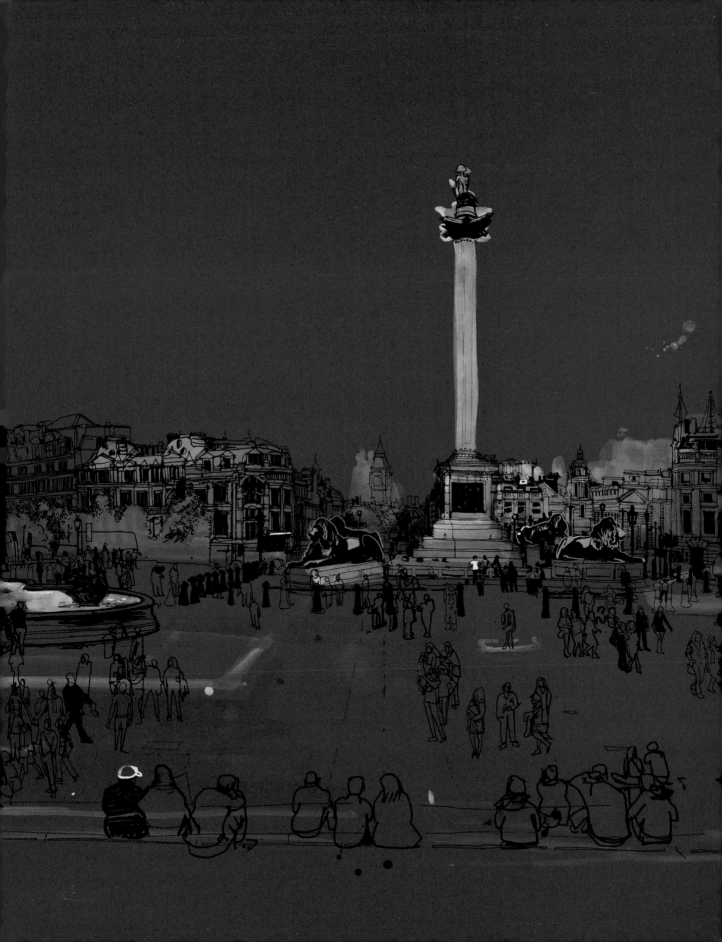

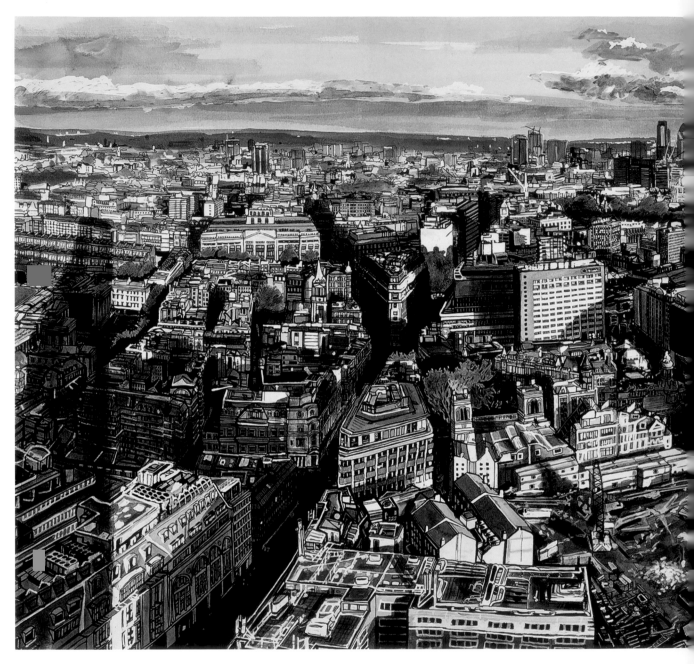

View from Centre Point, London, 2011
Personal work; ink and wash

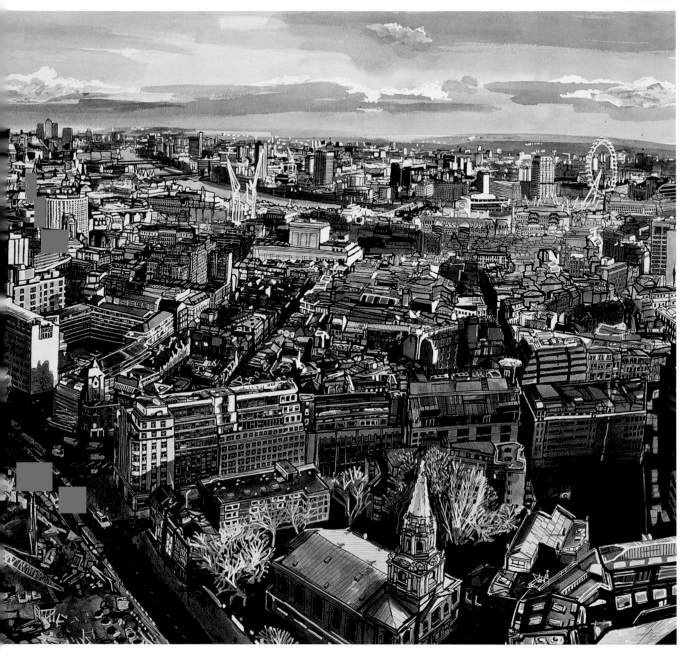

Andrea Ventura

1968 born in Milan | lives and works in Berlin
www.andreaventuraart.com

CLIENTS
Newsweek, Time, Die Zeit, Harper's
Bazaar, Farrar Straus & Giroux,
The New Yorker, The New York Times

EXHIBITIONS
Twin, solo show, Gallery Baton, Seoul, 2013
Carnevale, solo show, Gestalten Gallery, Berlin, 2013
Portraits, solo show, Oneroom, Rome, 2013

AGENT
2agenten, Germany

"The best is yet to come!..."

Portrait of Elsa Morante, 2001
Abitare, Design: Italo Lupi;
mixed media

→ **Portrait of a Soldier, 2013**
Personal work; mixed media

→→ **Portrait of Nefertiti, 2013**
Weltkunst magazine, Art Direction: Lisa
Zeitz; mixed media

Alexander Vorodeyev

1979 born in Tokmak, Ukraine | lives and works in Dnepropetrovsk, Ukraine
www.alexvorodeyev.com

CLIENTS
Billboard Russia, Kommersant FM, Men's
Health Russia/Ukraine, CEO, Art Culinaire,
Harvard Business Review, Eristoff, Treazures of Oz

EXHIBITIONS
COW International Design Festival, group show,
Dnepropetrovsk, 2011

AGENT
Bang! Bang! Studio,
Russia

"While creating my images I always keep the aim of preserving
the vitality of comics as well as the vivid detailing of engraving.
Between comics and engraving."

„Ich bemühe mich ständig darum, die Lebendigkeit von Comics und gleichzeitig
die Detailfülle von Radierungen zu bewahren. Zwischen Comics und Radierungen."

« Quand je crée mes images j'essaie toujours de conserver la vitalité des bandes
dessinées ainsi que les détails précis de la gravure. Entre BD et gravure. »

Business School, 2013
CEO magazine; hand-drawn,
scratchboard and digital

→ Model, 2012
Personal work; brush, ink and gouache

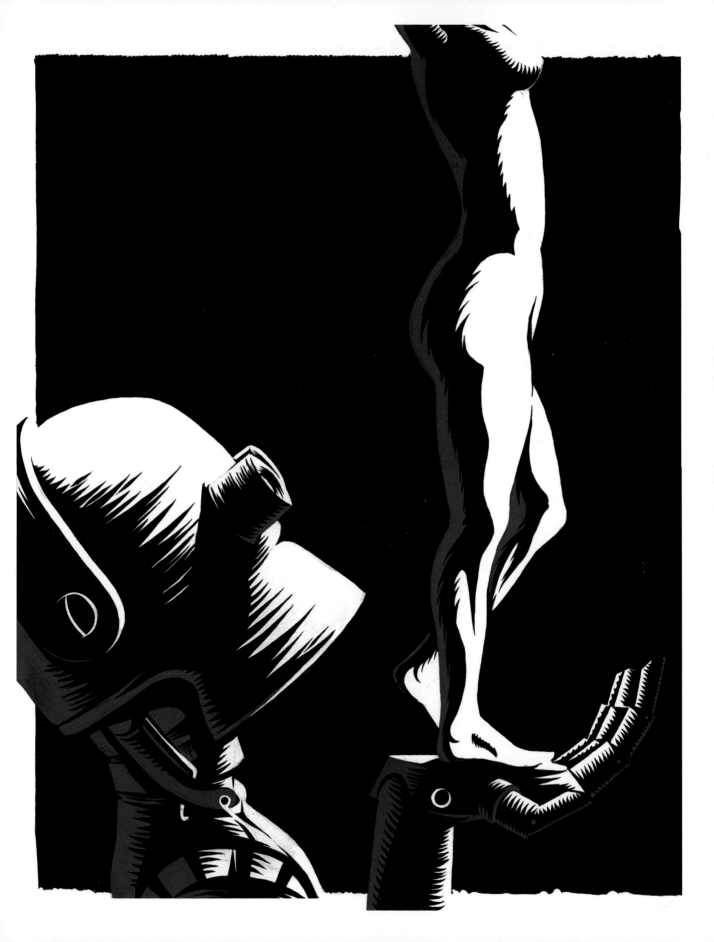

Holly Wales

1983 born in Worcester, UK | lives and works in London
www.hollywales.com

CLIENTS
Frieze Art Fair, Nintendo, Esquire, Urban Outfitters,
GQ, Uniqlo, Film4, The New York Times, V&A,
Jamie Oliver, Wieden+Kennedy

EXHIBITIONS
Film 4 Summer Screen, group show, Somerset House, London, 2013
PWEKKA, group show, Wieden+Kennedy, Amsterdam, 2013
Secret Blisters, group show, Print Club London, London, 2009

AGENT
Agent Pekka, Finland

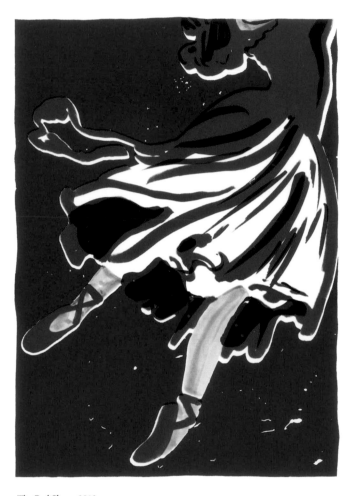

"My work explores a variety of
subject matter and is predominantly
drawing-based. I work with multiple
layers of color to highlight
moments in time."

„In meinen Arbeiten, vorwiegend im
Zeichenmedium, geht es um verschiedenste
Themen. Ich arbeite mit vielen Farbschichten,
um einen bestimmten Moment festzuhalten."

« Mon travail explore différents thèmes et
se base principalement sur le dessin.
Je travaille en multiples strates de couleur
pour souligner des instants isolés. »

The Red Shoes, 2013
Film 4 Summer Screen; hand-drawn
and screenprint

→ Hill Top Motel, 2011
Personal work; hand-drawn and
risograph print

→→ Launderette, 2013
Personal work; hand-drawn and
screenprint

Sarah Walton

1985 born in Harrogate, UK | lives and works in Manchester
www.sewsarahwalton.com

CLIENT
Hudd Traxx

EXHIBITIONS
Creative ID, group show, Great Yorkshire Show, Harrogate, 2013
Sarah Walton, solo show, Frog, Manchester, 2011

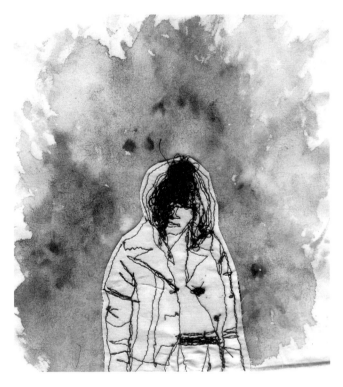

"I make embroidered illustrations on my sewing machine using the thread as a pencil to create whimsical scenes of everyday life."

„Ich mache auf meiner Nähmaschine gestickte Illustrationen, der Faden fungiert als Stift, mit dem ich kleine Alltagsszenen festhalte."

« Je fais des illustrations brodées sur ma machine à coudre en utilisant le fil comme un crayon pour créer des scènes fantasques de la vie quotidienne. »

Colour Splash, 2008
Personal work; mixed media

→ Old Lady, 2008
Personal work; mixed media

→ → Colour Ray Girl, 2010
Personal work; mixed media

Angie Wang

1986 born in Shanghai | lives and works in Los Angeles
www.okchickadee.com

CLIENTS
The New York Times, The New Yorker, Macmillan, GQ,
Escada, Houghton Mifflin Harcourt, Cartoon Network,
Criterion Collection, Lucky Peach, Nylon Magazine

EXHIBITIONS
Glades and Ragged Underwoods, group show,
Compound Gallery, Portland, 2012

"My interest is in narrative and
emotional approaches to illustration,
rendered in a mixed-media and
watercolor-wash style."

„Ich interessiere mich für das Narrative und
Emotionale in Illustrationen, die ich aus
Mixed Media und lavierten Wasserfarben herstelle."

« Je m'intéresse aux démarches narratives
et émotionnelles de l'illustration, travaillées
en technique mixte et en lavis d'aquarelle. »

Koh Do Scent Memory, 2013
WW No. 5; watercolor, pencil,
ink and digital

→ **Kiss, 2013**
Portland Mercury; watercolor,
pencil, ink and digital

→→ **Under The Covers, 2013**
Personal work; watercolor,
pencil, ink and digital

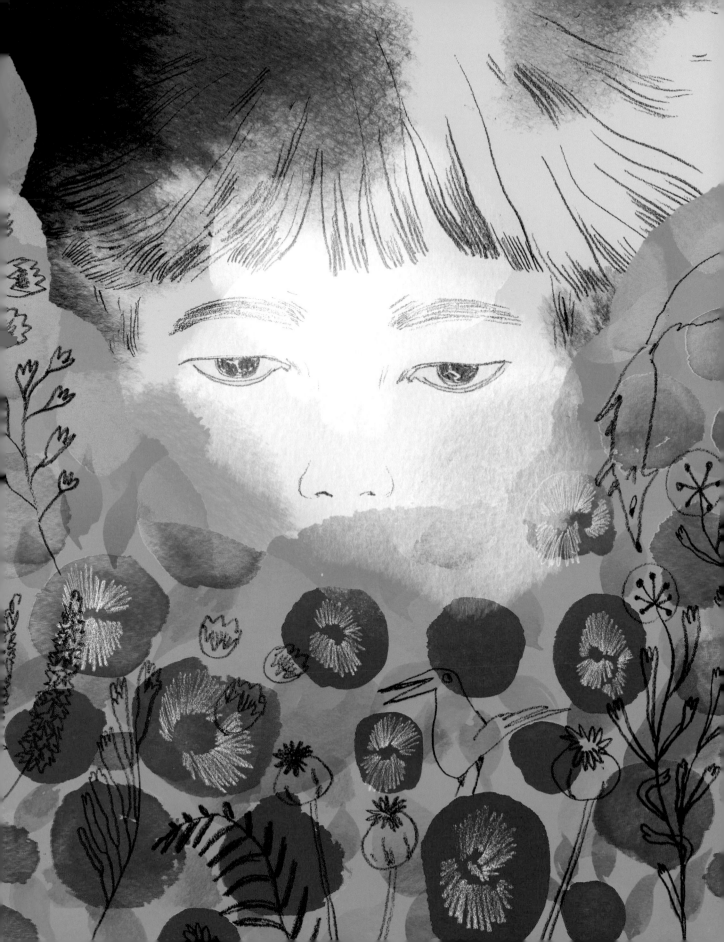

Tempus Est Iocundum, 2013
Personal work; watercolor, ink,
pencil, and digital

→ Depression, 2012
New York Times; watercolor,
ink, pencil and digital

↓ Untitled, 2013
San Francisco Chronicle; pencil,
watercolor, ink and digital

Zhang Weber

1974 born in Beijing | lives and works in Shanghai
www.illustrationweb.com/artists/WeberZhang/view

CLIENTS
Martell, E.P., Anta Sports, Autodesk

EXHIBITIONS
Game&Comic Art Exhibition, group show, Shanghai, 2012
4th Korea Illustration Exhibition, group show, Daejeon, 1997

AGENTS
Illustrationweb, China
Ubies, Japan

"Pencils, watercolors, Adobe Photoshop and Autodesk SketchBook."

„Farbstifte, Wasserfarben, Adobe Photoshop und Autodesk SketchBook."

« Crayons, aquarelle, Adobe Photoshop et Autodesk SketchBook. »

Smile When We Say Bye, 2011
Personal work; pencil and digital

→ **Breath You Take, 2013**
Personal work; pencil and digital

Ellen Weinstein

1939 born in New York | lives and works in New York
www.ellenweinstein.com

CLIENTS

The Atlantic, The New York Times, NPR, Houghton
Mifflin Harcourt, Georges Duboeuf Wine, Nautilus,
Mastercard Advisors, Time, Plansponsor

EXHIBITIONS

Faculty Exhibition, group show, Rhode Island School of Design, Providence, 2013
Society of Illustrators Annual, group show, New York, 2012
The Cannonball Lady, group show, Cassa di Risparmio di Venezia, Venice, 2011

"My work goes back and forth between digital and more
traditional elements but the essence of it is the idea
and what I want to convey."

„Bei der Arbeit variiere ich digitale und traditionellere Elemente,
aber das Wesentliche sind die Idee und das, was ich zum
Ausdruck bringen möchte."

« Mon travail va et vient entre le numérique et les éléments
plus traditionnels, mais son essence se trouve dans
l'idée et dans ce que je veux exprimer. »

Dream On, 2013
JW Marriott, Art Direction: Rob Smith;
gouache and collage

→ The Unbelievers, 2011
The New York Times, Art Direction:
Barbara Richter; gouache and collage

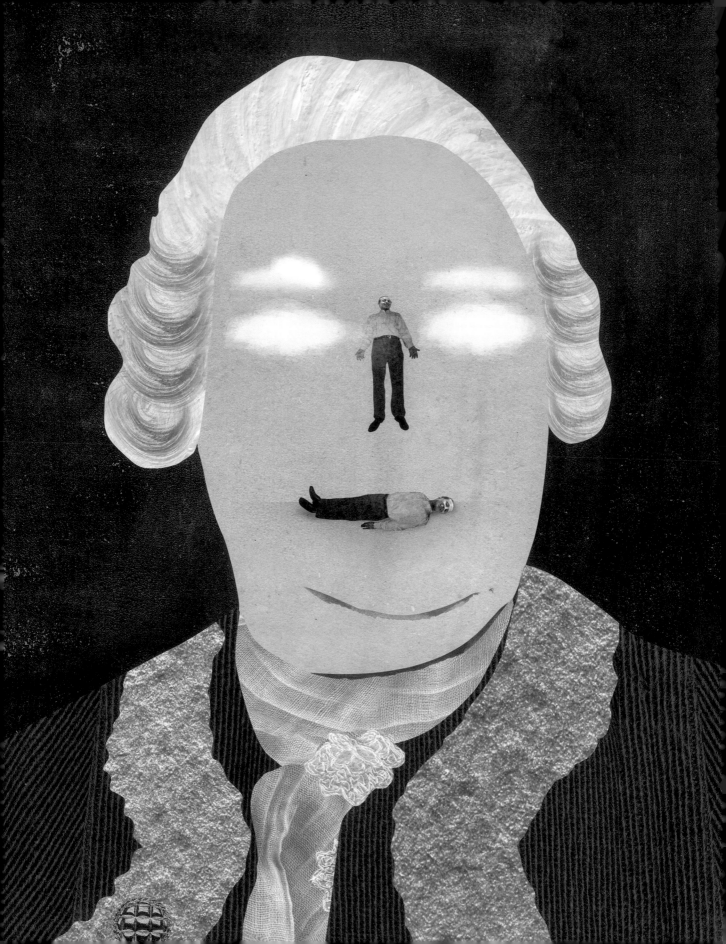

Arab Spring, 2011
Barnard, Art Direction: Anna Nozaki;
gouache and collage

← **Of Miracles, 2013**
Nautilus, Art Direction: Len Small;
gouache and collage

↓ **A Dance for Japan, 2011**
Personal work; gouache and collage

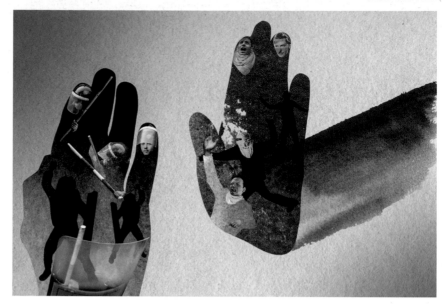

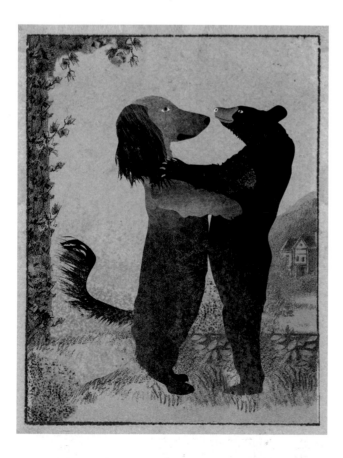

Dave White

1971 born in Liverpool | lives and works in Beaminster, UK
www.davewhiteart.com

CLIENTS
Nike, Jordan, Coca-Cola,
AOL, Microsoft, Red Bull

EXHIBITIONS
MTV Redefine, group show, Goss Michael Foundation, Dallas, 2012
Natural Selection, solo show, Hospital Club Gallery, London, 2012
Project on Creativity, group show, New Museum of Contemporary Art,
New York, 2010

AGENT
Début Art, UK

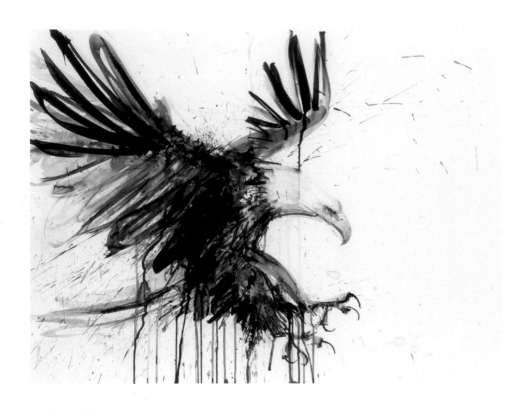

"My work has always been spontaneous and dynamic,
a fine balance between order and chaos, giving life
and energy to all I depict."

„Meine Arbeiten sind spontan und dynamisch, eine ausgewogene
Mischung von Ordnung und Chaos, sodass alles, was ich abbilde,
lebendig ist und Schwung hat."

« Mon travail a toujours été spontané et dynamique,
un équilibre délicat entre ordre et chaos, qui insuffle vie
et énergie à ce que je veux représenter. »

Eagle, 2011
AOL; watercolor

→ Orangutan, 2012
Personal work; oil on linen

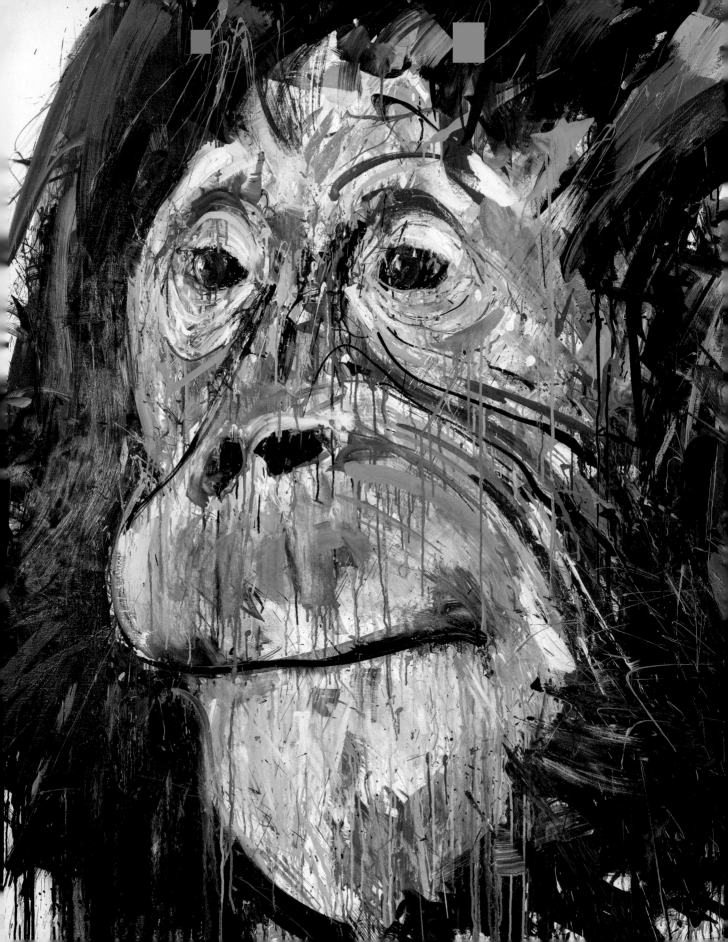

Richard Wilkinson

1972 born in London | lives and works in Brighton
www.richard-wilkinson.com

CLIENTS
New Scientist, Intelligent Life, Saatchi & Saatchi,
Lowe, HarperCollins, Der Spiegel, Penguin, TBWA,
Time, BBH, Honda, The Telegraph, Random House

AGENT
Central Illustration Agency, UK

"I try to create images that communicate
in the two seconds most readers give
them, but also reward the one reader
who stops to explore them."

„Ich möchte immer, dass meine Bilder ihre
Botschaft in den zwei Sekunden vermitteln,
die die meisten Leser ihnen zugestehen,
dass sie aber auch den einen Leser befriedigen,
der sie genauer studiert."

« J'essaie de créer des images qui communiquent
dans les deux secondes que la plupart des
lecteurs leur consacrent, mais je récompense
aussi ceux qui s›attardent pour les explorer. »

The Birds and the Bees, 2008
The Telegraph Magazine, Art Direction:
Danielle Campbell; digital

→ **Dyslexia, 2008**
The Telegraph Magazine, Art Direction:
Danielle Campbell; digital

→ → **Evolution in the Fast Lane, 2011**
New Scientist, magazine cover, Art
Direction: Craig Mackie; digital

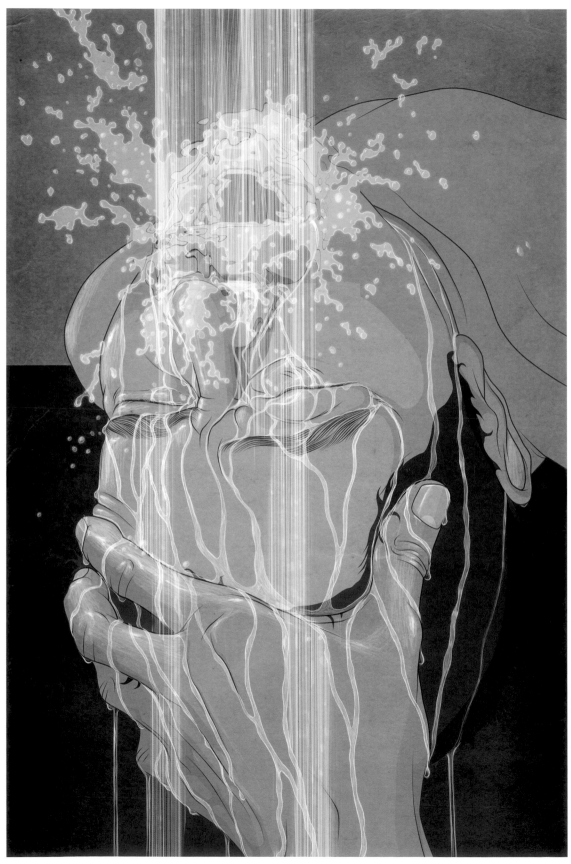

I'm So Sorry … Your Son …, 2011
Intelligent Life, series Breaking Bad
News, Art Direction: Graham Black;
digital

→ **We Did All We Could, 2011**
Intelligent Life, series Breaking Bad
News, Art Direction: Graham Black;
digital

← **Waterboarding, 2009**
HarperCollins / Harper Voyager,
book Little Brother, Art Direction:
Chris Michaels; digital

Ben Wiseman

1986 born in Lexington, USA | lives and works in Brooklyn
www.benwiseman.com

CLIENTS

The New York Times, Travel+Leisure, Le Monde,
Chandon, Variety, Golf Digest, Der Spiegel, Real
Simple, ESPN, Lucky Brand, Random House, Penguin

Living Separately, 2013
The New York Times; digital

→ **Working & Women, 2012**
The New York Times; digital

→→ **How to Get Through
TSA Faster, 2013**
Travel+Leisure; digital

"I often find that the smartest
solution is the simplest."

„Ich stelle immer wieder fest, dass
die einfachste Lösung oft die beste ist."

« Je trouve souvent que la solution
la plus intelligente est la plus simple. »

Last Minute Travel, 2012
Travel+Leisure; digital

↗ Sunday in the Park, 2012
The New York Times; digital

→ You Can Only Hope
to Contain Them, 2013
ESPN; digital

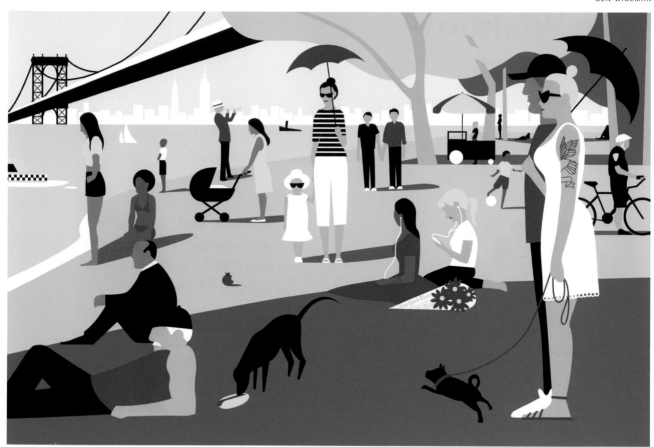

Pam Wishbow

1987 born in Seattle | lives and works in Seattle
www.pamwishbow.com

CLIENTS
Newcity, Skullastic, Kurt Vonnegut
Memorial Library, You and Who

EXHIBITIONS
Banned Books Recovered, group show, Kurt Vonnegut Memorial Library, Indianapolis, 2013
Solo show, Greyhouse, West Lafayette, USA, 2012
Dodgeball. Street and Playground Games, group show, Associazione Culturale
Teatrio, Venice, 2009

AGENT
Illo Zoo, USA

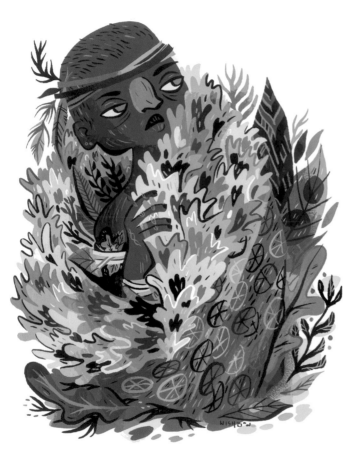

"Colorful work for those who
are ham-handed, near-sighted
and blunt. I want to create
a world I want to live in."

„Farbenfrohe Bilder für alle Ungeschickten,
Kurzsichtigen und Unverblümten.
Ich versuche, eine Welt zu schaffen, in
der ich selbst gerne leben würde."

« Du travail coloré pour ceux qui ont la
main lourde, la vue basse et les sens
émoussés. Je veux créer un monde
où j'aimerais vivre. »

Huntress, 2013
Personal work; ink and digital

→ **Telltale Signs, 2013**
Personal work; ink and digital

→→ **Hunted, 2013**
Personal work; ink and digital

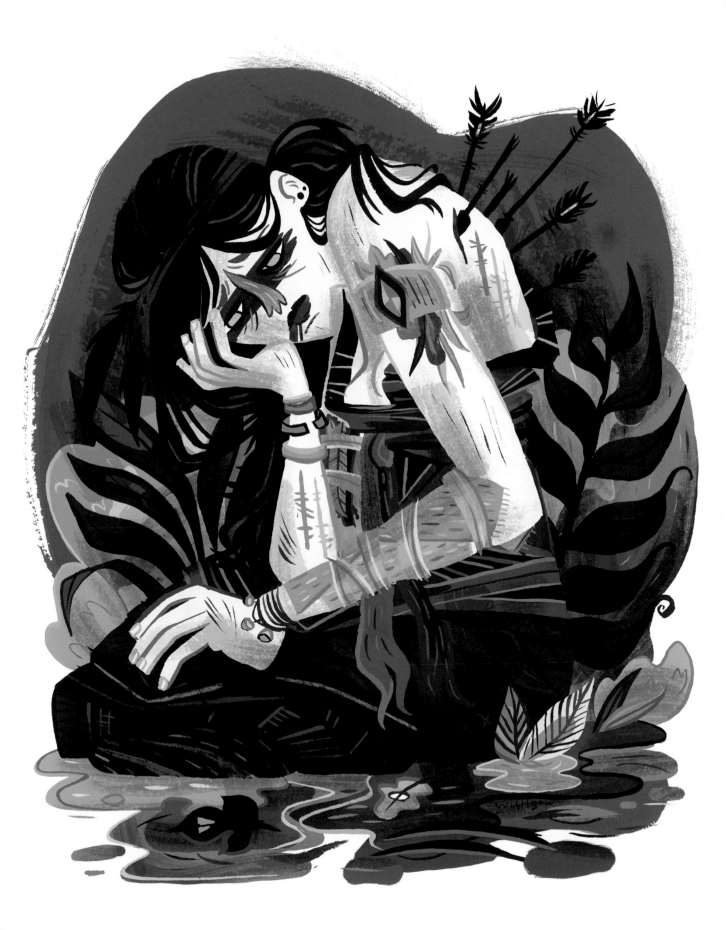

Wishcandy

born in Fayetteville, USA | lives and works in Los Angeles
www.wishcandy.net

CLIENTS
Solestruck, Domestic Etch, Giant
Robot, Bear & Bird Boutique + Gallery

EXHIBITIONS
Draw, group show, Auguste Clown Gallery, Melbourne, 2013
Printed Matter 8, group show, Giant Robot, Los Angeles, 2012
Monsterbation, group show, Pony Club Gallery, Portland, 2010

"A candy-coated horror show inspired by life,
horror, street fashion and kitsch."

„Eine vom Leben, Horror, Street Fashion und Kitsch
inspirierte, mit Zuckerguss glasierte Horrorshow."

« Un cirque des horreurs nappé de caramel,
inspiré par la vie, l'horreur, la mode
de la rue et le kitsch. »

Awwwkward, 2011
Personal work; mixed media

← Nerves, 2012
Personal work; mixed media

→ Secret Ambition, 2013
Personal work; mixed media

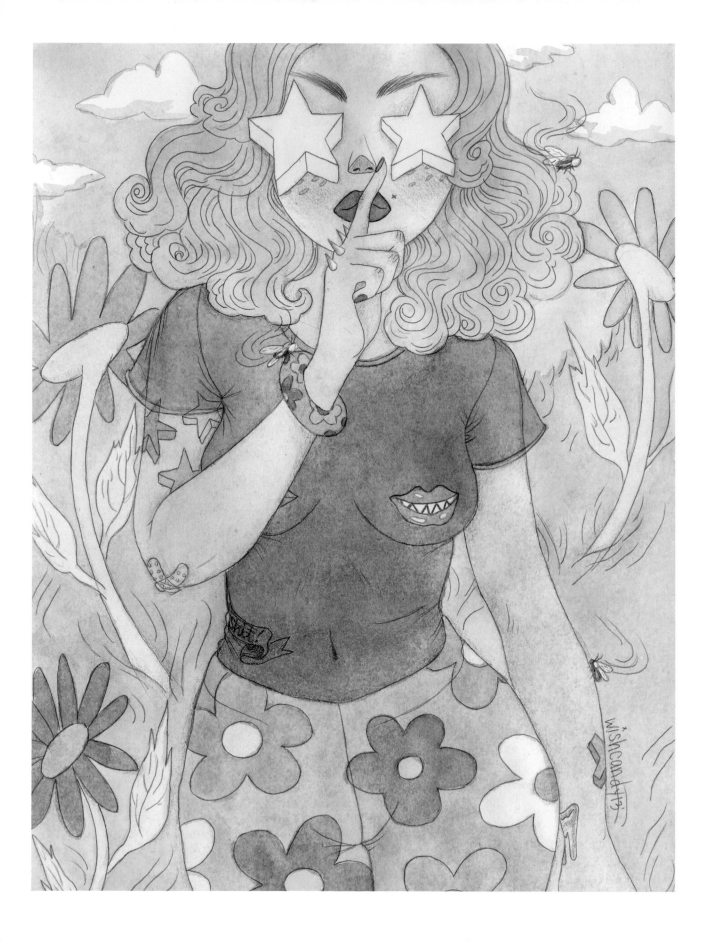

Andy Yang

1973 born in Batu Pahat, Malaysia | lives and works in Singapore
www.andyyangillustrates.wordpress.com

EXHIBITIONS
Abstract Innovation, group show, One East Asia Artspace, Singapore, 2013
Passions, solo show, Shots Gallery, Singapore, 2012
Emotions, solo show, Instinc Space, Singapore, 2011

"Always read and understand the brief properly. Research and gather as many references as are needed for the project. Experiment with different media."

„Die Projektbeschreibung immer genau durchlesen und verstehen. So viele Verweise wie möglich recherchieren und zusammentragen. Mit verschiedenen Medien experimentieren."

« Lisez et comprenez la mission correctement. Faites des recherches et rassemblez autant de références que nécessaire. Expérimentez avec différentes techniques. »

Bad Hair Day and Big Butt, 2011
Breast Cancer Foundation Singapore,
poster Are You Obsessed with the Right
Things?, Agency: DDB Worldwide,
Singapore, Photography: Allan Ng
Republic Studios; kryolan grease
paint on skin

→→ **Planes, 2013**
F&N Magnolia, Smart Kids Campaign,
Agency: Publicis Singapore, ; digital

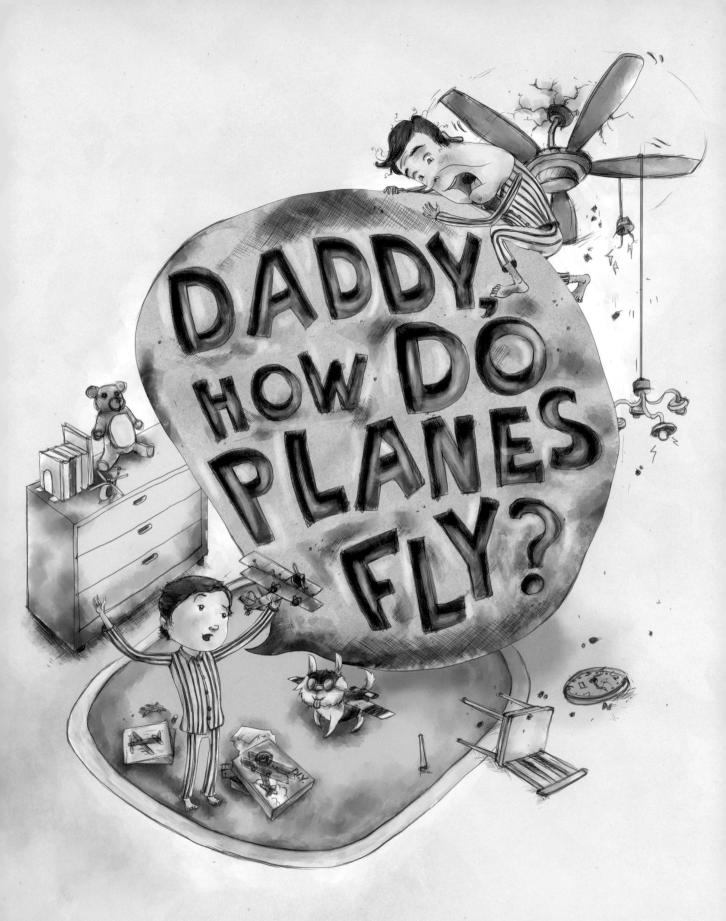

Ping Zhu

1988 born in Seattle | lives and works in Brooklyn and Los Angeles
www.pingszoo.com

CLIENTS
The New York Times, New Yorker,
Nobrow Press, Pentagram, Plansponsor,
Printed Pages, Royal BC Museum

EXHIBITIONS
Pick Me Up, group show, Somerset House, London, 2013
The Parisianer, group show, Cité Internationale des Arts, Paris, 2013
Young Guns 11, group show, Art Directors Club, New York, 2013

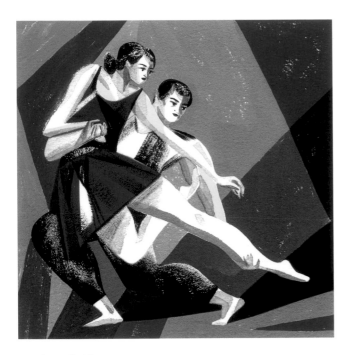

"To capture dimension and gesture. Avoid redundancies and contribute meaningful ideas rather than succumb to trends. Work is play and play is work."

„Dimension und Gestik vermitteln. Überflüssiges vermeiden, lieber gehaltvolle Ideen beitragen, als Trends zu folgen. Arbeit ist Spiel, und Spiel ist Arbeit."

« Saisir la dimension et le geste. Éviter les redondances et apporter des idées intéressantes plutôt que succomber aux tendances. Travailler c'est jouer, et jouer c'est travailler. »

American Ballet Theatre, 2013
The New Yorker, Art Direction:
Jordan Awan; gouache on paper

→ **Away, 2013**
Personal work; gouache on paper

→→ **Sorting, 2013**
Plansponsor, Art Direction:
SooJin Buzelli; gouache on paper

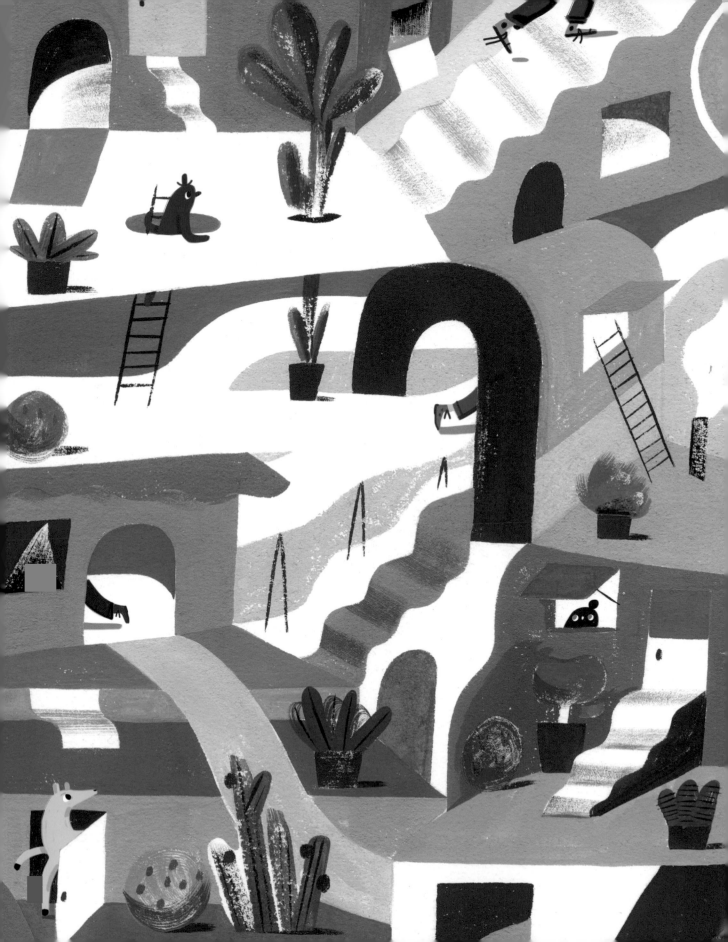

Lynnie Zulu

1988 born in Dumfries, UK | lives and works in London
www.lynniezulu.com

CLIENTS
V&A Museum of Childhood,
Sony Music, Thames & Hudson,
Fanny & Jessy, Peek & Cloppenburg

EXHIBITIONS
Pick Me Up, group show, Somerset House, 2014
Jungle Fever, solo show, Something in the Attic, London, 2013
Rumble in the Jungle, group show, Ridley Road Market Bar,
London, 2013

AGENT
Central Illustration Agency, UK

"It is important to me that my illustrations have energy, spontaneity and most important of all, personality."

„Mir kommt es darauf an, dass meine Illustrationen spontan und voller Energie sind, und vor allem, dass sie eine Persönlichkeit haben."

«Pour moi il est important que les illustrations aient de l'énergie, de la spontanéité, et surtout de la personnalité.»

The Boxer, 2012
Personal work; ink

→ Women of the Jungle, 2013
Something in the Attic, exhibition;
paint, pens and ink

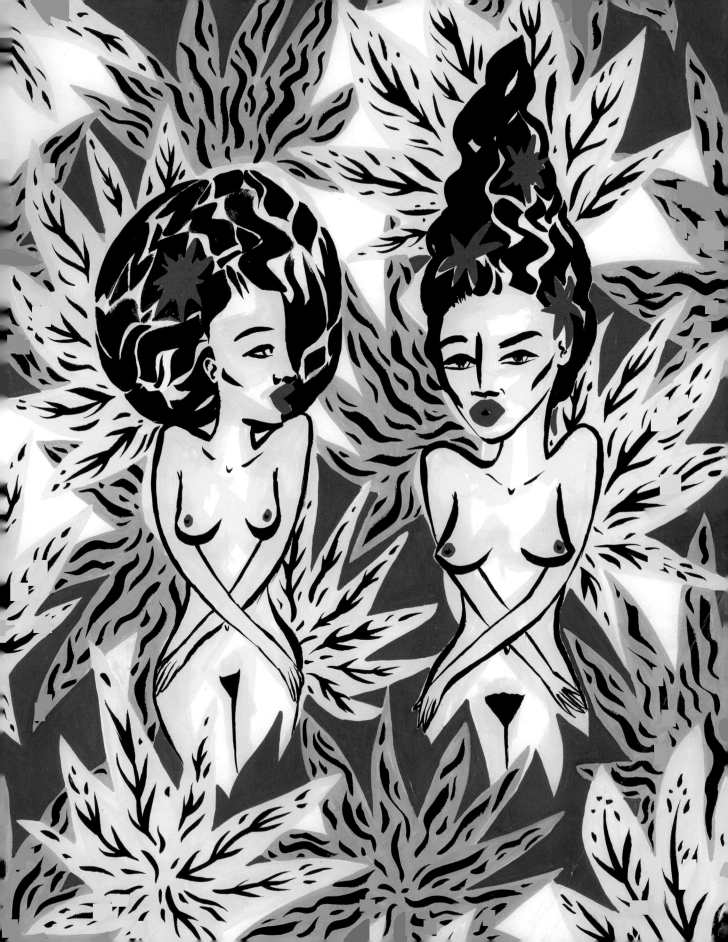

Agents Index

2agenten
Germany
2agenten.com
Maren Esdar, 146
Carmen Segovia, 378
Andrea Ventura, 408

Agent 002
France
agent002.com
Cachetejack, 88
Sophie Robert, 350

Agent Bauer
Sweden
agentbauer.com
Clara Aldén, 36

Agent Molly & Co.
Sweden
agentmolly.com
Lina Bodén, 62
Malin Rosenqvist, 360

Agent Pekka
Finland
agentpekka.com
Ugo Gattoni, 176
Owen Gildersleeve, 182
Jack Hughes, 208
Tim Lahan, 260
Sac Magique, 370
Holly Wales, 412

Alison Eldred
UK, USA
alisoneldred.com
Paul Cox, 116

Anna Goodson
Canada
agoodson.com
Emma Hanquist, 196
Mágoz, 278

Bang! Bang! Studio
Russia
bangbangstudio.ru
Alexander Vorodeyev, 410

Bernstein & Andriulli
UK, USA, China
ba-reps.com
Stanley Chow, 102
Dan Craig, 118
Nathan Fox, 156
Nomoco, 316

Big Active
UK
bigactive.com
Adrian Johnson, 224

b.m-r fotografen
Switzerland
bmr-fotografen.ch
Catell Ronca, 356

Caroline Seidler
Austria
carolineseidler.com
Sarah Egbert Eiersholt, 132

**Central Illustration
Agency**
UK
centralillustration.com
Christopher Brown, 72
Jill Calder, 92
Stanley Chow, 102
Elzo Durt, 130
Jakob Hinrichs, 206
Chris Kasch, 236
Richard Wilkinson, 428
Lynnie Zulu, 444

Coates and Scarry
UK
coatesandscarry.com
Deedee Cheriel, 126

CWC-Tokyo
Japan
cwctokyo.com
Lina Bodén, 62

Début Art
UK, USA
debutart.com
Pablo Bernasconi, 54
Russell Cobb, 108
Yann Legendre, 268
Patrick Vale, 404
Dave White, 426

Dutch Uncle
UK
dutchuncle.co.uk
Noma Bar, 46

EW Agency
UK
ew-agency.com
Eiko Ojala, 328

Fabulous Noble
UK
fabulousnoble.com
Robert Nippoldt, 312

Folio
UK
folioart.co.uk
Ricardo Bessa, 58
Ellakookoo, 140

Friend + Johnson
USA
friendandjohnson.com
Jill Calder, 92

Galerie Claude Lemand
France
claude-lemand.com
Youssef Abdelké, 26

Galerie St. Etienne
USA
gseart.com
Sue Coe, 110

Galerie Tanit, Beirut
Lebanon
galerietanit.com
Youssef Abdelké, 26

Garance
USA
garance-illustration.com
Gwendal Le Bec, 266
Jérémy Schneider, 374

Gerald & Cullen Rapp
USA
rappart.com
Jakob Hinrichs, 206

Handsome Frank
UK
handsomefrank.com
Malika Favre, 154

Heart
UK, USA
heartagency.com
Yann Kebbi, 240
Adam Simpson, 384

Heflinreps
UK, USA
heflinreps.com
Jared Schorr, 376

Hilde Agency
France
hildeagency.com
Toril Bækmark, 44

Illo
Poland
illo.pl
Agata Nowicka, 324

Illo Zoo
International
illozoo.com
T. Dylan Moore, 300
David de Ramón, 346
Matthias Seifarth, 380
Pam Wishbow, 436

Illustrationweb
International
illustrationweb.com
Zhang Weber, 420

Illustrissimo
France
illustrissimo.fr
Gwénola Carrère, 100
Yann Kebbi, 240
Gwendal Le Bec, 266

John Brewster Creative
USA
brewstercreative.com
Peter Donnelly, 128

Kate Ryan
USA
kateryaninc.com
Katy Smail, 388

Kombinatrotweiss
Germany
kombinatrotweiss.de
Roya Hamburger, 194
Matthias Seifarth, 380

La Suite
France
lasuite-illustration.com
Ellakookoo, 140
Eiko Ojala, 328

La Superette
France
lasuperette.com
Elzo Durt, 130

**Levy Creative
Management**
USA
levycreative.com
Rory Kurtz, 254
Zé Otavio, 336

Lezilus
France
lezilus.fr
Ugo Gattoni, 176

Magnet Reps
USA
magnetreps.com
Yelena Bryksenkova, 76
Jungyeon Roh, 354
Catell Ronca, 356

Margarethe Hubauer
Germany
margarethe-illustration.com
Cachetejack, 88

Marlena Agency
USA
marlenaagency.com
Agata Nowicka, 324
Carmen Segovia, 378

Mashrabia Art Gallery
Egypt
*facebook.com/pages/
mashrabia-gallery/
313299652141518*
Youssef Abdelké, 26

Merry Karnowsky Gallery
USA
mkgallery.com
Deedee Cheriel, 126

Morgan Gaynin Inc.
USA
morgangaynin.com
Paul Garland, 174

MP Arts
UK
mp-arts.co.uk
Owen Gildersleeve, 182

NU Agency
Sweden
nuagency.se
Beata Boucht, 68
Jonna Fransson, 158

Peppercookies
UK
peppercookies.com
Lisa Billvik, 60
Lina Bodén, 62
Sarah Egbert Eiersholt, 132

Pippin Properties
USA
pippinproperties.com
James McMullan, 286

Pocko
UK, USA
pocko.com
Nomoco, 316

Red Ape Design
Australia
redape.com.au
Peter Donnelly, 128

Red Propeller
UK
redpropeller.co.uk
Russ Mills, 290

Richard Solomon
USA
richardsolomon.com
Paul Cox, 116
Thomas Ehretsmann, 134
Gary Kelley, 244
Edward Kinsella, 248
Gregory Manchess, 282
Mark T. Smith, 390

Rocket Sloth
Canada
rocketsloth.com
Ricardo Bessa, 58

Scott Hull Associates
USA
scotthull.com
Meg Hunt, 216

Shannon Associates
USA
shannonassociates.com
Pablo Bernasconi, 54

Snyder & The Swedes
USA
snydernewyork.com
Lisa Billvik, 60

Söderberg Agentur
Sweden
soderbergagentur.com
Mattias Adolfsson, 30

Taiko & Associates
Japan
ua-net.com/taiko
Natsuki Camino, 96
Kera Till, 394

Talkie Walkie
France
talkiewalkie.tw
Jules Le Barazer, 264
Jérémy Schneider, 374

The Illustration Room
Australia
illustrationroom.com.au
Cachetejack, 88

The Loud Cloud
USA
theloudcloud.com
Justin Gabbard, 166

The Mushroom Co.
Spain
mushroom.es
David de Ramón, 346

The Overall Picture
Australia
overallpicture.com
Emma Hanquist, 196
David de Ramón, 346

Thorsten Osterberger
Germany
thorstenosterberger.com
Kera Till, 394

**Traffic Creative
Management**
USA
traffic-nyc.com
Maren Esdar, 146

Ubies
Japan
ubies.net
Zhang Weber, 420

Unit
Netherlands
unit.nl
Maren Esdar, 146

Urban Arts
Brazil
urbanarts.com.br
Diogo Machado, 274

Woo Agentur
Sweden
woo.se
Sac Magique, 370

YCN Talent Agency
UK
ycntalentagency.com
Jack Hughes, 208

© 2014 TASCHEN GmbH
Hohenzollernring 53, D-50672 Köln
www.taschen.com

To stay informed about TASCHEN and our upcoming titles,
please subscribe to our free magazine at www.taschen.com/magazine,
download our magazine app for iPad, follow us on Twitter and
Facebook, or e-mail your questions to contact@taschen.com.

EDITOR IN CHARGE
Julius Wiedemann

EDITORIAL COORDINATION
Daniel Siciliano Bretas
Nora Dohrmann

DESIGN
Daniel Siciliano Bretas
Nora Dohrmann

PRODUCTION
Frauke Kaiser

ENGLISH REVISION
Chris Allen

GERMAN TRANSLATION
Ursula Wulfekamp for Grapevine Publishing Services, London

FRENCH TRANSLATION
Aurélie Daniel for Delivering iBooks & Design, Barcelona

Printed in Italy
ISBN 978-3-8365-4528-0

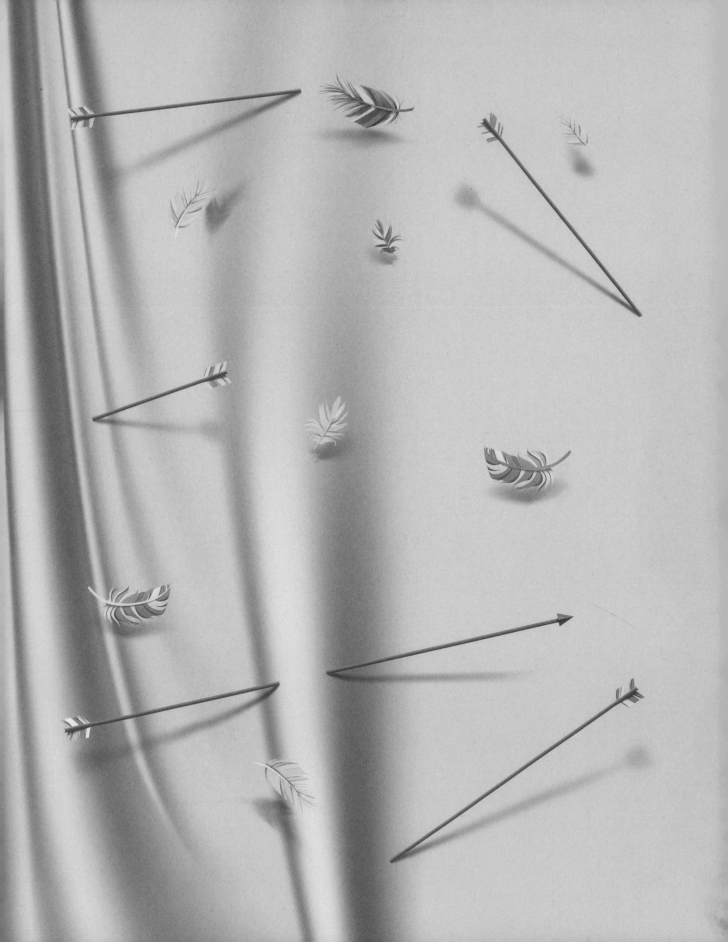